P9-DDG-558

24 DAYS

24 DAYS

How Two *Wall Street Journal* Reporters Uncovered the Lies That Destroyed Faith in Corporate America

Rebecca Smith and John R. Emshwiller

HarperBusiness
An Imprint of HarperCollins*Publishers*

24 DAYS. Copyright © 2003, 2004, by Rebecca Smith and John R. Emshwiller. All rights reserved. Printed in the United States of America. No part of this book may be used or reproduced in any manner whatsoever without written permission except in the case of brief quotations embodied in critical articles and reviews. For information, address Harper-Collins Publishers, Inc., 10 East 53rd Street, New York, NY 10022.

HarperCollins books may be purchased for educational, business, or sales promotional use. For information please write: Special Markets Department, HarperCollins Publishers, Inc., 10 East 53rd Street, New York, NY 10022.

Designed by Joy O'Meara

Library of Congress Cataloging-in-Publication Data has been applied for.

ISBN 0-06-052073-6
ISBN 0-06-052074-4 (pbk.)

04 05 06 07 08 10 9 8 7 6 5 4 3 2 1

To Kevin and Susan, my beloved children,
and to people who tell the truth, no matter what.
—RAS

To Molly, Rebecca and Deborah, now and forever.
—JRE

Contents

Acknowledgments xi

Prologue to the Paperback Edition xiii

PART ONE
Red Sky Warning

1 "Our CEO Is Resigning." 3

2 "Who's Andy Fastow?" 12

3 "You Won't Believe What Skilling Just Told Me." 22

4 "I Have Found That Mr. Lay Doesn't Take Kindly
to Criticism." 31

5 "It Isn't a Conflict of Interest." 42

6 "You're Just Scratching the Surface." 47

7 "You Are About to Topple a $20B House of Cards." 57

8 "I Want to Be CFO of the Year." 67

9 "It's Okay to Have a Conflict." 76

10 "Make the *Journal* Go Away." 83

11 "He Would Have Done Nothing to Harm Enron." 89

12 "Amend My Last Statement." 94

PART TWO
The 24 Days

13 "I'm Not Sure It Had a Name." 104

14 "You Missed Something That Could Be Really Big." 119

15 "Looks Like the SEC Read Your Stories." 134

16 "There Is an Appearance That You Are Hiding Something." 142

17 "I Must Have Heard the Term *Death Spiral* a Dozen Times Today." 156

18 "Oh, I Expect to Be in the Office All Weekend." 172

19 "Those Liars!" 183

PART THREE
The Party's Over

20 "Does Ken Lay Know About This Meeting?" 193

21 "Don't Approach Their People Again." 210

22 "At Least We're Going to Be Part of the Biggest Bankruptcy Ever!" 220

23 "Laydoff.com" 228

PART FOUR
Aftershocks and Revelations

24 "There Will Be Something Else Fun and Exciting on the Other Side." 241

25 "Enron Has a Problem You May Want to Write About." 258

26 "I Really Got Sucked into This One." 271

27 "We Notified Enron's Audit Committee of Possible Illegal Acts Within the Company." 278

28 "Do You Guys Have a Shredder Here?" 286

29 "I Didn't Look Closely. I Didn't Want to Know Too Much." 296

30 "You've Got to Be Kidding Me." 306

31 "I Feel I Just Can't Go On." 313

32 "There Was a Young Turk Arrogance." 329

33 "Next Time Fastow Is Going to Run a Racket, I Want to Be Part of It." 341

34 "Often He Was Just Goofy." 345

PART FIVE
The Perp Walk

35 "The Arrogance. The Lack of Accountability." 353

36 "Enron's CFO, Kopper, and Others Devised a Scheme to Defraud Enron and Its Shareholders." 363

37 "If It Isn't Criminal, It Ought to Be." 373

Index 399

Acknowledgments

MANY PEOPLE CONTRIBUTED TO THIS BOOK. THANKS MUST BEGIN AT our favorite newspaper, the *Wall Street Journal*. Numerous colleagues did terrific work prying open the Enron puzzle box. All were generous with their time when we sought their assistance. We felt very fortunate to work with some of the best reporters and editors in the country on a story that turned into an unexpectedly long ride. Though many earned our gratitude, we'd like to give particular thanks to: Alexei Barrionuevo, Mitchel Benson, Karen Blumenthal, Marcus Brauchli, Ken Brown, Barney Calame, Jeanne Cummings, Chip Cummins, Bob Davis, Larry Greenberg, Bryan Gruley, Tom Hamburger, Thaddeus Herrick, Greg Hitt, Larry Ingrassia, Steve Liesman, Gary McWilliams, Mike Miller, Mitch Pacelle, Scot Paltrow, Martin Peers, Ellen Pollock, Susan Pulliam, Anita Raghavan, Robin Sidel, Jay Sapsford, Mike Schroeder, Ellen Schultz, Leslie Scism, Mike Siconolfi, Glenn Simpson, Randy Smith, Scott Thurm, Jonathan Weil, John Wilke, and Stephen Yoder. We'd also like to thank managing editor Paul Steiger and deputy managing editor Dan Hertzberg for their unwavering enthusiasm and grit in chasing the Enron story—wherever it led us—as well as their willingness to grant us leaves of absence to write this book. Among our current and former colleagues in the *Journal's* Los Angeles bureau, particular thanks go to Ben Holden, Kathryn Kranhold, Andy Pasztor, Rhonda Rundle, Rick Wartzman, and, of course, to our boss, the *Journal's* L.A.

bureau chief, Jonathan Friedland, who was the editor most involved in shaping the paper's Enron coverage and who pushed us to tell the story "in long form" through this book.

Getting beaten on a story is never fun. But, over the months of covering the story, many of our competitors added greatly to our understanding of Enron even as their work spurred us to dig harder. Some of the best work on Enron was done by Peter Behr and April Witt of the *Washington Post*, Peter Eavis of *TheStreet.com*, and Kurt Eichenwald and Floyd Norris of *The New York Times*, to name a few.

Numerous individuals who worked at Enron, or were connected to it in important ways, shared with us their precious documents and invaluable insights and experiences. Neither the stories we wrote for the newspaper nor this book would have been possible without their help. In a real sense, this book is devoted to the many Enron people who rendered honest and faithful service to the company, its shareholders, and society. Several of them took professional risks to get the unvarnished truth to the public. Some are named in this book, but several have asked us to preserve their anonymity. To each, we give heartfelt thanks and hopes for a satisfying post-Enron life.

Many others helped us get this book into print. Our agent, Geri Thoma, was ever steady and cheerful. The people at HarperCollins— particularly Cathy Hemming, Steve Hanselman, Marion Maneker, Jeff Stone, and our principal editor there, Dave Conti—greatly helped focus this project and bring it to fruition. But on the editing front nobody deserves more praise than Victoria Pope, an accomplished writer and editor, whose clarity, patience, and good humor helped keep us moving forward.

Last, but hardly least, we offer deepest thanks to our family members and friends, most especially Eugene Bryant, Christine Ervine, Michael Miller, Elena Schmid, Steven Smith, and Bradley Warren, whose reading of the manuscript, at various stages, or unflagging moral support and assistance on the home front provided a bulwark against the pressures of the past two years.

Prologue to the Paperback Edition

FOR ENRON, OCTOBER 16, 2001, BEGAN AS A ROUTINE ENOUGH DAY, one of four each year when it released its quarterly earnings results. Though the announced numbers that day were hardly pretty—a huge write-off and a big loss—such was Enron's reputation and its ability to sell its story that the company's stock rose by the close of trading that day. But the stock's next "up" day wouldn't come for a seeming eternity and then only as a death rattle.

For the two of us, *Wall Street Journal* reporters, October 16 started out less momentous than hectic and frustrating. For weeks, we had been trying to dig up information on two shadowy partnerships partly owned and run by Enron's chief financial officer, Andrew Fastow. The partnerships and Enron had done hundreds of millions of dollars' worth of business together. We were trying to find out whether any underhanded activities had been part of the deal.

On the morning of October 16, Rebecca Smith, the *Journal*'s national energy reporter, was juggling the competing demands of the beat she covered. Fortified by an early morning cup of strong coffee, she spent time on her home computer reading through Enron's nine-page earnings announcement as well as the earnings release of another of her big companies, Duke Energy Corp. She knew she would also face editing questions that day on a September 11–related feature story about the threat of nuclear terrorism that she and John had helped prepare. By the

end of that day, she had done a string of interviews, one that prevented her from listening, live, to Enron's quarterly conference call with analysts. She had to listen to a taped replay of it, a short time later, while writing the Duke story and working with John to write the Enron earnings story. To top off October 16, Enron's longtime chairman and chief executive, Ken Lay, accused her of being "sneaky" during a telephone interview when she asked questions related to the Fastow partnerships, knowing full well he didn't want to discuss it. The gibe was delivered in a patronizing way, as if Lay were trying to correct the misbehavior of a child.

John, who usually covered white-collar crime, spent October 16 writing up everything that we had been able to nail down about the Fastow partnerships. The material formed the heart of that night's Enron earnings story, but John wasn't wild about including the partnerships in that piece, hoping instead to get a front-page *Journal* story out of them. Rebecca, though, was keen to get the information in the paper, ahead of any competitors. As we put the finishing touches to our story that night, neither of us suspected that Enron would soon become a fixture on the front page of the *Journal* and almost every other newspaper in the land.

In the days after October 16, we would write many more stories about Enron, some concerning questionable new partnership deals and the millions of dollars that Enron officials had reaped from them. On the twenty-fourth day, November 8, Enron offered up its own piece of writing, spurred partly by the *Journal* stories. The Enron document was a filing with the U.S. Securities and Exchange Commission that laid out an astonishing array of misdeeds, hidden deals, and bogus accounting. That November 8 document provided the final spark and kindling for Enron's own immolation—and a blaze that quickly spread through the halls of government and business. The conflagration cost investors tens of billions of dollars, put once lionized corporate chieftains into the criminal docket, and demolished many people's trust in corporate America.

Some senior Enron executives, as they tried to explain the ruination of their own company, would point to the *Journal*'s coverage of those first twenty-four days. For some of these executives, it may have marked

the first time in their careers that they were overly modest about their own contributions.

During the ensuing three years, a procession of indictments, plea bargains, and trials would command the nation's attention. In time, more than two dozen former Enron managers and executives would face federal criminal fraud charges, including onetime chief executive Jeffrey Skilling and former finance wizard Fastow. But time would also show that Enron's culture of greedy opportunism was nothing unique. Many companies had misled investors, violated securities laws, and lied in their financial filings. In time, a dust of disgust settled on corporate America that, Smith and Emshwiller thought as they surveyed the pockmarked landscape in early 2004, might take decades to wipe clean. The stories followed a well-worn groove: allegations of wrongdoing were followed by fraud charges and, eventually, trials or plea deals. Everybody felt he or she was being tried for the sins of others. Everybody was a scapegoat.

March 2004 would prove a very busy month for CEOs in the criminal dockets. Style maven Martha Stewart, the head of Martha Stewart Living Omnimedia Inc., would be convicted of lying to federal investigators about her sale of stock in ImClone, the company run by her friend Sam Waksal, who earlier had been sentenced to serve seven years in prison for numerous financial crimes. In April 2004, a stunning mistrial declaration for jury tampering would forestall the prosecution of Dennis Kozlowski, ex-CEO of Tyco Corp. and his ex-CFO Mark Swartz for defrauding the company they'd once led. Adelphia cable executives John Rigas and sons Timothy and Michael would defend themselves against charges they looted their firm for years. Four former Qwest executives would stand trial, accused of accounting fraud and conspiracy.

The unraveling of public faith in company executives and public officials left us with mixed emotions. We were heartened that the American legal and financial system reacted swiftly to corporate misdeeds. But we sometimes wondered if justice might lie somewhere between the collective shrug that had been the response to executive greed in the 1990s, and the relentless prosecutions that typified the 2001–2004 period.

For Smith, there was a feeling the justice system had lost its sense of proportion and balance. This came into high relief in March 2004, when Jamie Olis, formerly a midlevel manager at Houston-based Dynegy Inc., was sentenced to twenty-four years in prison for his role in a scam. He was found guilty of having participated in a deal in which $300 million in bank loans was dressed up to look like operating revenues at Dynegy, an Enron "wannabe" firm.

It was a stunning sentence. Others even more senior than Olis were charged in the same scheme but appeared likely to emerge from the mess with prison sentences of five years or less. They'd cooperated with prosecutors and Olis had not.

By May 2004, we continued to wonder whether America produced a just outcome for what had happened, and if not, the reasons why. What should have been the cultural response to the revelations of malfeasance that filled the newspaper pages and nightly news during the previous three years?

Smith found the lack of contrition on the part of the accused to be the most striking feature. Even those who pleaded guilty—in exchange for reduced sentences—rarely did more than simply admit they'd exploited opportunities to make money for themselves and their employers even when it meant breaking the law. They didn't seem to reach the bedrock of honest self-examination—not the way others in earlier times had done.

Smith was thinking about a Seattle attorney whom she met in 2002 who had deep personal reasons to reflect on the theme of corruption. It had altered the course of his life, and what he learned from it seemed more pertinent now than ever before.

Egil "Bud" Krogh had been an eager young attorney in Richard Nixon's White House in 1971 when he got involved in something that changed his life. By 1973, he faced a criminal indictment accusing him of obstructing justice by impeding an investigation into a break-in of a California psychiatrist's office—a break-in conducted by men who reported to him.

The object of the burglary was to gather evidence that could be used to discredit a Pentagon analyst, Daniel Ellsberg, the psychiatrist's patient, who was believed to be the source of a leak of classified material

known as the Pentagon Papers. The papers, fed to *The New York Times* and others, consisted of secret government reports that showed the American public had been deceived about the U.S. involvement in Vietnam. The revelations undermined the war effort, and in consequence, Krogh was put in charge of a new special investigations unit known euphemistically as the "White House Plumbers," whose job it was to stop further "leaks."

Krogh was so honored to work in the White House, he told Smith, that he never balked at ordering acts that were "illegal in every state in the Union." For the first seven or eight months after his arrest, he denied his role, and these denials ultimately opened him to a charge of making "false declarations" to investigators.

The special prosecutor assigned to investigate the case, Leon Jaworski, encouraged him to cooperate with federal investigators. Krogh wasn't the big-game trophy they were after, of course, but squeezing him might help them build cases against more senior people, including the president. Krogh told Jaworski he would plead guilty but insisted on doing it before he was interviewed by a federal grand jury. "I couldn't stand it if I were going to get a lighter sentence based on implicating others," he said. "I hate the plea bargain system." With that act of defiance, the process of reclaiming his honor had begun.

Krogh sees parallels between his experience and what he imagines must have been the experience of many upwardly mobile managers at Enron. "We were part of an 'in' group," he says. "We did not ask basic questions that anyone should ask. Is it right? What are the risks? Sometimes, in large organizations with immense power, you feel almost immune from scrutiny." Likewise, he says, it's clear that many people at Enron knew bad things were being done in the name of profit but did nothing to stop it.

In November 1973, Krogh pleaded guilty to federal charges and two months later was sentenced to federal prison. Nixon considered granting him a pardon but was talked out of it by one of Krogh's friends who knew Krogh wouldn't want a pardon. "I knew a price had to be paid for my conduct," says Krogh. "I wasn't *exclusively* responsible for what happened, but I was *fully* responsible."

At his sentencing hearing on January 24, 1974, Judge Gerhard Gesell

said that while Krogh had served the government and community "in an exceptionally competent manner on many occasions," the fact remained that he had participated in an illegal scheme. He praised Krogh for the fact that "you have made no effort, as you very well might have, to place the primary blame on others who initiated and who approved the undertaking. A wholly improper, illegal task was assigned to you by a higher authority and you carried it out because of a combination of loyalty, and I believe a degree of vanity."

Gesell said Krogh's "genuine remorse" called for mercy. He was sentenced to serve six months in prison and was let go after four months and seventeen days at a federal prison farm in Pennsylvania.

Enron, says Krogh, was "a corporate Watergate. The real Watergate was a governmental meltdown, of course. You had people of good intent who were basically honest and wanted to do a good job who came into a world where there was enormous pressure for results. In government, it's carrying the president's program forward. In the corporate world, it's creating shareholder value and profits. Those internal drivers become more important than anything else. It's very difficult to adhere to your own moral code, especially if you think, Well, this is just the way things are done. It's the way government runs. It's the way corporations run."

A ship is said to have integrity if it is watertight, and a piece of art has integrity if no essential feature is left out. Krogh says it should be the same in government and business. The late U.S. senator Patrick Moynihan, he says, pushed young staffers to ask whether or not the information they presented the president would help him reach a balanced decision. What if the same had happened at Enron?

Looking back on the Enron story, it seems some players have been punished or may be, but few have shown evidence of understanding the full weight of their own actions. Still, at the time of this revised edition, the final scene in the fifth act of the tragedy remains to be played. While key figures in the Enron scandal face those clarifying choices of conduct Krogh faced so many years ago, Smith and Emshwiller see continued evidence of the grip of greed in America's corporate boardrooms, as lavish pay packages continue to be bestowed for even mediocre performance.

In late 2001, as these reporters' story begins, all the figures who would

later come falling down were still riding high. On the eve of the twenty-four-day period that crumbled Enron, reputations were still intact, financial filings were still believed, at least mostly, and executives were still thought to be worth the money they were paid.

Rebecca Smith
John R. Emshwiller
April 26, 2004

PART ONE
Red Sky Warning

1

"Our CEO Is Resigning."

SOME DAYS, THE NEWSPAPER GODS REFUSE TO SMILE. THE KEYBOARD won't cough up coherent sentences. A crucial source doesn't call back. The wall clock, warning of approaching deadlines, seems to be running a time zone too fast. Within minutes of getting that call on the morning of August 14, 2001, Jonathan Friedland, *The Wall Street Journal's* Los Angeles bureau chief, suspected it was going to be one of those days.

The caller was Mark Palmer, the public relations chief for Enron Corp., the Houston-based energy giant that the *Journal* covered out of its Los Angeles office. Normally, Palmer's call would have gone to the paper's national energy reporter, Rebecca Smith, or her de facto backup on the beat, John Emshwiller. But Smith was on vacation and Emshwiller was out of town on a story.

The PR man got right to the point. "Jeff Skilling, our CEO, is resigning," Palmer said. "Ken Lay is going to step up and assume the president and CEO duties."

"You're kidding me," Friedland replied. He couldn't believe what he was hearing.

"No," said Palmer. "There'll be a press release in about an hour." There would also be a conference call with Lay and Skilling for the press and stock analysts at about 12:30 P.M. Los Angeles time.

"Why's Skilling quitting?" asked Friedland, still trying to absorb the news. He knew that Skilling had been Enron's golden boy for more than

a decade and had just gotten the chief executive's job a few months earlier. It was unthinkable that he would quit so abruptly.

"Purely personal reasons," said Palmer. "The board didn't ask him to resign, nor did Ken Lay. It's got nothing to do with Enron or its future. He'll elaborate on the call." With that, Palmer said a hurried good-bye.

Friedland sat back in his chair in his cluttered corner office, his face furrowed in concentration. After more than twenty years as a journalist, the last ten with the *Journal,* he'd handled many big, unexpected announcements from companies, but this was Enron, one of America's premier companies, talked about in the same breath as General Electric and Microsoft and IBM. In a decade and a half, it had transformed itself from a sleepy natural gas pipeline company to a trading colossus with products ranging from gas and electricity to space on the information superhighway and insurance against inclement weather. In 2000, Enron's revenues had topped $100 billion, earning it seventh place on *Fortune* magazine's widely followed list of five hundred largest companies. Revenues for 2001 were on course to hit nearly $200 billion, an astonishing growth rate for a company of that size.

Enron's management team—headed by its chairman, Kenneth Lay, who had been chief executive for fifteen years before Skilling took the helm—was one of the best. Skilling was only in his late forties. Everybody expected him to be running Enron for years. Instead, he'd barely gotten the seat warm.

And what was this about "purely personal reasons"? Enron's explanation sounded implausible. In Friedland's experience, almost nothing was more important to a corporate chief than staying at the top once he'd gotten there. Maybe Skilling has some fatal disease he doesn't want to talk about, Friedland thought. Or, the bureau chief wondered with a pang of professional worry, is something going on inside of Enron that we should know about and don't?

Even as Friedland mulled over the mystery, he knew he wasn't the person to solve it. Silently he cursed the rotten timing of the announcement. Why did Smith have to be on vacation this week? Ironically, his energy reporter had been trying to schedule time off for most of the summer, but work had been too hectic. Working out of the Los Angeles bureau, the forty-six-year-old Smith had been covering Enron and

about twenty other large energy companies for two years. She had moved to Los Angeles to take the *Journal* job, but she was eager to move back to the San Francisco area, where she'd lived for fourteen years. The Bay Area was her home; she had worked for the *Oakland Tribune*, *San Jose Mercury News*, and *San Francisco Chronicle* before joining the *Journal* in September 1999. She had another reason for wanting to move back north. She was divorced, and when she took the *Journal* job, she promised her ex-husband and her children, at the time ages eight and eleven, that they would treat the L.A. assignment as a tour of duty. At the earliest time possible, she'd get herself and the children back to the Bay Area.

Friedland called Smith on her cell phone and gave her a quick rundown of what had happened. "Can you think of any reason why Skilling would quit?" he asked.

As it happened, the call caught Smith on moving day, in an empty upstairs bedroom of her Bay Area home. She had been up since before daylight—mopping floors and vacuuming empty rooms. Her first thought when Friedland called was an exasperated, Can't I ever get away from work! As she talked with Friedland, she suddenly had the sinking realization that she might be expected to write a story on the Skilling departure while sitting on the hardwood floor with her company-issued laptop literally in her lap. She winced as she imagined the worst-case scenario: By the time she finished, every piece of furniture and heavy box would be in the wrong room, the "strong backs" would be gone, and a carefully orchestrated move—that allowed nine days for packing everything, getting it all north, and unpacking more than two hundred boxes—would be in shambles. Skilling couldn't have chosen a lousier moment to resign.

Normally, Emshwiller would have been ready to pitch in. Although his beat was white-collar crime, he had been tapped to help Smith in late 2000, as the California electricity crisis spiraled into a story too big for one reporter to manage. Smith's duties also included covering utilities and energy-trading companies, which was how Houston-based Enron fell into the lap of a Los Angeles–based reporter. Emshwiller was asked to take on the assignment partly because he had covered energy when the electric industry was choking on a string of nuclear power

plant construction disasters in the aftermath of the 1979 Three Mile Island accident.

Smith and Emshwiller worked together almost daily during the prior six months as California's electricity market, deregulated in March 1998, melted down. The crisis began in May 2000, when electricity prices suddenly spiked during a hot spell. Supplies became oddly stretched. Everyone thought it was an anomaly and would soon disappear. But that didn't happen. In fact, during the next thirteen months, there were more than a hundred electrical emergencies, though only a handful resulted in rolling blackouts.

On that particular Tuesday Emshwiller was in San Diego, going through the files of an attorney who had been looking for evidence of manipulation of the California market by Enron and other big energy companies. Given the often firehouse nature of the California crisis, flaring up at the least expected times, Friedland hadn't wanted both his energy reporters out simultaneously. But Emshwiller reminded him that things had been quiet lately on the California front, as the threat of massive summer blackouts had failed to materialize. "I'm sure nothing will happen," Emshwiller assured his boss. Now, Friedland faced the reality of having to cover the Skilling story with his main energy reporter four hundred miles to the north sorting through boxes of belongings and her backup one hundred miles to the south sorting through boxes of documents. Friedland mentally scanned the roster of the seventeen-person bureau. Everyone who was in that day was busy with stories of their own, on beats that ranged from the aerospace industry to the entertainment business. Smith would be out for the rest of the week, and Emshwiller wasn't due back until the next day. That left only one person to cover Skilling's resignation.

"Don't worry. I'll handle the story," Friedland told Smith, who felt grateful and relieved. Next to the two reporters, Friedland knew more about Enron and the energy business than anyone else at the bureau.

While on the phone with Friedland, Smith searched her memory for any hint that Skilling was unhappy—or that others were unhappy with him. Nothing came to mind. There'd been frustration with certain Enron projects, like its $600 million investment in the Dabhol power plant project in India, but she'd never heard anyone intimate that Skill-

ing was being blamed for it. Quite the contrary, he'd pushed out a rival for the Enron throne, Rebecca Mark, based partly on her backing of hard-to-manage, costly ventures such as Dabhol.

In Smith's last conversation with Skilling, a couple of months earlier, he'd been upbeat, as usual. Enron, he said, was "firing on all cylinders" and exceeding expectations on all fronts. As a reporter, she viewed Skilling as bright and talented, but she had never much warmed to his demeanor. He reminded her of Silicon Valley executives she'd known years before while covering the semiconductor industry for the *San Jose Mercury News*. Having been groomed for success, sent through the finest schools, and mentored early in their careers, they nonetheless portrayed themselves as self-made. Moreover, Skilling was possessed of an arrogance that came from having been a star at America's most famous business school—Harvard—and its most famous business consulting firm—McKinsey & Co.—before riding a rocket to the top of what was becoming the nation's hottest energy company.

But Skilling was not one to rest on his laurels. Driven and restless, he seemed at times to work without sleep, sometimes convening staff meetings at 3:00 A.M. He gave long speeches, sometimes an hour or more, filled with facts and numbers and grand visions for the company at the center of a global marketplace—and he almost never spoke from a prepared text. Just him and his PowerPoint deck.

His personality and ambitions were large, but at five feet nine he was less than physically imposing. After years of weighing as much as 187 pounds, he lost 50 pounds on doctor's orders in 1996. He became an avid exerciser, taking up long-distance bicycle riding and sports like rafting. Laser surgery later allowed him to shed his glasses. He also used medication to thicken his thinning hair.

Skilling had a remarkable ability to dominate through his intellect and his self-confidence. His favorite put-down for those who disagreed with him was "You just don't get it." Others at Enron picked up the phrase, adding to the company's know-it-all reputation.

During a long interview with Smith in his spacious fiftieth-floor office at Enron's 1400 Smith Street headquarters in downtown Houston, Skilling had paced the room, describing Enron's grand future, sometimes snatching the reporter's pen to sketch a quick graph or chart. It

seemed a little over the top, but Smith didn't mind; Skilling was enter-
taining and energetic, and those were welcome qualities in an industry
that saw virtue in being bland and drab. Brash as Skilling could seem,
Smith saw that characteristic as reflecting the first-generation drive cru-
cial to getting companies established against vested interests that didn't
appreciate competition from upstarts like Enron. It was Skilling, while
still a senior partner at McKinsey, who convinced Ken Lay that Enron
needed to set up a system of buying gas from producers and selling gas to
customers. Once he joined the company, Skilling's vision—to embrace
risk and innovate through a loose management structure—became the
centerpiece of Enron's philosophy. Skilling even moved to knock down
actual walls within Enron headquarters so people could see and talk
with one another more easily. It was an approach that made Enron the
darling of management gurus and other company watchers, who saw it
as a prime example of free market creativity.

Skilling relished the iconoclast role, perhaps even came to revel in it.
As far as Smith could tell, becoming chief executive had done nothing
to soften him. Early in his tenure, he had stunned listeners during a con-
ference call with a few hundred investment professionals when he
called one company critic an "asshole." It was a startling departure from
boardroom decorum, even for the indecorous 1990s, but then Enron
prided itself on pushing the boundaries. As Sandi McCubbin, a former
California lobbyist for the company, once told Smith: "The saying
around Enron was, 'If you are not on the edge, you are taking up too
much room.'" It was a business ethic that promoted competition among
co-workers and intense jockeying for position. Even the performance
review process was ruthless, with only an elite cadre—about 5 percent
of the company workforce—receiving the highest rating and as many as
15 percent getting the lowest rating, a signal for a possible early exit
from Enron.

However abrasive, Skilling was a "good interview"—smart, nimble,
and—best of all—extremely accessible. That meant he was the sort of
CEO a reporter wanted to keep, not lose. He wasn't someone a reporter
wanted to see resign. Smith turned over the event in her mind. The res-
ignation seems so out of character, she thought.

It was a lot easier to like Lay than Skilling. Most people liked Ken

Lay. Where Skilling seemed impetuous and curt, Lay was smooth, almost courtly. Lay had soft features and a round face topped by thinning white hair; he could have played the part of the favorite uncle in a TV sitcom. In all his contacts with Smith, he was unfailingly polite in a genteel southern sort of way. At a company that seemed to have been outfitted by the Gap, the fifty-nine-year-old chairman still favored business suits and shirts with monograms and French cuffs. Though awash in wealth and power, Lay retained a noticeable dusting of his origins as a poor Missouri farm boy and son of a Baptist preacher. Even when he ran Enron, Lay would sometimes fetch Cokes for colleagues on the corporate jet. When he spoke, he still had a bit of the Show Me state accent, and he sprinkled his conversation with quaint expressions. Rather than call a man a "drunk," for instance, Lay would say that he'd "been imbibing."

Either from cunning or self-confidence, he was able to admit he didn't know everything. And he didn't humiliate others for their ignorance. When a *New York Times* reporter once pressed him on a complex point about Enron, Lay responded—affably, of course—"You're getting way over my head." Smith could never imagine Skilling uttering that line.

Smith was pretty certain that Lay hadn't shoved out Skilling because he missed the chief executive's job. She knew that Lay had never liked the day-to-day grind of running Enron and in recent years had left that task largely to subordinates, chiefly to Skilling. Lay was much more interested in trying to shape "big ideas" such as federal energy policy. He also loved hobnobbing with powerful politicians, most notably George W. Bush, who could count Lay as the single largest individual contributor to his campaigns. The two knew each other well enough that President Bush referred to Lay as "Kenny boy," the same term of endearment used by Lay's wife and onetime secretary, Linda. Indeed, when Skilling took over the chief executive post at Enron in February 2001, many observers thought it only a matter of time before Lay took a cabinet post or an ambassadorship in the Bush administration.

Enron's stock price had fallen some 50 percent in the past year, from above $80 a share to about $40. Some of that drop seemed due to the broader fall-off of stock prices, some to the fact that Enron had risen so

much in the prior twelve months. Besides, if falling stock prices had been a criteria for replacing a CEO, half the major companies in America would have been looking for new bosses. Enron had problems in various business sectors—including an expensive foray into high-speed telecommunications, known as "broadband," that Skilling had championed. Indeed, during the Internet euphoria of the late 1990s, the stock market had treated Enron almost as if it were another red-hot high-tech company. When Enron announced a deal with Sun Microsystems in 2000, Enron's stock shot up more than $13 a share in one day. The later bursting of the Internet stock bubble damaged the stock price and raised questions about some of the company's extremely aggressive growth projections. But Smith didn't know anyone who thought the company had the kinds of headaches that would cost the top guy his job.

"This makes no sense," Smith told Friedland as they continued to discuss the resignation. "He just spent ten years clawing his way to the top. Why would he quit now? Personal reasons? I don't buy it."

"Well, I don't, either, but who would know for sure?" he asked.

That was a tough question to answer. Obviously, it was unlikely that anyone inside the company would talk.

"Who are the better analysts?" Friedland asked.

Smith offered to provide him with names and numbers of Wall Street stock analysts who might have some insights, very much aware that it was about an hour till deadline.

Friedland sent a note to the New York editors notifying them that he would be writing the Skilling story. The bureau chief then turned his attention to reporting. Enron had just sent out the phone number and access code for listening in on the conference call. Friedland punched the numbers into his phone pad and joined hundreds of others around the country waiting for Lay and Skilling to join the call.

"As you have probably read, Enron announced earlier today that Jeff Skilling is resigning from the company for personal reasons," Lay said in his pleasant drawl. "I, and the board, regret Jeff's decisions, but we certainly respect his reasons." In reassuming the chief executive post, Lay said, "I can honestly say that I have never felt better about the company."

Skilling came in next. "This is a purely personal decision. I can't

stress enough that this has nothing to do with Enron." He sounded earnest, even upbeat, as senior executives often do when talking in public. "I am doing it solely for personal and family reasons" and "I'd just as soon keep those private."

Throughout the call, both men emphasized repeatedly that Skilling's decision had nothing to do with Enron. "I feel a little bad that anything that I do is somehow construed as something related to the company," Skilling said. "The company is in great shape."

Lay jumped in: "There are no accounting issues, no trading issues, no reserve issues, no previously unknown problem issues. . . . I think I can honestly say that the company is probably in the strongest and best shape that it has probably ever been in."

In a separate telephone interview later that day with Friedland, Lay and Skilling repeated their mantra. What about the drop in Enron's stock price? Friedland asked. Any connection to Skilling's resignation?

"Absolutely nothing to do" with it, Lay said emphatically.

While Friedland still didn't buy Enron's explanation for Skilling's resignation, he didn't have the goods to refute it in print. So he wrote what he could, noting that the company's stock price had fallen sharply over the past few months but also including Lay's statement that the decline was irrelevant to Skilling's exit. The editors in New York placed the story on page A3, the *Journal*'s main page for breaking daily business news. Friedland knew it was an adequate piece, given the constraints. He also knew that anything better, if there was anything, would have to wait for another day.

2

"Who's Andy Fastow?"

THE NEXT MORNING, WITH SMITH STILL UNLOADING BOXES IN THE BAY Area, Emshwiller arrived back at the *Journal's* Los Angeles bureau. Friedland immediately called Emshwiller into his office, a fifteenth-floor corner office with great views north to the Hollywood Hills and west to the shimmering Pacific, beyond Beverly Hills. Emshwiller plopped onto the rose-colored love seat that shared a corner of the office with an armchair and end tables. Over his shoulder were photos of New Guinea tribesmen and Burmese villagers, stops on Friedland's postings as a foreign correspondent. On the wall, two clocks hung next to each other, one showing California time, one New York time. Atop a bookcase stood a whiskey decanter in the form of a pink-jacketed Elvis.

"We need a second-day story on Skilling's departure," Friedland said, slouching his compact frame back in his swivel chair and chewing determinedly on nicotine-laced gum that he still used regularly to keep away the cigarette cravings.

Emshwiller nodded as he leaned back into the couch, chewing away on his own cigarette substitute, a piece of sugarless bubble gum. He realized that somebody needed to chase the Skilling story, but he wasn't wild about getting the assignment. He didn't expect to have any more luck than Friedland had in getting beyond the "personal reasons" cited by Enron. Emshwiller's contacts with the company had pretty much been confined to occasional conversations with the company's public

relations department in connection with the California electricity mess. He didn't expect anyone there to volunteer that top corporate officials might not be telling the whole truth. The reporter also didn't need to look up at either of Friedland's two clocks to know that *Journal* copy deadlines would begin hitting in the middle of the afternoon, the bane of being on the West Coast for an East Coast newspaper that was perpetually three hours ahead. "You know I might not be able to get much today," he warned Friedland.

"Do what you can," the bureau chief replied, turning his attention to a ringing phone. "Try talking to Skilling again. Maybe he'll have something more to say today."

Fat chance, Emshwiller thought as he left the bureau chief's office. While the reporter didn't have much hope of getting a story, he understood why Friedland had made the assignment. Enron was big and important and, perhaps most to the point, had been a subject of keen interest for other publications, including *The New York Times*—the paper universally viewed within the *Journal's* news operation as the main competition. Over the previous several months, the *Times* had done a series of stories on Enron's ties to the Bush administration and the company's controversial role in the California electricity crisis.

As the nation's biggest energy trader, Enron had become Public Enemy No. 1 for California political leaders. The *Times* had assigned one of its top investigative reporters, Jeff Gerth, to the story. While it hadn't been looking at Enron's management per se, the Skilling resignation could shift that paper's focus. Emshwiller knew that Friedland had no desire to get an angry early morning phone call from a New York editor asking why the *Journal* had been beaten by the *Times* on something related to Skilling's resignation. If Skilling had other reasons for quitting, the *Journal* needed to discover them—or at least be able to show that its reporters had made every effort.

As Emshwiller walked the length of the newsroom back to his office, he could feel the tension beginning to grip him. Though he'd been writing newspaper stories for more than a quarter century, the prospect of a deadline only hours away still managed to start the tightening of a small internal vise. He walked past his colleagues' cubicles. As usual, the office was quiet, broken only by the conversation of phone interviews and

the muted clacking of computer keyboards. *Journal* news bureaus around the world had often been compared to insurance offices, and the Los Angeles bureau did nothing to challenge that description. The news staffers were scattered across a space that could easily have housed double that number—a monument to late 1980s expansion plans that hadn't materialized.

Having once been L.A. bureau chief, the fifty-one-year-old Emshwiller had his own office, tucked into the back end of the newsroom and crammed with a desk, three chairs, three filing cabinets, a bookshelf that groaned with books, and tall stacks of files rising precariously from the floor. Aside from family pictures, the only photograph showed a dead fish wrapped in a copy of *The Wall Street Journal*. Bill Blundell, a near legendary writer at the *Journal*, had bequeathed it to him as a humble reminder of the shelf life of most newspaper stories.

A Los Angeles native, Emshwiller was a *Journal* "lifer" who had gone to work for the paper just after he graduated from the University of California at Berkeley in 1972. He'd worked in San Francisco, Detroit, and New York before going home to Los Angeles in 1985. A Detroit colleague once likened Emshwiller to Cassius, the Roman senator in *Julius Caesar*, because of his "lean and hungry look."

Emshwiller mulled his options for the assignment. It didn't take long. He didn't have Skilling's home phone number and knew only one person at Enron—Mark Palmer, Enron's media chief. So he called Palmer and left a message. Emshwiller had last talked with Enron's chief spokesman in late May in connection with an interview he'd done with California attorney general Bill Lockyer. Like other top state officials, Lockyer firmly believed that big power traders, especially Enron, were using the deregulation mess to illegally rip billions of dollars out of the pockets of Californians.

Enron became the target of Californians' wrath not because it was a major owner of power plants—it wasn't—but because it was the brashest of all the energy traders and the most outspoken advocate of electricity deregulation. As the biggest trader, Enron was thought by officials such as Lockyer to be using its market position to manipulate prices, no matter how many times the company denied those charges.

While the state authorities didn't buy Enron's claims of innocence,

they didn't, as of August 2001, have hard evidence to prove their suspicions. Particularly galling, Enron was plainly refusing to answer many of their inquiries, and the California Public Utilities Commission twice had to go to the California Supreme Court to enforce its subpoenas for access to Enron documents. Lockyer's office had similarly tough court battles to get company records. When authorities did obtain court orders, Enron then poured forth such a volume of paper (including the pizza boxes from the meals of company employees copying the documents) that it was hard not to conclude that the energy trader was trying to sabotage the process. One state prosecutor had told Smith that "it looked like it would take us forever to hack our way through." Even as the documents began streaming in, prosecutors contended that the most damning evidence likely was locked away in files protected by attorney-client privilege.

As Emshwiller interviewed Lockyer, he could tell that the lack of progress in the investigations grated on the attorney general. At one point, the reporter asked Lockyer if he thought there would be criminal prosecutions. "I don't doubt there will be civil lawsuits prosecuted by the state," the attorney general replied. There was an uncomfortable pause, as if Lockyer realized he hadn't really answered the question. "There is nothing I would rather do than nail a high executive," he said. Another pause.

"You know what I really would like to do," he told Emshwiller.

"What?" asked the reporter.

"I'm not really sure I should say this. Well, why not? I'd love to personally escort Lay to an eight-by-ten cell that he could share with a tattooed dude who says, 'Hi, my name is Spike, honey.' "

When Emshwiller called Palmer on that May day for comment, the vice president for public relations was nonplussed.

"He said what?" Emshwiller repeated the quote.

"What do you say to that," Palmer mused. Finally, he said, "That remark is so counterproductive, it doesn't merit a response."

Skilling disagreed. About three weeks after Lockyer's quote appeared in the *Journal*, the Enron president fired back. In a speech at an industry conference in Las Vegas, Skilling asked: What's the difference between California and the *Titanic*? He had his own answer at the ready: The *Ti-*

tanic went down with its lights on. Given that Californians were suffering through soaring electric prices and power outages and looking at a potentially catastrophic summer, Skilling's remark certainly did nothing to dispel his reputation for insensitivity.

During the thick of the crisis, in late 2000 and early 2001, there'd been so much rancor between state officials and Enron executives that Lay stopped coming to California, fearing he'd be slapped with a subpoena to testify before one or another angry legislative committee. Skilling, though, accepted an invitation to speak before the Commonwealth Club in downtown San Francisco in June 2001. There, a conservatively dressed woman decked him on the side of the head with a blueberry pie. Publicly, at least, he took it good-naturedly. "Tell her she's got a good arm," he told reporters affably. But one Enron insider said that Skilling and his three children privately were shaken by the incident.

As part of the follow-up story on August 15 to Skilling's resignation, Emshwiller put out a round of calls to Wall Street analysts, though with few expectations. Friedland's efforts a day earlier hadn't netted much.

Emshwiller reached only one analyst. "Skilling says that he is tired of doing his job. He apparently isn't ill," the analyst said. "Nothing jumps out at you."

Like other top Enron executives, Skilling had made enormous amounts of money from the success of Enron, this analyst noted. In the 1990s, the surging stock market had brought astonishing wealth to the top levels of corporate America. Salaries and bonuses, even when measured in the millions of dollars annually, were dwarfed by the value of company stock that senior executives were given the opportunity to buy and then sell. This was particularly true at Enron, whose stock price during the 1990s rose three times faster than the S&P 500 Index, a major measure of the broader market, and twice as fast as other major energy companies. Lay realized over $192.7 million in Enron stock sales after 1986 and Skilling over $107 million during his tenure at the firm, according to Thomson Financial, a leading stock market information firm. And they still had unexercised options on millions of additional shares.

The analyst whom Emshwiller called noted that several Enron executives had recently left the company after cashing out stock options

that ran into the tens and even hundreds of millions of dollars. He recalled Skilling coming to New York in July, about a month earlier, to talk with a group of analysts. Someone asked him about the resignations of those Enron executives. Skilling noted that many senior executives had gotten very rich from exercising their Enron stock options; after years of a frenetic work pace, some simply wanted to relax and enjoy the wealth. The analyst asked Skilling if he ever felt a similar desire.

Those other people weren't chief executive, replied the Enron chief executive.

Palmer returned Emshwiller's phone call. Despite an occupational distrust of public relations people, Emshwiller had come to like Palmer in their occasional dealings. Though he was a company man and displayed some of the typical Enron swagger, he was also personable and smart and even had a pretty decent sense of humor.

Now, not having any better ideas, Emshwiller figured he'd try the direct approach. "I'm doing a follow-up story and need to talk to Skilling. Nobody believes that he really left for just personal reasons," said Emshwiller in a claim not yet burdened by any evidence.

Palmer knew enough about handling reporters not to simply toe the company line.

"I had my own doubts when I first heard about it," he replied in a confidential tone. But after checking with others at the company, he said that he came to believe that Skilling had experienced some sort of epiphany. "He wants to spend more time with his three kids. He is divorced and they are teenagers. If he doesn't spend time with them now, he worries that they will be grown up and be gone," said Palmer. Plus, he'd heard that there might be a particular family problem that had to be addressed quickly, though he couldn't say for sure.

"An illness?" Emshwiller asked.

"Don't know," said Palmer. Besides, he added, Skilling had always seemed ambivalent about being Enron's top executive. Skilling liked thinking up big ideas and building businesses more than attending to the nitty-gritty of running a giant corporation. "He wanted to prove that his business model was the right business model," and he'd already done that at Enron, Palmer said.

"It would still help a lot to talk directly to Skilling," Emshwiller said.

"I'll pass along the request," Palmer said.

As they hung up, Emshwiller hoped that Skilling would stay true to top Enron executive type: in the past, company brass was unusually accommodating in granting interview requests. Such accessibility had become an Enron hallmark, one more tangible sign of a supreme self-confidence. After putting in his Skilling interview request, Emshwiller turned his computer's Internet browser to a Web site called 10Kwizard. com. This was one of the many nifty little services offering instant access to financial filings that publicly held companies made with the U.S. Securities and Exchange Commission (SEC). These filings, which under the law big companies such as Enron had to make at least quarterly, were usually long, dull, and complex. But they could also be an invaluable source of information about a company's finances and operations. When he called up the recent Enron filings, Emshwiller noticed that the company had, coincidentally, filed its latest quarterly report a day earlier.

Emshwiller didn't have the time or inclination to closely read the thirty-seven single-spaced pages of numbers and legalese. So he fell back on some of the shortcuts he'd been taught as a young *Journal* reporter. He checked the "litigation and other contingencies" section on the theory that you can often find some very interesting things by seeing who is suing the company and vice versa. There was a description of a still pending 1995 lawsuit concerning a marketing program and a lawsuit related to a fatal 1996 explosion at an Enron facility in Puerto Rico. All the other litigation also looked old.

Emshwiller next found the section for "related-party transactions," or what he thought of as the corporate dirty-laundry list. This was where a company had to report any outside business deals involving directors or top officers.

As the reporter read Enron's related-party section, he felt a kick of adrenaline. He'd never seen a disclosure quite like this before. An unnamed "senior officer" had run and partly owned some partnerships that appeared to be doing vast amounts of business with Enron. For the life of him, Emshwiller couldn't make out exactly what the deals were, cloaked as they were in a bewildering string of words that talked about "share settled costless collar arrangements," "combined notional value,"

and the "contingent nature of existing restricted forward contracts." A few things seemed clear, though. The transactions involved hundreds of millions of dollars. And the unnamed senior officer had, for unstated reasons, severed ties to the partnerships as of July 31, two weeks earlier.

Could Skilling be that senior officer? This might be a scoop, he thought. The timing certainly seemed more than coincidental. Perhaps these partnerships had something to do with why he'd quit as chief executive. He quickly called Palmer back and left another message, asking to speak with him as soon as possible.

As he hung up, he thought of another person to call about Skilling. Bernard Glatzer had first phoned Emshwiller in early June after reading the quote about Lay and Spike. Glatzer had his own reasons for being unhappy with the giant energy company.

By the time the fifty-three-year-old Glatzer contacted Emshwiller, he was more than five years into a lonely crusade to prove that Enron had stolen energy-financing ideas from him that had produced hundreds of millions of dollars of profits, he contended, for the company. He was a lawyer and New Yorker who had gone to Houston in the mid-1970s with the aim of breaking into the energy business. In the late 1980s, Glatzer saw an opportunity in the turmoil caused by the federal government's decision—shaped by the unceasing lobbying of men such as Ken Lay—to deregulate the natural gas business. While free-floating gas prices spurred exploration, they also produced a great deal of risk for gas producers because they were making long-term investment decisions based on profits from short-term prices. Anyone who could act as a middleman to reduce some of the price risks of the new system stood to make a bundle of money. Glatzer claimed that he'd come up with some inventive ways to finance natural gas purchases, thus providing stability to producers, by selling securities. He said he presented these ideas, on a confidential basis, to Bear Stearns in hopes that the big Wall Street brokerage firm would back him. Instead, he said, Bear Stearns stole his plan and turned it over to a bigger and more important potential client, Enron. Glatzer alleged that Enron used his ideas in the early 1990s to create a new, and hugely profitable, business, which became known as the "gas bank"—a success that sent Skilling on a hand-over-hand scramble up the corporate ladder. Glatzer had made his allegations against Bear

Stearns and Enron in suits that had been filed in Texas but were later moved to New York federal and state courts. Skilling was not named as a defendant in those actions.

Emshwiller didn't see much prospect for a story. The accusations were complex, a decade old, and vehemently denied by the accused. Plus, one federal judge had already dismissed Glatzer's claims. Still, Emshwiller kept talking with Glatzer. For one thing, David Boies's law firm was representing Glatzer. Boies's clients had ranged from Al Gore in the Florida presidential recount battle to Uncle Sam in the Microsoft antitrust case. Glatzer had told him that the Boies firm was working on a contingent fee basis, which meant it didn't get paid unless Glatzer won some money—a show of faith that gave Glatzer's claims more credibility.

Besides, Emshwiller had developed a soft spot for Glatzer. The lawyer laughed a lot and loved to tell tales, ranging from his days at Yale with a certain fun-loving George W. Bush to his drinking parties in New York with his cousin the Lubavitcher rabbi and other Orthodox Jews. The reporter never checked out these stories, but they were entertaining. On the downside, Emshwiller quickly discovered that a call from Bernie routinely lasted at least a half hour and sometimes a good piece more. Whenever Emshwiller said that he *really* had to hang up, Glatzer effortlessly fired back with "just one more quick thing," which invariably consumed at least five more minutes, only to be followed by another not-so-quick thing.

"So did you finally drive Jeff Skilling out of Enron?" Emshwiller said half-jokingly when Glatzer answered the phone at his Bronx, New York, apartment.

"What are you talking about? Skilling got fired?"

"No, he resigned. Haven't you read the papers?"

"I haven't been out to pick them up yet," said Glatzer. "So he really quit?" He sounded truly shocked but recovered quickly. "I wouldn't be surprised if my case had something to do with it," he added. The reporter swallowed his impulse to disagree.

Emshwiller asked about the related-party transactions. "Had you heard about this before? Are they talking about Skilling?"

Glatzer said that he had just been reading the Enron quarterly filing

and had also seen the section about the partnerships. "I hadn't heard of them before. But I bet it's Skilling." Of course, Emshwiller thought, Glatzer might have had the same response if he'd been asked about the Kennedy assassination.

A short time later, Palmer called back. Emshwiller popped his partnership question.

"No, that's not Skilling," Palmer replied without missing a beat. "That's referring to Andy Fastow."

"Who's Andy Fastow?" Emshwiller asked with the innocence of the ignorant.

"Our chief financial officer," Palmer replied evenly. The partnerships had been around for years and been routinely reported in Enron's public filings the entire time, he added. They'd been set up to help Enron hedge against "market risks" from the fluctuating values of some of its investments, he added.

So why was Fastow quitting the arrangement now?

"He wasn't needed in that role anymore," Palmer said. Fastow ran the partnerships only to give comfort to outside investors who didn't fully understand Enron's complex finances, he explained. "But now those investors are familiar enough with Enron that Andy doesn't need to keep doing it."

Emshwiller couldn't help feeling a stab of disappointment as he hung up. While the partnerships certainly sounded strange and perhaps newsworthy, they wouldn't help him write a Skilling story this day. So far, Emshwiller had no story.

A short time later his phone rang again. A soft voice said, "Hi, it's Jeff Skilling."

3

"You Won't Believe
What Skilling Just Told Me."

THE REPORTER MUMBLED A HELLO AND THANKS FOR CALLING WHILE wishing that he'd spent more time getting together a list of questions. "I was hoping I could talk with you a little more about your reasons for leaving," Emshwiller said.

"It's pretty mundane," Skilling said. "There are a lot of people like me who have worked extremely hard for a very long time waiting to reach the point of living a real life. I have achieved a lot. We built a great company and changed an industry. As a result, I have freedom that the average person doesn't have."

"Why quit after six months?" Emshwiller asked.

"Ken and I talked about it at the time I was named CEO. It was always in my mind," said Skilling. But he felt he needed to stay at Enron long enough to help it get through the California crisis, which now seemed to be easing. "The decision had been building a long time," he continued. The "final straw," he said, came on a recent visit to the United Kingdom to attend the funerals of three Enron workers killed in a power plant accident. "It made me realize how tenuous life is. I realized that I needed to get on with life."

That struck the reporter as an odd remark. The interview quickly turned even stranger.

"The stock price has been very disappointing to me," Skilling said, and kept talking in what seemed like stream of consciousness, addressed

as much to himself as to the reporter. "It's the kind of ultimate score-card. The stock is at less than half what it was six months ago. I put a lot of pressure on myself. I felt I must not be communicating well enough. Day in and day out, that is the world you are living in. There are a lot of other things in life important to me. This was not a job to me. This was my life. I feel that in spite of the stock price we have made tremendous progress in the past six months. The California thing has sorted itself out. We've made progress on India and the broadband business. That was hard. We've cut our costs significantly in that business. I feel good about that. The company is in great shape. Had the stock price not done what it did . . ." Skilling paused for a few seconds. "Otherwise it would have been fine. I don't think I would have felt the pressure to leave if the stock price had stayed up."

"What was that, Mr. Skilling?" Emshwiller interjected, not quite sure he had heard what he'd just heard.

"Our employees are big shareholders," Skilling continued. "In the building, people would say, 'What is going on with the stock, Jeff?' I would have to say I didn't know. It has been frustrating."

"Are you saying that you don't think you would have quit if the stock price had stayed up?"

There was a silence on the other end of the line for what seemed like a long time to Emshwiller but was probably at most a few seconds. "I guess so," replied a small, almost boyish voice.

"Do you regret taking the CEO's job?" Emshwiller asked, still trying to absorb the startling admission that he'd just heard.

"I think I needed to be there. I was able to do some things to get the company through some pretty tough times," Skilling said.

The reporter assumed Skilling was referring to the California elec-tricity crisis, which the executive had talked about earlier in the inter-view. Only later would he wonder what exactly Skilling might have been referring to. "What are your plans for the future?" Emshwiller asked, looking to wind up the interview and get to writing the story.

"I'm engaged to be married," Skilling said, his voice brightening.

Emshwiller gave his quick congratulations and wished him luck as the two said good-bye. Well, Emshwiller thought to himself, now you've got a story. Lay, with Skilling on the line, had told Friedland just the day

before that the resignation had nothing to do with the fallen stock price. Now, here was Skilling saying the exact opposite. But his latest explanation only raised new questions: Why did he care so much about the stock price? Everybody seemed to think that on the whole the company was strong. Plus, the reporter kept coming back to how Skilling sounded, like a man tormented. Maybe he was simply obsessing over the stock price as part of some deeper personal crisis that had nothing to do with the operations of Enron.

"You won't believe what Skilling just told me," said Emshwiller as he walked into Friedland's office to relate the high points of the interview.

"Great," said Friedland with an enthusiasm tempered by the clock. "So start typing."

As Emshwiller began to write his story, he kept thinking about how Skilling had hardly sounded like a master of the corporate universe. In fact, he'd sounded depressed, almost haunted. The man he'd talked with seemed nothing like the supremely confident executive the reporter had heard about. Maybe Skilling is a manic-depressive, the reporter casually thought. Emshwiller's wife, Deborah, who was a psychiatrist, usually cringed whenever he made an armchair diagnosis of someone he was writing about. Still, there was something very strange about that conversation with Jeff Skilling.

The former chief executive had even mentioned how his anguish over the falling stock price had been heightened by reading some of the messages posted on Internet stock chatboards. That admission seemed truly bizarre to Emshwiller, who had written extensively about the chatboard world. While that corner of the Internet attracted some smart and sober investors, it was also a magnet for wackos, crooks, and even a few self-proclaimed extraterrestrials. Emshwiller had briefly related to Skilling his experiences writing about the message boards. "Did you read them much?" Emshwiller asked.

"I probably should have stopped," Skilling replied with a small, nervous laugh.

All in all, Emshwiller thought again, a very odd conversation, even by the standards of his usual beat. In covering white-collar crime, he'd done many interviews with strange characters telling strange tales that ranged from the fascinating to the absurd. Along with the lure of possi-

bly uncovering bad guys doing bad things, this aspect of the white-collar beat was one of the things that attracted Emshwiller.

As the reporter wrote the Skilling interview story, it occurred to him that he had forgotten to ask the executive about those partnerships. It would have been interesting to see what he'd said. He didn't mention the partnerships in the Skilling piece, which ran the next day, August 16. Emshwiller liked the headline, which clearly challenged the company's official line on the resignation: ENRON'S SKILLING CITES STOCK-PRICE PLUNGE AS MAIN REASON FOR LEAVING CEO POST.

The day that story ran, Smith, Emshwiller, and Friedland talked by telephone. They agreed that there was at least one more story to do when Smith returned from vacation the following Monday. "Now that Lay is back as CEO, we need a piece on the state of the company and what he plans to do," said Friedland.

Smith suggested focusing on Lay's promises to make Enron more open and its business dealings easier to understand. The company had long been criticized for having complex, nearly indecipherable financial statements. When Enron stock was at $80 a share and seemed headed toward triple digits, such complaints were muted. But at $40, with an unexpected upheaval in top management, the company's inscrutability loomed as a larger issue. Plus, Smith added, the story could also update Enron's efforts to sell off billions of dollars of poorly performing assets, many of them overseas electric power plants and gas pipelines.

And another story would provide an opportunity to at least mention the Fastow partnerships, Emshwiller added. "What they did just looks outrageous," he said. "How does a company justify having its chief financial officer running partnerships that could profit at the expense of the company?"

Smith agreed that the conflict of interest issue was important. But she worried that any story about the partnerships might seem irrelevant to investors since the chief financial officer already had terminated his relationship. "It would have been nice if we'd come across them a few months earlier," she said. Neither reporter was certain that they'd get enough information on the partnerships to carry a whole story, but Smith thought that packaging the information as a "Heard on the Street" column might flush out some new sources.

"Let's put it out there and see if it smokes out anything new," she said. "Can't hurt," said Emshwiller.

One of the things that impressed Smith, who had worked for a bunch of other papers, was how different the *Journal* readership was. She often put small slivers of information in stories, like messages in bottles, then tossed them into a receding tide and was amazed at what came back. Unsolicited e-mails from helpful readers sometimes yielded tips on where to look. She always tried to approach people as individuals, not as representatives of companies, because the affiliations changed. A person who was ferociously protecting a company, at one point in time, might later furnish a reporter with information—if he or she felt the reporter could be trusted and had treated the employee respectfully.

The *Journal's* culture reinforced that sensibility. Whenever the paper ran a story saying someone had resigned, for example, the reporter was expected to make a serious effort to find the person. More than once, Smith got a public relations person to give her a home or cell phone number by making it clear that "as a matter of personal courtesy" she needed to give the person the opportunity to speak for him- or herself. "I'd do the same for you," she'd tell the PR person. "Don't you think people have a right to talk for themselves when it's their name in the paper?"

As its name implied, the "Heard on the Street" column, which appeared in the *Journal's* "Money & Investing" section, related what Wall Street types were saying about a particular company's or sector's prospects. It often had an insider feel and, because it was a column, gave the writer a little more stylistic latitude. Reporters were expected to talk to investors—not just analysts—and get as close to the center of action as possible. The column was passed among editors via personal e-mail, which meant it was handled differently from a regular news story, which was moved through a series of open queues in the *Journal's* copy system.

The reason for the special handling was that the *Journal* wanted as few people as possible to see the column before it saw print to minimize any chance someone might try to make money off the news.

Once a reporter wrote a "Heard" piece, his or her local bureau chief would edit the piece and then e-mail it to the editor in New York who was in charge of putting out the column daily. At the time that Smith

and Emshwiller did their "Heard," that editor was Leslie Scism. Scism would further edit the column, asking her own questions. Often her boss, Larry Ingrassia, who headed the entire "Money & Investing" section of the *Journal*, would read a "Heard" and request changes. Then the piece would go to the national copy desk for a final detailed line edit. Positive "Heard" columns could move stock up; critical columns could depress prices. The *Journal* was especially sensitive to this issue because in the early 1980s it had weathered its own crisis when it was learned that a regular writer of the column, R. Foster Winans, had been providing advance information on the pieces to Wall Street professionals who traded on the information. Winans was fired and later went to federal prison.

Used responsibly, though, the "Heard" was a powerful tool that touched an influential readership.

Smith began making calls to analysts to get their views on Enron post-Skilling. She knew she would have to take their comments with a grain of salt. Smith was sometimes struck by how little of the questioning of company executives on the quarterly analyst calls had to do with the practical matters of building products and running businesses. (Though, in all fairness, the analysts did try to add to their store of knowledge by making periodic company visits.) Yet so much appeared designed to get specific numbers that could be plugged into forecasting models to predict future cash flows, revenues, and the all-important statistic of earnings per share. She was amazed at how little an hour's worth of questions and answers produced. The analysts seemed intent on the numeric minutiae about the company while disregarding more telling issues, such as how the company was being run and the character of those running it—qualities that were far harder to quantify.

Nonetheless, as her knowledge base grew so did her drive to get to the bottom of the Enron story. With a twinge of frustration she considered the probability that Friedland expected the two reporters to continue working together on this story until further notice. She knew that doubling up would have obvious benefits for the paper, of course. But the prospect of sharing the assignment with Emshwiller was less than thrilling. While the two reporters respected each other and had worked well together under pressure during the California electricity crisis,

their relationship had begun to fray. Both preferred to work alone and found it exasperating to make the compromises necessary to create stories with a single voice. More than once, the two had argued over changes the other had made to the copy.

Adding to the tension, the two often approached stories in very different ways. Emshwiller spent a lot of time chatting with sources that Smith felt could never pass any sort of cost-benefit analysis. Bernie Glatzer was the archetype, someone who might eventually produce some kernel of something useful—or might never. To Smith, who was under constant pressure to keep current with the activities of a few dozen companies, cultivating random sources was a luxury she could not afford. From the time she had begun covering energy in 1995, she was intent on chronicling an industry as it shed a century of often inept regulation and began to apply market principles to the selling of electricity. She focused on expert sources who could help her understand how and if the industry could be reformed, to make workable markets for electricity—a commodity that needed to be delivered to the exact place it was needed at precisely the right time and over a transmission system that wasn't designed to be the backbone of a market. California bit off more than it reckoned in 1998 and Smith had watched the unfolding tragedy first with fascination, then with distress as the cost of the debacle mounted into the billions.

Despite the occasional clashes, however, the two reporters recognized that they often produced better stories when they collaborated. In working on California electricity stories, Emshwiller came to rely on Smith's accumulated expertise on the ins and outs of the state's power market. Smith, in turn, appreciated her colleague's greater understanding of the intricacies of how the *Journal* worked, which was very different from the operations at the five other daily newspapers she'd known. *Journal* editors had fiefdoms such as page one or the "Heard" column, and for the reporters, success depended on being able to find the right home for a particular story. At every other paper where Smith had worked, you wrote the story; it ran. The most desirable stories were taken for page one. Everything else ran inside. Placement was not something she ever thought about or worried about because enough of her

stories had always made their way onto page one. But at the *Journal*, placement was critically important because it also determined length. If you didn't have a good slot, you wouldn't get much space. That meant you couldn't tell much of a story.

Friedland had clearly appreciated having the two reporters working as a team during several of the most intense months of the California electricity crisis and it was natural he would want to put them together again. The bureau chief also found that the pairing gave him extra reporting and writing resources that allowed him to keep more control over coverage—no small feat given all the other *Journal* bureaus that jumped in to get a piece of a story once it achieved national stature.

As career beat reporter, Smith found such an invasion of her turf familiar and frustrating. Few reporters wanted to cover unglamorous industrial beats during normal times. But as soon as a story heated up, it turned into a kind of irresistible land grab, with reporters rushing everywhere, trying to stake a claim to some aspect of the coverage. Yes, Smith thought, I am certainly looking forward to flying solo again.

Emshwiller was ready to get back to uncovering stock fraud. But he was drawn into the Enron story, in part for a selfish reason. He'd found the references to the Fastow partnerships and he didn't want to let someone else get credit for the discovery. He didn't know how newsworthy the partnerships might prove to be, but he wanted to be there to write about them.

The Skilling interview story drew a fair amount of reaction. Dan Hertzberg, the *Journal*'s deputy managing editor, sent a complimentary e-mail, urging continued digging. "There may be a great story inside Enron," he wrote. As a reporter in the mid-1980s, Hertzberg had teamed with fellow *Journal* staffer James Stewart to write a series of Pulitzer Prize–winning articles on the scandals and travails on Wall Street during the Milken-Boesky era. By August 2001, managing editor Paul Steiger had given Hertzberg much of the responsibility for the day-to-day running of the *Journal*'s news operation. Hertzberg loved breaking news stories and particularly loved beating the *Times*—and hated being beaten by them. He wasn't shy about making both his pleasure and his displeasure known.

The Skilling interview also prompted a call from Enron's Palmer. "I don't believe him," he said. Skilling's remark about the Enron stock price "just doesn't make sense."

"It doesn't jibe with the official explanation," Emshwiller needled back.

Palmer seemed surprised, almost stunned, by the remarks that Skilling had given to the *Journal*. The public relations vice president reminded the reporter about how just two days earlier, the Enron president had publicly and repeatedly proclaimed that he was leaving for personal reasons. It didn't make sense that Skilling's explanation for resigning would seemingly change so drastically in twenty-four hours.

Emshwiller could hardly disagree. But Skilling had said it. The reporter thought again about how subdued Skilling had been, how he'd seemed to ramble as he'd talked about the stock price. What, he wondered again, was going on with the guy?

As Emshwiller and Smith eventually learned from internal Enron documents, another company insider had a strong reaction to the Skilling interview story. Lay later recounted to investigators sifting through the rubble of Enron that when he read the piece, he was taken aback. What was Skilling doing? he thought. Why was he blaming the stock price? That wasn't part of the explanation that everyone had agreed on. He felt that Skilling had just undercut the company. Of course, neither Lay nor anyone else on that August day foresaw how quickly and ferociously the very foundations of Enron would come under full-scale assault.

4

"I Have Found That Mr. Lay Doesn't Take Kindly to Criticism."

"A COMPANY THIS SIZE COULDN'T POSSIBLY HAVE A CONSPIRACY TO mask."

Emshwiller had been reporting for a couple of days, and that had been the liveliest quote he'd snagged. It came courtesy of David Fleischer, a veteran energy analyst and managing director of Goldman Sachs & Co., one of the most powerful and prestigious firms on Wall Street. Fleischer was a longtime fan of Enron, and his enthusiasm hadn't been dampened by the Skilling resignation. "Jeff Skilling is an incredible individual," Fleischer said when Emshwiller called him at his Manhattan office. "He imagined what wasn't and created it. He gets an incredible amount of credit for that. He has created a machine. Much of it goes on without him. There is a great team there. In some ways, Enron might be stronger without him," Fleischer said. "He kept dreaming new dreams and spending money. Investors want the existing engines revved up to produce money." Plus, Skilling was sometimes too blunt for his own good, he added.

It was hard to argue with Enron's success. Revenues for the company in the 2001 second quarter tripled to $50 billion and profits were up nearly 40 percent to $404 million.

But by August 2001, the broadband initiative was in ruins. While such setbacks didn't dim Enron's overall future prospects, Fleischer insisted to Emshwiller, they likely didn't sit well with Skilling. "He put

the pressure on himself. He was probably feeling the weight of the world. Here is a guy that's not used to failing."

As Emshwiller listened to Fleischer, he couldn't help feeling a little sorry for the fallen Enron executive. For years, Skilling had been a superstar in the corporate world. In April, a mere two months after taking Enron's helm, Skilling had been awarded the number two spot on *Worth* magazine's list of America's fifty best corporate chief executives, behind only Microsoft's Steve Ballmer.

"So what do you think of Enron?" Emshwiller asked.

"I have a strong 'buy,' " Fleischer said, reiterating his projection of 25 percent annual earnings growth. "This is a great company with great prospects." As if anticipating the next question, he added, "That's not what most investors have thought in the past six months."

"Why do you think the stock is down?"

Part of the problem, Fleischer said, is that in recent years Enron's shareholder base had changed as it moved from being a traditional natural gas pipeline company to a high-tech energy-trading and telecommunications firm. The new shareholders looked at Enron more as a "momentum" stock than as a steady, long-term hold. When the stock market bubble for high-tech and telecommunications companies burst in 2000, those investors started madly selling shares. While Enron's broadband business had been a big disappointment, there was still enormous underlying value in the company, especially its trading operation, Fleischer said. "In Enron's case there was smoke but not fire." Though he was clearly an unabashed Enron booster, Fleischer's arguments didn't sound outrageous to Emshwiller. After all, almost everything the reporter had heard about Enron made him think that the company, despite some troubles, was firmly entrenched in the nation's business elite.

Fleischer went on to point out that "part of the criticism for Enron is that it has so little transparency" about its finances and operations. A March story in *Fortune* magazine by reporter Bethany McLean had raised that very issue. It bore the title "Is Enron Overpriced?" and went on to criticize the company's "complex businesses" and "nearly impenetrable" financial statements, likening the entire operation to a "black box" with a very high stock price.

"I think the company is trying to give more transparency," said Fleischer. "They can and should."

"What do you know about these partnerships that were run by Andy Fastow?"

"Fastow didn't want to do it," said Fleischer. "They asked him to do it."

You mean Enron management? Emshwiller asked.

That's right, Fleischer said, as well as the partnership investors, which included some of Enron's banks. The idea of the partnerships was to allow Enron to sell some of its assets to a third party to raise cash and reduce corporate debt. "The banks didn't know enough about the assets in Enron to operate the partnerships," Fleischer said. "They wanted Fastow. Enron pushed him to do it. He didn't want to." Over time, some on Wall Street started criticizing the idea of having the chief financial officer run these outside partnerships. With a falling stock price, Fleischer said, Enron felt pressure to do something about a situation that "smelled bad even though I don't think it was bad."

Fleischer's explanation of the partnerships sounded very much like the one from Enron, with a heavy emphasis—which Emshwiller presumed the analyst got from Fastow—on how reluctant the chief financial officer had been to take the assignment. Of course, the reporter thought, that would be a convenient explanation to deflect conflict of interest criticism. Fleischer was certainly right about the arrangement smelling bad; maybe he was right about it being nothing worse.

Smith and Emshwiller interviewed several other analysts. Almost all had "buy" recommendations on Enron. None seemed to know as much about the Fastow partnerships as Fleischer did. Some hadn't even heard of the partnerships or, if they had, didn't know who ran them. "I don't think the name has been released," one analyst said.

Smith wasn't surprised that so little was known. In the eight quarterly earnings calls she'd heard on Enron, she'd never been aware of a single reference to the partnerships. It was clearly under the radar. There was this whole subterranean world of Enron investments that didn't surface in any of the published research she'd seen. Aside from a focus on numbers used to form earnings models, the analysts were obsessed with how

specific Enron businesses were panning out. A few months earlier, Smith talked with Salomon Smith Barney analyst Ray Niles, who predicted that "Enron is going to take the same skills that made it the number one electricity player to become the dominant player in telecommunications."

"Can they really do this?" Smith asked, wondering if the skills were really that transferable.

"They've all but done it now," said Niles.

Emshwiller took on the task of going back through Enron's SEC filings to see what the company had said about the partnerships. He found the first reference to them in the company's report for the quarter that ended on June 30, 1999. Enron said it had "entered into a series of transactions" with "LJM Cayman LP . . . a private investment company which engages in acquiring or investing primarily in energy related investments. A senior officer of Enron is managing member of LJM's general partner." This partnership became known as LJM1. The second, much larger one, came later in 1999. It was named LJM2 Co-Investment LP, or LJM2, for short.

As he read through the filings, Emshwiller wondered with growing astonishment why so many analysts who followed Enron knew little or nothing about the partnerships. After all, many of these people earned $500,000 or more a year because of their expertise in dissecting and analyzing corporate financial statements. Their advice on stock could influence billions of investment dollars. Yet they apparently weren't reading the financial statements very thoroughly.

The press, for its part, hadn't done much better. Though there had been hundreds of stories about Enron, the coverage had a role quality to it, with the same anecdotes repeated over and over and the same quotations appearing from the same executives. To some extent, the press looked to other organizations to keep companies like Enron honest. As long as companies produced audited financial statements for the SEC, there was an assumption that the numbers were good. In the case of Enron, reporters, like the analysts, generally didn't read far enough into the company's SEC filings to discover the references to the LJM partnerships—or read right past them. As Emshwiller read through the SEC filings, he thought again about the irony of how he had found out

about the partnerships, given his normal beat. The reporter knew that he almost certainly would never have had reason to read an Enron SEC filing if Skilling hadn't chosen that particular week in August to quit.

In reporting for the "Heard on the Street" story, Emshwiller was given a glimmer of the conflict many analysts encountered in covering a company with powerful connections on Wall Street. But he didn't give the matter more than passing notice at the time. He was focused on finding analysts with interesting insights into Enron. In a call to John Olson, the research director for a Houston-based brokerage firm called Sanders Morris Harris, Emshwiller was surprised when the analyst asked that his name not appear in the *Journal* story.

"Why?" asked Emshwiller, mildly perplexed. As a rule, analysts loved getting their names in the nation's biggest business newspaper.

"I have found that Mr. Lay doesn't take kindly to criticism," said Olson.

"How so?" the reporter asked.

"He and others at Enron aren't shy about complaining to your boss if they don't like something you say." Olson didn't elaborate.

As Emshwiller talked with Olson in the succeeding weeks, he came to more deeply appreciate the analyst's level of caution. While an analyst at Merrill Lynch in 1997, Olson had dropped his rating on Enron to "neutral" from "accumulate" in part owing to higher-than-expected costs from the company's push into the retail electricity business. However, he continued to rate Enron as a long-term buy.

Enron wasn't happy about the downgrade. One night at a gala charity event in Houston, Olson found himself across a table from Jeff Skilling. When are you finally going to put out a strong buy on our stock? Skilling asked Olson with a smile.

Olson smiled back with a shrug, hoping to sidestep the awkward question. A few moments passed.

When are you going to put out a strong buy on our stock? Skilling asked again, only this time it sounded to Olson as though the Enron president were snarling.

"Jeff, I'm just a bargain hunter," Olson replied. Skilling, who felt Olson never understood the company, didn't reply.

But two of Merrill's investment bankers complained to senior execu-

tives at the Wall Street giant, arguing that Olson's failure to support Enron, despite its success, had hurt Merrill's ability to land investment-banking deals from the company. The investment bankers angrily blamed the analyst when Merrill wasn't picked for a lucrative Enron stock offering. Olson said that his boss flew in from New York and "his first three words were Enron, Enron, Enron. He wanted to take away all my stock and benefits at the firm." Olson said the pressure was such that he had lost 30 pounds and was down to 138 pounds on his six-foot-two frame. Finally, Olson worked out an early retirement agreement and happily left Merrill with a keener appreciation for investment bankers. "They're an abomination," he told the reporter bitterly.

Yet even Olson didn't know the full extent of his own story until months after Enron's collapse, when congressional investigators obtained some of Merrill's internal records of its dealings with the energy company. In an April 1998 memo to a senior Merrill executive, the two complaining investment bankers said that Olson "has a poor relationship with Jeff [Skilling], and, particularly, Ken [Lay]. . . . Enron views his research as flawed." Olson's replacement by Donato Eassey helped mend that relationship. A January 1999 memo from a Merrill investment banker said that Enron executives appreciated the brokerage firm's responsiveness "regarding our difficult relationship in Research" and said that "any animosity in that regard seems to have dissipated." The note added that Enron had recently given Merrill two investment-banking jobs, which were expected to produce $45 million to $50 million in fees. When these internal memos surfaced, Merrill said that the total fees from Enron were never more than a tiny percentage of the brokerage giant's overall revenues and that its research findings were never compromised by its investment-banking ambitions. Merrill also noted that both Olson and Eassey put "accumulate" ratings on Enron at the end of 1998. Eassey later raised his rating to "strong buy," a Merrill spokesman said. Olson dropped his rating to "hold." Eassey lowered Enron to "neutral" after Skilling quit.

In that first interview with Emshwiller in August 2001, Olson pointed out that for all the excitement Enron had created in the marketplace, it simply wasn't all that profitable. In 2000, Enron reported a little under $1 billion in net income, a scant 1 percent of its $100

billion of sales. "This is below grocery store margins," Olson told Emshwiller. Enron's trading operation had huge and growing cash needs, requiring more borrowings. Plus, the company had fluctuating cash flows. In some quarters, the company would use far more cash than its operations brought in. In other quarters, there would be big net cash inflows. Analysts generally preferred seeing steady, positive cash flow, quarter to quarter. It was a sign of stability. By the end of 2000, Enron's reported liabilities had jumped to some $54 billion from about $24 billion a year earlier. Even though the company posted fast-growing revenues and assets, the liability number was worrisome, particularly given the difficulty in deciphering Enron's extremely complex operations. "Wall Street was increasingly relying on Jeff Skilling," Olson said. "Suddenly, there is no Jeff Skilling."

Still, he was hardly an Enron doomsayer. The company had some very valuable assets and a huge franchise in the robust business of energy trading. Olson said that if the stock fell a little further from its current level in the high 30s, he'd look at giving it a "buy" recommendation. (Olson later did give Enron a buy rating.)

Olson also never really bought into Skilling's pitch about Enron morphing into a new kind of twenty-first-century company. Skilling loved to talk about how the era of the asset-laden corporation was ending under the pressure of the information and communications revolutions. Old-line industrial titans, such as the giant oil companies, "are going to break up into thousands and thousands of pieces," he predicted in a 2000 speech. Enron, by contrast, was a giant profit machine that could make money trading practically anything, anywhere, anytime. Skilling called this the "asset-lite" business model because "intellectual capital" had replaced bricks and mortar as a corporation's most enduring asset.

Skilling had certainly used his asset-lite arguments to beat out his most serious competitor for the top job at Enron—Rebecca Mark—as Smith had learned when Mark suddenly resigned from all Enron positions a year earlier.

The resignation had prompted Smith to work on a feature that examined the rivalry between the two executives—one that was both philosophical and personal. Only five years earlier, Skilling and Mark had been running neck-and-neck at the company, both rising stars with

strong credentials to lead the company one day. Both were in their early forties with MBAs from Harvard and heading divisions regarded as vital to Enron's future. Each was regarded as a Lay protégé. As one other senior executive told Smith, it was as if Lay had two children, Skilling and Mark, and were trying to decide who was more capable of running the family business. By 1996, Mark led the company's international division and had rescued a multibillion-dollar power project in India that had become a pawn in domestic Indian politics. Skilling, of course, was the driving force behind Enron's burgeoning commodities-trading business, which was seeking to give the company dominance in markets ranging from electricity to wood pulp to natural gas.

Mark and Skilling collected very different sets of subordinates. Skilling's group was brash, confident to the point of hubris, and ever eager to go off with their boss on what became known as the "mighty men" adventure trips, like a one-thousand-mile motorcycle trip down Baja California or tearing around in Land Rovers through the Australian Outback. Mark, who'd tramped through the jungles of Latin America, looked down on such junkets as something suited to dilettantes. Her kind of adventure travel was done to help build things, such as a one-thousand-mile gas pipeline from Brazil to Bolivia. Mark spent as little time at the Enron palace as possible and often was out of the country for weeks at a time—though, of course, she often globe-trotted first class or, whenever possible, on one of the Enron corporate jets. And Mark had one particular trait that made Smith take note. Underlings regularly described her as "kind." That wasn't a word that ever came up in the reporter's conversations about other Enron managers, not even Lay and certainly not Skilling.

When Smith met Mark for the first time in early 2000, she found herself impressed by Mark's lightning-quick mind and her professed mission to bring giant infrastructure projects to the developing world. While Mark had the biggest fiefdom in Enron, with some twelve thousand of the company's twenty thousand employees, hers was an increasingly troubled empire filled with hard-to-manage assets that severely tested the company's political skills in working with so many foreign governments.

The biggest headache came from a project that had once been Mark's

biggest foreign triumph, the giant Dabhol electric power plant, south of Bombay. At $2.5 billion, it was the largest foreign investment in India's history and was intended to put Enron on the map as a global player alongside the big oil companies. Unfortunately, that very prominence made Dabhol a perfect political football, especially since Enron and its partners had negotiated its key features with Indian officials but had not been required to put the project out to competitive bid.

But big investments had a way of creating big fights. During executive meetings in 1996 and 1997, Mark and Skilling had heated arguments over which of their operations, international or trading, was a bigger drain on Enron resources. While trading required little capital investment, since all you needed was computers and employees, it did require a huge amount of credit, which was often obtained by borrowing against the hard assets that Skilling bad-mouthed. "Sure, the trading operation uses no capital," Mark once exclaimed in exasperation. "It just consumes the entire balance sheet of the company."

Differences between the two came to a head at the end of 1996, when Enron's president and chief operating officer, Richard Kinder, quit unexpectedly. A cigar-chewing graduate of the University of Missouri, Kinder was known within the company as more of a "hard-ass" than anyone who got into the hard assets or "asset-lite" debate. He tried to rein in free-spending superstars like Skilling and Mark. But Kinder also wanted to be Enron's chief executive someday. When it became clear to him that he wouldn't get that post, he left to start his own energy company, Kinder Morgan, a natural gas storage and transportation company.

Lay had relied heavily on Kinder to worry about Enron's day-to-day operations. He had no desire to take on that chore. Though he initially formed a management committee to search for a new president, he quickly pulled the plug on that process. In late December, the board named Skilling president and chief operating officer, effective New Year's Day 1997. While Mark had more star power, Skilling had better numbers, and he had convinced Lay that Enron's future lay with him. Skilling's trading operation, known at the time as Enron Capital and Trade Resources, was growing rapidly and producing an ever larger part of Enron's reported earnings. In 1996, earnings at Skilling's operation

before taxes and certain other expenses jumped some 78 percent to $280 million. By contrast, income from international operations rose a relatively paltry 7 percent to $152 million.

Still, Skilling's quick selection caused some unhappiness. "Nobody thought Jeff was ready," one former division head later told Smith. "He was so predatory, so derogatory. He didn't like the pipelines. He didn't like international. He thought he knew better than everyone about everything."

Mark knew that her days at Enron were numbered. She'd agitated for Enron to spin off the international business into a separate company and had even courted Shell Oil as a possible joint venture partner. But Lay and Skilling nixed the proposal. So she found a graceful way to leave. Enron had been building a global water supply business and in 1999 spun it off as a new public company, called Azurix Corp. Mark became that company's chief executive. Azurix turned out to be a bust largely because the global water business, dominated by government monopolies, proved even rockier terrain than the global power business. In late 2000, Enron reabsorbed Azurix and paid public stockholders $8.25 a share—less than half the 1999 public offering price of $19. Mark was asked to leave Azurix and resigned a position on Enron's board as well. She cashed out her options and emerged, having accidentally caught the top of the market, with a total of $56 million, according to Thomson Financial.

In their reporting for the "Heard" piece, Smith and Emshwiller also talked to some of those shadowy denizens of Wall Street known as "short sellers." Short sellers make a living by taking positions on stocks that are profitable only if their value declines. The problem, from a reporter's standpoint, is that there are lots of ruthless shorts who will spread rumors, hoping to instigate a sell-off that will make them money. Smith always felt they were trying to use her and the newspaper, and she didn't like the fact they would never allow their names to be used in stories. The whole business seemed somewhat unsavory to her.

Emshwiller, on the other hand, generally found the shorts to be smarter and harder working than the average analyst. Companies gladly spoon-fed information to their fans on Wall Street. The critics had to go out and dig up their own information.

Starting in late 2000, a number of short sellers—particularly a New York–based trader named James Chanos—began privately to question some of Enron's accounting and financial-reporting practices, including the mysterious Fastow partnerships. None knew much beyond the scant information in the public filings. And none seemed to question Enron's fundamental viability. One short seller admitted sheepishly to Emshwiller that he and his firm had never actually traded Enron shares. "We never thought we could risk shorting Enron," the trader said. "It's such a huge company and so complex. We could get crushed."

Indeed, as Smith and Emshwiller finished reporting the story in August, Enron was still widely viewed as a business and political juggernaut. It was, by far, the biggest and most influential energy trader in the country and had reported fifteen straight quarters of year-over-year earnings gains, usually in the double-digit range. EnronOnline, the company's Internet-based trading market, had done nearly $1 trillion in transactions since it was started in November 1999. The outrage that California officials directed toward Enron over the state's electricity crisis only confirmed that the company, whether for good or ill, dominated the power-trading business.

Now, two of Enron's resident "geniuses," Mark and Skilling, were gone. Only Lay, old reliable, remained from that triumvirate. Smith and Emshwiller had left him as the last interview for the story. He was, as usual, happy to oblige.

5

"It Isn't a Conflict of Interest."

EMSHWILLER COULDN'T SEE PALMER'S FACE, BUT HE IMAGINED THE tiniest glisten of sweat gathering there. The reporter sat in his office, cluttered as ever, his telephone headset in place and connecting him some 1,600 miles southeast to Enron headquarters. There, on the other end of the line, Palmer fumbled with the phone system. He was trying to hook up a conference call with Smith, waiting at her desk in San Francisco. But he wasn't having any success. Once, twice, three times he tried. Each time, San Francisco didn't answer. As he struggled, Palmer apologized and laughed nervously. No doubt adding to his discomfort, Lay was sitting with him, waiting for the interview to begin. And his patience was wearing thin. "Well, Mark," he finally said. "I guess we're not going to make you Enron's chief technology officer." There had been an edge in Lay's voice that didn't quite fit with his affable image.

Palmer and Emshwiller both laughed, though the reporter suspected that only one of them actually found the remark humorous.

Finally, Palmer succeeded in connecting Smith to the call. "Nice to talk with you again, Rebecca," Lay said, once again his affable self.

"Thanks for taking the time to talk with us," she replied. Smith took the lead in asking the questions. Ahead of the interview, the two reporters had briefly gone over the subject areas they wanted to cover. It all seemed pretty straightforward. How was Enron planning to make its

operations more understandable to investors? What plans did it have for various business sectors? And, of course, they wanted to ask about Skilling's resignation and Fastow's partnerships.

Lay admitted that Enron had lost some credibility with Wall Street. "I want to make sure we restore that credibility," he said in the matter-of-fact way of a man who had a small stain on his suit and just needed to get it to the dry cleaners for a quick treatment. Enron would put out more financial data, as long as it didn't place the company at a "competitive disadvantage." Lay suspected the analysts' clamor for more information would be temporary, and he seemed confident that Enron's stock would soon be bouncing back as well. "As long as the stock price was doing well, they were not nearly as anxious to see more details," he said, seeming to imply that the problem was more one of perception than of actuality.

Lay reiterated Enron's intention to sell $10 billion worth of assets, mostly overseas, tacitly admitting that the company was overextended. The company would use the cash from the sales to pay down debt and invest in the trading operation. Even without the asset sales, he added, "we have strong cash flow, over $3 billion this year, and great liquidity."

What about the Fastow partnership arrangement and the conflicts it presented? Emshwiller asked.

"It isn't a conflict of interest," Lay replied firmly. "Almost all big companies have related-party transactions. Mark has a list of them if you'd like to see it."

"Well, but do any of them involve the CFO running partnerships that are doing enormous amounts of business with the company that employs him?" Smith asked.

Lay again made it clear he felt the conflict criticism was off the mark. "This was approved by our outside auditors, approved by our board," he said, sidestepping the question of whether it was nevertheless unorthodox. "It's in the best interest of the shareholders."

Smith continued. "How did Fastow come to head the partnerships?"

"He was asked to take this role. It was set up to be a related-party vehicle. The board and management trust him. Now he has withdrawn."

Why?

"His utility to that vehicle is no longer all that great," said the Enron

chairman. "Other parties now have a good understanding of the Enron business model." Lately, there had been "concern by some analysts" about Fastow being in the partnerships, he acknowledged. "If there is something they don't like, that's something we ought to stop doing."

The reporters asked about Skilling's resignation.

"I was very surprised by it," said Lay. "Until he came to talk, he had not shared some of these personal and family matters with me. But he couldn't put them off. When he talked to me, he made it very clear that primary reasons were personal and family matters."

The "family matters" proved something of a tease because Lay declined to say what those matters were. Emshwiller moved along to other subjects.

"He told me that if it wasn't for the stock price falling, he probably wouldn't have quit," said Emshwiller.

"He gave me and the board quite the opposite reasons," Lay replied. Then he added, "He probably did feel pressure from the stock price and probably personalized that pressure a little more than he should have." But the resignation, he reiterated, had nothing to do with Enron's operations.

Smith asked how he felt about coming back as chief executive when he thought he'd forever surrendered that task.

"I am recommitted, energized, and enthused," Lay said. Asked how long he would stay, he replied, "However long it takes. I will be here until I'm comfortable that we have the right person for the CEO job. Enron is a culture that if you don't have 100 percent commitment to the job and have your head in the game, you're not doing right by the company to stay." And publicly, at least, he was certainly welcomed back. When he'd walked into an all-employees meeting in August, two days after retaking the top job, he'd been met by a standing ovation from several hundred people.

But in private meetings there were more doubts. Some company executives worried that Lay, who long had relied on Kinder and Skilling to run operations, simply didn't have a good enough grasp of Enron's complexities to head the company without a strong no. 2.

Emshwiller had never before interviewed Lay. Smith, who'd been talking with him on and off since 1995, assured him Lay had stayed true

to type. Lay always sounded measured, in command, and completely convinced that any difficulties would be temporary, merely a preamble to more astonishing successes. Still, she felt uneasy that it didn't sound as though he'd made any effort to keep Skilling, making her wonder if he'd been as quick to jettison Skilling as he had been Mark a year earlier. There was definitely a sharper edge to Ken Lay than he generally allowed others to see.

As the reporters started writing the story, they went back and forth on how to handle the Fastow partnerships. Though intriguing, the information was somewhat irrelevant since Fastow was no longer connected to the partnerships. Both reporters felt strongly that they should include as much information in the story as they could confirm and keep their fingers crossed that it produced additional leads. They salted in several paragraphs about the Fastow partnerships in the second half of the story, with the top half focusing on Lay's plans for Enron. They took the unusual step of including a large block of copy from Enron's most recent SEC filing to illustrate how indecipherable the "public disclosure" about the partnerships had been:

"Enron has entered into agreements with entities formed in 2000, which included the obligation to deliver 12 million shares of Enron common stock in March 2005 and entered into derivative instruments which eliminated the contingent nature of existing restricted forward contracts executed in 2000. . . . In exchange, Enron received notes receivable from the Entities totaling approximately $827.6 million. In addition, Enron entered into share settled costless dollar arrangements with the Entities on the 12 million shares of Enron common stock. Such transactions will be accounted for as equity transactions when settled. Enron received a $6.5 million note receivable from the Entities to terminate share-settled options on 7.1 million shares of Enron common stock. The transactions resulted in noncash increases to noncurrent assets and equity."

The "Heard on the Street" story ran August 28 on the front page of the *Journal*'s "Money & Investing" section. Enron's stock price rose that day by about 70 cents a share to $38.62. One analyst called the piece a "positive article" and reiterated a "strong buy" recommendation on the company.

That day, Palmer called Emshwiller. "Nice story," he said.

"Did you like all the space we gave to your SEC filing?" the reporter asked, hoping that at least the Fastow stuff might have ruffled them a bit.

"You know, I talked to several people this morning who read that passage. None of them could make sense of it either," Palmer said with a laugh.

Always nice to be a source of amusement, Emshwiller thought acidly as he hung up the phone. Then he shrugged. Well, he thought, this was probably his one and only piece on Enron. He'd soon be back to covering white-collar crime. Enron and the rest of the energy beat would remain Smith's headache.

Then Smith got a phone call.

6

"You're Just Scratching
the Surface."

THE PERSON WHO PHONED SMITH HAD READ THE "HEARD" AND sounded eager to talk, if somewhat nervous. It was one thing for someone to read a story and, over a morning cup of coffee, grouse about its incompleteness. It was something else for a reader to pick up the phone and actually offer to fill in the holes for the reporter. The message left on Smith's office voice mail was vague and intriguing: "Hello, this is —— in ——. You had a good story about Enron. I've got some additional information that might interest you. You're just scratching the surface. If you'd like to chat, give me a call at ——."

Smith called back immediately. The voice that answered was friendly but also a trifle wary. The person worried that top Enron executives, especially Fastow, might find—and punish—anyone who criticized them. Smith gave the reassurance that reporters usually give in such circumstances. She'd protect the caller's identity except insofar as it had to be known to others at the newspaper. She said she understood how hard it was to step forward and told the caller not to worry. A reporter who violated a source's trust was like a farmer who ate his seed corn: he didn't stay in business long.

Still, the caller still seemed jumpy, worried about being identified if parts of the conversation made it into the paper. Smith wanted to hear the full story, but she feared that if she pushed for too much information too soon, the person would bolt. So she let the conversation flow, inter-

rupting only to get a few details in key places. Mostly she wanted to start establishing trust. On both sides. One possible downside to this approach, however, was that this initial encounter might turn into a venting session that would leave the caller so spent, there would be no desire to talk again.

Many people believe newspapers are so all-powerful that they can "make things happen." The caller seemed to share this view. But Smith had long ago learned that the truth was something less cataclysmic. Newspapers could instigate change not by being agents of change, but by *supporting* agents of change. It was an important distinction, and it made a reporter focus on working with sources that were in possession of better information than any outsider, including a reporter, could acquire.

As the source talked, Smith felt as if she'd found someone with a long-range scope. The caller knew a lot about Enron and came across as balanced, intelligent, and genuinely offended by Fastow's conduct. The person mentioned "internal documents," the most beautiful phrase in a reporter's lexicon.

According to this person, Fastow had been running what amounted to an internal investment fund at Enron that probably earned him more money than his paycheck as chief financial officer. Lots of people knew about the setup and hated it—some simply because they were jealous, others because they thought it was outrageous and unethical for Fastow to have such a glaring conflict of interest. But top management and the board of directors believed the arrangement served Enron's strategic interest. Fastow's entities helped the company bring cash through the door that could be used to prop up the whole operation. Enron was awash in poorly performing assets for which it often had overpaid. Fastow's entities enabled Enron to sell off some of the assets for cash for the partnerships while also removing from its balance sheet large amounts of debt originally used to buy those assets. This process of raising cash and reducing debt allowed Enron to create the appearance of growth that Wall Street wanted to see. But, given Fastow's hugely conflicted role, were these real transactions or just shams to buff up Enron's financial face? Smith had no idea at the time how large that question

would soon come to loom over the company's future or the course of events in corporate America.

Smith let Emshwiller know that their story had produced a very useful lead. She briefly related her conversation with the person. "I think this is the real deal," she said with an edge of excitement creeping into her voice. As a reporter, she'd learned the value of staying cool, ever skeptical. It was a guard against "needling a story," as journalists call reporting that hypes an angle, distorting reality. Plus, hot information had a way of cooling and sagging during the laborious process of verification. But there was no denying that the source had rekindled her desire to dig down to bedrock. More than anything, she loved the hunt. It was thrilling when the pieces began to come together and when sources came forward expecting no more reward than the satisfaction of seeing that as Chaucer wrote in a favorite phrase of hers, "murder will out," or the truth be told. After a second conversation with Smith a day or so later, the source—whom Smith dubbed "Our Mutual Friend"—sent the first set of documents related to one of the Fastow partnerships.

It was now about three weeks since Skilling's resignation, and the story had an unmistakable whiff of a scandal. Yet there were many questions that needed to be answered, among them why Skilling, Lay, and the board had cooperated in an arrangement that appeared to amount to featherbedding for Fastow. It looked as though Enron were saying one thing in public about its earnings prospects and then taking steps, privately, to shore up a weak structure that was little understood by investors.

Questions also were multiplying about the company's three central characters. How did Fastow get into the LJM partnerships, and what exactly was he getting out of them? Had Skilling's resignation been tied to some problems at LJM, coming as it did only about two weeks after Fastow severed his ties to the partnerships? How had Lay, Enron's gray eminence, a man who liked to talk about rectitude, allowed such a suspicious-looking operation to be set up in the first place?

The document from the source—a forty-one-page "road show" presentation for LJM2—indicated that the partnership looked to raise at least $200 million from outside investors. It appeared to be an outline

that Fastow and others had used to make pitches to would-be investors. While it was often written in short, incomplete sentences, the messages it contained were clear enough. These guys are working both sides of the street, Smith thought with rising indignation. Fastow was bragging about how he had access to special inside information that could be used to make money for partnership investors—not Enron shareholders. The chutzpah astonished Smith because it clearly violated Fastow's first obligations to Enron and its owners, which was to be a good fiduciary steward of their investment dollars. "Why would they put this stuff on paper?" she muttered as she flipped through the document with an almost giddy sense of surprise.

The document projected returns for investors of at least 30 percent. Under the heading "Why LJM2 Is Unique," the document boasted that the partnership would get "preferred access" to deals from a $10 billion Enron investment portfolio. Fastow and other Enron employees would run the partnership and be able to "evaluate investments with full knowledge" of how the assets had performed for Enron. They'd have the inside information not normally available to an investment partnership. In effect, they could cherry-pick from Enron's ample orchard. And if anyone doubted that Enron needed the orchard picked, the presentation proclaimed in all capital letters that "ENRON MUST SYNDICATE ITS MERCHANT INVESTMENT PORTFOLIO IN ORDER TO GROW."

It also was clear that the authors of the LJM2 document understood that having Enron's chief financial officer working both ends presented a problem. Enron's board of directors "has waived 'Code of Conduct' for A. Fastow's activities related to LJM2," the document said. Plus, an "advisory board" would "resolve all potential conflicts of interest."

The document made certain things very clear. Fastow was using the Enron name and his status as chief financial officer to raise money. He told prospective investors that as chief financial officer he could quickly identify lucrative Enron deals for the partners. Fastow had described these investment opportunities as the "low-hanging fruit," ready to be plucked, the source said.

Lest investors have any concerns about where Fastow's loyalties would lie, the document, in its shorthand way, stated that "General

Partner economics aligned with Limited Partners." This struck Smith as a stunning admission. Reading the document, she felt certain that some of LJM2's profit would come at the expense of Enron shareholders.

Yet only potential LJM2 investors had been privy to this document. Common shareholders of Enron had no inkling of its existence. None of the LJM2 documents were available through the SEC records. That's because the partnership was a private deal, pitched only to wealthy individuals or large institutions, outfits that presumably didn't need a lot of protection from federal securities laws. Thus, private partnership documents were exempt from federal public disclosure rules.

Both reporters read through the document several times. Emshwiller thought he'd gotten pretty cynical covering stock swindlers. But in some ways, Fastow's partnerships were starting to look every bit as sleazy as the average stock scam. Here Fastow was, getting first pick of his own company's pantry, with the blessing of the board.

After another long talk with "Our Mutual Friend," Smith arranged for a three-way phone conversation that included Emshwiller, who was eager to hear what the person had to say. The three ended up talking for more than an hour. While clearly not privy to everything in the Fastow/LJM operation, this person knew enough to convince the reporters that they had barely scratched the surface in their first story.

The source clearly disliked Enron's chief financial officer. "Fastow is very manipulative, self-centered. He screams. He's known to have tirades," said the person, hardly pausing for breath. With LJM, "Fastow created some very self-serving opportunities," the source said. "And he created enormous wealth for himself."

How much wealth? asked the reporters.

"Fastow had raised $350 million to $400 million by May 2000" for the LJM2 partnership, roughly double the original goal. As general partner he got an annual fee equal to 2 percent of the sum raised. "So that could be $8 million a year," the source said. But, "I bet Lay to this day doesn't know that Andy took out those kinds of management fees." Both Smith and Emshwiller wondered whether it would be worse for Enron shareholders if Lay did or didn't know. He'd be either complicit or clueless. It was one thing to be a hands-off chief executive, but this

was absurd. The source suspected that Skilling knew a lot more about the LJM arrangement than did Lay. After all, Fastow was his protégé.

But there was more than just management fees. Fastow had a profit participation in the partnerships. The source rattled off numbers involving residual interests, hurdle rates, preferred internal rates of return. It was hard to follow the calculations but pretty easy to grasp the result. "Fastow could be looking at $60 million" for himself over the first five years of the partnership, said the source, and LJM2 was expected to run ten years. "Andy was making millions off the Enron name."

The source didn't know much about LJM1, which was a much smaller entity than LJM2. It had been set up in the summer of 1999. Fastow supposedly told the directors that the company needed to be able to tap outside sources of equity to provide cash and help manage Enron's growing investment portfolio. The chief financial officer proposed putting together an outside partnership that would do business deals with Enron. Fastow would run the partnership. The much bigger LJM2 followed several months later.

Fastow had brought some of his closest subordinates into the LJM circle, the source said. Among them was Michael Kopper, who had been named one of Enron's managing directors, one of the top fifty or so positions in the company. Another was Ben Glisan, a managing director whom Fastow had championed as corporate treasurer. Both Kopper and Glisan were in their early thirties. "Fastow and Kopper are tight, tight, tight," said the source.

When he was soliciting investors for LJM2, Fastow targeted Enron's major banks and investment bankers. "Andy really twisted the arms of the banks to get them to do deals," said the source. The message: Invest in LJM2 and Enron business would flow in your firm's direction; don't invest and, well . . . The source added that for about six months, starting in the fall of 1999, Fastow spent two to three days a week working on the LJM2—even though he was supposed to be working full-time as Enron's chief financial officer.

Fastow lined up lots of commitments, usually in the range of $10 million to $15 million apiece, from institutions with Enron ties. LJM2 had recruited twenty to twenty-five limited partners, including some

wealthy individuals. The institutions included Enron's two principal banks, JPMorgan Chase & Co and Citigroup, as well as Lehman Brothers, First Union Bank, the Arkansas Teachers Fund, a Weyerhaeuser pension fund, and Merrill Lynch. Fastow had hired Merrill Lynch, the nation's biggest brokerage firm, to help sell interests in the LJM2 partnership.

Some institutions declined to participate and didn't change their minds, said the source. The most prominent was the California Public Employees Retirement System. "CalPERS," as it was known for short, was the nation's biggest public pension fund. Its investing ties with Enron went back to the early 1990s. But it said no to LJM2.

Fastow also allegedly pressured fellow Enron executives to cooperate on making the LJM arrangement successful. "If you were head of an Enron business unit with assets to sell and didn't offer to sell them to LJM, Andy would visit you," the source said. Besides being Enron's finance chief, Fastow sat on the performance review committee that decided compensation for subordinate executives. He also played up his close ties to Skilling. So angering Fastow wasn't a wise career move at Enron.

The Fastow partnerships caused lots of unhappiness inside Enron, though few knew more than hazy details about the arrangement. "There was rampant coffee room speculation last year about Andy's LJM compensation," the source said. Even the name of the partnerships rankled among those who knew its origin. The "LJM" had been plucked from the initials of the first names of Fastow's wife, Lea, and two sons, Jeffrey and Matthew. "It was like he was rubbing it in that it was his deal and he could do what he liked with it," said the source.

And to hear tell, Fastow didn't take kindly to criticism of the LJM arrangement. The source told of the case of Jeff McMahon, Enron's one-time treasurer, who felt the LJM arrangement was riddled with problems. As treasurer, he handled Enron's relations with its major bankers, and bankers had called complaining about being pressured to invest in LJM2. However, McMahon was in a difficult position, since as treasurer he reported to the chief financial official. "McMahon was dinged on his bonus one year for raising questions about LJM," the source claimed. Finally, in the spring of 2000, McMahon went over Fastow's head and

complained directly to Skilling about the partnership arrangement. But the treasurer's call fell on deaf ears. "Andy was a star in Skilling's eyes," said the source.

Fastow, however, angrily confronted McMahon after Skilling told him about the treasurer's complaints. He told McMahon that he didn't think the two of them could work together anymore. A short time later, McMahon was offered a job running an Enron business unit that was trying to create markets in industrial products like pulp and metals. Fastow tapped Glisan, a young and loyal follower, as the new treasurer.

But pressure within Enron against LJM kept rising. By the spring of 2001, Skilling had begun telling Enron executives that "there are so many issues involving LJM, that don't use LJM anymore except as a last resort," said the source, adding that McMahon had said, "Skilling finally found out about the kind of money Andy was making." By the summer, "something snapped" inside of Enron, which led Fastow to sell his LJM interests to Kopper. The source didn't say what precisely led to that decision or how much Kopper had paid for that interest. But the reasons must have been pretty powerful. "Andy wouldn't leave a penny on the table if he didn't have to," the source said.

Near the end of the interview, the source provided the names of others who might be willing to talk, including Enron employees and officials at investing institutions. What about any additional paperwork? the reporters asked.

"I was wondering when you would ask about that," said the source with a laugh. A short time later, another very interesting document rolled in over the fax.

It was the private placement memorandum for LJM2 that went to each would-be investor laying out the terms of the partnership. Though this memorandum was a much denser and more legalistic document than the road show circular, it too emphasized Enron's rapid growth and unquenchable thirst for more money. Enron's desire to execute deals quickly "should result in a steady flow of opportunities for the Partnership to make investments at attractive prices," the memorandum assured potential investors. It noted that Enron had $34 billion in publicly disclosed assets on its balance sheet as of June 1999 but was owner of assets valued at a total of $51 billion. "The difference between

these numbers represents the amount of assets financed off balance sheet," the document said.

"You sure don't see this stuff being told to the average Enron shareholder," Smith said in a phone conversation with Emshwiller after the two had each read through the document.

"You have to wonder how many billions of dollars Enron is keeping off its balance sheet that ought to be there," he replied.

As Smith reflected on the second document, her astonishment over the LJM partnerships kept growing. In all the conversations she'd had with Enron officials and analysts who tracked the company, she'd never heard any mention of this netherworld of off-balance-sheet financing. "And you have all these insiders possibly making millions or more," she said. Even for Enron, the sheer gall seemed incredible.

Though they tried to sound professionally cool, both could feel the excitement rising inside them. Out of the blue, they had been presented with a chance to possibly uncover a big scandal in one of America's biggest companies. It wasn't an opportunity that came along very often. Still, the two tried to temper their enthusiasm. While they realized that the pair of LJM documents had more than enough information to justify another story, they also knew that nailing down the most incendiary and important of the source's allegations would be extremely difficult.

"All we have to do is show that internal self-dealing was going on while Andy Fastow was getting money from Enron's banks. Shouldn't take too long," Emshwiller said sarcastically.

"Why on earth would Enron let Fastow do this stuff?" Smith asked.

"It seems incredibly stupid," said Emshwiller, especially for a company that was run by such supposedly smart people.

Despite the very encouraging interview with their tipster, both reporters knew that they needed a lot more than a couple of documents and one anonymous source. Smith, at least, had now talked with that source enough times to feel comfortable that this wasn't some disgruntled individual with a little information and a big ax to grind. If even a reasonable chunk of the allegations was true, the reporters knew they had a strong story.

Friedland heartily agreed, as did editors in New York. "They might want the story for page one," the bureau chief told Emshwiller and

Smith. At the *Journal*, getting on the front page was a bigger deal than at most other newspapers. At the typical newspaper, six or eight stories made the front page each day. The *Journal* had only three front-page stories daily. Two were longer feature pieces—called "leders"—that took anywhere from several days to several months to report and write. The third piece each day was usually a whimsical story, known internally as the "A HED." (The name came from the border of lines over the top of that story and a horizontal line of three stars that cut through the head-line, forming a rough approximation of a capital "A.") With more than three hundred reporters around the world, there was lots of competition for those three spaces. While reporters were routinely encouraged to write for all parts of the *Journal*, it was also widely understood that the way to succeed at the paper was to have your byline on the front page as often as possible.

While the story told by their source definitely sounded like "leder" material, one had to be careful. The reporters knew they faced at least two large obstacles. Even if the information was true, it wouldn't be printable unless it could be confirmed.

7

"You Are About to Topple a $20B House of Cards."

SMITH AND EMSHWILLER STARTED MAKING THEIR CALLS, ALL THE while zapping e-mails back and forth to each other. Their source had named a blue-chip group of institutions and individuals as investors in the LJM partnership, and the two reporters had found that revelation puzzling, if not unsettling. "It doesn't make sense—so many wealthy, sophisticated people putting money into these partnerships," Smith wrote to Emshwiller, who quickly fired back, "Yeah, these clearly aren't your run-of-the-mill partnerships, not with Fastow's conflict of interest looming over the entire setup."

"Maybe Our Mutual Friend is right," said Smith, now on the telephone with Emshwiller after a series of fruitless calls to assorted banks, brokerage firms, investment funds, and individuals who supposedly invested in LJM2. "They were either pressured by Fastow, in the hope of getting more business, or they just thought it looked like easy money."

Emshwiller thought both explanations made sense. Firms that did business with Enron might well fear losing future business if they didn't invest in the partnerships.

What little he knew about Enron made him think the company knew how to press any advantage it had; indeed, such an approach was integral to the corporate culture. From their source's description, Fastow sounded like someone willing and able to turn the screws.

As a reporter, Emshwiller tended to expect the worst when calling

sources. Even after so many years making calls, he was still mildly surprised when people were willing to talk to a perfect stranger calling on the phone. This time, his pessimism was more than borne out. Calls to the brokerage firms and banks that were on the reporters' list of LJM2 investors were generally returned by public relations officials who declined, either politely or perfunctorily, to comment. A spokeswoman for Wachovia Corp. acknowledged that the important Charlotte, North Carolina–based bank and holding company had made an LJM2 investment, though she could hardly have done otherwise. Wachovia had included the investment in a long list of properties. Emshwiller had found the reference through the magic of computer database search engines. In a matter of seconds, he skipped through tens of thousands of documents in 10Kwizard for the "LJM" combination of letters. Though again impressed at the power of computers, he was also grateful that the Fastow family initials didn't spell "THE."

Though the Wachovia spokeswoman wouldn't talk about the LJM2 investment, she did have a brief comment about Enron. "We do lend to Enron and want to continue. Enron is an important relationship," she said, and requested that any story mentioning LJM2 and Wachovia specifically mention that desire. Having long ago been taught never to promise that anything will appear in a *Journal* story, Emshwiller gave no such assurance. Privately, he wondered why any institution would want to appear so obsequious. Was Enron that desirable a customer? Was Wachovia that hard up for business?

Smith heard a similar tune from Adebayo Ogunlesi, a senior Credit Suisse First Boston banker and Enron admirer. He didn't want to talk about the partnership—that much was clear—and he nimbly maneuvered the conversation to a discussion of the virtues of Enron, "a great, great company" that Credit Suisse "looks forward to doing more business with." Smith felt mildly irked that she hadn't gotten anything more than platitudes from Ogunlesi about how important the Enron relationship was to his firm.

General Electric, among the bluest of America's corporate blue chips, acknowledged that its GE Capital unit had put money into LJM2. "We are the smallest investor in it, under $5 million, though," a company public relations official told Emshwiller in the course of a telephone in-

terview, giving the reporter one of the first useful nuggets of information he'd gotten. Now, they at least had some sense of the size of the investments. LJM2 was just one of many "routine small investments" made by GE Capital, the spokesman said, and then reiterated that "our involvement is a very, very small one." Emshwiller thought that the guy seemed to be making a large effort to emphasize the puniness of the deal.

The GE investment intrigued the reporters. The $5 million clearly was chump change for a company that had nearly $500 billion in assets. So why bother with it at all, given the controversial aspects of the partnership? Was GE Capital hoping to do some financial deals with Enron, or was GE looking to humor a customer that had bought many expensive electricity-generating turbines? Ever since the boom in U.S. power plant construction that began in the late 1990s, the company had been in keen competition with Siemens-Westinghouse for that market. Was it trying to curry favor with Enron? The GE spokesman insisted the LJM2 stake was just one of hundreds of investments that it had made in any number of ventures. Nothing out of the ordinary. And, of course, it was a very small investment.

The two reporters were talking by phone and e-mailing several times a day from their desks four hundred miles apart. Emshwiller almost invariably wore a headset to talk on the phone. It saved his neck from getting stiff and freed his hands to type on the keyboard. Sometimes, while he and Smith chatted, he'd do other tasks such as reading e-mails and scrolling through newswires. He had search engines on his computer to pull down any wire stories about investment frauds and the electricity crisis. (He'd later add one for Enron.) The two reporters usually didn't have much new information to share, but just trading reactions helped them keep motivated. Though both were still excited by what they were chasing, it was easy to get discouraged in the daily drudgery of being turned away by most of your potential sources.

While the desire to keep Enron happy might have been important to many firms investing in LJM2, some partnership investors had no apparent ties to Enron and thus didn't seem subject to the same motivations. This group was apparently enticed by the prospect of fat partnership profits that had been dangled in the initial private offering documents. Smith contacted Bill Shirron, an investment manager at the Arkansas

Teachers Retirement System. She was glad to come across an investor that represented public employees, because in her experience officials at such places seemed to feel more obliged to talk to the press than their private sector counterparts. And Shirron, as it turned out, was quite willing to talk—and on the record. The pension plan had pledged $30 million, he said, simply because LJM2 looked like a good investment. He didn't seem to recall any significant conflict issues. If there were any, he felt certain the company would deal with them appropriately. So far, things had gone spectacularly well. The Arkansas pension plan had put in about $7.4 million of its $30 million commitment and already gotten back $6 million. While such eye-popping returns "won't keep up" over the partnership's expected ten-year life, "the early-stage investment has been a home run," Shirron said.

The reporters' original source had identified several wealthy individuals as LJM2 investors, including two who the source said were big players on Wall Street: Leon Levy and Jack Nash. Levy and Nash had met in the early 1950s at the brokerage firm of Oppenheimer & Co. and through a separate venture had been doing deals together since, ranging from big investments in public companies to purchasing the IBM building on Madison Avenue. By the late 1990s, the twosome had made *Forbes* magazine's list of four hundred richest Americans, with fortunes estimated at $675 million and $475 million, respectively. News stories described Nash, who was in his late sixties, as a brilliant deal maker, "supersecretive," and an afficionado of abstract art. Levy, a few years older, was more outgoing. (Levy died in April 2003.)

"Don't expect them to talk with you," Friedland told Emshwiller when the reporter mentioned their names.

Besides trying to reach LJM2 investors, Smith and Emshwiller very much wanted to talk to people who had turned down a chance to invest. "CalPERS"—the giant California Public Employees Retirement System pension fund—had been the most promising lead. Emshwiller couldn't find an investment manager at the pension fund willing to talk. But he did eventually find someone familiar with the CalPERS/Enron dealings who agreed to be interviewed on a not-for-attribution basis.

CalPERS was concerned about "the Fastow connection," said this person. Fastow's dual role "was a real conflict of interest. Here you have

Fastow being the CFO, who is supposed to maximize shareholder value, also being the general partner, who is supposed to maximize partners' investments."

Still, he added, LJM2 "was an ingenious financial creation." Enron needed outside parties to do deals. The LJM partnerships filled that bill without being truly independent parties. "I think Enron perceived Andy as providing almost a financial engineering function to help the company manage its balance sheet," said this person.

When he heard the term *financial engineering*, Emshwiller had a quick vision of Fastow as some kind of high-priced plumber fixing any leaks in the piping that linked Enron's finances. He had heard the term a couple of other times in the past, in connection with other companies. He'd never thought much about it before. "Financial engineering," "balance sheet management," "smoothing out the earnings," all seemed like phrases talking about a process common in publicly traded companies—a process in which very smart people got paid lots of money to try to ensure that corporations didn't have unpleasant news to report to shareholders. He'd mostly assumed that the engineering was also basically legal. As he learned more about LJM2, though, he began to wonder about that assumption.

Fastow had tried hard to convince CalPERS to invest. In his pitch to the pension fund's managers, he argued that any conflict of interest problems would have been "mitigated" because any deal offered to LJM2 would also be offered to other outside parties. But this seemed to ignore the fact that Fastow's presence, therefore, would likely discourage any other parties from bidding against LJM2 for Enron assets. All in all, CalPERS officials decided that the whole LJM2 setup was just too fraught with trip wires to be worth the risk.

"How did Fastow take the rejection?" Emshwiller asked.

"I think he was okay with it," the source said slowly. "He recognized that CalPERS already had a huge Enron relationship."

Emshwiller thanked the person for his time and was just about to say good-bye when he thought of one more question. "By the way, have you ever seen anything like LJM2 elsewhere?"

"No, I've never seen a similar deal at other companies," he replied.

Hearing that CalPERS had conflict of interest concerns made Em-

shwiller feel more confident in his own assessment. The interview had also given his spirits a nice lift. Though he and Smith hadn't expected to find many people willing to talk, the process of hitting lots of blank walls was still discouraging. Here, finally, was confirmation that the LJM setup had caused at least some sophisticated investors to hold their noses. Besides being an enormous and respected entity, CalPERS had been heavily involved with Enron for nearly a decade and committed hundreds of millions of dollars to two joint investment partnerships with the company. The partnerships went by the name Joint Energy Development Investments but were better known by their acronyms, JEDI and JEDI II. In 1993, CalPERS and Enron had agreed to each put in $250 million to form JEDI. Enron operated the partnership and invested the money in dozens of privately held energy companies. The aim was to help nurture these companies and then cash in as they grew and, in some cases, went public. Being chosen as an investment partner by CalPERS, which at the time was far better known in the financial world than was Enron, had been a giant boost for the company and its reputation. In a 1993 story in *Institutional Investor* magazine, Fastow predicted that the JEDI partnership " 'could be one of the major components of Enron Corp.'s becoming the first natural-gas major' on a par with the oil giants." At the time, Fastow was a vice president in Skilling's unit, which operated JEDI.

The partnership went so well that Enron and CalPERS partners created JEDI II in 1997. This time, each partner agreed to kick in up to $500 million. Besides the two JEDI partnerships, CalPERS owned some three million Enron shares in its huge stock portfolio. Yet despite all this familiarity, LJM2 didn't pass the pension fund's smell test.

During the LJM reporting, Smith drove to CalPERS headquarters in Sacramento, after a public records act request shook loose thousands of pages of documents. Working with another *Journal* reporter, Mitchel Benson, the reporters photocopied more than six thousand pages of documents related to the CalPERS-Enron relationship. That trove showed that Enron was constantly pitching investment ideas to CalPERS and had an almost chatty relationship in which it sought the pension fund's money and offered fat returns—and flattery in return.

Among the documents was a transcript of a meeting that had taken

place between CalPERS directors and Fastow that followed a presenta-
tion he made in October 2000. Fastow was remarkably candid about
why he was there, in Sacramento, acknowledging that Enron had a
problem with expensive projects that took years to generate earnings.
"That's not a good thing from a credit-rating standpoint," Fastow said,
adding that companies like his often "look for outside private equity
money that will help invest alongside them and, if I can use a term, be
more patient money."

The three major ratings agencies—Moody's Investors Service, the
Standard & Poor's (S&P) unit of McGraw-Hill, and Fitch—were ex-
tremely important in the Enron universe, as they were to many big com-
panies. These agencies rated a company's publicly traded debt. The
higher the rating, the easier it was for a company to sell new debt, in the
form of bonds or commercial paper, and the lower the interest rate it
had to pay to debt holders. For a company such as Enron, which had
huge cash and borrowing needs, having the highest possible credit rat-
ing was vital. Indeed, as crisis engulfed Enron in late October, propping
up the credit rating became a top priority for company executives. Be-
cause of Enron's extremely complex, interrelated financial structure,
a sharp drop in the credit rating, down to so-called junk status, could
immediately spark billions of dollars of debt repayment obligations—
obligations that the company didn't have the cash to cover. It also could
create a massive cash crunch in the energy trading business.

CalPERS not only had deep pockets, it was able to afford a long-term
investment position, an intoxicating combination for a company that
had multimillion-dollar projects that would take years to come to
fruition. Fastow noted that Enron had $60 billion in assets at the time,
but only $33 billion showed up on its balance sheet. "So the difference
between the two, about $27 billion, are those investments that have
short-term earnings problems or short-term cash flow problems that
we've looked to outside investors like CalPERS to invest [in] alongside
us to help solve those problems," he said.

It sounded to Smith and Emshwiller as though Fastow took the occa-
sional rejection from CalPERS in stride primarily because he knew
there would be plenty of other chances to make a pitch. No use ruffling
feathers.

Emshwiller called Merrill Lynch officials and asked for an interview about LJM2. The two reporters were interested in hearing what the nation's biggest brokerage firm had to say about its role as selling agent for the partnership. The LJM2 private placement memorandum wasn't very informative. It merely said that Merrill Lynch "has been engaged as a placement agent in connection with the formation of the Partnership and may use its affiliates to assist in its placing activities." Not surprisingly, the document didn't explain how Merrill Lynch got the job as placement agent or whether the firm had any qualms about taking the assignment. Those and other questions that the reporters had were left unanswered as a Merrill spokesman added to the lengthening list of no-comments.

The reporters tried reaching current and former Enron executives. Few called back. None who did knew much about the LJM partnerships. One person did tell Smith that there was a current Enron executive who supposedly had been raising concerns internally about the partnerships and had even written a memo criticizing them to top brass. Someone named Sherron Watkins, the source said. Smith had never heard of her, although soon enough her name would be known around the world. Smith dialed the main number at Houston's headquarters and left a message, which she followed with an e-mail. She never heard back.

While Smith and Emshwiller weren't having much luck reaching people about Fastow and LJM, they continued to hear from *Journal* readers about the August 28 "Heard on the Street" story. The e-mails were generally attached to the on-line version of the stories that appeared on the *WSJ.com* Web site. "Stay with it," said one anonymous e-mail to Smith. "You are about to topple a $20B house of cards." The reporter assumed the "B" stood for "billion," though the writer seemed to be short-changing the house of Enron a bit. At the time, the company's stock market value was closer to $30 billion.

In their database searches, the reporters found LJM2 tucked into the footnotes of the financial statements of a few other companies. The partnership showed up as a shareholder in New Power Holdings Inc. Enron had spun off New Power as a separately traded company in 2000, and its job was to sell energy services to small retail customers that Enron no longer wanted to serve. But the public filing by New Power

didn't explain how or why LJM2 had gotten involved in that company. CalPERS had also invested in New Power. The government filings showed that New Power had different classes of stock, and a plethora of investors, including some that appeared to be other Enron partnerships. It looked like a terribly complicated setup for a fairly minor company. Since Enron still effectively controlled New Power, the reporters held off calling it for comment. They figured they could do that after interviewing Enron officials about the LJM partnerships.

LJM2 also appeared in the public filings of a Reston, Virginia–based company called Pathnet Telecommunications Inc. It appeared that Enron had used LJM2 and two entities, both with "Backbone" in their names, as middlemen in a circuitous late 2000 transaction to sell Pathnet a chunk of Enron's much touted broadband network. LJM2 had just been a momentary middleman. But why? the reporters wondered. And why did Enron sell off a piece of its broadband network at the same time that it was still bragging about how big that business would get? By the summer of 2001, Pathnet had gone into federal bankruptcy court, one more victim of the great telecommunications industry meltdown. Emshwiller wasn't able to reach any company officials.

LJM-related complexities piled up. Fastow wasn't officially the general partner of LJM2 Co-Investment LP, though that appeared to be how he was introduced to potential investors. Strictly speaking, the general partner's position was filled by something called the LJM2 Capital Management LP. The general partner of that limited partnership was LJM2 Capital Management LLC (which stands for "limited liability company," a business structure that is a sort of cross between a partnership and a corporation). Finally, the "managing member" of that entity was one Andrew S. Fastow.

Fastow's name appeared, along with other senior Enron officers, in the SEC filing of a little energy company called Kafus Industries Ltd., in which Enron had an indirect stake. Kafus's shares were held by an entity called SE Thunderbird LP, whose general partner was Blue Heron I LLC, whose sole member was Whitewing Associates LP, whose general partner was Whitewing Management LLC, whose managing member was Egret I LLC, and whose managing member was, at last, Enron Corp.

In covering swindlers, Emshwiller had often seen such chains of enti-

ties that eventually led back to an actual person. In those cases, it was almost always done to hide the involvement of a crook. Perhaps Enron had some reason other than subterfuge for such an elaborate chain of ownership. But for the life of him, he couldn't think what it might be.

The more the reporters dug through the public databases, drawn by the keywords *LJM* and *Fastow*, the more they felt they had entered some kind of funhouse maze. Indeed, it looked as if some transactions had been designed to be indecipherable. The level of complexity alone made the reporters suspicious that Enron was trying to hide something. But the two still had mostly just suspicions and conjecture. Until they had something more tangible, they knew they'd have a hard time writing a story.

"I Want to Be CFO of the Year."

As the reporters dug into the LJM world, they also started trying to compile a profile of Andy Fastow. Smith had never interviewed him or seen him. He'd been present during some of the quarterly telephone conference calls Enron had with analysts, but he almost never spoke. And prior to about two weeks earlier, Emshwiller had never even heard of the guy. He did, however, know one person who had and was more than willing to talk.

"Fastow made $20 million off of my idea," Glatzer proclaimed when Emshwiller called about the Enron chief financial officer. The reporter didn't ask how he had reached that number, and Glatzer mercifully didn't elaborate.

If Skilling was Glatzer's Public Enemy No. 1 at Enron, then Fastow was No. 2 on that list. Glatzer claimed that Fastow had been hired by Skilling to implement his stolen gas-financing ideas. At least in Glatzer's mind, Skilling and Fastow had launched their Enron careers off his back. In conversations with Emshwiller, he routinely mentioned that he was looking to add Skilling and Fastow as defendants in his litigation. Of course, he had to get his Enron lawsuit reinstated by the courts first.

As it turned out, Glatzer had something far more valuable than animus toward the two Enron executives. He had copies of depositions taken of Skilling and Fastow by his lawyer in 1997 as part of the litiga-

tion. When Emshwiller heard that news, he felt a small thrill. The next best thing to actually interviewing a guy was to be able to read what he had to say under oath. If nothing else, depositions usually started off with the witness providing a brief personal history, which was always helpful for a reporter trying to put together a coherent chronology of a person's life. Especially if the profile subject declined to be interviewed.

In his deposition, Fastow flashed a certain disdain for lawyers. When Glatzer's attorney pressed him on why he had pushed so hard to complete certain financial transactions in the early 1990s, Fastow shot back that "unlike lawyers, we don't get paid by the hour."

While the deposition was taken long before LJM came into being, it did at least provide some personal background on Fastow, supplemented by interviews and other reporting. For instance, his middle initial "S" stood for Stuart. Fastow was born in Washington, D.C., on December 22, 1961, the middle of three sons. His mother, Jean, worked as a real estate agent. His father, Carl, was a buyer for supermarket and department store chains. Fastow grew up in the suburbs in Virginia, Long Island, and New Jersey, where he graduated from New Providence High School in 1980 (after a stint as student body president). He earned his undergraduate degree, in economics and Chinese, at Tufts University in Massachusetts. A joke soon circulated in the Enron building: Andy had such an ear for languages that he'd turned economics into Chinese.

Fastow earned his MBA from the Kellogg School at Northwestern University, outside of Chicago. He'd worked at Continental Bank in Chicago, learning to put together complex financing deals. He was hired by Skilling's operation, then known as Enron Finance Corp., in December 1990. He recalled being interviewed by Skilling for the job but said he couldn't remember much about the conversation. "I don't recollect everything that occurred, but with—my understanding of what Mr. Skilling was looking for was a person to assist in funding the activities of Enron Finance," Fastow said. And, Emshwiller thought, he evidently found him.

The reporters, of course, knew that Fastow had a wife and two kids, all of whom had initials. Glatzer, something of a follower of Houston society, told Emshwiller that Lea Fastow had previously been Lea Weingarten, a member of a prominent and wealthy local family that had

initially made its money in the supermarket business and then shifted over to real estate investing. The Weingartens had long been pillars of an active Jewish community in Houston, Glatzer said. "Houston was surprisingly accepting of Jews. It wasn't something I expected as a New Yorker." While this was interesting sociology, Emshwiller tried to steer Glatzer back to Fastow and the Weingartens. "They were a very respected family in Houston, active in the community," he said. He speculated that Fastow was pushing so hard to make money at Enron as a way to show that he belonged in the kind of stratum of society traveled by his wife's family.

Fastow met Lea at Tufts, where she too was an undergraduate. For a time, she also worked at Enron, in various finance jobs, but left in 1997 to focus on raising their sons. Enron officials who had known Lea Fastow described her as bright, pleasant, and outgoing. In fact, "There were some who thought she was the smarter member of the couple," one official told Emshwiller.

In keeping with her family's position in Houston, Lea Fastow was active in civic affairs, such as the local contemporary art museum. In 1995, she co-chaired a fund-raiser, dubbed "Mixed Nuts," for the museum that the Houston Chronicle's society writer called the "zaniest" charity event of the year—complete with parking attendants in tutus, fire eaters, hot-coal walkers, and human centerpieces holding glow lights. She and Andy became aspiring collectors of modern art. When Enron was looking to decorate its new downtown office tower, next to the corporate headquarters, Lea Fastow joined the committee that selected the artwork. The Fastows pushed Enron to begin building a corporate art collection, including a $575,000 Claes Oldenburg sculpture.

The Journal's computerized database, with stories from some six thousand publications, contained only about half a dozen mentions of Andy Fastow through the end of 1997. By then Lea Fastow had appeared in fourteen stories, mostly having to do with her local charity work. Fastow's first newspaper notice, in 1985, involved a bizarre incident that had nothing to do with Enron. The Chicago Tribune did a piece about complaints customers had made to the Chicago taxi commission. Fastow, who was with Continental Bank at the time, was punched in the face by a cabbie in a dispute over a fare. The punch cost the taxi driver

a fifteen-day suspension, according to the *Tribune*. Clearly, controversies involving money had dogged Fastow for some time, though they had grown in size at Enron.

In a 1997 interview with *American Banker*, Fastow discussed the kinds of banks Enron was looking to do business with. At the time, Enron had relationships with more than seventy commercial banks. "More and more," Fastow said, "we've found that the winners among the banks are the ones that have excellent relationship managers that not only understand Enron but understand how to build consensus within their own institution." He added that a bank working for Enron must "have creative, value-added ideas."

In going through the clips containing Fastow's name, Emshwiller came across a June 1999 piece in *CFO* magazine, a trade publication for corporate finance executives, that looked as though it might have been relevant to LJM. The piece was about a proposed accounting industry rule that would make it tougher to keep debt off a company's balance sheet. Like other big companies, Enron kept billions of dollars of debt sitting in separate entities that it partly owned but didn't include in its financial statements. The proposed rule would require a corporation to include such entities unless it could show it didn't control the entity, and the article estimated that such a move could add $10 billion in debt and threaten the company's credit rating. "My credit rating is strategically critical," Fastow told the magazine.

Enron had for some time been rated at BBB+ by the major credit agencies. That ratings level was seven notches down from the top rank of AAA, a pinnacle reached only by a handful of companies. The top ten levels, which included Enron's BBB+, were considered "investment-grade" ratings. Any rating below BBB− was considered "non-investment-grade," which was also less charitably known as a "junk bond" rating. This was a critical demarcation point because many major institutional investors such as pension funds, which were not supposed to be gambling with pension assets, could buy the debt only of investment-grade companies. Plus, in the trading business, the lower the credit rating, the tougher the credit terms demanded by trading partners. While Enron's BBB+ rating was in the investment-grade range, it also had plenty of room for improvement.

Like Wall Street stock analysts, the credit-rating agencies had their own conflict of interest issues. In one sense, their constituency consisted of millions of bondholders who bought corporate debt and relied, in no small measure, on the security's credit rating. At the same time, the ratings agencies were actually paid by the companies to do the evaluation work on their debt issues. Up to the 1970s, ratings agencies derived most of their revenues by publishing books of ratings that interested parties would buy. But then the agencies switched to charging the issuers, arguing that the old subscription system didn't produce enough revenue to cover the cost of analyzing the growing flood of increasingly complex bond issues. For its part, Enron paid millions of dollars a year for ratings agency services. Officials at each ratings agency maintained that their independence wasn't compromised by the revised payment arrangement because no single client contributed even a single percentage point to overall revenue. (Moody's, for instance, later calculated that Enron's annual fees of $1.5 million to $2 million came to less than a quarter of a percent of the firm's total take. Standard & Poor's officials also said that fees from Enron contributed only a tiny part of the firm's overall revenues.)

Over the years, Enron had lobbied consistently, determinedly, sometimes almost comically, to get its credit rating raised. At a February 2001 meeting in Houston, Fastow pressed ratings agency officials to raise Enron into the A category. The officials responded that Enron didn't have sufficient cash flow, debt coverage, or earnings for such an upgrade, one credit analyst told Smith. Undeterred, Fastow said the higher rating would so strengthen the company's basic finances and performance that the higher rating then would be justified. This example of putting the cart before the horse didn't produce a ratings increase, though it did produce laughs among the analysts, who joked that perhaps they should create a new A rating category especially for Enron. The A would represent "Anticipated performance"—or perhaps, simply, "Arrogance" on the part of the company that always thought credit standards were for everybody else.

In the 1999 magazine interview, Fastow expressed confidence that Enron's credit rating wouldn't be jeopardized by any change in accounting rules, though the article was a bit vague on how Enron would pro-

tect its status quo. The piece did observe that Enron had become a "master of creative financing." It cited an instance where Enron had kept over $1 billion in power plant debt off its balance sheet by selling an interest in the plant to a "Special-Purpose Entity."

Emshwiller couldn't recall running across that phrase before—though it would soon be an integral phrase in the reporting on Enron. Stock swindlers, he'd learned, had their own toolbox of devices—clean shells, reverse splits, Reg S offerings—but Special-Purpose Entity wasn't among them. He wondered briefly if LJM, which wasn't mentioned in the article, might be a special-purpose entity.

The biggest story about Fastow came courtesy of CFO magazine, which in October 1999 awarded the thirty-seven-year-old executive a "CFO Excellence Award." The magazine credited Fastow with playing a key role in Enron's "amazing transformation from pipelines to piping hot." He had found creative ways to manage Enron's debt, protect its credit rating, and still provide enough money to rapidly expand the company, the article said, and noted that Enron's stock market value had increased to $35 billion from $3.5 billion during the prior decade. "Andy has the intelligence and youthful exuberance to think in new ways," Skilling told the magazine. The CFO article made no mention of LJM. Smith and Emshwiller learned from an Enron insider that after seeing a CFO at another company singled out for the limelight, Fastow had sought out the award. An Enron executive told Smith he was amazed to get a blunt call from Fastow saying, "I want to be CFO of the Year. Can you make me CFO of the Year?"

The colleague responded, "Gee, Andy, why not *Time* Man of the Year?" as a kind of joke. Fastow didn't laugh. In the end, it didn't prove that difficult. All they had to do was make him accessible and the tiles fell into place.

Mostly, though, the reporters found Fastow to be a low-profile, almost reclusive figure—a sharp contrast to Lay and Skilling. Wall Street analysts didn't know him well or have much contact with him. "Fastow never appeared at analyst meetings," said Olson, the analyst. Normally, a big corporation's chief financial officer is the company's point man with the financial community.

Even people who didn't much like him admitted that Fastow was a

good-looking guy, his boyish features framed by thick and wavy black hair that turned progressively more silver as he moved through his thirties and up the Enron ladder. Some thought he boosted the silver with a little dye to make himself look more distinguished. Like Lay and Skilling, Fastow was on the short side. The handsome face often carried the hint of a smirk, as if he were privy to some joke, which some people found more than a little annoying.

Fastow also had a reputation as a screamer, who negotiated by intimidation and tirade. An official at one major bank recalled getting awakened at 2:00 A.M. by a shouting Fastow, who was unhappy about the pace of a particular loan transaction. "He would call you an idiot, though in more colorful language," said the banker. "Then the next day you'd talk to him and he would apologize profusely. It was all part of his persona." Charm and brimstone.

While working on their Fastow file, Emshwiller and Smith also tried to gather information on his lieutenants, Kopper and Glisan. Both were listed as principals of the LJM2 in the private offering document for the partnership.

However, Enron sources said that Glisan didn't take an active role in managing the partnership. Glisan had gotten his bachelor's and master's degrees at the University of Texas and then worked at the accounting firms of Coopers & Lybrand and Arthur Andersen. He'd joined Enron in 1996, helping to structure complex financing deals. In May 2000, at the age of thirty-four, Fastow picked him over several other candidates to be Enron's treasurer, which made him the main contact with the company's banks. Tall, with close-cropped dark hair, Glisan struck colleagues as friendly and good-natured, though perhaps a little naive. He was considered very smart and knowledgeable about complex accounting issues. And he very much wanted to be part of Fastow's inner circle in the finance group, to the point of picking up on some of the CFO's braggadocio. He'd brag about how he had just cowed one or another reluctant banker. "That wasn't Ben at the beginning," said a former colleague. "He picked that up from Andy."

Glisan also seemed to try to mimic Kopper, who was only about a year older than the treasurer. Around Enron, Kopper was known as something of a bon vivant. He always seemed to have suggestions about the

best restaurants or hotels in a given city, right down to the best hotel health clubs. Dark haired and slim, Kopper boasted having some two dozen different pairs of eyeglasses and seemed to change his hairstyle every few months. One Enron official said that Glisan would try to emulate Kopper's haberdashery but not quite get it right.

Kopper's 1999 LJM2 biography said he earned his undergraduate degree in economics at Duke University and then completed graduate work in accounting and finance at the London School of Economics. Before joining Enron in 1994, he had worked at Chemical Bank and Toronto Dominion Bank, and many of his bank clients were energy companies. Like Fastow and Glisan, he had experience in putting together complex financing deals. His then current position at Enron was managing director in the company's global equity markets group.

Neither reporter had any idea what that group did, though it certainly sounded as though it had a wide vista. The managing director title caught the reporters' attention. Mostly corporations had vice presidents or senior vice presidents or executive vice presidents. While Enron had some of those, company sources explained that it also had this class of managing directors, about fifty of them worldwide, who were sandwiched between the more numerous vice presidents and the top-level executives, such as Lay, Skilling, Fastow, and chief accounting officer Richard Causey. Managing director tended to be a title found at Wall Street firms. Emshwiller recalled that David Fleischer, the analyst, was a managing director at Goldman Sachs.

People had been telling the reporters that Enron, particularly Skilling and Fastow, wanted to model the company more along the lines of Wall Street giants. Like Enron, these firms did big, complicated financing deals and specialized in trading, albeit mostly in financial instruments such as stocks and Treasury bills rather than gas and electricity. Hence the borrowing of job titles. In one of those 1999 CFO magazine articles, an official at Fitch, a big credit-rating agency, had said, "Enron operates like an investment bank." Still, mimicking Wall Street titans seemed a curious ambition for an energy company.

Some viewed Kopper as Fastow's closest confidant at the company. One official said that on visits to Fastow's fiftieth-floor executive office,

he saw Kopper there so often, usually lounging on a sofa, that he thought the guy was part of the decor.

The LJM2 biography also mentioned that Kopper "manages the general partner of Chewco, an investment fund with approximately $400 million in capital commitments that was established in 1997 to purchase from Enron an interest in a defined pool of Enron assets." The reporters had never heard of Chewco. There was no other reference in the document to Chewco. And the name didn't show up anywhere in a 10Kwizard search of Enron's SEC filings or in any news database. And what did it mean to manage the general partner? Usually, the general partner was a person or entity that ran the affairs of a limited partnership.

"Sounds like Chewco is similar to LJM," Smith said to Emshwiller during one of their phone conversations.

"Yea, but there's no reference to it anywhere," Emshwiller replied. Chewco was almost like a ghost that flashed briefly into view and then disappeared. At $400 million, however, it certainly might be a noteworthy specter. The two reporters agreed that Chewco should be added to their list of unanswered questions. Unfortunately, after more than a week of reporting on Fastow and LJM, that list seemed to be growing instead of shrinking.

9

"It's Okay to Have a Conflict."

Besides trying to pick their way through the LJM labyrinth, Smith and Emshwiller had a second, related reporting assignment. By the summer of 2001, the *Journal's* New York editors had again become concerned about an arcane and largely unregulated field known as "derivatives trading." Derivatives in their basic form were financial instruments used by companies to control risk.

Derivatives trading had grown into a multitrillion-dollar business covering everything from pork bellies to Treasury bills. It was a highly leveraged activity, meaning that the companies writing the contracts had little of their own money at risk compared to the amounts they borrowed. And while some derivative instruments were simple, others were almost mind-bendingly complex. Derivatives and their dangers had first become a big issue following the collapses of such major trading companies as Long-Term Capital Management and Barings Bank. Both had been done in by huge and complex derivatives positions that swiftly went sour.

As *Journal* editors looked at a booming derivatives market and slowing economy in the summer of 2001, they wondered whether a new crisis was brewing at companies such as Enron. Enron had stunning growth, much of it outside regulatory scrutiny.

Journal editors wanted to know more about energy trading, particularly in light of the California electricity crisis that had generated tens

of billions of dollars of trades by Enron and other big companies. Enron's trading operation handled a dizzying array of different contracts and deals on several continents.

The trader culture gradually came to dominate everything. The old pipeline culture was close to that of regulated utilities. Because assets took a long time to build and were depreciated over thirty or forty years, nobody was in it to make a fast buck. Trading was the opposite. The fast buck was the best buck. Traders didn't care if they were building an enduring enterprise or one that would last only for a time. They were occupational gypsies, perfectly willing to take their fat salaries and bonuses and find a job somewhere else. But when it came to the gas business, you couldn't exactly pull up your pipelines and move on. Skilling's "asset-lite" philosophy epitomized this tight time frame, which demanded much more than it gave. So Smith and Emshwiller, along with reporting on Fastow, tried to get a better handle on Enron's trading business, particularly how the company accounted for that operation. It was slower on this front, even worse than on LJM. Trading and accounting was a marriage that mated secrecy with jargon. Traders rarely wanted to talk about the specifics of deals. And accounting for these deals had become so complex that one almost needed a code book to decipher it.

The reporters quickly learned that many of the reported numbers in the energy-trading business didn't necessarily mean anything. Enron, like other big energy traders, used a method known as "mark-to-market" accounting to keep track of its thousands of purchase and sales contracts. Mark-to-market accounting sought to solve a relatively straightforward but major question in the deregulated world of energy. How do you value a portfolio of contracts in the face of constantly shifting prices? Under traditional accounting methods, a company valued an asset at its purchase price, less any depreciation for wear and tear. That approach worked fine for a drill press, but not so wonderfully for a contract that called for delivering natural gas for the next ten years. If natural gas prices doubled, the contract would be a lot less valuable to the seller, who was now stuck with selling gas at below market prices. Conversely, if prices went down, that contract would be worth more, since the contract would have an above-market price. So Enron and similar compa-

nies had a legitimate reason to look for an accounting method that better reflected their fluctuating economic realities.

Under mark-to-market accounting, Enron each day revalued its portfolio, which consisted of thousands of contracts to buy or sell energy, as prices fluctuated. Each day, the value of each contract went up or down. Say the price of electricity went up by $10 a megawatt hour. Any contract in which Enron had to buy electricity at a fixed price would go up in value that day because its profit margin had grown. Any deal it had to sell electricity would go down in value. At the end of each quarter, Enron took a snapshot of the collective value of all of its contracts. If the number was higher than at the end of the previous quarter, Enron reported that surplus as income. If the value was lower, Enron had to take a charge against earnings. Such gains or charges were simply paper entries, since no cash had changed hands. However, they were entries that could have a very big impact on reported earnings.

The value of the contracts affected the company in another huge way. Companies had to back their contracts with cash collateral whenever it looked as if they might have an incentive to walk away from an obligation. Because the industry was so new, there was no central clearinghouse to manage these cash postings. As a result, a big trader like Enron would have millions and millions of dollars tied up in cash collateral or letters of credit with its trading partners. In general, companies with strong credit ratings got better terms than a firm with weaker credit and were required to tie up less money.

Jonathan Weil, a *Journal* colleague, had made a stab at determining just how big an impact the energy contracts had on earnings. In a September 2000 article about energy industry accounting practices, Weil wrote that absent its calculated accounting gains, Enron would have reported a loss instead of $609 million in profits for the second quarter of 2000. The Weil story ran only in the Texas regional edition of the *Journal* and never got the national attention it deserved. The piece did, however, get lots of notice from Enron and some of its fans. "That was a terrible story," Palmer told Emshwiller when the reporter first called about Enron's accounting practices on energy trading. Palmer quickly faxed over eleven pages of analyst reports attacking the Weil piece when it came out. "Article's Innuendoes Conjures Up a Series of Mis-

placed Fears," wrote one analyst. The analysts claimed that a single-quarter snapshot didn't show the full picture, because over a period of several quarters, Enron sold large numbers of contracts for cash. While some quarters might show a big paper profit, owing to mark-to-market accounting gains, other periods would show a big cash influx when those profitable contracts were actually sold. Or so went the claim, made by Enron and accepted by most analysts. Perhaps more interesting than the technical arguments was the readiness of Wall Street to defend Enron when a reporter challenged the company.

Besides sending a rapid fax, Palmer quickly set up an interview for Smith and Emshwiller to discuss mark-to-market matters with Richard Causey. When Weil was doing his story, Enron was worried enough to fly Causey and a team of officials to Dallas to talk with the reporter. Smith and Emshwiller found the forty-one-year-old Causey to be pleasant, patient, upbeat—but more likely to give a reporter a headache than useful information. He interspersed occasionally usable, though bland, quotes with nearly impenetrable accounting jargon. After the interview, the reporters felt an hour older and no closer to understanding the mechanics of mark-to-market accounting.

"Mark-to-market is the only way to monitor changes in economic value" brought on by deregulation, said Causey. He proudly noted that in the early 1990s, Enron had been a leader in carrying this argument to the SEC and the Financial Accounting Standards Board (FASB), a private accounting industry group that helped write the corporate world's accounting rules. "We went to the SEC in 1991, spent about six months, and got them to agree that this made sense," said Causey. "We caught a little flak in the early nineties from people who, I guess, thought we were pulling a fast one." Enron most assuredly wasn't trying any trickery, Causey assured the reporters.

But like other companies, Enron didn't have to—and didn't—disclose the myriad assumptions about future prices that it used to calculate the current value of its contracts. As best as the reporters could tell, a company had near carte blanche to make assumptions—or guesses—about where prices would be in five or ten years. Simply by raising or lowering assumptions about future energy prices, a company could literally produce millions of dollars of "profits." These profits in-

volved no actual cash and might be wiped out by a change of assumptions in six months. But in the meantime, such profits could be the difference between a company meeting its quarterly earnings projections and not. Marking asset values to market was fine as long as there was a verifiable market. But what if the contracts went out so far into the future that there were no reliable benchmarks? Neither the SEC nor any other government agency monitored how a company carried out its mark-to-market accounting work. The outside oversight came from the auditing work done by a corporation's independent accountant, Arthur Andersen in Enron's case.

Near the end of the interview, the reporters switched topics. "What about the LJM partnerships?" Smith asked.

"There is a private institutional investment fund named LJM. For a time, an Enron officer was an officer of the general partner in that fund. As of July 31, he no longer owns any interest or has any position there," said Causey, sounding almost as if he were reading from a script.

"Why did Mr. Fastow leave on July 31?" Emshwiller said.

"You'd have to ask him. He made that decision on his own, as far as I know," said Causey, who added that as chief accounting officer he had helped oversee Enron's dealings with the LJM partnerships. "My job was to make sure they were done at arm's length," Causey said. And he had, he insisted.

But wasn't there an inherent conflict in having Enron's chief financial officer running partnerships that were doing business with the company?

"It's okay to have a conflict," Causey replied blandly. "You kind of overkill them with controls and then disclose them to the public." In the case of the LJM partnerships, "that's what we did."

Smith and Emshwiller tried to press him for more details about the partnerships. "Go to Andy for any details," Causey said, closing off the discussion.

After the interview, the two reporters compared notes.

"What a bunch of mumbo-jumbo," said Smith.

"I guess this is why we're not accountants," said Emshwiller.

"Well, it was pretty clear he didn't want to talk about Fastow, wasn't it," said Smith.

"Yeah, like I'm sure Fastow is going to answer our questions now," said Emshwiller. "Another dead end."

As they delved into the Enron accounting world, the reporters encountered a miasma of confusing terminology, such as "accumulated other comprehensive income." Under a 1993 accounting industry rule, companies could classify certain securities and trading contracts as "available for sale," according to short sellers. In that case, any gains or losses, whether paper or real, wouldn't show up in the quarterly earnings statement. Instead, the impact would appear in the "shareholder equity" section of the financial report—a section, tucked into the balance sheet, that gets read rarely by the average investor.

Short sellers argued to the reporters that Enron seemed to be exploiting these different classifications to massage its earnings and hide its troubles. When the securities and contracts were producing a profit, they were put in a category that allowed the company to book a gain on the income statement. When they were falling in value, Enron allegedly reclassified them as "available for sale," which shoved the losses over to the shareholder equity section.

The "accumulated other comprehensive income" line in Enron's financial reports had been growing at a rapid clip. At the end of 1999, the company had a deficit of $700 million. By June 30, 2001, that number had ballooned to $1.6 billion. It appeared that $900 million in potential charges had been moved safely away from the income statement. "They had a 'Get out of Jail Free' card that they exercised each quarter to make their financial health look rosier than it was," one short seller quipped to Smith.

The explosive growth of EnronOnline since its November 1999 launch also invited suspicion. Because Enron ran this on-line marketplace and served as either the buyer or seller in every transaction, critics argued that the company had lots of opportunities to engage in back-to-back "wash" trades with another party. In a wash trade, Party A would sell X amount to Party B, who would then sell the same amount back to Party A at the same price. While the two transactions wouldn't produce any profits, they would inflate each party's trading, making them look busier than they really were. Big volumes gave the company valuable bragging rights and made it appear to be a more powerful market player.

There also were suspicions that a company could use the trades to set phony values for certain contracts. Enron became such a big market player, with so many different trading activities within its overall operation, that "the left side of the room trades with the right side of the room," one short seller contended to Smith. "We think up to 60 percent of [Enron's] trading is being done with itself"—though he didn't have any specific evidence to back up that contention. If the contracts called for prices and deliveries stretched far into the future, some suspected, it might also be used as the basis of mark-to-market accounting wizardry. In other words, Enron could create whatever level of prices and profits it wanted.

In interviewing stock traders, the two reporters tried to be very careful whenever they asked about the LJM partnerships. They especially didn't want outsiders to know that they had started getting inside information about the partnerships. Besides worrying that the traders would pass the information to competing reporters, Emshwiller and Smith didn't want their reporting to influence trading in Enron stock. Often in the past, a company's stock had reacted when word started spreading around Wall Street that a story in a major publication was in the works. *Journal* senior editors routinely hammered into reporters the need for discretion. As much as possible, they cautioned, save what you have to say for the pages of the paper.

Certainly few outsiders seemed to know much about the Fastow partnerships or the many other Enron-related entities that went by names such as Thunderbird and Egret. The list of subsidiaries and affiliates in Enron's annual report consisted of hundreds of names. Many of these entities seemed to involve big dollar numbers and appeared to be deeply entwined in Enron's operations. But what exactly they did and how they did it "remains one of the great mysteries of Enron," said a short seller. Though not much of a quote, Emshwiller would later remember it because it came near the end of his last Enron interview of the day. The day was September 10.

10

"Make the *Journal* Go Away."

September 11, 2001: Smith and Emshwiller watched the televised carnage at the World Trade Center with a sense of shock and disbelief that was intensified by the *Journal*'s proximity to the events. The newspaper's headquarters stood across the street from the World Trade Center, and it would be several hours before word came that their colleagues in New York were safe. And there was a paper to get out, even though the entire headquarters had to be quickly evacuated. The *Journal* put out an edition that night under enormous duress, with staffers scattered around New York and New Jersey. On the day of the attacks, Emshwiller talked briefly to Palmer as part of the *Journal*'s coverage of what was happening in the energy industry in the aftermath of the tragedy. Enron had shut down its headquarters building and sent people home. The trading operation shut down halfway through the day. "People aren't robots," Palmer told Smith in a separate conversation, suggesting that even ravenous traders had lost their appetite for deal making. But like other energy companies, Enron continued to make normal deliveries of natural gas and electricity. Before hanging up with Emshwiller, Palmer asked, "Have you heard anything about Kranny?"

He was using the nickname for Kathryn Kranhold, a *Journal* reporter who was based in New York but had covered Enron out of the Los Angeles bureau before Smith was hired. During her time in Los Angeles, she'd become a friend of both Palmer and Emshwiller. She'd later also

gotten to know Smith, whom she had recommended as a candidate for the *Journal*'s energy beat.

"They've evacuated the office. But we haven't heard if anybody's been hurt," said Emshwiller. He couldn't quite bring himself to say "killed." Yet he also couldn't believe that people from the *Journal* hadn't been gravely injured or killed, given the paper's proximity to the site. Miraculously, though, nobody was hurt, and Emshwiller called Palmer back later in the day to let him know that Kranhold hadn't been injured.

In the days following the attacks, Smith focused on security issues involving power plants, transmission lines, and nuclear facilities, the other parts of her beat. What with earnings reports, acquisition announcements, changes in executive personnel, and the continuing fallout from the California electricity mess, she usually had several other stories a week to write.

Both reporters were assigned to work on a terrorism-related front-page story. It was late September before the pair refocused on Enron. They decided it was time to contact the company. As reporters often did with contentious stories, they had held off making a call to the subject until they knew enough to at least have a shot at distinguishing between answers that should be accepted and answers that should be challenged.

The reporters figured that some of the LJM2 partners had already informed Enron about the *Journal*'s digging. But they hadn't gotten any feedback yet from the Enron public relations department. Smith called Palmer, explained the story briefly, and asked for interviews with Lay, Fastow, and Causey. Given Enron's track record of making top executives available, she fully expected to get interviews with some, if not all, of the men. Palmer said he would get back to her.

When Palmer eventually called the reporters back, he wanted a list of written questions. "They'd like a better idea of what you want to talk about," he said. Palmer didn't identify who the "they" were, but the reporters figured that Fastow made up part, if not all, of that group. After all, Lay had always been willing to talk without any prescreening of questions.

In fact, though, an increasing number of companies had over the

years begun asking for questions in advance of major interviews. It was a good way to get a preview of what information—or dirt—a reporter had. The tactic also reduced the chances of an executive being stuck without an answer and looking stupid or, even worse, being caught in a contradiction or lie. In addition, it allowed firms to come up with answers that finessed unpleasant topics. All in all, it was a great advance in promoting the cause of corporate obfuscation.

Reporters, not surprisingly, hated such requests. Unfortunately, it was hard to just flatly turn them down. Enron was press savvy enough to know that the *Journal* wouldn't run a major story about the company without giving it every chance to respond. If that meant giving an advance peek at the questions, the paper would almost certainly end up doing it.

Emshwiller and Smith drew up a list of twenty-one questions, among them the following:

- Did Enron know the general partner of LJM2 had a profit participation in the partnership that would earn him millions of dollars?
- Did Mr. Fastow ever give the Enron board of directors or top management an estimate of the time he would be devoting to the LJM2 project that was significantly different from what he actually devoted to the project?
- Why did Enron feel it was necessary or advisable to waive certain provisions of the company's employee code of conduct to allow Messrs. Fastow, Kopper, and Glisan to take part in the LJM2 project?
- Did Enron management ever receive a complaint that Mr. Fastow or anyone else connected with the LJM2 partnership was trying to pressure Enron officials into selling company assets to the partnership?
- Were the Enron assets sold to LJM2 ever offered to other potential buyers?
- Did Mr. Fastow have access to all Enron units' books and records prior to making bids for assets? Was he aware of each unit's quarterly goals? If so, did such knowledge affect what assets went into the LJM2 transactions?

The two reporters had one last phone discussion about sending the list back to Palmer. "We are tipping our hand too much," Smith said as she read over the list one more time. "We're showing them too much. It's going to undercut us."

"I know," Emshwiller said. How could he disagree? But he took a basically more optimistic view than his colleague. Perhaps it came from having fewer dealings with Enron. He reminded Smith that they'd have to ask the questions at some point, whether verbally or in writing, before the story ran. "We might as well do it now as later," he said. Plus, he figured that once they got the interviews they could press the Enron executives as hard as possible for answers.

But Smith felt they should try to get more information before unloading such a long list. In the end, she relented. "Well, let's send them, then," she said.

Emshwiller could hear the reluctance in her voice. He wasn't happy about sending off the list, either. But since he saw no real alternative, he was anxious to get it sent so they could get a response.

On September 25, they e-mailed the questions to Palmer and waited. And waited. Several days passed. Palmer said company officials still were considering the matter. The reporters later learned that during that time there was intense debate within Enron about how the company should respond to the *Journal*. Palmer and the public relations officials argued that the company should give interviews. After all, they said, top company executives had a long history of convincing outsiders about the rightness of their actions.

Fastow stridently disagreed. According to one person involved in the discussions, he saw no value in talking about LJM with the *Journal*. "What's the upside?" he shouted during one discussion on the matter. "Can you tell me that? What's the upside?" The partnerships were complicated and hard to explain, he said.

During one phone conversation, Fastow berated Palmer, a former TV newsman, for not being able to "make the *Journal* go away." Fastow screamed at him, said a bit more in the same vein, then slammed down the receiver.

A minute later, the phone rang at the nearby desk of Palmer's boss, Steve Kean, who was also a longtime personal friend of Palmer. It was

the CFO on the phone. Nearby listeners heard Kean coolly tell Fastow to lower his voice and calm down. Then he told him that if he didn't get control of himself, he was going to hang up. Then he hung up. It was the kind of act that won Kean the loyalty and respect of his co-workers again and again.

Lay initially wanted to answer the *Journal*'s questions but waffled. One executive with knowledge of the discussions said that Fastow strongly argued against talking to the *Journal* and refused to take part in an interview unless ordered to do so. Lay later said he couldn't remember if Fastow played a role in the discussion or not. But in the end, Lay told Palmer to turn down the interview request and, instead, give the *Journal* a written reply. Palmer drafted a response that ran a page and a half. Ultimately a single paragraph emerged.

Palmer called Smith and Emshwiller to tell them that there would be no interviews. Based on the questions, "our guys decided they are going to hate this story, whatever they do," he said. "But we have a written response." Palmer e-mailed them each a copy. It read: "Enron's Board of Directors reviewed and approved of Enron's CFO's participation in the LJM partnerships. There never was any obligation for Enron to do any transaction with LJM. Enron and its Board established special review and approval processes with its senior management and external audit and legal counsel to ensure that each transaction with the LJM partnerships was fair, in the best interest of Enron and its shareholders, and appropriately disclosed."

What a lot of crap, Smith thought. Furious, she sent Palmer a terse e-mail: "That's all?"

"That's all," Palmer typed in reply.

Smith followed up with a phone call trying to convince him that it was stupid to clam up at just the time it made the most sense to be forthright. "That's all you're going to get," Palmer said. "They don't want to talk about it. I've tried. They won't budge. I hear what you're saying and I don't disagree."

She knew Palmer well enough to believe that he had, indeed, tried. As much as anything, she was angry that they'd sent such a long list and furious with herself for not persuading Emshwiller to see it her way.

"We were really stupid," she told Emshwiller. "I knew we shouldn't have unloaded such a long list of questions."

"Well, they were going to have to hear them eventually anyway," he replied.

"Better to have broken it up into bite-size pieces, so they wouldn't gag," she said before giving up.

Looking at Enron's tart reply, she concluded that they'd made a tactical mistake. The list made it clear that a negative story was coming. By waiting on the sidelines, Enron officials probably figured they could bushwhack the reporters if they got anything wrong. Plus, the company wouldn't get into the position of confirming damaging information that the reporters could then use in the piece.

Emshwiller also called Palmer after getting the one-paragraph response. "You said more than that in your SEC filings," the reporter said.

"That's all we have to say," Palmer said once more. His voice sounded unusually tight.

Emshwiller was surprised by the company's decision. Given Enron's reputation for being willing, even eager, to talk to the press, he never thought the company would stonewall them. Still, he was less upset about Enron's decision than was Smith. He was used to writing stories about stock swindlers who routinely refused even to acknowledge receiving the written questions he'd sent them. At least with the detailed questions sent, Enron couldn't complain after the fact about being left in the dark about anything the story said.

While Enron's decision made their reporting and writing job harder, it also provided what Smith and Emshwiller thought was one extremely useful piece of information. More than anything else they'd come across since that first interview with their original source, Enron's silence seemed to shout that the reporters were on to something.

11

"He Would Have Done Nothing to Harm Enron."

BEFORE WRITING THEIR STORY, SMITH AND EMSHWILLER HAD ONE MORE group to try. These were the people who, at least officially, stood as Enron's final authority: the board of directors.

Like all such bodies at public companies, Enron's board consisted of two kinds of people: company employees, who were called "inside directors," and nonemployees, the "outside directors." Enron had two inside directors, Lay and Skilling, and twelve outside directors. Though neither Emshwiller nor Smith had ever done much reporting on such matters, they realized that from a shareholder's point of view, Enron had a good ratio of outside to inside directors. One theory of corporate governance held that the greater the number of outside directors, the better the chance of real oversight and the lower the risk of self-dealing by top corporate officials.

Of course, that theory assumed that outside directors took seriously their role as watchdogs for the shareholders. Both reporters had read enough stories and run across enough instances in their own reporting to realize that outside directors were rarely the epitomes of vigilance. Part of the problem was time. Outside directors were part-timers, coming every month or two to a board meeting or a board committee meeting. In 2000, for instance, Enron's board met only five times, though it held four other sessions by teleconference to deal with one or

another matter that couldn't wait for the next scheduled session. Board committees—such as finance, audit, and compensation—met anywhere from five to ten times that year, again sometimes via conference call. The board's audit and compliance committee, which oversaw Enron's vast tangle of accounting and financial-reporting practices, met only five times in 2000. With such a limited schedule, the average intelligent person might have problems keeping up with the affairs of even a simple company. Keeping up with the complexities of Enron would be a truly daunting task.

A bigger problem than time was intent. Companies almost never chose firebrands as directors. Many directors were prominent academics or retired business executives or politicians who were out of office. Often, the director candidate knew the company's chairman or an influential member of the board. Almost all were well established, well respected, and well versed in the finer points of corporate gentility, which frowned upon asking hard questions in hard ways. Boat rockers might not be invited back for another term on the board.

Companies also worked to keep directors well fed and happy. Enron paid its average outside directors $79,107 in 2000. Though board meetings were typically held in Houston—where Enron put directors up at the local Four Seasons hotel—the company held a meeting in a more exotic locale, such as the London headquarters of its European operations, usually once a year. While the directors met, Enron squired their spouses around on sightseeing outings.

In preparation for calling Enron's directors, the reporters accumulated phone numbers or e-mail addresses for the directors and put calls to them in a one-day blitz. They hoped to get through to at least one director before Enron got wind of the effort and took steps to block it. They weren't particularly hopeful that a director would talk. Directors at big companies rarely met with reporters unless they had a prior relationship with him or her. In this case, neither Smith nor Emshwiller had a relationship with any of the Enron directors. Still, they knew they needed to make the calls.

And they got lucky. Emshwiller managed to reach board member Dr. Charles A. "Mickey" LeMaistre, the retired president of M. D. Anderson Cancer Center in Houston, at his home. A young person, who the

reporter imagined might be LeMaistre's grandson, answered the phone. Emshwiller identified himself as a *Journal* reporter and asked to speak with the Enron director. The line went dead for a moment. And then LeMaistre came on.

Emshwiller explained that he was working on a story about the LJM partnerships and asked LeMaistre if he remembered the board discussing them.

"I remember. It was thoroughly discussed," he replied. "I don't recall that it was any great concern."

"Do you remember any detail of what was discussed?"

"I don't really recall the details."

"Mr. Fastow recently resigned from the partnerships. Do you know why?"

"I think Fastow made his own decision there," LeMaistre said. Then he added, as if answering one of the previous questions, "I think we reviewed carefully before approving it."

Did the board exert any pressure on Fastow to quit? Emshwiller asked.

"No one discussed it with me."

Did Arthur Andersen raise concerns?

"As far as I know, the outside auditors didn't have a problem," LeMaistre said. "There were regular reports by the CEO about it."

"Did you hear of complaints from other Enron executives about the Fastow partnerships?"

No, LeMaistre replied. If any executive made such a complaint, "I've not seen it."

Emshwiller could see he wasn't getting very far, and LeMaistre seemed to be getting impatient with the questioning. There was an increasing edge to his voice as he answered. The reporter decided to stop pressing him on details and tried a broader, more philosophical question. "Why would the board want its chief financial officer to run outside partnerships that did business with Enron?"

"It would retain Mr. Fastow," LeMaistre replied mildly. The partnerships "appeared to be of advantage to Enron," and the arrangement would "allow us to keep Fastow," added the man who headed the board's compensation committee. "This would keep him employed. We try to

make sure that all our executives at Enron are sufficiently well paid to meet what the market would offer."

Seems like an awfully weird way to give Andy Fastow a pay hike, thought Emshwiller. It also seemed to contradict the company line on LJM. Never had Lay mentioned that the partnerships were viewed as a way to pad the chief financial officer's wallet. According to them, Fastow had taken on the LJM assignment only to help out Enron. Apparently that message hadn't gotten to at least one director.

"Did the board waive Enron's code of conduct in connection with Mr. Fastow and the partnerships?"

"We examined all the unusual aspects and approved it. If that was one, we did," LeMaistre said. He then said that he had to get off the line. He did, however, add one parting thought about Fastow: "I have complete confidence in his integrity. He would have done nothing to harm Enron."

All in all, Emshwiller couldn't tell whether LeMaistre was being evasive or simply hadn't paid much attention to the whole LJM matter. The reporter had sort of assumed that waiving a company's code of conduct—if that happened—would have been an unusual enough event to stick in a director's mind. (Speaking through his attorney, Bruce Collins, Lay said in response to written questions from Smith in July 2003 that embellishing Fastow's salary through LJM "was not a consideration." Collins added that Lay did "not recall at any time any discussion that Mr. Fastow's compensation was being supplemented by his work with LJM, and he shared this view with Dr. LeMaistre subsequent" to the director's remarks appearing in an October 2001 *Journal* story.)

Smith and Emshwiller had no luck reaching the other directors. Emshwiller did manage to reach Robert Jaedicke's wife at their house in Bozeman, Montana. She said that her husband, a former dean of the Stanford Business School, was traveling, but she would pass along the reporter's message. About a half an hour later, she called back. "My husband just received a fax from Enron asking him to refer any calls from *The Wall Street Journal* to the company. You should talk to Mark Palmer," she said. She asked if he knew Palmer. Emshwiller assured her he did and thanked her for calling back. The reporter checked his watch. The Enron fax had gone out less than two hours after he and

Smith had begun calling directors. Fairly efficient, he thought. On a whim, he called Palmer.

"Can I have a copy of the fax?" Emshwiller asked.

Palmer gave something between a laugh and a snort. "What fax?"

"The one you sent to all the directors about us."

"What makes you think we did that?"

"Mrs. Jaedicke was kind enough to call me back. Apparently I'm supposed to direct inquiries to you."

"So, do you have an inquiry?"

"Can I have a copy of the fax?"

"No, you can't have a copy of the fax," replied Palmer in a tone that he must have usually reserved for his kids.

Emshwiller never expected to get a copy of the fax and didn't really care. He mostly wanted to let Palmer know that he knew about it. The fax, he thought, was a sort of perverse compliment. Not only was Enron's normally talkative management clamming up, it was trying to keep others from talking. He later learned it was the corporate secretary who wanted the fax sent out, not Palmer.

The reporter was feeling good about the LeMaistre interview—an interview that he was careful not to mention to Palmer. Since he hadn't expected to reach any director, talking to one seemed like a victory. Even better, LeMaistre had actually said some interesting things, especially those remarks about the partnerships being partly a financial reward for Andy Fastow. That statement seemed to be the first contradiction in the LJM story that Enron had been putting out. As the reporters worked to finish their reporting and begin writing the LJM piece, Enron prepared for its next big public event: the announcement of sales and earnings for the third quarter, which had ended September 30. The announcement was scheduled for October 16.

The two reporters noted the date with their usual professional interest. Sales and earnings announcements were always a key responsibility for *Wall Street Journal* beat reporters, and they would give October 16 their undivided attention, especially now that Enron had become the focus of their reporting.

12

"Amend My Last Statement."

A FEW WEEKS BEFORE THE OCTOBER 16 EVENT, SMITH BEGAN TAKING her soundings on Enron. After making a number of calls to analysts, she quickly determined that there was broad consensus in investment banking circles that it would be a "cleanup" quarter for Enron, one in which it would take a hit for some of its poorly performing investments, such as Enron's broadband venture and a lingering mess associated with its investments in the water business that Rebecca Mark had once run. The wisdom on Wall Street was that Enron was a giant company with a huge, and seemingly thriving, energy-trading franchise and it could easily withstand these small blips in its performance. For reasons that always somewhat baffled Smith, analysts were always happy to see companies "put mistakes behind them," as if multimillion-dollar snafus somehow looked smaller through the rearview mirror than out the front windshield.

Enron executives also began briefing the credit-rating agencies about the upcoming earnings report. Because of the vital importance of a good credit rating, companies routinely gave the agencies insider status. The agencies were allowed to see confidential financial information and to get previews of announcements before the public did. In return for such access, the ratings agencies and their employees were, of course, barred from trading in any way on that information. This didn't mean they had as much access to information as, say, the CEO. But it did mean they

could ask. Companies refusing information risked offending the credit analysts and getting harsher treatment. Analysts weren't going to give companies credit for anything they couldn't verify.

On October 4, an Enron official met over breakfast at New York's Palace hotel with S&P officials to discuss the upcoming third-quarter earnings report.

The Enron executive assured the S&P officials that the company was still pushing to sell assets. But the substance of the discussion revolved around the third-quarter earnings report. For weeks, Enron had been telling the ratings agencies the company expected to be taking a big third-quarter write-off to reflect the fallen value of its investments in the water, telecommunications, and retail electricity businesses. The company had been saying that they expected the total charge to be in the range of $1 billion. At the breakfast meeting, the official confirmed that the charge to earnings would be almost exactly $1 billion. But, added the company official, "core" earnings from the trading operation would be up sharply and, overall, Enron remained extremely healthy.

S&P officials viewed the planned write-off, big as it was, with a measure of approval. Enron had made some disappointing investments, and it needed to adjust the value of those assets to more realistic levels. They believed that the charge was a necessary financial housecleaning.

There was one more piece of news that in retrospect might have set off alarm bells. The company would be reducing shareholder equity by $1.2 billion, or about 10 percent. The Enron official explained that much of the $1.2 billion equity hit stemmed from the need to reverse a $1 billion accounting error. Enron had used some of its own stock in connection with several off-balance-sheet entities that the company had set up to manage its finances. In one set of transactions, the company and its auditor, Arthur Andersen, had mistakenly added $1 billion to its equity computation. Now that error had to be corrected, particularly since those off-balance-sheet structures were being unwound. The Enron executive didn't provide detail about those structures. But he emphasized that the equity reduction was simply an accounting adjustment that wouldn't affect the company's cash position or overall financial strength.

While a regrettable and embarrassing mistake, the equity reduction

didn't look like a financial bombshell to the S&P officials. It didn't affect Enron's ability to repay its debt—the matters that ratings agencies most cared about.

Still, $1.2 billion was a large number and involved an accounting error by some high-powered accountants at Enron and Andersen. The matter should be disclosed publicly, sooner rather than later, thought Ronald Barone, director of S&P's utility and energy group. He asked whether Enron intended to make an "8K" filing with the SEC. A Form 8K was used when a company had an unexpected and material occurrence that was too important to wait to be included in the next quarterly financial filing. Regulators encouraged their use as a way to keep investors up-to-date on a company's affairs.

The Enron executive said that the company was still deciding how to disclose the equity reduction. A few days later, Barone received a call from the company. Enron had decided not to file an 8K. Officials felt that the equity reduction simply wasn't an important enough event to warrant such an action.

Barone thought Enron was making a mistake and began to have qualms about the company's conduct. "But, at least you'll put it in your third-quarter earnings release," he said.

The Enron official was noncommittal. There had been talk of just mentioning it during the traditional question-and-answer telephone session with analysts, he said. Company lawyers felt that would be adequate disclosure.

While disagreeing with that assessment, Standard & Poor's officials didn't see anything on the horizon to make them change their assessment of Enron's fundamental creditworthiness. Triple B plus still looked like the correct rating.

Standard & Poor's main competitor, Moody's, took a less sanguine view after getting its third-quarter earnings briefing. Susan Abbott, who headed the credit agency's energy team, had for some time been troubled by Enron's byzantine structure, with those hundreds of affiliates and partnerships. She remembered a meeting with Fastow around the time he became chief financial officer in March 1998. He acknowledged that the company's balance sheet was terribly complex. "He said his first order of business was to simplify the company," Abbott later told Smith.

"I thought to myself, Thank God. I always thought the deals they did didn't need to be so complicated. But then the balance sheet got even more complicated. Rather than just borrow money like other companies did, they did all these complicated structures. Understanding the terms and conditions was very frustrating. . . . Unwittingly, it seemed, they had come up with a mess."

To Abbott, the company had a credibility problem in October 2001. The chief financial officer had said he would do something and he hadn't.

After being briefed about third-quarter earnings, Moody's officials decided that they had to do something. But they didn't want to overreact and create undue fear in the market about Enron's creditworthiness. "You create panic and you become part of the problem," Abbott said later. In the end, Moody's decided that on the day of Enron's earnings announcement, it would put the company on so-called credit watch for a possible downgrade. This was an intermediate step that allowed the agency to express concern without actually lowering the company's credit rating. If the company shored up its finances or took other necessary steps, the credit watch could be ended without an actual downgrade.

As the ratings agencies pondered Enron's soon-to-be-released third-quarter report, Emshwiller and Smith were still scrambling to dig up information about the LJM partnerships. They continued to pester Palmer with questions. Though Enron's top management remained unwilling to talk, the company did relent slightly on one matter. The LJM private placement memorandum had said that the company had waived portions of its code of conduct to allow Fastow to run the partnerships. Was that accurate? Smith asked again during a phone conversation with Palmer. The reporters had asked this question before verbally and in writing. But she figured it couldn't hurt to ask again.

This time, Palmer was willing to answer. "The board did waive the employee code of conduct for Andy to participate as general partner in LJM," the Enron spokesman said. He gave no indication why he was suddenly willing to respond to this particular question.

A short time later, Palmer called Smith back. "Amend my last statement," Palmer said. "I just got a call from our general counsel, who said

that, in fact, our employee code of conduct was not waived, it was complied with. What we had to do, because of the employee code, was notify the board that one of our employees was going to enter into a related-party transaction. So the thing wasn't waived, it was complied with in that the board had to approve it. That's what, in fact, happened. It sounds like a bit of a technicality," Palmer conceded. But if it was described as a waiver, "our guys would get really worked up," he added.

Smith felt this was splitting hairs. The important fact remained that the company had a policy in effect that was intended to protect shareholders—and it had been effectively neutralized. She suspected that she was hearing from the same lawyers who were behind the one-paragraph reply. Well, at least she should be able to get a copy of the code of conduct, she reasoned. "Can you shoot me a copy?" Smith asked Palmer. "Need my fax?"

Surprisingly, Palmer refused to supply a copy of the company's code of conduct. "It's largely boilerplate, standard stuff," he told Smith.

"Then what's the problem with seeing it?" she responded.

"There's a little bit of hesitancy to actually release" it, Palmer said. He didn't elaborate on who had had the hesitancy, though he implied it was the attorneys that—more and more, in Smith's view—were taking on the aspect of a cabal. (The reporters later obtained a copy of Enron's "Code of Ethics" from federal investigators that was dated July 2000. One part certainly seemed to apply to the LJM situation. It stated: "An employee shall not conduct himself or herself in a manner which directly or indirectly would be detrimental to the best interest of the Company or in a manner which would bring to the employee financial gain separately derived as direct consequence of his or her employment with the Company.") Smith was surprised and then indignant over Palmer's refusal to release the code, but she chalked it up as the kind of stonewalling that companies routinely practiced in their dealings with the press. She later learned it was the Human Resources department that put the nix on it.

Each quarter, the night before Enron put out its earnings announcement, Palmer and his public relations staff took rooms at the Hyatt Regency, a huge cavern of a hotel a short walk from company headquarters, or at another nearby hotel. They often got the pertinent earnings

numbers only late in the evening and then had to format them for the wires before sending the press release early the next morning. Earnings were announced early in the morning to give analysts and investors a chance to digest the numbers before Enron shares began trading on the New York Stock Exchange at 9:30 A.M., eastern time.

But on the night of October 15, Enron's public relations people waited and waited. By 2:00 A.M., they still hadn't received the numbers. The numbers had never been this late before. The only word coming back was that some problems had surfaced that were keeping Andersen, the outside auditor, from signing off on the earnings release. But if those problems weren't resolved quickly, Enron wouldn't make its morning release deadline—an event that itself might raise questions in the investment community and would certainly get noticed.

Finally, after 5:00 A.M. on October 16, the earnings information arrived. The Enron staffers barely completed the release in time to make the morning deadline. Nobody told Palmer what was behind the holdup. But from now on, there would be no complaints of delays, of feet dragging. The next twenty-four days would radically change Enron and the companies and individuals in its path.

PART TWO
The 24 Days

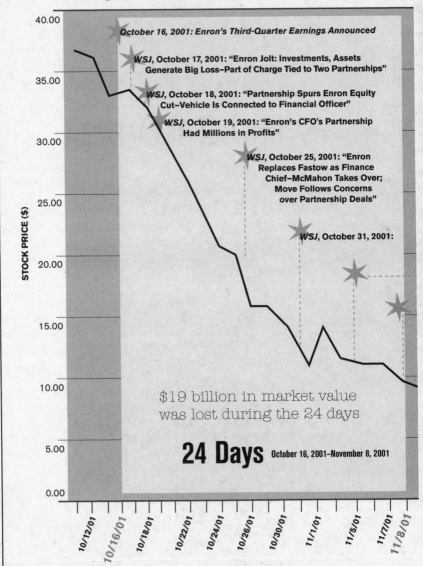

Enron Under Fire

A Barrage of *Wall Street Journal* Headlines That Exposed Enron

October 16, 2001: Enron's Third-Quarter Earnings Announced

WSJ, October 17, 2001: "Enron Jolt: Investments, Assets Generate Big Loss–Part of Charge Tied to Two Partnerships"

WSJ, October 18, 2001: "Partnership Spurs Enron Equity Cut–Vehicle Is Connected to Financial Officer"

WSJ, October 19, 2001: "Enron's CFO's Partnership Had Millions in Profits"

WSJ, October 25, 2001: "Enron Replaces Fastow as Finance Chief–McMahon Takes Over; Move Follows Concerns over Partnership Deals"

WSJ, October 31, 2001:

STOCK PRICE ($)

40.00
35.00
30.00
25.00
20.00
15.00
10.00
5.00
0.00

10/12/01 10/16/01 10/18/01 10/22/01 10/24/01 10/26/01 10/30/01 11/1/01 11/5/01 11/7/01 11/8/01

$19 billion in market value was lost during the 24 days

24 Days October 16, 2001–November 8, 2001

"With Enron Stock Trading at Book Value,
Some See Company as Takeover Target"

WSJ, November 5, 2001: "Enron Transaction Raises New Questions–A Company
Executive Ran Entity That Received $35 Million in March"

WSJ, November 8, 2001: "Trading Places: Fancy Finances Were Key to Enron's Success,
and Now to Its Distress–Impenetrable Deals Have Put Firm in Position Where It
May Lose Independence–Talks with Rival Dynegy"

WSJ, November 29, 2001: "Running on Empty: Enron Faces
Collapse as Credit, Stock Dive and Dynegy Bolts"

WSJ, December 3, 2001: "Enron Files for
Chapter 11 Bankruptcy, Sues Dynegy–
Wrongful Termination of
Merger Is Charged"

11/9/01 11/13/01 11/15/01 11/19/01 11/21/01 11/23/01 11/27/01 11/29/01 12/3/01

13

"I'm Not Sure It Had a Name."

THE REPORTERS DIDN'T GET AN LJM STORY IN THE PAPER BEFORE October 16. While Enron's third-quarter earnings report would doubtless produce stories in competing publications, they felt it unlikely that those stories would touch on LJM unless the company raised the issue itself. Since Enron had spent two years burying the partnerships, it didn't seem likely that the company would voluntarily exhume them now.

Still, there was always the possibility that something unexpected might surface in the earnings announcement. The two reporters and Friedland agreed that it made sense to rough out a story about the LJM partnerships so they'd be prepared to move quickly, if need be. Emshwiller took a whack at writing the first draft. During the California electricity crisis, he and Smith had often alternated writing the first drafts for longer feature stories that were going to bear both bylines. Then they'd e-mail the drafts back and forth until they were in good enough shape to send on to Friedland. The process generally went smoothly, though as the months wore on they found themselves at loggerheads more often than not. Friedland let them sort out their differences on their own.

Emshwiller began trying to write the LJM story from a hospital room in Santa Monica. His wife, Deborah, had gone in for an operation and he'd taken a couple of days off to be with her. He hauled along his laptop, figuring he'd probably have some free hours while she slept fol-

lowing the operation. She had a private room, which was quiet and even had a small table by a window overlooking a courtyard. Unlike his *Journal* office, here there were no phone calls or e-mails to interrupt his writing.

Though Smith and Emshwiller had made dozens of phone calls, they still hadn't come close to nailing down the most sensational matters raised by their original source. Had Fastow pressured Enron's banks to invest in LJM2? Had Enron executives, such as McMahon, been punished for criticizing the partnerships? While Fastow could have made millions from the LJM partnerships, the reporters didn't know whether he actually had. More important, how much of Fastow's profits came at the expense of Enron shareholders? The two reporters had learned nothing more specific about the actual transactions between Enron and the partnerships. What assets were bought or sold? What precise benefits, if any, did the deals have for Enron and its shareholders? Significant questions such as these still dotted the LJM landscape, and even the quiet orderliness of the hospital room couldn't change that fact.

Emshwiller found himself writing a story based mostly on the two LJM2 documents the source had provided. The material was interesting enough. Then October 16 arrived.

As on most weekdays, Smith was seated at her laptop computer by 6:30 that morning, on the lookout for stories she would need to write that day. Like other beat reporters at the paper, she had a lot of electronic sentries that automatically categorized press releases, wire stories, and information on SEC filings in customized queues. She could scroll through the unedited wires if she wanted, but she found it much easier to move through these electronic queues, which would earmark anything that appeared on roughly three dozen energy companies as well as lots of key words like "transmission" and "generation" and "utility commission."

The early morning schedule had been an adjustment—especially since it consumed a block of time she would have preferred to spend on the treadmill—but she understood the need to let New York editors know, by 10:00 A.M. their time, about any stories that were coming that day. The laptop was perched on the edge of her bed, resting atop an old sewing board that had belonged to her grandmother. The board was just

big enough for the computer, a notepad, and a mug of industrial-strength coffee. Smith scrolled through the newswires, trying to get organized before rousing the kids at 7:00 A.M. to get them off to school. She could see it was going to be an ugly day.

Duke Energy Corp., another giant company on her beat, was also announcing its quarterly earnings, and she'd already arranged to interview the North Carolina firm's chief financial officer in half an hour. While Enron was regarded as the more important company to the *Journal*, Duke was a multibillion-dollar firm and far too big to ignore. Besides the two earnings stories, the paper's front-page editor had decided to run in the next day's paper a post–September 11 story on nuclear terrorism that Smith had worked on with Emshwiller and two other reporters. If the front page's editing ran true to form, all four reporters could expect questions from New York editors throughout the day.

She began to read the Enron earnings release that had just come across the wires. Getting through the document required several gulps of coffee. Lay had made good on his promise to put out a lot more information. The release ran nine pages, topped by a headline that read "Enron Reports Recurring Third Quarter Earnings of $0.43 Per Diluted Share; Reports Non-Recurring Charges of $1.01 Billion After-Tax; Reaffirms Recurring Earnings Estimates of $1.80 for 2001 and $2.15 for 2002; and Expands Financial Reporting."

The release clearly favored events that were "recurring," or likely to be repeated. In the lexicon of business flackery, "recurring" earnings usually referred to income from continuing operations, such as business lines that hadn't been shut down or sold. Bread-and-butter stuff. Of course, just because an operation continued didn't mean that its earnings would simply recur, as regular as the tides.

Conversely, "non-recurring" earnings generally derived from onetime events, such as proceeds from the sale of real estate or some transaction that wouldn't be repeated. Enron clearly had decided to commence its period of greater openness with some of the meaningless, baffling, happy talk that had infected the pronouncements of public companies with increasing frequency in recent years. In this chipper world, only good things recurred. The bad passed by but once—and hardly warranted much more than a glance.

The release reported that recurring earnings were up 26 percent from a year earlier. Lay praised "the very strong results in our core wholesale and retail energy businesses and our natural gas pipelines." The Enron chairman reiterated the company's earnings projections for the fourth quarter, for all 2001 and for 2002. Up, up, and up seemed to be the document's recurring theme.

There was the little matter of that billion-buck charge, which produced a net loss of $618 million for the quarter. Since it was deemed a not-to-be-repeated event, Enron didn't bother mentioning the loss until the third paragraph. "After a thorough review of our businesses, we have decided to take these charges to clear away issues that have clouded the performance and earnings potential of our core energy businesses," said Lay in the release.

These are awful results, thought Smith. Far worse than what she'd been led to expect by the analysts who had predicted this would be a "cleanup" quarter. But what really interested her was the company's explanation for that giant write-off. She found it in the middle of page four, just before the tables of numbers began. The company wrote off $287 million on its investment in Azurix, the troubled water company that Rebecca Mark had run. No surprise there. Everybody knew Azurix was a dog. The "restructuring" of Skilling's beloved broadband unit— and another member of the Enron kennel club—contributed $180 million to the charge. The third and final item, the relative whopper, was a $544 million item "related to losses associated with certain investments, principally Enron's interest in The New Power Company, broadband and technology investments, and early termination during the third quarter of certain structured finance arrangements with a previously disclosed entity."

What the heck was that? Smith thought. She read it again, puzzled. "Structured finance arrangements with a previously disclosed entity." What did it mean? LJM probably was the "previously disclosed entity," but what were the arrangements? October 16 was beginning to look like a big day, for better or worse.

She looked for detail. The New Power write-off made sense. New Power was the retail electricity business that Enron had spun off into a public offering a year or so earlier. It had fallen sharply in value when its

hoped-for markets didn't materialize. The stock Enron held in New Power, consequently, had fallen sharply in value. So a write-down was in order. Smith couldn't figure out why there seemed to be some repetition in the way the write-downs were described. Broadband seemed to have generated losses in relation to the $180 million as well as the $544 million, for reasons that were never explained. Normally, you'd bundle them all together.

She couldn't find anything to explain that $544 million, just gibberish. If the Fastow partnerships had caused hundreds of millions of dollars of charges, the story had suddenly taken a very big—and very hot— turn. Smith quickly messaged Friedland, who was always on-line at that early hour, to let him know what was afoot. He already was seeing the first snippets cross the Dow Jones newswire.

Then she got on her 7:00 A.M. call with Duke, though she was so antsy to get off the line to get her children off to school and herself in to work that she feared she was a bit terse. As soon as she was done, Smith, Emshwiller, and Friedland conferred and worked out a plan. "We're going to have to put what you've got on LJM into tonight's story," said the bureau chief. The reporters agreed, Emshwiller somewhat regretfully since he'd still been hoping to get a page-one story out of it. Smith didn't really care. She felt she'd had her share the previous year and now was just worried about getting their facts straight and moving quickly.

A write-off this big would attract the attention of other reporters, which could produce questions and copy about LJM. Both reporters were concerned they might get squeezed for space. "I'll see how much extra space I can get for tonight's story," Friedland said. "I'll make sure they know this isn't an ordinary earnings story."

The reporters divided up the tasks at hand. Smith would listen to Enron's conference call with analysts. Such conference calls had become regular events for companies on the days that they released quarterly earnings. These telephonic gatherings were a good chance to answer questions and spin the information in a way most beneficial to the corporation. She also would call analysts and others to see what they had to say about the earnings release. And she'd handle the one-on-one interview with Lay. Those interviews had become another fix-

In March 2002, Kenneth and Linda Lay attend a ceremony in Houston honoring former senator Bob Dole. The event was partly funded by the Ken and Linda Lay Foundation.

(AP/Wide World Photos)

Andy and Lea Fastow leave the federal courthouse in Houston in May 2003, after a superceding indictment against Fastow expands to 109 counts against the onetime chief financial officer. An indictment was also issued against Lea Fastow.

(AP/Wide World Photos)

Former Enron chief executive Jeffrey Skilling testifies before a House subcommittee in February 2002.

(AP/Wide World Photos)

Michael Kopper outside the federal courthouse in Houston in August 2002, following his decision to cooperate with federal officials investigating Enron.

(AP/Wide World Photos)

Ben Glisan, former Enron treasurer, leaves the federal courthouse in Houston in May 2003. He was named in a superceding indictment that expanded the counts against his onetime boss, Andy Fastow.

(AP/Wide World Photos)

Cliff Baxter, a former Enron vice chairman, who committed suicide about seven weeks after the company's bankruptcy filing.

(Enron)

Carol,

I am so sorry for this. I feel I just can't go on. I have always tried to do the right thing but where there was once great pride now its gone. I love you and the children so much. I just can't be any good to you or myself. The pain is overwhelming. Please try to forgive me.

Cliff

Note left by Cliff Baxter for his wife prior to his January 2002 death in a Houston suburb that later was ruled a suicide. The family fought to keep the note private, but it was released in April 2002 by the Texas attorney general.

(AP/Wide World Photos)

David B. Duncan, onetime head of Arthur Andersen's audit practice at Enron, leaves the federal courthouse in Houston in May 2002, after testifying in the Andersen document destruction case.

(AP/Wide World Photos)

Enron employees sit outside the Houston headquarters building with boxes of possessions on December 3, 2001, the day thousands were let go. The layoffs came one day after Enron filed for bankruptcy-law protection.

(AP/Wide World Photos)

Mark Palmer, Enron's corporate communications chief, examines an Enron sign that's to be auctioned in Houston, in September 2002.

(AP/Wide World Photos)

Kenneth Lay and Dynegy Inc. chairman Chuck Watson during the Houston news conference on November 9, 2001, announcing that Enron would be purchased by its smaller Houston rival.

(AP/Wide World Photos)

Enron's corporate headquarters in Houston, a onetime symbol of the company's soaring ambition and gleaming reputation.

(AP/Wide World Photos)

January 15, 2002.

(Gary Markstein,
Copley News Service)

May 9, 2002.

(Bruce Beattie,
Copley News Service)

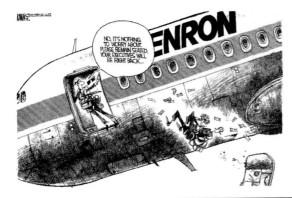

February 11, 2002.

(Michael Ramirez,
Copley News Service)

January 28, 2002.

(Gary Markstein,
Copley News Service)

Retirees With Pensions in ENRON Stock Wiped Out

December 1, 2001.

(Jeff Danziger, Tribune Media, New York)

ture of quarterly earnings day at many companies. Each quarter Lay gave brief interviews with about ten print and television journalists to further spread the good word. She'd also have to find time to throw together a story on Duke's earnings and field any questions for the nuclear terrorism story. With the day already feeling like a mess, she showered and dressed quickly and raced to the BART commuter station to catch her train to San Francisco. Rather than read her three morning papers, she scribbled a list of questions she needed answered.

Emshwiller would start writing the earnings story, using the draft of the LJM piece. He also called Enron to find out more about that $544 million charge. "Is LJM that 'previously disclosed entity'?" Emshwiller asked Palmer. "And if so, how much of the write-off was due to LJM?"

Palmer seemed ready for the question. "You wouldn't be wrong if you said less than a half but more than a quarter," he said. His voice had a vaguely conspiratorial tone.

My God, thought Emshwiller, that big? He'd been hoping for a large number, not quite believing they'd get one. This really pumped up the importance of the story. He tried to hold down his excitement and focus on seeing what more he could get from Palmer. "So, maybe a little over $200 million?" he asked, trying to quickly split the difference between a half and a quarter in his head.

"Maybe a little under," came the reply.

Were there any other details available? Emshwiller asked.

"Doubt it," Palmer said.

With a hurried thanks, Emshwiller hung up and headed over to Friedland's office.

He gave a quick recap. The number impressed Friedland, too. "New York has agreed to give the story about thirty inches, and they're going to put it on the third front," he said. Thirty inches came out to about 1,200 words, very long for a daily story, though still only a little more than half the length of a front-page piece. The "third front" was the term used inside the paper for the cover of the "Money & Investing" section, which was very prominent placement—if you couldn't get the story on the actual front page. Emshwiller put in a quick call to Smith, by then at the office, to tell her about the conversation with Palmer.

"Hey, I just talked to Palmer. Guess what he said? Two hundred million of that $544 million hit is from LJM," he said, and briefly recounted the conversation.

"Jeez," said Smith. "That's a lot! Did he explain what this structured finance thing was?"

Emshwiller told as much as he knew, mostly hoping that Smith could get more information out of Lay when she talked with him later that day.

The excitement at the $200 million lasted somewhere between fifteen and thirty minutes. Then Palmer called back. He sounded out of breath. "I was wrong. I made a mistake," he said. With all the commotion of an earnings announcement day and all the numbers Enron was releasing, he'd gotten confused. When he double-checked, Palmer discovered that he'd given the wrong number for the LJM portion of the write-off. He said something that Emshwiller didn't understand, about the nearly $200 million being connected to writing down goodwill relating to various investments.

"So how much was related to LJM?" Emshwiller asked with the sinking certainty that Palmer wasn't going to say, "Oh, it was the other $344-plus million."

"Thirty-five million," Palmer said.

"Thirty-five million," Emshwiller echoed, as if repeating the number might reinflate it.

"That's right," replied the Enron spokesman.

Never had $35 million sounded so measly. Emshwiller wanted to yell at Palmer, though he wasn't quite sure whether he wanted to call him an idiot, a liar, both, or neither.

Instead he said, "How could you be that wrong?"

"I just made a mistake," Palmer said in a tight voice. "I was wrong. Flat-out wrong."

Emshwiller brought Friedland the bad news. "You think he's lying?" the bureau chief asked.

"Maybe," Emshwiller said with a shrug. Maybe even probably, he thought.

But the two of them, and Smith when they called her, agreed that

there wasn't a lot they could do about it. They had no way independently to verify any number, and they didn't think Palmer had ever knowingly given them bad information.

As Emshwiller thought more about it later, the incident, in an odd way, bolstered Palmer's credibility. If the Enron official had really set out that morning to be a corporate shill, ready to lie for the cause, he would have had no reason to give the much larger number. It seemed obvious that he'd been trying to be helpful and honest in the first call. The second call had only three possible explanations: Palmer really had been wrong, someone had ordered him to lie, or someone had lied to him. What he knew of Palmer made Emshwiller lean toward Door No. 3.

While Smith and Emshwiller grappled with their work, the rest of the financial press also began to digest and spit out the Enron earnings release. A morning stock market story by *FT.com*, the on-line publication of the London-based *Financial Times* newspaper, mentioned that Enron's earnings of 43 cents a share were "in line with expectations" and that "Enron shares edged slightly higher in pre-market trade." In a later version, *FT.com* added the big write-off, attributing it to "losses associated with various investments including New Power." CNBC's early morning *Squawk Box* newscast noted that Enron's earnings were "in line" with analyst estimates and that the company "reaffirmed guidance for the year." Then *Squawk Box* moved on to Knight Ridder earnings.

"In line with analyst expectations" had become a common coin in reporting about corporate earnings. Thomson Financial/First Call, the stock market research firm, even monitored, tabulated, and summarized analysts' earnings predictions for hundreds of public companies. Meeting those predictions was good. Exceeding them was very good and usually pushed up the company's stock price, at least for that day. Falling short of expectations was, well . . . not something that happened all that often.

Corporations had long ago figured out that meeting analyst expectations made both the company and the analysts look good. While it would have been illegal for company officials to give a specific earnings estimate to stock analysts without making the same prediction public, there were numerous ways to provide more general, informal "guid-

ance." Analysts and company officials routinely talked and frequently formed working friendships. In that kind of congenial atmosphere, it wasn't hard to come to some understandings about where future earnings might land.

Any large corporation made hundreds of business and accounting decisions a year that affected earnings. Which quarter did certain revenues get booked into the income statement? How were certain expenses treated? Were they recognized all at once or stretched over a period of years? At the end of each quarter, corporations usually had a flurry of activity to get asset sales made or sales contracts signed so that the benefits could show up in that period. By many accounts, Enron officials had become masters of this accounting symphony. And in the background, Andersen was always reviewing Enron's accounting actions, giving the initiatives the crucial patina of legitimacy and independent scrutiny. All in all, a system had evolved that helped ensure analysts didn't look stupid and a company didn't see its stock price thrashed.

Reporters took part in this little game, even though they knew it resembled a sort of shooting gallery where the targets were very hard to miss. Journalists rationalized that even if the company had massaged analyst expectations, the expectations were newsworthy. If nothing else, investors bought and sold stock based on analysts' predictions. It was a standing rule at the *Journal* to include a few words, in all earnings stories, explaining how the company's performance jibed with expectations, giving further credence to the measure.

As they did each quarter, Enron officials set up a round of morning interviews for Lay on the financial news shows of major cable channels. Back in the 1990s, when the stock market seemed like an endless party with no bar tab running, these cable shows had become a staple for hundreds of thousands of semifanatic Internet stock traders. These people would sit at their computer terminals with the financial news blaring in the background, ready to execute trades at the click of the mouse and the bark of the boob tube. Television appearances by top executives frequently moved up the company's stock price, at least temporarily. Such interviews became part of the earnings-reporting ritual for hundreds of companies.

Enron had taken extra pains to prepare for this round of television interviews. With Skilling's sudden departure, company public relations officials wanted to visually emphasize that Lay was back in the saddle. Instead of using the board of directors' fiftieth-floor conference room, the normal location for such interviews, they set up the camera amid the hubbub of the trading operation eighteen floors below. The idea was to show Lay surrounded by action.

Lay thought the backdrop was too busy. He ordered the camera turned so that he would sit with his back to the windows, thereby negating the reason for coming down to the trading floor. Lay was unusually testy that morning, snapping at subordinates and slouching in his chair. He complained about having to do the interviews.

But he sailed through with hardly a ruffle. The CNBC interviewer never mentioned the billion-dollar charge or $618 million loss. Instead, he reported that earnings were "in line" with analyst estimates and that "as of this morning, there were eighteen analysts covering it. Thirteen say it's a 'strong buy,' three a 'moderate buy,' two a 'hold.' Nobody is selling it."

The Enron chairman happily seconded that line of thinking. "Well, first of all, we had a very strong third quarter," Lay said. "Of course, [it's] right on the Street's expectations. We had very strong growth in volumes, about 65 percent. Our retail business showed a very strong quarter with income before interest and taxes up about three and a half–fold. So we had a good strong quarter . . . overall we're very pleased with it, particularly given the current economy." Lay did mention the write-offs, albeit briefly. "Now, we did take some write-offs to kind of clean up some balance sheet items," he said. Sort of like washing and waxing your Mercedes after a dusty trip to the country club.

The CNBC interviewer noted that earlier in the morning, Moody's had announced that it put Enron on review for a possible downgrade of its credit rating. What did Lay have to say about that?

Standard & Poor's and Fitch had reaffirmed their credit ratings of the company, the chairman responded. And, he added, Enron was looking for another 20 percent increase in per-share earnings in 2002.

The CNNfn interviewer didn't specifically mention the billion-dollar charge or $618 million loss, though she did note that there "were

some charges in this earnings report." She seemed to be under the impression that Lay was new to his job, noting there had been a change in the chief executive's post over the summer. "You have not held your position for that long," she said. "What's been the toughest challenge for you as you sit down and try to figure out which way the company's heading next?"

"As you know, I held this position for over fifteen years before Jeff Skilling became CEO in February this year," Lay replied without missing a beat. "So I really have not been out of this chair very long." He went on to say that he basically planned to have Enron just keep doing the things it had been doing so well.

The Fox channel interviewer said Enron "beat Street estimates." The earnings recap seemed to be getting better as the day progressed. At the end of the interview, Lay was asked about whether Enron's management team, post-Skilling, offered such "slim pickings" that he was forced to return as chief executive.

"Well, it's really quite the contrary," Lay said. "Going back over fifteen years, I've never had the bench strength or depth that I have right now."

It was hard to blame the TV journalists for not throwing tougher questions at Lay. Executives from all kinds of companies popped up for brief interviews throughout the day. It would have been impossible to get well versed in each company before each interview. And then the entire interview might only last a couple of minutes. Not exactly a system designed for in-depth and hard-edged reporting.

Meanwhile, Smith was having problems of her own. She'd been on the phone interviewing the Duke executive when Enron's quarterly conference call with analysts got under way at 7:00 A.M., Pacific time. As she often did on busy days, she figured she'd listen to the replay, which was usually available an hour or so after the conclusion of a conference call. Since the conference call was for analysts and investors, reporters couldn't ask questions anyway. So the replay was as good as the original.

As she tuned in to the replay, she felt growing anxiety about the approaching deadline. She skipped quickly through the beginning of the

call, repeatedly hitting the "9" button to fast-forward through the recording. As was usually the case, Lay's presentation sounded pretty much like a recap of the written release. She wanted to get to the question-and-answer session since that's where penetrating questions could sometimes elicit unexpectedly blunt and illuminating replies.

She listened to as much as she could. Then it was time for the Lay interview. "Hello, Rebecca, good to talk with you again," said Lay in his usual friendly, relaxed voice. He didn't sound like a man who'd just lost $600 million. He wanted to talk about Enron's big gains in trading volumes. She wanted to talk about the LJM charge—$200 million, $35 million, whatever the amount.

When she had an opportunity, she asked her question: "Ken, can you explain this $544 million charge that relates to LJM and some structured financings? What is that, exactly?"

Lay gave a disjointed and confusing explanation of how the LJM-related charge had been related to "the early termination of a structured finance" arrangement. He talked without really answering the question, saying that these were transactions the company occasionally entered into, and not all of them turned out well.

Smith pressed for more detail. "I don't understand what this was," she said. "What was the name of the structured finance deal? Didn't it have a name?" She thought it might be easier to get her arms around it if they at least began with a proper noun and then described what the beast had been doing.

"I'm not sure it had a name," Lay said. "It was an internal vehicle set up to finance certain assets."

"What was it called?" Smith asked, taking another shot at it. "It had to have a name if it was doing business with Enron. I mean, everything has a legal name or you can't do business with it, right?"

Lay fumbled uncharacteristically for a moment, as if not quite sure what to say. Then he muffled the telephone mouthpiece and asked someone nearby, "What's the name of the thing?" When he came back on the line he said, again, "I'm sorry, Rebecca, but I don't know if it had a name."

Oh, give me a break, thought Smith. How can something generate

millions of dollars' worth of losses and not have a legal name? She didn't believe it for a minute. But why weren't they saying what it was? Was it another company whose name she'd recognize?

Lay repeated the press release wording about an "early termination" of "certain structured finance arrangements." And, yes, LJM had been a participant in these arrangements. It was clear he either didn't know the details or wasn't prepared to say. It was also clear that Lay's patience was giving out. He cut her off midsentence. "We've said about all we're going to say on that," he said. And he reminded her that the reporters already had been told that Enron wasn't going to discuss LJM, when they'd submitted that earlier long list of questions.

Smith could feel her anger rising. "How can I write about something that doesn't have a name?" she asked. "None of this makes any sense, Ken." She could already hear questions from her editors, who would focus with laserlike precision on the fuzzy explanation. One last time, she tried to get more detail.

"Now, Rebecca," Lay chided. "You're being sneaky again." He sounded like a grandmother scolding a child for trying to filch a cookie from the cooling rack. The conversation ended moments later with Lay promising that the company would be providing more information when it could. Much later, in response to written questions from Smith, Lay attorney Bruce Collins said his client could not remember the name of the vehicle, but added that, "Mr. Lay was familiar with what the problems were regarding the structured finance arrangement."

Back in Los Angeles, Emshwiller was writing a draft of the story. It was early afternoon and he was acutely aware, spurred by Friedland's gentle reminders, of the approaching 2:00 P.M. first copy deadline on the afternoon of October 16. Every reporter knew the newspaper corollary to Einstein's theory of relativity. Time slowed as you approached the speed of light and sped up as you approached a deadline.

Partly because $35 million just wasn't that much money in the Enron scheme of things, Friedland, Smith, and Emshwiller agreed that reference to LJM wouldn't go into the first sentence, or lead, of the story. The $1.01 billion charge and $618 million loss for the quarter got top billing.

But of that giant charge, "a particular slice raises anew vexing con-

flict-of-interest questions," the second paragraph stated. The "anew" was included for any readers who remembered the August "Heard on the Street" article. The reporters also mentioned the $35 million figure, both thinking again that "nearly $200 million" would have carried a lot more oomph. Smith sent a memo with information and quotes that should be included. Friedland and Emshwiller sent her back a draft. She wanted more material quoted directly from the LJM documents. "We're pulling our punches if we don't include it. It's outrageous," she said. They talked about other changes before the story went to New York. Throughout the rest of the day, they chased subsequent editions of the newspaper with additions and changes.

While Emshwiller and Smith often felt as though they were shoveling faster than they were thinking, they ended the day feeling good about the story that ran. They had gotten in a fair amount of information about the partnerships. The Enron story contained quotes from the LJM2 private placement memorandum that gave readers a strong dose of the conflict-of-interest problem stemming from Fastow's dual role, quotes such as how Fastow's involvement "should result in a steady flow of opportunities . . . to make investments at attractive prices" and how the Enron chief financial officer's interests would be "aligned" with LJM2 investors because the "economics of the partnership would have significant impact on the general partner's wealth."

And there was that document's rather stunning statement about how Fastow's responsibilities to Enron could "from time to time conflict with fiduciary responsibilities owed to the Partnership and its partners." Of course, by implication, the opposite was also true. The story talked about how Fastow stood to make millions of dollars from the partnerships, though it couldn't say how much he had pocketed. The piece named several LJM2 investors. Near the bottom of the story, the reporters also squeezed in the quotes from Charles LeMaistre, the Enron director, about how the partnerships were a way to compensate Fastow and keep him at the company. Emshwiller and Smith decided not to raise the issue of whether Enron had waived its code of conduct for Fastow. Given the company's denial, they thought it better to try to gather more information before putting anything in print.

While the reporters were happy to see the hectic day end, so were

members of Enron's media team. After all, Enron had reported the biggest loss in its history, yet Enron's stock rose 67 cents to $33.84 a share. Clearly Enron had gotten good spin. By the close of business, Palmer and his crew hardly had the energy to savor the moment. With the all-night scramble to get out the earnings release, several of them hadn't slept for thirty-six hours. They were hoping to get a little rest over the next few days.

14

"You Missed Something That Could Be Really Big."

THE NEXT MORNING, OCTOBER 17, EMSHWILLER WOKE UP A LITTLE after 6:00 A.M. and immediately went outside to pick up the copies of the *Los Angeles Times* and *New York Times* waiting on his driveway. Normally, he didn't bother with the papers until he had made coffee and downed at least part of a cup. At that hour, he'd found that stories almost always made more sense when aided by a shot of caffeine. But this morning he had enough adrenaline left over from the day before that he didn't feel the need for any extra stimulants. Today the piece he and Smith had written would be in the papers, and he was eager to see what two of the *Journal*'s main competitors had done with Enron's earnings. He scanned the front page of the business section of the *Los Angeles Times* after first taking a quick peek at the front page of the sports section; it had nothing about Enron. He looked inside. Nothing on page two or page three or . . . any of the pages. The *L.A. Times* hadn't run an Enron earnings story. Well, thought the reporter, that's certainly an economical approach. But he also thought it was odd, given what hot news Enron had been for the paper in connection with the California electricity crisis.

The New York Times ran a roughly six hundred-word story on page five of its business section. The piece led off with Enron's big write-off and loss. It refrained from using the word *recurring* or mentioning anything about meeting analyst expectations. It quoted UBS Warburg

stock analyst Ronald Barone (who to the confusion of many had the same name as the energy ratings official at Standard & Poor's) calling the write-offs "a step in the right direction. Investors can look at this with more confidence that problems are being faced and addressed," he said. The story also quoted a subdued-sounding David Fleischer, who argued that Enron management needed to regain investor trust. "They need to convince investors these earnings are real, that the company is for real and that growth will be realized. That has to be proven over time," said the Goldman Sachs analyst. He called for even more disclosure of financial information by the company.

Not bad, Emshwiller decided as he finished the *New York Times* piece. But they didn't have anything about LJM, he thought with a small touch of glee, followed briefly by a touch of regret. He was certainly happy to have beaten two major competitors with information about the partnerships. (Later that day, he would see that the *Journal*'s third major daily newspaper competitor, *The Washington Post,* had done only a paragraph, with no mention of LJM, as part of a long roundup of business news.) The regret came from wondering whether they had squandered their exclusive information on a daily story instead of saving it for a possible page-one piece. Rationally, he knew they had made the right decision, really the only one they could. Still, he thought, it would have been sweet to have gotten a front-page piece out of LJM.

Hertzberg certainly felt that using the LJM material had been the right move. That morning, the *Journal*'s deputy managing editor sent Smith and Emshwiller an uncharacteristically long e-mail. "You made the absolutely correct decision to unload the details of the Fastow partnerships in the paper today; they added immeasurably to the impact of your story," he wrote. "I want you to know that we still have a big appetite for more on Enron. We need to get to the bottom of all these huge, 'complex hedging transactions'—what they really were and why they failed. We need to get the real story of how Ken Lay created what was widely hailed as the world's hottest energy company, and the huge, risky moves he took. Did Enron's board really understand what he was doing? How could they possibly have approved Fastow's incredible conflict of interest, and are there more insider deals like these? Did Lay and his lieutenants really understand the risks of what they were doing,

or was this really a Long Term Capital-type of situation? What about Enron's rapid and ill-fated diversification into telecom and water? There's plenty of fodder here for a great story. Best, Dan."

Nice note, thought Smith, but also a classic editor's message: Thanks for what you did yesterday, now what are you going to do for me today? She certainly didn't disagree with Hertzberg's sentiments. Both she and Emshwiller wanted to know a whole lot more about Enron's inner workings. But a month of reporting by the two of them had shown how tough a task that could be. And while New York had an appetite for more Enron stories, coming up with more food for the beast was another matter.

Unbeknownst to the reporters, at least one other reader was also very happy with the story: Andy Fastow. The chief financial officer had been privately warning friends and associates that a critical piece about him might be coming out in the *Journal*, though he'd assured everyone that he'd done nothing wrong. Just the press, once again, looking for negative things to say. But when the story appeared, he gloated openly. The shot from the *Journal* had barely nicked him, Fastow told one Enron colleague. His arguments for not cooperating with the reporters had been proven correct, he added. They'd hardly gotten much at all about the partnerships.

Other readers had reactions that might have tempered Fastow's smugness. Two senior Wall Street analysts who followed Enron later told Emshwiller that they'd never heard of the LJM partnerships until the October 17 *Journal* story. Both felt anger, almost a sense of betrayal, when they read the piece. How could Fastow have gotten into such a situation? How could Enron have let him? In part, the two admitted, they were also upset with themselves, feeling that they had allowed themselves to be duped. After all, references to LJM were in Enron's public filings with the SEC. Buried, but there. One of the analysts was so indignant that he called a contact of his at Enron that day. "Fastow has to go," he told the company official. He couldn't believe that anyone in so compromised and conflicted a situation could remain as Enron's chief financial officer.

How could people in the financial community, such as himself, have any faith in the guy? By implication, of course, the next logical question

was, how much faith should be placed in a company that allowed its CFO to get into such a position? But this analyst, like others, wasn't quite ready yet to fully address that question. Instead, he just vented briefly to his Enron contact on the other end of the phone—who, not surprisingly, didn't rush to agree with the proposal that Fastow should go.

On October 17, the first shareholder lawsuit was filed against Enron in Houston state court. Such litigation had also become part of the quarterly earnings cycle in corporate America. When a company reported a loss or a profit that was below analyst predictions or had some unexpected piece of bad news, class-action lawsuits followed almost automatically.

More ominous for Enron than the arrival of the class-action attorneys was the activity of the company's stock on October 17. After its little bump-up on Tuesday, the stock started falling Wednesday morning. It would end the day down by more than $1.60 a share, or nearly 5 percent.

Smith and Emshwiller received calls from readers of that day's story. "You missed something that could be really big," said a voice on the other end of the line when Emshwiller answered his phone. The voice belonged to a short seller whom the reporter had talked with before.

That's always nice to hear, Emshwiller thought. "What exactly did we miss?"

During the conference call the day before, Lay had mentioned briefly that Enron was retiring fifty-five million shares of stock, about 7 percent of the total number of shares outstanding, which reduced shareholder equity by $1.2 billion, the stock trader said. He thought this fact was extremely important because having fewer shares made it easier for Enron to meet its projections for per-share earnings growth. "So when Enron predicts 15 percent growth in earnings per share, about half of that is going to come from just having fewer shares outstanding," the short seller argued in a piece of arithmetic too quick for Emshwiller to follow. What's more, he added with words he undoubtedly knew reporters loved to hear, "nobody seems to have picked up on this."

Emshwiller thanked the trader for the call and said he'd look into the matter. The information, if accurate, certainly seemed strange. In covering the stock fraud beat, he had written about small companies—some-

times for crooked purposes—reducing the number of shares outstanding through a so-called reverse stock split, in an effort to boost their stock price and make their firms seem more substantial. And it was a common practice for big companies to buy back their own shares when they thought the stock was trading at too low a price. But this sounded like something different. And, he wondered, could it possibly be related to LJM?

Emshwiller called Smith, who'd listened to the conference call. "Do you remember hearing anything about some kind of equity reduction?" he asked.

"Nothing. But I'll go back and check," she said. The recordings of the analyst calls could usually be listened to for several days after the event. Like Emshwiller, Smith didn't know what the short seller was referring to. But it sounded big, and if the tip proved to be true and important, she knew that she'd be mortified. It would mean there was a hole in that day's story, and she'd feel responsible for it.

Before dialing back in for a closer listen to the prior day's conference call, Smith reread Enron's earnings release. At least there's nothing in there about an equity hit, she thought with relief after going through the document. She looked back through her notes. None of the analysts interviewed the day before had mentioned it, either. Lay certainly hadn't said anything about a $1.2 billion equity reduction. But when she listened to the tape, she found the telltale sentence. In Lay's prepared remarks, while breezing through the $544 million charge and the ending of that "structured vehicle," the chairman added: "In connection with the early termination, shareholders' equity will be reduced approximately $1.2 billion with a corresponding significant reduction in the number of diluted shares outstanding." In the next breath, Lay moved on to a description of Enron's operating cash flow.

A few listeners besides the caller to Emshwiller caught the remark. As Barone and his Standard & Poor's colleagues listened to the conference call, they couldn't believe that Enron had actually chosen such an oblique disclosure method. It was one thing not to announce the equity reduction in a separate SEC filing. But this made it look as if the company were trying to hide the matter. (One senior Enron accounting executive later claimed that the equity reduction had been included in a

draft of the earnings press release but was eventually taken out to save space—at best, a curious rationale in a document that rambled on for nine pages, chock-full of far less important information.)

At least one reporter caught Lay's statement about the equity reduction. Peter Eavis, a columnist for an on-line stock market publication called *TheStreet.com*, wrote a long piece about Enron's earnings on October 16. About halfway down in his piece, he quoted Lay telling the conference call that the $1.2 billion reduction in shareholders' equity stemmed from a " 'removal of an obligation to issue a number of shares.' " Eavis speculated that the transaction might have been connected to LJM and also questioned whether some undisclosed portion of the $1.01 billion charge to earnings could have been LJM related.

(While Emshwiller occasionally read *TheStreet.com*, neither her nor Smith learned of the Eavis article until weeks later. When they did, they found that Eavis had been doing some of the most critical coverage of Enron of anybody in the press. Twice earlier in the year, he had briefly mentioned the LJM partnerships. But the references were buried in longer pieces. And without the benefit of internal LJM documents, neither Eavis nor the shorts made much headway in figuring out the partnerships. In one piece, he did speculate that they may have been used by Enron "to goose earnings." Others who knew about the partnerships also didn't know what to make of them. *Fortune* magazine editors later acknowledged that they knew about the partnerships before running their March story criticizing Enron. Bethany McLean, the story's author, even asked Fastow about them during an interview in New York in connection with the piece. He was willing to talk only generally about them. In the end, the magazine decided not to include the LJM matter in the piece.)

As Smith listened to the tape, she silently berated herself. Of all the days to skip through the prepared remarks, she thought ruefully. Some analysts later told the two that these comments went right past them with one analyst saying that he thought the $1.2 billion was simply a reference to the announced $1.01 billion charge against earnings. But the fact that others had also missed the remark didn't make Smith feel much better.

She, Emshwiller, and Friedland had a brief three-way conversation.

"Seems like this reduction is our best angle for a follow-up tonight," Friedland said.

"If we can figure out what it means," Emshwiller said. Still, he and Smith agreed that it was clearly the best lead they had to follow. The two reporters again divided up the task of making calls. Emshwiller would call a few analysts to see what they knew about it. Meanwhile, Smith would put the call in to Enron. She was more than a little interested in hearing how the company explained this one.

Palmer called her back quickly. "Mark, what's this about an equity reduction?" Smith asked him. "Why wasn't it mentioned more prominently on the call yesterday? You guys really buried it."

"We didn't bury it. We talked about it," he said defensively. Palmer did, however, acknowledge that the equity cut was related to the Fastow partnerships.

"Well, how's it tied to LJM?" she asked. Smith didn't feel like letting him off that easy. "I feel like I was lied to yesterday," she told Palmer. She heatedly recounted her discussion with Lay the day before, even though Palmer had been listening to that conversation as well. "Ken only mentioned the $35 million charge in relation with LJM," Smith said. "He clearly implied that this represented the entire impact related to the Fastow partnerships. Now, suddenly, there's this $1.2 billion item that's somehow related to LJM. Why didn't you mention it? You knew how interested we were in LJM." Besides being angry about what she hadn't been told, she was perhaps even madder at the way Lay had treated her, especially that condescending "You're being sneaky again" crack when she'd tried to circle back to LJM. Hiding $1.2 billion, now that seemed to her a real example of being sneaky.

Palmer tried to calm Smith. "I'm sure Ken wasn't trying to mislead you," the Enron press spokesman assured her. He promised to try to get more details on the equity reduction and call her back. But, he added, Enron hadn't lied to anyone or hidden the item. "They mentioned it on the analyst call," he said. True, it was only a sentence in the opening statement, but it was there.

"Well, why wasn't it in the printed earnings materials?" Smith asked, her voice growing louder again. "Don't you think a $1.2 billion hit is material?"

Palmer promised to get back to her quickly. Though she didn't know it at the time, he quickly called Causey, the chief accounting officer, for an explanation.

After a few minutes, he phoned back. "We didn't include it in the earnings report because it's a balance sheet issue, not an income issue," he said. Thus, equity reduction would appear in the company's next regular Form 10-Q quarterly filing with the SEC, which included an updated balance sheet. Enron expected to make that filing by November 14.

What nonsense, Smith thought. This was exactly the kind of thing that had drawn the derision, earlier in the year, that had elicited the infamous "asshole" quote from Skilling. Back then, the analyst who was the object of Skilling's scorn had been criticizing the company for not issuing its balance sheet at the same time that it issued its earnings announcement. Many companies released both at the same time, to give investors a more complete view of a firm's finances and cash flow. Why couldn't Enron? Maybe, Smith thought, because Enron really did want to hide things.

Palmer took a stab at explaining the structured finance vehicle, but none of it made any sense to Smith. She'd never be able to get such a half-baked explanation past her editors. She couldn't understand how the company had been using its own stock to back some sort of investment with this structured finance vehicle.

After a minute or two of additional venting by the reporter, Palmer signed off and said he would get Rick Causey, the chief accounting officer, on the phone with Smith to further explain the move.

Smith didn't have any great expectation that the conversation would be terribly illuminating. She remembered the August session with Causey and half expected another mind-numbing conversation. But he was Enron's chief accountant, and there certainly seemed to be some accounting questions here. "Okay," she replied. "But I obviously need to talk to Causey as soon as possible."

A short while later, Palmer called back with Causey in tow. Causey tried walking Smith through the chain of events that culminated in the equity reduction. It related, he said, to a "structured finance vehicle."

No, Causey couldn't tell Smith its name either. "We had various investments in broadband that we hedged with the structured entity," Causey said. "Its principal assets were contingent shares of Enron stock. The value of the hedges has declined because Enron shares have declined." The recitation went on for several more very long, jargon-filled minutes that once again convinced Smith that the chief accounting officer should never be Enron's chief spokesman. "We terminated the hedges and the entity," Causey said. LJM2, he added, had been the sole outside investor in this vehicle.

That's one understandable piece of information, Smith thought. But the partnership's role in the unnamed entity was still far from clear.

Apparently others had shared in Smith's bewilderment. One reason Enron terminated the financing vehicle had to do with the "confusion factor" surrounding the arrangement, said Causey, though he never identified precisely who was confused. The arrangement had required Enron to issue shares of its own stock, he said. With the termination, Enron retired those shares, which created the need to subtract money from shareholder equity. The $35 million charge to earnings was a cash payment Enron made to LJM in connection with the termination, Enron officials said.

While Smith struggled to decipher Causey's explanation, Emshwiller tried to find Wall Street analysts to talk about the $1.2 billion hit. He left a lot of messages. It was after 5:00 P.M. New York time, and most people had left their offices. Finally, he reached David Fleischer at his Manhattan apartment. Emshwiller heard what sounded like young children playing in the background. The Goldman Sachs analyst was friendly, as usual, though he sounded tired. He said he'd just spent several hours that day talking with Enron about the earnings report.

"What do you make of this $1.2 billion equity hit?" Emshwiller asked.

There was silence on the other end of the line before Fleischer replied, "One point two billion?" At least it sounded to Emshwiller like a question mark at the end. "Their disclosure on these partnerships is so horrendous," Fleischer added.

The reporter couldn't argue with that, though it wasn't quite an answer to his question. So he tried again. "Enron is retiring fifty-five

million shares and cutting shareholder equity by $1.2 billion. Lay mentioned it in the conference call. We're just trying to see what analysts think about it."

Another pause from inside the Fleischer home. "That number wasn't addressed that way," the analyst said. He seemed to be groping for something to say.

"What do you think it means?" Emshwiller asked.

Another pause. "I hesitate to speculate," Fleischer said finally. He said he needed to get off the line. The noise of children in the background did seem to be rising.

Emshwiller threw in a quick thanks and said good-bye as the analyst hung up. It seemed clear that Fleischer wasn't familiar with the equity hit. Emshwiller wondered how many others were in the same boat. But he didn't have too much time to think about that. He still needed to find some outside voice to say something about the $1.2 billion.

Jeff Dietert, a Houston-based analyst, came to the rescue and returned the reporter's phone call. Dietert said that reducing shareholder equity can be bad news for a company because it worsens the debt-to-equity ratio, which was one venerable measure of a firm's financial health. Hardly a Hall of Fame quote, Emshwiller thought, but deadlines were *already* rolling by. He wrote up a paragraph and e-mailed it off to Smith, who was writing that night's story.

The reporters wrote the story as clearly as they could, but it would be months before they would understand the full portent of what had happened. Its lead of the October 18 story read: "Enron Corp. shrank its shareholder equity by $1.2 billion as the company decided to repurchase 55 million of its shares that it had issued as part of a series of complex transactions with an investment vehicle connected to its Chief Financial Officer Andrew S. Fastow." That first paragraph took a while to write, since neither reporter had a very clear grasp of what had happened. Fortunately for them, the headline was the headache of the New York editors.

The story emphasized that Enron hadn't included this information in its third-quarter earnings announcement but made it public only as a brief mention in a conference call with analysts. Palmer was quoted as calling the equity reduction "just a balance sheet issue" that wasn't

deemed "material" for disclosure purposes—a quote that would come back to haunt the company when people came to view the handling of the disclosure as a particularly graphic example of Enron's attempt to hide bad news.

Though the *Journal* editors put the story on the front of the third section again, neither Smith nor Emshwiller felt particularly happy with the piece. They had only a very superficial understanding of what was behind the equity reduction and felt, as a consequence, that the import of the piece was murky. The reporters didn't have much time to dwell on the shortcomings of their story when it appeared on October 18. That afternoon, they received another call.

This one, from another short seller, came to Smith. She liked him because he was older than many of the shorts she'd known and seemed to understand she wasn't interested in "dishing" when it came to information. He also seemed to have a lot of documents related to various investments by energy companies—the sort of stuff that only well-heeled private investors ever saw. He said he had a copy of a recent quarterly report that Fastow had sent to LJM2 investors. "Would you like to see a copy?" he asked.

"I sure would," she replied without hesitation. "Would you have time to fax it over fairly soon?" A short time later, a thirty-one-page report came spewing out of the fax machine in the *Journal's* San Francisco bureau. Smith quickly scanned it and refaxed it down to Emshwiller in Los Angeles with a cover page on which she wrote "OUR COLLECTIVE HEADACHE."

As the reporters read through the report, they could see that it was potentially even more important than the private placement memorandum that had been slipped to them by their original source. While that first document provided a rough outline of the structure of LJM2, this one, which covered the first quarter of 2001, gave a snapshot of the partnership in action and was much more detailed. And it clearly had been busy.

The report listed fourteen active investments and fifteen more that already had been "liquidated." The transactions ranged from investments in Enron power plants to picking up pieces of Enron holdings in private energy companies. LJM2 partners had committed $394 million

in capital, which essentially matched the $400 million number given to Smith and Emshwiller by their original source—one more notch in that person's credibility belt. Besides the equity from the partners, LJM2 had lined up $185 million in credit lines with Dresdner Bank and JPMorgan Chase. All told, LJM2 had more than $500 million at its disposal.

The document also gave the first concrete information about how much Fastow was making as general partner. It showed management fees for 2000 to be nearly $7.5 million. The general partner had decided to forgo another $1.8 million due it. No explanation was given for that decision. "Maybe the extra money would have pushed Fastow into a higher tax bracket," Emshwiller cracked as he and Smith discussed the document.

The report's financial tables showed that the general partner's capital account in LJM2 increased in 2000 by more than $4 million, presumably as a result of profits reaped by the partnership during that period. It wasn't clear from the document whether Fastow could yet tap into that increased capital. But if their original source was right, Fastow had been telling Enron's board that he was putting only a few hours a week into LJM2. At that rate, even just the $7.5 million in management fees made a very hefty payday.

Because of the volatile stock market in late 2000 and early 2001, the general partner had "focused its efforts on insulating LJM2 from as much market risk as possible," the report said. Because of problems in some of LJM2's investments, particularly its stock holdings in New Power (the retail electricity company that Enron had sold to the public), Fastow had reduced the partners' projected annual return from an eye-popping 48 percent to a hardly shabby 29 percent. To help cushion the disappointment, LJM2 had distributed $75 million in proceeds back to partners during the quarter.

The report also introduced another member of the national accounting fraternity, known as the Big Five, into the LJM/Enron mix. While Enron had Arthur Andersen auditing its books, LJM2 had KPMG for the same job. A letter from that accounting firm, included in the report, assured investors that the accompanying financial statements "present fairly, in all material respect, the financial condition" of the partnership. The LJM2 financial statements included a footnote, which stated

that the "managing member of the general partner of the General Partner of the Partnership is a senior officer of Enron." Even here, in a private document with a very select readership, it seemed that Fastow had a hard time putting his name next to that "senior officer" label. The footnote said that LJM2 had engaged in nearly $400 million of purchases from and sales to Enron. More might be done in the future. "The General Partner believes that the terms of the transactions were reasonable and no less favorable than the terms of similar arrangements with unrelated third parties," the report added. It was essentially identical to the wording that Enron used in its public filings about its dealings with the LJM partnerships.

The quarterly partnership report contained pages and pages of descriptions of various LJM2 investments, complete with schematic diagrams. Each schematic showed a web of entities tied together through investments or loans. While the names of most of the entities changed from chart to chart, "Enron" and "LJM2" appeared somewhere on each page. However, in no chart were those two names ever directly connected. Intermediary entities with names such as Rawhide, Osprey, and Margaux stood between them. Emshwiller and Smith recognized some of the names. Many they did not.

The reporters didn't have time that day to do any digging into what all these entities were or what the deals entailed. Once again deadlines were rushing at them, and Friedland was nudging them impatiently for at least a few top paragraphs of the story. They decided to lead the story with the millions of dollars that Fastow had made off the partnership. This struck them and Friedland as news, since before they had been able to say only that he stood to make millions. Now it was concrete. He had made millions, though the exact amount still wasn't clear. The story said Fastow, and possibly colleagues, had "realized more than $7 million last year in management fees and about $4 million in capital increases."

The reporters, with an increasing sense of urgency, were trying to find at least one transaction between LJM2 and Enron that they could describe to readers. A couple of items caught their attention. The list of liquidated investments showed one transaction in which LJM2 invested $30 million on September 28, 2000, and then unloaded the investment one week later for $39.5 million. In the column showing rate of return,

that deal simply said "INF," which Emshwiller and Smith took to mean "infinite." However, there was a footnote calculating a rate of return somewhere in the neighborhood of 2,500 percent.

In another transaction, the reporters saw what seemed to be their first hard evidence of a deal being done to help LJM2 at the expense of Enron. LJM2 had sold the company a "put" option on Enron stock, which obligated the partnership to buy a certain number of shares at a certain price for a certain period of time from Enron. But with the market volatile, LJM2 and Enron agreed to end the put option a month early. In that month, Enron stock price dropped $8 a share—money LJM2 would have been on the hook for, had the put remained in place. Finally, the theoretical problems posed by Fastow's conflicting jobs had become all too tangible.

For the third straight day, the *Journal* put the Enron story on the front of the third section, a sign that the New York editors believed the paper was on to a particularly big breaking story. Even aside from the information in the new LJM2 internal document, the action in Enron's stock was heating up as a news story.

On that day, October 18, Enron shares plunged nearly 10 percent and were down to $29 a share. A *Financial Times* story that day said Enron was having new credibility problems as result of the way it handled disclosure of the $1.2 billion equity reduction. The article said Lay had only "fleetingly mentioned" the action and quoted one unnamed analyst accusing Enron of "trying to sneak it by. They already have a credibility problem and this did not help it."

The next day, Friday, October 19, the stock price continued plummeting. It ended up the week at just above $26 a share. In only three days, Enron stock had lost a fifth of its value, which translated into the erosion of $6 billion of market value.

Meanwhile, Enron's longtime friends and fans on Wall Street were maneuvering to deal with the rapidly worsening problem. On October 19, Merrill Lynch held a morning conference call for investors. Analysts Steve Fleishman and Donato Eassey began by saying they weren't "here to be a defender or cheerleader of Enron" and added that a "fear factor has set in on Enron."

The analysts generally defended Enron's dealings with the LJM part-

nerships—not surprising, perhaps, given Merrill's fund-raising work for LJM2. Eassey said Enron's aim in using the LJM partnerships was to "lessen the burden on the balance sheet and manage and smooth earnings." While he emphasized that he was "as bothered as anyone" about Fastow's LJM role, the analyst added that "somebody had to be in charge."

Fleishman said, "Fastow was there because he could analyze transactions quickly and facilitate them quickly." But from the tenor of the questions, investors clearly were struggling to understand how this seemingly brilliant company had gotten involved in something so messy. Though the call was billed as an information session, Merrill clearly was also trying to spread some calm. Fleishman and Eassey pointed out how central Enron was to the energy market. "No one benefits if things get worse," said Fleishman.

Since it was Friday and the *Journal* wouldn't have another paper until Monday, Smith and Emshwiller had a small space of time to try to digest the week's events. They wanted to look deeper into some of the transactions discussed in the LJM2 quarterly report. One set of transactions, involving four entities, had particularly caught their eye. A good chunk of the report had been given over to discussing them, and the transaction representing a possible Fastow conflict of interest that the reporters had put in that day's story involved one of the entities. Indeed, the handling of these entities seemed to have been a preoccupation for Fastow in recent months.

Neither of the reporters had any idea how large a role these entities would soon come to play in the Enron story. But they did manage to mention the common name of the four entities—the Raptors—in the very last paragraph of that night's story. Smith, a bird-watcher, pulled out her Peterson's guide and told Emshwiller that the entities were named for the classification of birds that includes great flying hunters like hawks, peregrines, and eagles. But Emshwiller associated the word with nastier predators, perhaps the most dangerous creatures (with the exception, of course, of man) ever to walk the earth or a Steven Spielberg movie. Either way, the four entities would soon rip through Enron like hungry carnivores.

15

"Looks Like the SEC
Read Your Stories."

EMSHWILLER WALKED INTO THE OFFICE ON MONDAY MORNING, October 22, and stopped at the stock ticker machine. He'd gotten into the habit of checking Enron's share price before settling down to work. He typed the company's stock symbol, ENE, on the keyboard, fully expecting to see that it had bounced back that morning after the beating it took in the prior three trading days. Often, when a company gets a respite from a spate of bad news, bargain hunters emerge and bid it up again. Instead, the numbers that flashed on the screen showed Enron's stock down by several dollars a share on a huge trading volume. "Damn, what's going on with Enron?" Emshwiller said to nobody in particular.

"Looks like the SEC read your stories," replied Rhonda Rundle, a news editor who was sitting nearby.

That morning, Enron had issued the following press release: "Enron Corp. announced today that the Securities and Exchange Commission (SEC) has requested that Enron voluntarily provide information regarding certain related-party transactions.

" 'We welcome this request,' said Kenneth L. Lay, Enron chairman and CEO. 'We will cooperate fully with the SEC and look forward to the opportunity to put any concern about these transactions to rest. In the meantime, we will continue to focus on our core businesses and on serving our customers around the world.' " Enron noted that its internal and external auditors and attorneys reviewed the related-party arrangements,

the Board was fully informed of and approved these arrangements, and they were disclosed in the company's SEC filings. " 'We believe everything that needed to be considered and done in connection with these transactions was considered and done,' Lay said." End of statement.

Well, thought Emshwiller, nothing like the arrival of the cops to ruin a company's Monday morning. He kept watching the stock quote machine, almost transfixed, for what must have been a minute or two. Enron's stock price looked to be in free fall. (It would end the day off 20 percent at $20.65 a share. Its trading volume of thirty-six million shares was about nine times normal for the company and made it the most actively traded issue of the day on the New York Stock Exchange—hardly the last day it would have that distinction.)

Emshwiller hoped that Rundle was correct when she suggested that the *Journal* stories had sparked the government inquiry. Like most journalists, he liked to think that what he did had an impact. Getting a major government agency interested in possible wrongdoing certainly qualified on that front. He didn't expect any confirmation that day from the commission and didn't get any. In accordance with standard practice, the agency declined even to confirm or deny whether an inquiry had been started.

(Only months later did commission officials acknowledge that they'd opened the probe as a result of the *Journal* stories. Like many others, they hadn't read Enron's public filings closely enough on their own to have discovered the oblique references to the officer-led partnerships. While the agency had hundreds of dedicated, hardworking people, it tended to be overwhelmed by its tasks, and never more so than in the Roaring 1990s. Thousands of complicated financial statements poured into the commission every quarter. The agency was supposed to review those filings to ensure that they contained enough information, presented accurately and clearly enough, to allow an investor to get an understanding of a company's financial condition. But these documents often ran dozens of pages or more. Any one could take days to dissect for signs of incomplete or inaccurate information. With a limited staff, the SEC made a crucial—and at the time sensible—decision. It focused its review resources on the submissions from the torrent of hot new technology and Internet companies that were making their initial public offerings of stock. These dot-com corporations raised billions of dollars

from the public despite having no track record and, as it turned out, wildly exaggerated expectations of future profits. By comparison, companies such as Enron looked venerable, solid, and safe enough to warrant only occasional glances from the stock market cops. The SEC did periodic reviews of the filings of major companies. In Enron's case, one hadn't been done by the agency for several years.) After finally pulling himself away from the stock quote, Emshwiller walked back to his office and saw that his phone message light was on. "Hey, John, looks like we have another story to do tonight," said Smith's voice when he played back the recording. "Call me when you get in."

"At least Enron seems to be getting better about disclosure," Emshwiller said, only half-jokingly, when he reached his colleague. After all, corporations didn't always put out press releases about SEC inquiries. Frequently they simply noted such an event in their quarterly report with the SEC and left it for investors to find the nugget.

"Maybe they're feeling gun-shy after last week's fiasco with the equity hit," said Smith, referring to the nearly covert disclosure of the $1.2 billion equity reduction. "I bet they don't want to get accused of hiding the ball again." Several analysts had already told the reporters that they thought Enron's method for revealing the equity hit was far more damaging to the company than the hit itself because Enron had acted like a company that had something to hide.

He and Smith had not done an Enron story for that Monday's paper (Smith had spent part of the weekend writing about Edison International, which had been knocked to its knees by the California electricity crisis.) Nor had there been much coverage of Enron in other papers over the weekend. The two reporters planned to dip into some of the LJM2 transactions that had been mentioned in the last partnership document they'd received, particularly those Raptor transactions that Fastow had been spending so much time on. With the last week's rush of news behind them, Emshwiller hoped they would be able to work the Enron traps at a less frantic pace. Raptor would have to wait, for now.

The two again divided up the calls to be made for that day's story. Smith phoned Palmer. He said the company had received a fax from the SEC the previous Wednesday, October 17, and a follow-up phone call the same day.

"Why did you wait until today to announce it?" she asked.

"Ken wanted to talk to the directors first, and it took time to arrange a meeting," he said.

"Can you give me any more detail on the investigation?"

"Not beyond what's in the press release," Palmer replied. "And let me emphasize," he added in what would become a mantra for him and other Enron officials that day, "it's not an investigation. It's only an informal inquiry by the SEC." Technically, the Enron PR man was correct. In the lexicon of the SEC, there is a distinction between an informal inquiry and a formal investigation. The latter had to be authorized by the agency's five-member commission and gave the SEC staff the power to subpoena documents and compel witnesses to appear, under oath, for questioning. In an informal inquiry, the staff had neither of those powers. While a formal investigation was a bigger deal, an informal inquiry was bad enough for Enron. It meant that the agency's staff thought something might be rotten at the company and that Enron might drag its feet and not fully cooperate.

Despite this latest blow to the company's image, Enron still had fans on Wall Street. Credit Suisse First Boston analyst Curt Launer told the Associated Press that the government's request for information creates "a reaction and, in my opinion, an overreaction." In other words, Launer seemed to be saying that an SEC inquiry, while hardly good news, was no cause for panic.

But Peter Eavis of *TheStreet.com* continued to bang away at Enron. On that Monday, Eavis chided Lay for disclosing the $1.2 billion equity reduction in a "dubiously discreet manner." Eavis also turned his attention to "other big deals that have yet to receive much public scrutiny [but] could further damage the company's balance sheet." He noted that Enron had helped create two supposedly independent entities, known as the Osprey Trust and the Marlin Water Trust II. These trusts had sold about $3.3 billion of notes to the public and then used the money from that debt sale to buy assets from Enron, thus giving the company a big slug of cash. Like the LJM partnerships, these two trusts were essentially big pots of money that Enron could call upon to help finance its myriad business dealings. Unlike the LJM entities, these trusts had raised billions of dollars by borrowing money from the public through the sale of

notes. They filed lengthy disclosure statements in connection with the debt offerings.

While these trusts were relatively well-known and straightforward compared with the LJM partnerships, they did have potentially troubling aspects. Under certain conditions, Enron was on the hook for at least a chunk of those billions of dollars of notes. When the trusts liquidated, starting in 2003, they were supposed to pay back the public debt holders by selling their assets. But if those assets didn't fetch enough money, Enron was obligated to make up for any shortfall.

Eavis quoted Enron treasurer Glisan as saying that it didn't look as though the assets in Marlin II, which had more than $900 million in debt, would be sufficient to fully pay back the note holders. He said Enron was looking to sell other assets to make up the difference. When asked if there would be enough money within the much larger Osprey Trust, with about $2.4 billion in debt, Glisan replied: "We believe so."

These possible liabilities weren't immediate headaches. But they loomed down the road and added to the uncertainty building around Enron. Eavis also reported that Enron was currently working on setting up yet another trust and selling over $225 million in notes for that one. "Could Enron be setting up new trusts to pay off damaged old trusts?" the on-line columnist wrote.

Smith and Emshwiller also touched on the Marlin trust in that night's story, though much more briefly and from a slightly different angle. The short seller whom Smith liked had sent her copies of the fat Marlin and Osprey prospectuses, and she'd spent several hours one evening reading through them. While Marlin wasn't due to unwind until 2003, it contained a provision that allowed note holders to demand repayment immediately on the $900 million in debt if two things happened. A so-called double trigger provision accelerated debt repayment if Enron's stock price fell below $34.13 for three trading days and if the company's credit rating was dropped below investment-grade by either Moody's or Standard & Poor's. Enron had already blown past the stock price trigger. So now only its investment-grade status protected the company from facing hundreds of millions of dollars in pressing new liabilities.

In that story, the reporters finally were able to include another anec-
dote that their "mutual friend" had given in that first interview. It con-
cerned Jeff McMahon going to Skilling in 2000 to complain about LJM
and a short time later being moved out of the treasurer's job and being
replaced by Glisan, the Fastow lieutenant. Smith and Emshwiller had
been trying to confirm this anecdote for weeks with no luck. McMahon
and Skilling wouldn't talk to them. But in his round of calls for the SEC
story, Emshwiller reached an Enron official who in the past had refused
to talk about the alleged incident, even on a not-for-attribution basis.
He was of a different mind that day.

The two were chatting about the SEC inquiry when Emshwiller again
brought up the supposed meeting between Skilling and McMahon.

"I don't think you would be wrong if you put that in the paper," the
Enron official responded.

"So you're saying that the meeting did happen, that McMahon did
complain, and that as a result he got moved to a new job," the reporter
said, not quite believing what he'd heard.

"As I said, I don't think you would be wrong putting that in the pa-
per," the source replied.

Emshwiller was tempted to ask the person, who was certainly in a po-
sition to know about the incident, why he was suddenly offering confir-
mation on a matter he had previously refused to touch. What's going on
inside of Enron? he wondered. It almost looked as if some people were
trying to undermine Fastow's position at the company. McMahon had
been viewed by some as a rival to Fastow to fill the chief financial
officer's job back in 1998. At the very least, publicizing the incident
would be embarrassing to the current holder of that title.

Other people were making Enron-related announcements that day.
Three more law firms issued press releases saying that they had filed suits
on behalf of Enron shareholders against top company officers, including
Lay, Skilling, and Fastow. Enron's list of antagonists and investigators
was growing at an impressive rate.

Not to be outdone on the announcement front, Enron issued one
more of its own at the end of the day. The company would hold a con-
ference call for analysts and investors the next morning, October 23, at

9:30. As usual, reporters could connect in on a listen-only status. Enron kept its explanation for the conference call short and to the obvious: "to address investor concerns."

Enron had successfully used such conference calls in the past to calm market jitters when rumors of one or another problem had started to circulate. In 1995, Enron shares dropped 8 percent in one day on rumors of big trading losses at the company. Enron quickly called a conference call to deny rumors and to announce a buyback of some of its stock. In the conference call, Skilling mockingly said that the last time Enron had been targeted for Wall Street whispers, "the rumors said I got in a fistfight . . . on the trading floor." Within days, Enron's stock regained the ground it had lost.

So Enron officials had some reason to hope that one more conference call, one more sparkling performance, could once again help right the ship. To be sure, Enron wouldn't have Skilling, their longtime dazzler in chief, for this one. But didn't Ken Lay just tell the world what a deep management team he had?

But ready or not, Team Enron clearly had to do something. Besides the stock price, which had plunged 40 percent in a week, the number of stories about Enron and its woes were multiplying daily. On that Tuesday in October, prompted by the announcement concerning the federal inquiry, dozens of stories appeared in newspapers and wire services around the country, along with some in Canada and England. The biggest and most influential media outlets were getting interested. Floyd Norris of *The New York Times*, one the nation's best business columnists, wrote a critical piece under the headline WHERE DID THE VALUE GO AT ENRON? *The Washington Post*, the *Los Angeles Times*, and *The Times* of London had stories. Even *USA Today* weighed in—albeit with a single paragraph at the top of its "Moneyline" column.

Enron certainly didn't want its woes, which suddenly sprang up in the third week of October, to become a long-term source of interest to reporters. The last thing the company needed was a pack of journalists picking at the LJM scab. If Enron could calm investor fears and stabilize the stock price, press interest would be more likely to fade. Company executives realized a lot was riding on the success of this October 23 conference call.

And they took some care preparing for it. Lay and other top Enron officials conferred with company lawyers to map out what they'd say at the conference call. One of those was Ronald Astin, a partner with Enron's principal outside law firm, Houston-based Vinson & Elkins, one of the nation's biggest law firms with roots that went deep in the history of Texas and the oil and gas industry. By the late 1990s, Enron was the firm's largest client, producing more than $25 million a year in billings, or about 7 percent of the firm's revenues.

According to various accounts of that meeting, all agreed that everyone should emphasize that Enron, despite the recent upsets, was fundamentally strong and on course. But what to say about LJM? Everyone knew this topic would be at the top of the listeners' list of questions. Vinson & Elkins's Astin later recalled that the group went over a list of possible questions that would come up—and answers to give—including a section on LJM.

Astin later claimed that his effort to modify that memo produced a flare-up with Fastow. The attorney tried to insert a section saying that Fastow had brought the LJM idea to the board of directors. Not true, Fastow shouted at him. Skilling had asked him to create LJM. Astin also recalled telling Lay and the others that they should disclose all they could about the related-party transactions. But he cautioned against discussing the SEC inquiry.

While that advice might have been clear to the lawyer, it could well have been confusing to his listeners. How exactly do you talk about transactions that are the focus of the federal inquiry without talking about the inquiry? It would soon become apparent that nobody who took part in the conference call had a good answer for that question. The normally surefooted Enron investor relations machine was beginning to stumble. Even the announcement of the SEC inquiry, while laudable from a disclosure point of view, meant another day's worth of negative headlines about the company. From a damage control point of view, Enron might have been better off announcing the SEC probe in the prior week, when it was already suffering from a raft of negative stories. But events were starting to move faster than the company's ability to keep pace. One Enron insider later told Emshwiller, "We were like the deer in the headlights."

"There Is an Appearance That You Are Hiding Something."

MUCH OF ENRON'S TOP BRASS ASSEMBLED IN A MEETING ROOM NEAR Lay's fiftieth-floor office on the morning of October 23 for the conference call. Lay, of course, led the team, supported by Greg Whalley, the new president; Causey, Enron's chief accounting officer; and investor relations chief Mark Koenig. Glisan, treasurer and accounting whiz, was there to answer more technical questions—though it couldn't have boosted his self-confidence when Lay introduced him as Ben "Gleason." His last name was actually pronounced like "listen." Appropriately enough, even Andy Fastow made a rare public appearance. He was, in a sense, the guest of honor and a key reason for the gathering. On the other end of the line were several hundred analysts, institutional investors, and journalists, including Smith and Emshwiller.

"To say the least, we are very, even extremely, disappointed with our stock price," Lay began, "particularly since our businesses are performing very well and we are continuing to conduct business as usual. We recognize, however, that these are uncertain times in the capital markets."

Lay then dipped his toe into LJM waters. "There has been a lot of recent attention to transactions Enron previously entered into with LJM," the chairman acknowledged, but he added that the company had "clearly heard investor concerns." Fastow had quit the partnerships, and Enron had terminated financial arrangements with them. Lay ran back

over the $1.2 billion equity reduction, though he said the matter in-volved sixty-two million Enron shares, seven million more than com-pany officials had previously said. He didn't explain the reason for the change.

Lay called upon Fastow to discuss Enron's "liquidity position and credit rating." But first, Lay said, "I might add that I and Enron's board of directors continue to have the highest faith and confidence in Andy and believe he is doing an outstanding job as CFO." He later added, "We're very concerned with the way Andy's character has been loosely thrown about over the last few days in certain articles."

After thanking Lay for that vote of confidence, Fastow talked about Enron's $3.35 billion in available bank credit lines. He talked about on-going plans to sell Enron's Portland General Electric utility unit for $1.9 billion. He reminded listeners that Enron still had a solid investment-grade credit rating. He never mentioned LJM.

During the question-and-answer session, Richard Grubman, a short seller and the pesky critic whom Skilling called an "asshole," got on the line. He asked about Marlin Water Trust II, noting that it had about $1 billion of outstanding debt but appeared to have only about $100 mil-lion in assets, in the form of stock in Enron's troubled Azurix water company. That would leave Enron on the hook to Marlin debt holders to the tune of about $900 million. "Have you taken any reserves against that liability?" Grubman asked pointedly.

Grubman and Causey went back and forth on the matter several times with no clear answer emerging. Finally, Lay cut off Grubman in an uncharacteristically curt manner. "Now, I know you want to drive the stock price down, and you have done a good job of doing that, but I think . . . let's move on to the next question."

However, the next questioner began by saying, "I certainly don't want to beat a dead horse," and then proceeded to ask more about Enron's potential liabilities from Marlin and other such entities.

Lay noted that the only way Enron could immediately be on the hook to the note holders of those entities would be if the company's credit rating fell below investment-grade. "We'd have to be downgraded three notches to go below investment-grade, and there's—at least we don't think there is any chance of that. Andy you wanta . . ."

"I think that says it all," chimed in the chief financial officer.

Glisan explained that Enron had invested in a lot of new areas in 1997 and 1998. The resulting "balance sheet expansion" had presented the company with a choice, he said. Either it had to permanently expand its balance sheet or it had to use other structures, such as Marlin, to hold its obligations. Now Enron was in the process of selling unneeded assets to cut debt. Glisan, like his colleagues, tried to make it sound as if this whole process were just the normal course of business.

But even longtime Enron fans were starting to have doubts. David Fleischer came on the line. The Goldman analyst offered not so much a question as a plea. "With all due respect," Fleischer said, a note of urgency in his voice, "you know what you are hearing from some of these people and many others that you haven't heard from on this call is that the company's credibility is being severely questioned and there really is a need for much more disclosure, and I, you know, appreciate where it is real difficult for you to get into a lot of details on one specific issue with one questioner, but that is exactly what I think needs to happen over maybe a series of conference calls. There is an appearance that you are hiding something." He urged Lay to have daily conference calls and bring in Andersen auditors to help answer questions. In a stunning admission for a man who had so enthusiastically recommended Enron stock for so long, Fleischer said that "the disclosure there in the footnotes is not complete enough for me to understand and explain all the intricacies of those transactions. . . . I think you are now in a position where you really need to give us a lot more information."

Emshwiller was struck by the plaintive, almost begging tone in Fleischer's voice.

Unfortunately, Lay responded, "there are limitations on what we can or should talk about with LJM in particular or related-party transactions in general" because of the SEC probe and the private lawsuits. "We're not hiding anything. Probably we scrubbed and rescrubbed things more the last couple of months than we have in a long, long time, if ever."

At the end of the conference call, John Olson, grizzled and never really dazzled by the Enron magic, made one last try to get more information about LJM. "I think it would be important, in terms of credibility, to restore a little bit, if you would be so kind as to have Andy Fastow de-

scribe the role he played as general partner in LJM1 and LJM2 and how closely monitored he was and how, what kind of review was imposed on the general partner."

With the SEC inquiry, "I would prefer that Andy not get into too much detail on, as far as LJM," Lay said. "And let me say there was a Chinese wall between LJM and Enron . . . the board put in place and the company adhered to some very strict procedures."

"*The Wall Street Journal* makes a circumstantial case" of wrongdoing, said Olson. "It might be helpful if you would be able to put out something just answering them on a point-by-point issue."

But there would be no further information on LJM that day. Listeners would later point to this conference call, particularly the Lay-Grubman exchange, as a pivotal moment for Enron, perhaps the company's last real chance to regain its once regal footing in the investment community. Many had come to the call hoping, some desperately so, that Enron could convince them that all was well. Many analysts and investors had big chunks of money—and in some cases their careers—riding on the success of Enron. Instead of tangible, reassuring information, they had gotten essentially a "no comment" on LJM and other matters. All in all, analysts said afterward, the conference call increased unease that Enron was hiding unpleasant financial facts.

Palmer would later succinctly sum up the call: "a disaster." One very intent listener to that call was Skilling, a person familiar with the proceedings told Emshwiller. After the former Enron president listened to his longtime colleagues' dismal performance and thought about what it meant for his beloved company, he wept.

Some would also later wonder whether the conference call might have gone differently if Skilling had still been at the company. His energy, his grasp of details, and his seeming certitude about the future had done much to create the Enron mystique. Perhaps his talents could have one more time calmed the waters. Or perhaps his combative, emotional nature in front of a suddenly more skeptical audience would have only made matters worse—though in retrospect it was difficult to imagine how things could have gone worse for Enron than they did. During those increasingly crazy days of late October, Skilling called Lay and offered to return at no pay to help the company through the crisis. Skill-

ing wanted to immediately lead an Enron team to New York to negotiate some $3 billion in new borrowings from the company's banks. That money, he believed, was necessary to show the increasingly jittery markets that Enron's vast operation had enough short-term cash to weather the crisis. He feared that if market worries became too great, Enron could reach a point of no return. Skilling was ready "to rev up the [Enron] jet" and fly to New York, one person close to those discussions said. However, Lay and the board ultimately turned down Skilling's offer. They worried that his sudden return to the company might raise even more questions than had been raised by his sudden departure two months earlier.

For years, almost everyone listening on that phone call had been ignorant to one degree or another about the inner workings of Enron. Company officials had used that lack of knowledge, played it like a musical instrument, and produced a tune that made them fabulous amounts of money. As long as things went well, as long as Enron reported those quarters of spectacular growth and painted those pictures of an even grander future, almost everyone seemed satisfied that ignorance really could be bliss. Finally, though, bland reassurances and promises of great things to come were no longer enough. Faith was being replaced by doubt. And doubt could be deadly for a company that lived off credit.

Enron seemed quickly to realize its error in handling Grubman's question. As with its handling of the equity hit, Enron's failure to appear forthright was even more damaging than the information itself. Later that afternoon, they made Glisan available for an interview with Smith. He said that Enron's exposure to several off-balance-sheet entities could hit $1 billion—seemingly the very information Grubman was seeking. Unfortunately for Enron, its candor with the *Journal* didn't undo the damage of the morning. In response to written questions from Smith in July 2003, Lay agreed that the conference call had not gone well. Bruce Collins, his attorney, said that "Knowing what he knows now, it could have been handled differently. Unfortunately, the information that would have made a difference to Mr. Lay's approach was unknown to him at the time of the call." Collins didn't specify what information that was.

The reviews of Enron's performance started rolling in quickly and negatively, even from longtime fans. "Management had an opportunity to set the record straight," JP Morgan analyst Anatol Feygin told CNBC. "I think that was a big opportunity missed. And until management comes out and reassures the credit markets, primarily, and then the equities markets, there is risk to the fundamental business, which I still consider to be the premier energy marketing and trading franchise."

The more analysts looked at Enron's numbers in the fading light of late October, the less they liked what they saw. The company's overseas assets, such as power plants and pipelines, were carried on Enron's books at a value of $6 billion. Yet in the first nine months of 2001 they had produced only $12 million in earnings, a minuscule 0.2 percent return—and that was before taxes and interest expenses were subtracted.

Prudential's Carol Coale let fly the rarest of Wall Street birds, a "sell" recommendation, on Enron stock. The rise of investment banking had contributed to the decline in the frequency of sell recommendations. Investment bankers hated it when analysts at their brokerage firms put out a sell recommendation on a stock. The reaction was understandable from their perspective, since few if any companies were going to throw underwriting business to a firm that was telling clients to dump the company's stock. Coale had more freedom on this front because Prudential had sold off its investment-banking business. At brokerage firms where "sell" had been stricken from the vocabulary, analysts had evolved a tortured vocabulary of happy talk, where the average investor needed a code book to decipher a stock recommendation. For example, "market perform" might sound neutral on its face. But it was really a negative recommendation because the analyst was saying that the stock would do no better than the general market—which really meant "So why not put your money into one of our great picks that will outperform the market?" At some firms, "hold" became the most discouraging word that could be uttered about a stock.

(The absurdity of the language of Wall Street analysis was later captured by the humorist Dave Barry. The stock, Barry wrote in one of his columns, had been "rated as 'Can't Miss' until it became clear that the company was in desperate trouble, at which point analysts lowered the rating to 'Sure Thing.'" Only when the company went under, Barry

added, "did a few bold analysts demote its stock to the lowest possible Wall Street analyst rating, 'Hot Buy.' ")

Coale told Emshwiller that her sell recommendation was the final chapter of a long-running drama of ups and downs with Enron. In 1994, she'd dropped her rating on the company to a "hold" from a "buy" and held it there for three years. In 1997, she raised it back to a "buy" and later raised it for a time to a "strong buy." Even after the third-quarter earnings report, Coale was recommending the stock to Prudential clients.

Coale, who worked out of Houston, had been following Enron since the early 1990s. Over the years, she'd tried to develop relationships with top energy industry executives, particularly Skilling. When he took part in a local eight-kilometer "fun run" for charity, so did Coale. She knew she couldn't keep up with Skilling's running pace, but at least he noticed she was there.

Despite rough patches, Coale always felt more comfortable with Skilling than with Lay. She felt that the Enron president was more candid about the company's challenges. With Lay, everything was always depicted as going great.

Skilling had helped talk her out of downgrading the company in August after his resignation. On August 15, the day after the resignation announcement, she had private meetings at Enron headquarters with both Lay and Skilling. The lunch meeting with Lay had been scheduled, but the half-hour get-together with Skilling was impromptu—and effective. Though Coale had been skeptical about Skilling's reasons for quitting, he convinced her that they were personal. Coale shelved her plan to drop her "buy" rating on Enron.

But by the time Emshwiller talked to Coale in late October, she felt angry and abused. She said that Lay and others had given her "false answers" on at least two occasions in recent months. At that August 15 lunch, Lay had assured her that the company wasn't planning big writeoffs during the third quarter. Yet Enron ended up taking that $1.01 billion charge. More recently, she'd asked whether the company was under SEC investigation and been told no. Now she felt that Enron had used the difference between a formal agency investigation and an informal

inquiry to avoid straight talk. "When it comes down to semantics be-
tween an investigation and an inquiry, we start getting to details that
compromise management's credibility," Coale said angrily. "It sounds al-
most Clintonesque."

Emshwiller couldn't nail down exactly when Coale asked Enron
about the SEC probe. Possibly the SEC hadn't yet contacted Enron.
However, the reporter also knew—and would learn again by hard expe-
rience in the days ahead—that Enron's management was extremely pro-
ficient at parsing the difference between words such as "investigation"
and "inquiry."

(Emshwiller would later learn of an incident that echoed Coale's
concern. During a meeting between Enron and S&P officials, the com-
pany was asked if it had hired bankruptcy counsel. No, a company offi-
cial had replied in an unequivocal tone. S&P later learned that Enron
already had met with a bankruptcy firm and hired it soon after. So the
credit agency received a technically correct answer to its question. It
was just fundamentally misleading. "Enron does that a lot," S&P's
Barone told Emshwiller. "In retrospect, Enron found ways to lie.")

Not long after speaking with the analyst, Emshwiller received a call
that in the coming weeks he would have reason to think back on more
than once. The caller would identify himself only as "Ray." He wouldn't
leave a return phone number or any way to contact him. "I know a lot
about Enron," he said.

"Do you work there?" Emshwiller asked.

"Let's just say I know a lot about it," Ray replied. The guy talked in a
low voice, an almost conspiratorial whisper, cut with a touch of smugness.

"Okay, so what do you know?" Emshwiller realized he probably
sounded a little too flip. But there was something mildly grating in the
guy's manner.

If Ray was offended, he didn't show it. "I've been reading your sto-
ries," he said. "LJM wasn't set up to make Fastow rich."

"Why was it set up?"

"To meet its quarterly profit targets, Enron had to have LJM," Ray
said. "LJM helped to create entities that had small amounts of equity
and high amounts of debt. These entities would purchase Enron assets."

The assets would be sold at prices and under terms that would produce large profits for Enron. "They created an accounting game that couldn't be done with truly independent third parties. Enron wanted to book the accounting gains but not lose control of the assets."

Like the reporters' original source, Ray suggested that Fastow had pressured Enron's banks into investing in the LJM partnerships. "He presented investing in LJM as part of doing business with Enron," Ray said.

Enron stock was the key to making the asset deals work, he continued. "Enron put a huge amount of stock into these entities, and the entities would give Enron back a note for it. That way, any losses would get charged against Enron's equity and not its income. There was a huge amount of equity sitting there."

Emshwiller was starting to get lost. He assumed that the guy was talking about the $1.2 billion equity reduction Enron had just taken. Precisely how, he asked, had the stock and the notes somehow helped Enron's earnings?

"The whole goal was to get around accounting rules and declare a profit. Under Skilling, an orthodoxy of mark-to-market accounting grew up. And there was no downside as long as the stock price was going up," Ray replied, not quite answering the question.

Emshwiller asked the same question a few more times in a couple of different ways but didn't get any better explanation. He glanced at his watch, torn about how much more time to take with Ray. He knew he had more calls to make for the story that night. Ray sounded like either a current or former Enron official, and perhaps a relatively high-ranking one. While Ray obviously had some strong opinions, it wasn't clear how solid his information—or reasoning—was. The ideal thing, the reporter decided, would be to talk to him at length later in the day or evening, after deadlines. Emshwiller suggested that option.

"Maybe. I've got to get off anyway," Ray said. He once again declined to give his name or phone number. "Maybe I'll call you back."

"What kind of financial shape do you think Enron's in?" Emshwiller said quickly, deciding that he should take at least a little more time in case this was their only conversation.

"There is a cash crunch," Ray said without hesitation. "Look very

carefully at the cash flow. I believe LJM borrowed $2 billion to $3 billion. In the past, the company would have plenty of cash by the end of each year. But in 2000, a transaction to sell international assets for $7 billion to $8 billion was almost done but wasn't done. Since then, the perceived values for those assets have gone down." The cash worries are so bad that "there is a gallows humor about it in the halls of Enron."

So perhaps Ray still does work there, Emshwiller thought. He recalled that Lay in the August interview with him and Smith had talked about selling several billion dollars of foreign assets over the next few years. But he was pretty sure the chairman hadn't mentioned anything about a single megadeal. I'll have to ask Becky about that, Emshwiller told himself.

"I've got to go," Ray said, suddenly sounding impatient.

"I really would like to talk with you some more," Emshwiller said. "Would you be available later today or tomorrow?"

"Not sure. Maybe I'll call you." With that Ray said an abrupt good-bye and hung up. He never called back. (Emshwiller and Smith would later learn that there had been an effort, called Project Summer, to sell most of Enron's overseas assets in 2000 to a group of wealthy Middle Eastern investors for about $7 billion. It fell through at the last minute, partly because a leading member of the investment group became ill. Several Enron insiders argued that the billions of dollars of cash from Project Summer would have completely changed the company's financial picture and could have averted the calamity of late 2001.) Lay's answering of questions on the conference call alarmed some senior executives. As stories kept breaking, day by day, they realized that the *Journal* appeared to have better information on LJM than Enron executives. One senior official called Fastow at home one night and told him he had to be more forthcoming; that the company was getting killed. "We need to have at least as much information as the *Journal*, if we're going to deal with this," he told Fastow and asked for documents. But the executive said Fastow replied: "I don't have it," adding that he'd left all his material on LJM behind, when he resigned from the partnerships in July.

Lay's October 23 verbal calisthenics didn't end with the conference call. That same day, he headed over to the ballroom of the Hyatt Re-

gency hotel about a block away from Enron headquarters. Enron had scheduled an all-employees meeting to discuss the burgeoning crisis.

When Lay grasped the podium, he gazed out over hundreds of faces. While many still believed in him and liked him, this wasn't going to be just another Enron pep rally. Nowhere was the unhappiness voiced more loudly than from Enron's trading floor cadres. That was partly due to the self-image of the traders as the elite, the ones who made Enron's money. Partly it was just the nature of traders to be loudmouthed, cocksure, and in-your-face. Things had gotten particularly tense in recent days. "All these things were coming out, but management wasn't coming out and saying anything. There was no internal communications," Jim Schwieger, a veteran Enron trader, told Emshwiller. "On the trading floor we were yelling at [Greg] Whalley and [John] Lavorato [another Enron executive]. We were yelling that we made this company and you're not telling us anything. People were getting mouthy."

Schwieger and some of the other traders looked at the October 23 meeting as a chance to ask some questions and get some answers. He volunteered to collect the questions and ask them at the meeting. Schwieger stood out in the trading operation. At forty-eight, he was a good deal older than most of the peach fuzz crowd around him. He'd been working for Enron or its predecessor companies since 1978. He got his first taste of Lay at an all-employees meeting back then. Sixteen years later, he found himself heading to another employees meeting, and this time he didn't intend just to listen. He had volunteered for the assignment partly because he didn't have anything to lose. Schwieger had planned to retire in early 2001 and, as a result, had sold his Enron stock. He then decided to stay on for another year or so because the trading was booming and Enron needed experienced hands. As he walked into the Hyatt Regency, though, Schwieger knew that even if he completely alienated Lay and got fired, it wouldn't at this point make a big dent in his lifestyle.

Lay opened the meeting by talking about September 11 and tying it to Enron. "Just like America is under attack by terrorism, I think we're under attack, and we're going to talk about that today," he told the crowd, which packed the hotel ballroom. The chairman assured them

that "the underlying fundamentals of our businesses are very strong—indeed, the strongest they have ever been. But, regrettably, that's not what Wall Street is focusing on, and I doubt that's what you are focusing on. And let me say right up front, I am absolutely heartbroken about what has happened." However, he reminded them that Enron had long been the nation's preeminent energy-trading company. While its reputation was "a little tarnished right now," Lay added, "we will return to that preeminence and we'll take that tarnish away with a little time."

In the front rows were other top Enron executives, including Fastow. "And despite what you have read in *The Wall Street Journal* and probably elsewhere," Lay said, "I and the board are also sure that Andy has operated in the most ethical and appropriate manner possible." The chairman called Fastow up and put his arm around the chief financial officer as he said this. But then, in a comment that might have made Fastow's well-tailored suit feel a little tighter, Lay added, "But I will say here today in Andy's presence that if anything comes up indicating to the contrary, then a totally different decision would be made, just like it would for anybody else in a senior management job."

Lay turned his attention to trying to pep up the troops. "Now, it's okay to be mad, it's okay to be frustrated, it's okay to kind of feel the world is not fair," he said. "But now is our testing time. These are tough times. Will we measure up to the challenge or will we not? True character is born in times of crisis."

While Lay drew applause during and after his speech, not everyone in the crowd was won over—as became clear when the chairman began to read out written questions from the audience.

"I would like to know if you are on crack," read one note card. "If so, it would explain a lot. If not, you may want to start because it's going to be a long time before we trust you again."

When the laughter had subsided, Lay responded, to more chuckles, that "I think that's probably not a very happy employee, and it's understandable. I'm sure a lot of you have some hatred. No, I'm not on crack. It might have been easier to take the last few days if I was."

Not all the questions were so pointed. One asked about the status of the employee-parking subsidy. Lay said he would have to get back on

that one. "Any truth to the rumor that the Christmas party will be a companywide event at Enron Field?" Indeed it would, replied the chairman.

Schwieger had sent forward a sheet with more than a dozen questions, ranging from requests for details about LJM to why Arthur Andersen and the current board of directors hadn't been replaced for failing to protect shareholders. When Lay got to Schwieger's list of questions, he glanced over it and put it aside.

Later, when Lay opened up the floor to questions from the audience, Schwieger walked to one of the microphones to wait his turn. When Lay called on him, the trader made what he later viewed as a tactical error. He asked a compound question concerning Enron's third-quarter loss and what risks, if any, the LJM partnerships faced in their dealings with Enron. He felt Lay was only partially answering the questions, avoiding the part about LJM.

When Lay turned his attention to other questioners, Schwieger began waving his hands wildly to get the chief executive's attention. When that failed, he shouted out, "Ken, are you going to answer my question?"

Lay didn't respond to Schwieger's shouts. Instead he made one last effort to rouse the troops. "This is a time that will build some character, and tough times always build character. But we will come through it, and we will be even a greater company on the other side."

Schwieger walked out of the ballroom and through the Hyatt's huge atrium lobby area, with the walkways to the rooms rising in layers above him. After his public hectoring of Lay, Schwieger felt as if there were a three- or four-foot empty space around him. A friend passing by joked about how the sniper in the upper regions of the Hyatt needed a clear field of fire.

Then a woman he didn't recognize walked up to him. She shook his hand and congratulated him for speaking up. In her hand was her business card. On it was the name Sherron Watkins—the supposed insider unhappy about LJM whom Smith had tried unsuccessfully to reach. Call me, I can tell you things, Watkins told the trader. The two briefly talked, but nothing came of it.

Schwieger's performance at the all-employees meeting brought him

another visitor that day. He was back on the trading floor, standing by a fax machine, when Fastow, still in his well-tailored suit, walked up to offer a handshake and congratulations. He hadn't enjoyed Schwieger's questions, he said, but they needed to be asked.

Fastow's arrival shocked the trader, and he said so. Still, he had to admire the chief financial officer's guts, coming to the trading floor, of all places, given what was happening. Maybe, Schwieger thought, Fastow isn't such a bad guy. Maybe the LJM deals weren't as dirty as they looked. Schwieger noticed that everyone within earshot had pretty much stopped what they were doing to eavesdrop on the conversation.

Fastow offered to explain the partnerships to Schwieger. Call my secretary tomorrow morning, Fastow said. We'll sit down and hash this out.

Fine, said Schwieger.

As it turned out, Fastow wouldn't be able to make good on that offer.

17

"I Must Have Heard the Term *Death Spiral* a Dozen Times Today."

THE NEXT DAY, WEDNESDAY, OCTOBER 24, WAS ANOTHER GUT wrencher for Enron shareholders. By the 4:00 P.M. close of trading on the New York Stock Exchange, the stock had fallen to $16.41 a share, a plunge of 17 percent from the day earlier. In the eight days since Enron's earnings announcement, its stock price had lost half its value. Perhaps even more ominous, Enron's volume that Wednesday hit nearly seventy-six million shares, about fifteen times normal and more than twice the volume of the next most actively traded stock on the Big Board. Several of the trades involved single blocks of eight hundred thousand shares or more. These were signs that big pension and mutual funds, the core investors of most giant corporations, were heading for the exits. So much for the confidence-restoring conference call of the previous day.

As the pressure built, pillars of Enron's business began snapping one by one. Only fifteen minutes after the close of trading, with investors still trying to catch their breath over the plummeting stock, the company served up another unsettling announcement. Jeff McMahon, the former corporate treasurer and LJM critic, was leaving his job as chief executive of Enron's industrial markets group for a new post at the company. "Jeff has unparalleled qualifications and a deep and thorough understanding of Enron," said Lay in the press release. Such qualities would come in handy in McMahon's new job as Enron's chief financial officer.

Enron disposed of that job's previous occupant in the release's third

paragraph. "Andrew Fastow, previously Enron's CFO, will be on a leave of absence from the company. 'In my continued discussions with the financial community, it became clear to me that restoring investor confidence would require us to replace Andy as CFO,' Lay said."

"What's going on here?" Emshwiller said to Smith in another of their long string of phone calls. "Lay just gave the guy a 100 percent vote of confidence." He paused and then added: "Looks like you were right and I was wrong."

Smith had been predicting for several days that it would only be a short time before Enron dumped Fastow. "He's become an enormous liability," she said at one point. "And if he did all the things we think he did, he deserves to be fired."

"Yeah, but that's why they can't afford to fire him," Emshwiller replied. "If they let him go, it's like admitting wrongdoing."

While the announcement of Fastow's departure didn't surprise Smith, Enron's ham-handed handling of it certainly did. "These guys are getting to be like the Keystone Kops," she said.

Still, both of them wondered what had happened in the prior twenty-four hours to reverse Lay's position regarding Fastow. Emshwiller thought back on how Lay had been digging a hole for himself on LJM and Fastow way back in August. "Remember Lay telling us back in August that Enron was completely aware of everything Fastow was doing at LJM and completely supported it?" he said.

"Sure. He even said that Enron had asked Fastow to take on the partnerships," said Smith.

As he chatted with his colleague four hundred miles away, Emshwiller reread the press release, still trying to absorb the latest turn of events. "What do you think Lay means when he says 'continued discussions with the financial community'?"

"Could be the banks or Wall Street or the ratings agencies or big investors or maybe all of them," said Smith. As the days went on, she was putting less and less trust in anything the company said. Perhaps Lay discovered some new revelation of wrongdoing by Fastow in the last twenty-four hours. More likely, Enron realized that its conference call had been a failure and something more needed to be done to try to arrest the stock's free fall. "Yesterday's performance was so awful that Lay

probably got lots of calls," she added with a touch of impatience. It was already 4:30 P.M. in New York, and the first deadline was half an hour away. "We'd better start making some calls," she said. "The desk will be screaming for copy soon." (Lay's attorney, Bruce Collins, later told the reporters that early that morning of the 24th Fastow approached Lay and related a conversation he had had with Glisan, the treasurer: Glisan said that Enron's lead banks had told him that "they would have difficulty lending any new financing as long as Mr. Fastow was still CFO." With that information, Lay determined he needed to call a board meeting "to discuss Mr. Fastow's continued stay with the company.")

Though Emshwiller didn't mention it, he hoped that their stories had a role in Fastow's departure. It was one of those perversities of journalism that reporters sometimes took satisfaction from the woes of people they hardly knew and, in the case of Fastow, had never even met. In that sense, Fastow's refusal to be interviewed probably worked against him. In Emshwiller's opinion, it was usually harder to write critical things about someone if you'd met and found the person at all likable. Smith didn't share this view—in fact, it made her somewhat uncomfortable. She always figured it was her job to do the stories and it was somebody else's job to react. Another person's disgrace was sobering, not satisfying, as in the sense of, "there, but for the grace of God, go I." But Emshwiller had spent so many years ferreting out frauds that he felt as though his job had been only half done if prosecutions didn't follow.

Nobody that Smith and Emshwiller talked with that day shed any further light on the reasons for Fastow's departure and Lay's sudden change of heart. A fuller story on that wouldn't come out for weeks, and when it did it would raise serious questions about Lay's honesty and the conduct of Enron's board.

(After Enron's fall, Senate investigators would find out that the *Journal's* story of October 19, putting Fastow's LJM compensation at over $7 million, had been a catalyst for the CFO's departure. LeMaistre told a Senate hearing that he and his fellow directors were upset by the $7 million figure, which was far more than they thought Fastow was making from a partnership venture that the CFO had told the board was taking only about three hours a week of his time. The *Journal* story "was

the first time that any of us knew that there was something wrong going on," LeMaistre testified. When the October 19 story ran, the board quickly designated LeMaistre and fellow director John Duncan to ask Fastow about his LJM compensation—more than two years after directors had approved the setup. The two directors talked with Fastow on October 23, the day of the ill-fated analyst conference call. There, Fastow said that his LJM take had actually been about $45 million—a number so monstrously large that LeMaistre scribbled down a single word when he heard it: "Incredible." The next day, the board agreed that Fastow had to go.

When Emshwiller read LeMaistre's Senate testimony, he thought back to that early October interview where the director had talked about LJM being a way to compensate Fastow. What, the reporter wondered, were those directors thinking? It certainly wouldn't have taken a lot of investigation to figure out that Fastow's LJM take could easily run into the millions annually. The standard management fee in a big private partnership was around 2 percent of the amount invested. With nearly $400 million in just LJM2, one didn't need an abacus to reach $8 million. Could the board really have been that lax? Or were Lay and his fellow directors undergoing some postfacto conversion where "heard no evil," "saw no evil," and "knew no evil" had become the new mantra?)

Fastow's ousting naturally led the *Journal* story that ran on October 25. But in some ways it was already getting pushed into the background by the quickening rush of the crisis enveloping the company. As the reporters made a rapid series of calls about the Fastow announcement, they found people less concerned about the demise of the chief financial officer than they were about the possible demise of Enron itself.

"I must have heard the term *death spiral* a dozen times today," Goldman Sachs's Fleischer told Emshwiller.

"Do you really think that's possible?" asked the reporter, taken aback. He'd heard the term used only in connection with companies that were going under. Up to that moment, he'd never really thought that Enron, for all its headaches, was in danger of failing. After all, it was one of America's blue-chip corporations.

"If Enron doesn't address the issues, anything is possible," Fleischer replied, sounding worried. Then, as if remembering that he was talking

to a reporter, the analyst hurriedly, in one long breath, added: "But that is highly unlikely. Enron needs to give out information and disclosure on all these partnerships and entities and get investors beyond wondering what's the next piece of information that is going to come up from *The Wall Street Journal*. Now it's a matter of trust and credibility. It's not easy to regain something as basic as trust. But there is no reason they can't if nothing is being hidden here."

"So you still have a 'buy' recommendation?" Emshwiller asked almost automatically, though it suddenly seemed like a strange question to ask of a man who'd just been talking of corporate death spirals.

"I have a 'buy' recommendation," said Fleischer, though he seemed to hesitate for the briefest moment before speaking. "I think it is extraordinarily attractive at the current price."

"Nobody can accuse Fleischer of being a fair weather friend," Emshwiller said to Smith as he recounted the conversation later in the day. "Still can't believe he used Enron and 'death spiral' in the same breath."

"Well, he liked it at 33. Why not like it twice as much—at 16.50 a share," Smith cracked.

In her interviews on October 24, Smith had encountered concerns that spread beyond Enron. The stocks of other big energy companies were beginning to fall as investors worried about possible blowback from Enron's woes. EnronOnline had become one of the principal energy marketplaces. In that marketplace, Enron was either the buyer or seller in about one-fourth of all the nation's electricity and natural gas trades. In less than two years of existence, EnronOnline had handled nearly $1 trillion in transactions. "Enron makes the market. Make no mistake about that," Merrill Lynch analyst Donato Eassey told Smith. "There's not a trader out there that doesn't use EnronOnline." If Enron couldn't pull out of its tailspin, some analysts worried that the company could take down a big chunk of the energy markets.

"They could end up in bankruptcy court," Glatzer told Emshwiller after Fastow's departure.

The reporter laughed into the phone, thinking that Glatzer was indulging in more wishful thinking. Glatzer was still calling the reporter a few times a week. While he still routinely urged Emshwiller to do a story about his Enron complaints, he hadn't been pushing the matter very

hard lately. Mostly he seemed to be calling just to chat about the almost daily bombshells that the company was dropping on itself. Emshwiller found the conversations oddly relaxing, though they took on the quality of a broken record when Glatzer drifted onto the subject of his own dispute with Enron. "Bankruptcy may be a ways off, Bernie," the reporter said, probably sounding more condescending than he meant to. "I think Enron still has a few financial resources."

But Glatzer was persistent. "No, I really think the company could be in trouble. Look at the stock price," he said. "I've told you all along that they are corrupt. The LJM stuff is just another sign of it. Look what they did to me."

After he hung up, Emshwiller shook his head. Even with mutterings about death spirals, the reporter still thought that the idea of Enron collapsing was something close to absurd. He expected that Enron's stock price would soon stop dropping. And when it did, the sense of emergency would begin to fade.

But Emshwiller hadn't yet grasped that a crucial shift was beginning to take place in the world's view of Enron, one that would gain momentum and power with dizzying speed. Until a little more than a week earlier, the company was still universally viewed as one of the titans of American business and one of the great business success stories of recent times. Then, in the blink of a week filled with bad news and public missteps, the public image of Enron became much darker. Suddenly contentment was being replaced by doubt, which was breeding fear that was beginning to carry the odor of panic. Forces beyond Enron were also at work. The eighteen-month bear market for stocks had wounded the wallets and confidence of millions of investors; the events of September 11 had dealt an even heavier blow to investor confidence. People were spooked, and when that happens, bliss and ignorance rarely are a pair. What investors *knew* about Enron hadn't changed all that much in the past week—a couple of smelly partnerships had surfaced, and the company had botched a conference call and the disclosure of an equity reduction. None exactly qualified as earth-shattering events at a company headed toward $200 billion a year in revenues. What was changing was how investors felt about what they *didn't know* concerning Enron. And in the gathering fall of 2001, that attitude shift had people

running for the exits. In some ways, this wave of pessimism had no better basis than the prior burst of exuberance. But unlike that happier state, the new one posed a potentially grave threat to the company's future.

The threat arose on several, interrelated fronts, all having to do with cash. The greatest danger came at Enron's vast trading operation. Like traders throughout history, Enron fed from the troughs of cash and credit, with trust being the crucial governor between the two. The better Enron's reputation for financial strength, the better terms it could extract from its trading partners on transactions. Conversely, the more that turmoil surrounded Enron, the more others worried about its ability to perform on transactions and the more those parties demanded that the company put up additional security for each transaction. Such security in the industry typically took the form of cash collateral or letters of credit. Given the size of Enron's trading operation, which did billions of dollars of transactions a week, any significant drop in trust could quickly bring on demands for millions more in cash—money that Enron didn't have. The trading operation, Enron's main engine, could go into vapor lock. Each new burst of negative headlines ramped up the risk of that happening.

Enron officials insisted that the company's trading operation was still humming along. The company was bragging about how important EnronOnline was to traders. But analysts were worrying that the volume still was impressive, primarily because Enron's many trading partners were closing out positions they had with the Houston firm. What made EnronOnline different from other trading platforms was that Enron was a participant in each trade, either as buyer or seller. Smith heard anecdotally that companies were trying to eliminate Enron as a counterparty and then were going to competing trading platforms, like DynegyDirect or Atlanta-based Intercontinental Exchange, and replicating the positions they'd once had with Enron.

For example, a company might have signed a contract with Enron to buy some quantity of electricity or natural gas from Enron during the following year. Now the company might be afraid Enron wouldn't be around to make good on its contract. So it would reverse its position—reselling the energy supply back to Enron. Then it would go to a com-

peting supplier and buy the fuel originally procured. An outsider would see strong trading volumes on EnronOnline, but it was impossible to know if it was new business or the "unwinding" of old business. While this gave EnronOnline a rosy countenance, Smith felt it was the misleading glow of a consumptive.

Enron trading partners, at least publicly, were supportive of the company. Jim Donnell, chief executive of Duke Energy North America, told Smith that when Enron needed to post money to back its trades, "they post money. We do not see a carryover to what's happening in the equities market." Joe Bob Perkins, head of Reliant Energy's wholesale-trading operation, said that despite the pressure Enron was under, he still believed "their balance sheet is pretty strong." As for Enron's trading operations, he added, "That's where they make their money, and they will do all they can to protect it." Business as usual was clearly the message being broadcast by Enron's trading partners.

Still, Smith had the feeling that the traders were keeping Enron on a sort of life-support system just long enough to harvest the company's vital organs. A precipitous collapse of the energy market's biggest trader would have been bad for everyone. But a more orderly divvying up of Enron's carcass could make all the survivors richer.

Besides the trading woes, several billion dollars of debt hung over the company in those off-balance-sheet entities such as Marlin. Nobody Emshwiller and Smith talked to could say precisely how big a number this was, since nobody was sure about how many such entities were out there and what obligations were contained in each. Of the known debt, none would come due for months or, in some cases, years—as long as Enron maintained its investment-grade credit rating. But if it lost that rating, the debt holders in some of those outside entities could demand payment immediately, and Enron would be responsible for ensuring that they were paid. That scenario could also produce huge new cash demands. So maintaining its investment-grade rating became ever more crucial to Enron.

The credit-rating agencies hadn't yet downgraded Enron's debt from its BBB+, three rungs above junk status. However, by October 25, Standard & Poor's and Fitch had joined Moody's in putting the company on credit watch for a possible downgrade. In its credit watch announce-

ment, Fitch cited "additional concern" that certain "structured transactions" could "unwind" and force Enron to sell stock to make investors whole. Fitch mentioned Osprey and Marlin. Plus, people were wondering what other entities, with additional giant liabilities, might be hiding in Enron's weeds, unnoticed as LJM had been for so long. "To say I'm on the phone daily with Enron would be an understatement," Ralph Pellecchia, a senior director at Fitch, told Smith.

Enron's outstanding bonds were also falling in price. Like many other giant corporations, it had sold billions of dollars of bonds over the years to help fund its expansion. There was a vast trading market for such bonds. However, unlike the stock market, where any person could buy his or her one hundred shares, the bond markets were largely the province of big institutions, buying and selling multimillion-dollar slugs of securities. Bond traders could be a notably sensitive—some would say skittish—lot, and they didn't necessarily wait for guidance from Standard & Poor's or Moody's. While the daily bond trading didn't directly affect Enron's operations or financial obligations, it was another measure of the investment community's evolving view of the company—a view that offered no comfort to Ken Lay and his colleagues.

Enron faced a more immediate problem with its commercial paper. Like a bond, commercial paper is a debt instrument sold by a company to raise money. However, while a company usually doesn't have to repurchase a bond for years or decades, commercial paper is a short-term obligation, with repayment usually due anywhere from 2 to 270 days. The short duration meant that a company had to pay a lower interest rate on commercial paper than on bonds or even bank borrowings. Almost all big companies strove to keep a balance among those three money sources, with commercial paper viewed as an essential component in that mix. But because of the short duration, a corporation such as Enron was redeeming old commercial paper on a daily basis and issuing new securities. In October 2001, Enron had about $1.85 billion in commercial paper outstanding. As the crisis deepened, Enron had a tougher time finding buyers. Those that did buy wanted a higher interest rate. If Enron lost access to the commercial paper market to any significant degree, its cash problems would ratchet upward sharply.

Company officials knew their cash options were limited. Given the deeply depressed state of its stock and bond prices, raising money through issuing more of those securities would be difficult and perhaps impossible. It wasn't exactly a seller's market for anyone trying to peddle paper bearing the word *Enron*. Besides, putting together a stock or bond offering to the public usually took weeks or even months of preparation. Enron's needs were being measured in days.

The readiest source of cash lay in Enron's untapped bank lines, the over $3 billion cache that Fastow had boasted about in the October 23 conference call. Enron officials began to discuss drawing down those lines. They knew they were playing with a very delicate issue. While calling on the bank lines would give the company a cash infusion, it would also confirm all the rumors that Enron needed cash—rumors that Enron had been emphatically denying. Indeed, in that conference call, Enron had mentioned the bank lines in the context that the company was so strong, it didn't even need to use them. The lines were portrayed as simply one more giant safety cushion that should help put to rest any worries about Enron's solvency.

Enron's two principal banks, JPMorgan Chase and Citigroup, were two of the world's biggest financial institutions, which for some two hundred years had been financing the growth of American businesses and America. Citigroup began as City Bank of New York in 1812 with some $800,000 in capital to help finance local merchants. By 1894, it was the nation's biggest bank, and twenty-five years later, it was the first U.S. bank to have $1 billion in assets. By 2001, Citigroup was a global colossus with $1 trillion in assets and huge holdings in banking, insurance, and the stock market through its ownership of the Salomon Smith Barney brokerage firm.

Though a tad smaller, at $694 billion in assets, JPMorgan Chase— which was formed by the merger in 2000 of J. P. Morgan & Co. with Chase Manhattan Corp.—had a storied history. J. Pierpont Morgan was perhaps the most famous and influential financier in American history. Morgan financed much of the industrialization of the nation—from mines and steel mills to railroads and utilities. He helped form such industrial giants as General Electric and U.S. Steel. During the financial panic of 1893, he helped round up $62 million in gold to resupply a de-

pleted U.S. Treasury and helped avert another panic in 1907 by financially propping up banks and corporations.

The Chase end of Morgan Chase had roots going back to 1799 and a company that had been co-founded by Alexander Hamilton and Aaron Burr. The bank helped finance the nation's westward expansion through underwriting such projects as the building of the Erie Canal. By the 1970s, it was one of the biggest and most aggressive lenders in the U.S. oil and gas business and was advancing hundreds of millions of dollars to scores of energy companies. (Indeed, as it would turn out, the financial ties between Enron and the two banking giants were much deeper, more complex, and more suspect than any outsiders realized at the time.)

In those increasingly frantic days of late October 2001, neither Smith nor Emshwiller focused much on trying to unravel the myriad relations between Enron and its big banks. All big American companies had extensive relationships with major banks. Only weeks later would they—along with many other reporters as well as government investigators—begin to explore that Enron financial maze and the dependencies between the company and mainstream financial institutions. For the moment, however, everyone's attention was focused on whether, and how extensively, the company would tap its bank credit lines.

As Enron officials wrestled with the decision on whether—and how much—to borrow, Lay also grappled with what he saw as perhaps a bigger problem than finances: the awful press coverage the company was receiving, especially in the *Journal*. Lay felt that the *Journal* was out to get his company. "They have a hate on for us," he told colleagues more than once, though he never elaborated on what he thought motivated the vendetta.

Others, including Enron's outside directors and bankers, also believed that Enron had an awful PR headache and needed to do something about it. At Enron's request, bankers at Morgan gave the company a list of outside public relations firms. One day, Lay told a subordinate about a conversation he'd had with Morgan's vice chairman James Lee, who supposedly suggested Enron think about hiring Steve Lipin, a highly regarded former *Journal* reporter and editor who'd gone into public relations after years of covering mergers and acquisitions. Enron hired Lipin's firm, the Brunswick Group. Though Lipin was smart and

savvy and proved helpful in dealing with the rising tidal wave of press calls, which was heading toward four hundred a day, Enron's image problems hardly got better.

Lay himself had a personal tie to the *Journal*. At the University of Missouri, he had been a fraternity brother of Barney Calame, who was one of the *Journal*'s deputy managing editors. Among his tasks at the *Journal*, the sixty-two-year-old Calame functioned as sort of an informal conscience and arbiter of taste for the paper. When Emshwiller came to Los Angeles in 1985 as the bureau chief, he'd worked closely with Calame for a time. He found Calame to be one of the most upright people he'd ever met, always concerned with doing the right thing, though he would sometimes chew over matters to the point of distraction. Emshwiller once joked that Calame was the only man he'd ever met who wouldn't take yes for an answer.

Because of his ties to Lay—the two kept in periodic touch—Calame had been very careful not to get involved in the developing coverage of Enron. He never called Smith or Emshwiller or sent them a note with any suggestions for coverage or reaction to stories. Lay did call Calame on several occasions to complain about the paper's coverage. He also had Palmer, another University of Missouri alum and fraternity brother, call Calame. Each time, Calame said that he wasn't involved in the Enron coverage. Any complaints, he added, should be taken to the two reporters and their boss, Friedland. If the Enron executives didn't get satisfaction there, they could take the matter to managing editor Steiger.

Enron's only direct complaint to the reporters came when Palmer called Smith on the morning of October 24, before the Fastow announcement. In Smith's experience, the call was completely out of character for Palmer, whom she still sincerely liked despite her exasperation at the quality of information he'd been relaying. The agitation in Palmer's voice made Smith think that he must have gotten his hide tanned to a pretty shiny patina that morning. "I want to talk about the story line," Palmer said. "You guys were spring-loaded" to put out negative coverage regarding the LJM partnerships and Enron's potential liabilities.

"We've been trying for two months to get you guys to talk about the

partnerships," Smith reminded him. She and Emshwiller believed they were putting out accurate information. If Enron officials disagreed, Smith added, they should start talking. "If we've made a mistake, we'll correct it," she told him.

Palmer also complained about the stories concerning Enron's possible future liabilities. "You're writing about things that may happen in twenty months and discounting what we're saying," he said.

Smith couldn't completely disagree with that statement. But, she pointed out, nobody had forced the company to set up complex and murky entities that left it on the hook potentially for hundreds of millions of dollars or more of liabilities that could suddenly materialize. While the piper might not have to be paid for twenty months, the bill could also come due tomorrow if Enron's credit rating fell to junk status. If that happened, Smith said, it didn't look as if the company had enough money to make good on all of its obligations. Not surprisingly, Palmer and Smith ended the call still disagreeing about how balanced the coverage had been.

On Thursday, October 25, Enron announced plans to draw on its credit lines. Concluding that an inch was as good as a mile, they drew down every last penny of the $3 billion. Of that amount, $1.85 billion would be used to retire all of Enron's outstanding commercial paper—a dramatic sign of how much upheaval the company was experiencing in that sector. The remaining $1 billion plus would bolster Enron's cash pile.

Of course, Enron tried to put the best possible face on the latest turn. "We are making it clear that Enron has the support of its banks and more than adequate liquidity to assure our customers that we can fulfill our commitments," said McMahon in a statement released by the company.

Palmer insisted to Emshwiller that Enron didn't really need all the money. "When the market is reacting as irrationally as it has been the last few days, we thought that cash was better than a commitment from a bank," he said.

News of the bank line drawdown led most Enron stories, including the *Journal's*, that ran on Friday, October 26. In their story, Emshwiller and Smith also finally got a chance to mention that line they'd run

across in Kopper's LJM2 biography, the one about that other entity Chewco. They still knew precious little about Chewco or Kopper. Neither had ever appeared in an Enron-related story anywhere that they could find. The reporters had asked their original source about Chewco. It had been some kind of investment fund connected to Fastow. "I don't know much about Chewco, but I think it would be worth looking into," said the person, who did have one nice little nugget of new information. Supposedly the partnership had, in somebody's idea of whimsy, taken its name from the huge and hairy *Star Wars* character Chewbacca.

As he was writing the Chewco section, Emshwiller called Palmer to ask about the entity. "Never heard of it," Palmer said. (The reporters later learned from company insiders that in response to the *Journal*'s inquiry, Lay started asking Enron colleagues if they had ever heard of Chewco.)

"Well, we have a document that says Chewco had $400 million to purchase assets from Enron and that one of your executives, Michael Kopper, ran Chewco," Emshwiller said. "If that's the case, we'd like to know more about Chewco and why Kopper's involvement hasn't been reported in any of your public filings."

With a line that was getting a lot of use from the PR executive, Palmer said, "I'll see what I can find out." That inquiry about Chewco helped set off a process within Enron that within two weeks would have enormous consequences for the company.

Emshwiller also put a call into the LJM offices, which the reporters' original source told them had moved to an office building across the street from Enron headquarters as a way to distance the partnerships from the company. Up to then, LJM had been operated out of Fastow's finance department. A woman answered the phone at LJM.

"Could I please speak to Mr. Kopper?" the reporter asked.

"Just a moment, please," she said, and put him on hold.

Fortunately, she didn't ask Emshwiller to identify himself. He figured that Kopper would be much less likely to come to the phone knowing that a *Wall Street Journal* reporter was at the other end. As he waited, he heard a recorded message bragging about various awards for excellence that Enron had won. LJM must be hooked into the Enron phone system, Emshwiller thought. Some separation from the company. As he lis-

tened to the message drone on, he recalled somebody telling him that for a time Enron had used Tina Turner singing "Simply the Best" to entertain callers as they waited on hold.

"Michael Kopper here," said a voice on the other end.

Emshwiller snapped back to attention, surprised that Kopper had actually come onto the line. With everything that was breaking around Enron, he thought the guy would be more careful about taking phone calls blind. "Hello, Mr. Kopper, my name is John Emshwiller. I'm a reporter for *The Wall Street Journal* and would like to talk with you about Chewco."

"I have no comment," he replied icily.

"Well, we are going with a story tomorrow mentioning Chewco and would at least like to confirm that you helped run the partnership and try to get a little better idea what it did. As we understand it, Chewco purchased something like $400 million of Enron assets. Is that correct?"

"I told you that I'm not going to comment," he repeated. He was clearly hostile but didn't hang up.

"Sir, we really are just trying to be accurate. I'm sure you realize that's in your interest and Enron's interest as well," said Emshwiller. Like other reporters, he used that line a lot on reluctant interviewees—even when he suspected that accuracy might be the last thing the person on the other end of the line wanted.

"I have nothing to say to you," said Kopper.

"Could you at least tell me what your current position is at LJM? We understand that you took over running the partnerships from Mr. Fastow sometime in the summer and that you resigned from Enron at the same time."

"I have nothing to say to you," he repeated, and finally hung up.

A short time later, Palmer called back with a terse and cryptic comment from the company. "Michael Kopper was never an executive officer of Enron." Beyond that, Palmer said he had nothing to say.

Something about that comment seemed vaguely familiar. Emshwiller looked back through the SEC rule that governed disclosures about a company's outside business dealings with officers and directors. Reading it again, he saw that the requirement applied only to "any director or executive officer." So that's why Enron used that phrasing, Emshwiller

said to himself. The company seemed to be indirectly confirming that Kopper had run Chewco and that because he hadn't been a sufficiently high-ranking official as a managing director, Enron hadn't been under any legal obligation to disclose it.

The reporter also checked a pronouncement concerning related-party disclosures that had been issued by the Financial Accounting Standards Board, the accounting industry standards-setting group. While such "guidance" from FASB didn't have the same force as a federal rule, it was an important indication of what the accounting industry's most influential group considered good reporting practices. The FASB document recommended that a company report any "material" piece of business involving a member of management. Management was defined as directors, top officers, vice presidents in charge of major business units, and "other persons who perform similar policy-making functions. Persons without formal titles may also be members of management." As a managing director and one of Enron's top fifty or so officials, Kopper could certainly fit in that group. And $400 million deals were material, even at Enron.

As they wrote their story that night, the reporters had absolutely no clue that in a mere two weeks Chewco would rise from utter obscurity to become a powerful force in the demolition of Enron. Still feeling their way along and fearful of getting too far ahead of what they could back up, they saved that first mention of Chewco for the bottom half of the story.

18

"Oh, I Expect to Be in the Office All Weekend."

OCTOBER 26 MARKED SOMETHING OF A MILESTONE IN THE JOURNAL'S coverage of the evolving crisis. Up until then, the task of covering Enron had been left pretty much up to Smith, Emshwiller, and Friedland. But on that day, the paper's first major package of Enron stories, involving half a dozen other reporters, appeared.

Among the stories in the October 26 package was a piece by Jathon Sapsford and Suzanne McGee about the falling prices for Enron's bonds. Another story, by Theo Francis and Cassell Bryan-Low, looked at the large amounts of Enron stock that top company executives had been selling in the first seven months of 2001. SEC filings by the executives showed that they had sold 1.8 million shares with a value of nearly $106 million. Lay led the way with sales totaling nearly $26 million. In 1999 and 2000, Enron insiders sold a total of 9.2 million shares with a value of over $570 million. Fastow bought ten thousand shares in August 2001. The story noted that executives at many companies routinely sold stock that they had obtained as part of their compensation package. During the boom years of the 1990s, giant stock sales by insiders hardly caused any controversy. After all, almost every investor felt as if he or she were getting rich. Why shouldn't the executives who had helped make all that prosperity possible also cash in? But by late 2001, with the market in the tank and Enron heading toward the toilet, those massive insider stock sales suddenly started looking a lot less innocent.

Suzanne Craig and Jonathan Weil did a story that focused on the continued bullishness of Wall Street analysts concerning Enron. "Rarely have so many analysts liked a stock they concede they know so little about," wrote the reporters. Of seventeen analysts who followed Enron, fifteen still had a "buy" recommendation on the stock. Only Prudential's Coale had put out a "sell" sign. The piece shined a particularly bright and unfavorable light on Fleischer of Goldman Sachs. While Fleischer had just issued a report criticizing Enron's "lack of transparency and disclosure," he remained a booster of the company. "Just because I can't be specific in being able to create a simple model . . . doesn't mean that you write off that industry and say 'I can't analyze it' or 'I can't figure it out,' " said Fleischer. "If that were the case, there would be an awful lot of industries we couldn't follow." That quote, perhaps as well as any, summed up the attitude of many on Wall Street—and Main Street—during the great bull market of the 1990s. After this story, Emshwiller noticed that Fleischer stopped returning his phone calls.

The drumbeat of bad news for Enron continued as October ended and November began. On Monday, October 29, Moody's downgraded the company's credit rating by one notch and kept it on review for possible further downgrades. While the Moody's action still left Enron two notches above junk bond status, worried investors once again pounded the company's stock that day and the next. By October 30, Enron's stock price stood at $11.16. It had fallen for ten straight trading days and lost two-thirds of its value in that time.

That dismal streak finally came to an end on the last day of October with the help of some perversely "good" news. Enron's stock price had dropped so low that rumors began circulating through the stock market that the company might be a takeover target—an almost unthinkable notion even a few weeks earlier. The *Journal*, for example, ran a story by Emshwiller and Smith on Halloween about the possibility of a takeover. Like other publications, the *Journal* also reported that Enron had approached some big-time investors about making a large investment that would allow the company to raise cash but remain independent. Among those approached was the nation's most famous individual investor, Warren Buffett of Omaha, Nebraska. Buffett quickly rejected the over-

ture. He hadn't become one of the world's richest men by throwing hundreds of millions of dollars down what looked increasingly like a black hole. Nonetheless, the stories of a possible takeover helped boost the stock, which on that last day of October rose nearly 25 percent to $13.91 a share.

In an effort to show that the company was bolstering its finances, Enron and its bankers also let it be known to reporters that they were negotiating for additional credit. On November 1, Enron announced that it had secured a new $1 billion credit line from its two main banks, Morgan and Citigroup.

Then, to show that it was trying to get a handle on its burgeoning partnership scandal, Enron on October 31 announced it was beginning a special internal investigation. It said it had appointed William "Bill" Powers Jr., the dean of the University of Texas Law School at Austin, to its board of directors. Powers would head a special board committee to investigate the LJM deals and any other "related-party" transactions. The special committee was to complete its probe in three months and report the findings publicly. Powers's name had been welcomed when suggested by Enron general counsel Jim Derrick, who'd been president of the law school's alumni association. When Derrick had called with the offer, Powers was surprised and hesitant. He'd never been on a board of directors before, and Enron, at least at that moment in its history, didn't look like the place to start. But Powers was persuaded to help out, partly because of his friendship with Derrick, but also because he was old friends with Harry Reasoner, who also was trying to put Humpty-Dumpty back together again. Reasoner was a longtime partner at Vinson & Elkins, Enron's primary law firm, and someone who was a good friend of Lay. And Powers felt reassured by the special committee's specific marching orders—it didn't have to completely unravel Enron's labyrinthine financial dealings; it just had to focus on explaining, as best it could, the partnerships in which Andy Fastow or other Enron managers were involved, presumably LJM1, LJM2, and Chewco. It seemed a viable goal in the three months allotted.

The inquiry would have a staff of roughly two dozen people from the Washington, D.C., law firm of Wilmer, Cutler & Pickering and the national accounting firm Deloitte & Touche. Heading this staff would be

attorney William McLucas, a former head of the enforcement division of the SEC—a position that had effectively made him the nation's top securities cop. In his stock fraud reporting over the years, Emshwiller had dealt with McLucas and found that he angered easily and wasn't shy about expressing it. The two had once gotten into a yelling match during a phone interview. McLucas accused Emshwiller of ridiculing one of his SEC subordinates in a story about the agency's difficulties catching career stock swindlers. "It was a cheap shot," McLucas said loudly. Emshwiller just as loudly disagreed. When the conversation ended, the reporter figured the enforcement chief wouldn't be returning his calls in the future. But he did, and Emshwiller admired him for it. McLucas had a temper, but he didn't hold a grudge.

But Enron's efforts to create a positive spin couldn't stop the continued flow of bad news. On October 31, the company said that the SEC had upgraded its informal inquiry of the company into a formal investigation. Such a move didn't necessarily mean that the government had already found some dark new information about Enron. Sometimes commission investigators simply needed the subpoena power accorded by a formal probe in order to obtain records from banks and other institutions. Whatever the reasons, the move to a formal investigation produced new headlines and reminded investors that Enron was under scrutiny for possible securities law violations.

Also, for the first time, Smith and Emshwiller split up their coverage of Enron. Since the August 28 "Heard on the Street" piece, they had done nearly all the Enron stories together. But now it looked as though they could separate their activities more.

Smith was trying to get a handle on the company's cash position, which appeared to be worsening no matter what it did. The new $1 billion credit line was secured by Enron's top gas pipeline as collateral. It struck Smith as ironic that, at the end of the day, it was the stodgy pipelines that still formed the backbone of the company. Unlike many other Enron investments, the regulated pipeline business threw off predictable cash and earnings—$450 million in revenues and $85 million in profits for the third quarter alone—that inspired comfort in lenders. The company said it would use $250 million to refinance debt but still would have $750 million left to boost liquidity. That should have been

reassuring to the stock market, but it appeared to have the opposite effect. Enron's stock slid a further 14 percent, or $1.91 per share, to $11.99, giving it the shopworn look of a bargain basement item.

The company claimed that once it got the $1 billion, it would have enough cash to tide it over. After all, it was trying to sell "non-core" assets. But only a few days later, Smith helped confirm rumors that Enron was out trying to raise private investment money, perhaps as much as $2 billion. The company explained that it needed a partner because asset sales were proceeding more slowly than expected. In a story that ran November 6, Dynegy Inc. surfaced as a possible partner for Enron, making a connection that would later become extremely important for both firms.

Emshwiller set about trying to dig up more on Chewco. He went back through the LJM2 private placement memorandum to see if they'd missed any other Chewco references in the forty pages. But no matter how many times he read the document, there was only that one mention in the one-paragraph Kopper biography. Emshwiller asked the *Journal*'s New York library to do a public records search on Chewco. With the rise of computer databases, such searches had become a standard tool for reporters, allowing them to get their hands on information in a few minutes that would have been almost impossible to find just a few years earlier in the pre-on-line age.

The library came back with one lead. A December 31, 1997, filing with the state government in Texas listed Chewco as the borrower in a lending transaction. The lender was Joint Energy Development Investments, aka JEDI. JEDI's address was listed as 1400 Smith St., Houston, aka Enron headquarters. The filing didn't show a dollar amount for the transaction.

That's odd, thought Emshwiller. He recalled that JEDI had been a partnership between Enron and CalPERS, the giant California public pension fund, to make energy investments. But why would JEDI lend money to Chewco?

A search of the *Journal*'s computerized news database turned up a January 6, 1998, press release issued by CalPERS announcing that the pension fund had "recently successfully concluded a $250 million in-

vestment in the Joint Energy Development Investments, LP (JEDI) earning approximately a 23 percent internal rate of return."

So CalPERS had been out of JEDI for over three years, Emshwiller thought. But Enron public filings showed JEDI continuing for years after that. The reporter rechecked the filing from Texas. Could Chewco have bought out CalPERS's interest in JEDI? If so, had JEDI lent Chewco money for that transaction, which might explain the Texas filing?

Emshwiller called CalPERS's headquarters in Sacramento. "We sold our portion of JEDI back to Enron," a public relations official said. The purchase price was about $375 million to $400 million, he recalled.

"Any idea what Enron did with it?" Emshwiller asked.

No, replied the CalPERS official. And no one at CalPERS had ever heard the name Chewco.

Emshwiller called another source, whom he had talked with before about CalPERS. This person said that CalPERS had sold its JEDI stake for $383 million, based on a valuation of the partnership done by Morgan. He didn't know what happened to CalPERS's partnership share after it was sold back to Enron.

"Ever hear of Michael Kopper or Chewco?" the reporter asked.

"Kopper was part of the Enron team that worked on JEDI II," he replied. "Chewco, I never heard of."

"So maybe Enron then sold that CalPERS portion of JEDI to Chewco," Emshwiller said to Friedland as he sprawled out on the bureau chief's office couch, which was short enough so that his feet dangled over the end. "And that would jibe with the reference in the LJM2 document that said Chewco held like $400 million of Enron assets. The half of JEDI was worth about $400 million. And if JEDI financed all or part of the sale, that would explain the [Texas] filing."

"Sort of makes sense," replied Friedland as he sat at his desk. He was half listening to Emshwiller while trying to deal with a steady stream of e-mails coming into his computer. It was a particularly busy news day, and Friedland didn't really have time to sit musing over Chewco. Emshwiller realized that not long after he had plopped on the couch and quickly started feeling guilty about intruding. "But if Enron wanted to sell the CalPERS interest in JEDI, why wouldn't it find someone who

could pay real money?" the bureau chief asked as he read a new incoming e-mail message.

"Haven't quite figured that out yet," said Emshwiller, knowing he should get out of Friedland's office.

"Keep me posted," Friedland replied absently.

Back at his desk, Emshwiller read through Enron's SEC filings for any references to the JEDI partnership. He found several. Enron related how it and CalPERS each put in $250 million in 1993 and how an Enron subsidiary operated the partnership. The SEC filings showed that JEDI had been a very profitable venture, though that information was buried deep in the footnotes. Between 1997 and 2000, the partnership had contributed $231 million to Enron's earnings.

As he read, the reporter began noticing some odd things. Prior to 1998, Enron routinely named CalPERS as its JEDI partner. After 1998, Enron referred only to its "limited partner" in JEDI but gave no name. Then, in its filing for the first quarter of 2001, Enron reported acquiring "the limited partner's interests" in JEDI for $35 million. As a result, JEDI became wholly owned by Enron and was consolidated into the company's financial statements. As part of that transaction, Enron said it paid off $620 million of debt owed by JEDI to outside lenders.

The debt could have been a reason for keeping JEDI separate, Emshwiller thought. Adding over $600 million in debt to the balance sheet in 1998, when Enron was a much smaller company, could have lowered the company's cherished credit rating. He reread the passage. There was no clue to the identity of the limited partner that had received the $35 million.

Another passage about JEDI caught his eye. It appeared in the discussions about the LJM partnerships in the company's 1999 annual report. After a sentence about a particular $11 million purchase of Enron assets by LJM2, the following appeared with no pause or paragraph: "At December 31, 1999, JEDI held approximately 12 million shares of Enron Corp. common stock. The value of the Enron Corp. common stock has been hedged. In addition, an officer of Enron has invested in the limited partner of JEDI and from time to time acts as agent on behalf of the limited partner's management." Who was that "officer of Enron" who'd in-

vested in JEDI? Emshwiller wondered. Emshwiller knew by then that Enron always referred to Fastow as a "senior officer." Seemingly, this was somebody else. If it was a reference to Kopper, why was it included in only the 1999 report? And why then? Emshwiller called Palmer. "Who are you guys talking about there?"

"Must be Fastow," Palmer replied.

"I don't think so," Emshwiller said, and explained why. "It looks like Chewco, run by Kopper, bought out the CalPERS interest in JEDI," he said.

"Sounds logical," Palmer said matter-of-factly. "But I don't know if any of it is true."

"Could you try to find someone in your place who will talk to me about all this? I'm looking at doing another story on Chewco."

"I'll try," Palmer replied in a tone that didn't exude optimism.

By late Thursday morning, November 1, Emshwiller didn't have any answers back from Palmer about Chewco. With Friedland's concurrence, he decided to try to write another Chewco piece for the next day's paper. In part, he was driven by the eternal Thursday afternoon angst of a *Journal* reporter. Friday marked the last paper of the week. With no weekend editions, there wouldn't be another chance to get a story in the paper until Monday. Like almost every *Journal* reporter and editor, Emshwiller had spent more than one weekend nervously waiting to see if the *Times* or some other major competitor would beat him to a story on Saturday or Sunday. Though he didn't know of anybody else working on a Chewco piece, he knew press interest in Enron was heating up. And Chewco's name was now public. He finished about fifteen inches of a draft early in the afternoon, barely an hour before the first deadline. It's a mess, he told himself. Dense and confusing. He sent copies to Friedland and Smith. Maybe they'd have some ideas on how to improve it.

"It's got way too many hedges in it," Friedland said as Emshwiller settled into a chair in the bureau chief's office. "There are too many 'seems' and 'appears' and 'mights.' If we're going to say that Kopper and Chewco were in JEDI and were paid millions for it, we need to say it more definitely."

"I think we do have to hedge it some," Emshwiller replied defensively, though he couldn't really disagree. Trying to write the story had made him realize how nervous he was about the piece.

"Of course you need to hedge it. But reading this, the reader would have a hard time figuring out exactly what we're trying to say," said Friedland.

"Let's see what Becky thinks," Emshwiller said. Friedland nodded and punched a button on his phone to put in a call to the San Francisco bureau.

"This draft is way too complicated. It doesn't make sense. I got lost trying to follow it," Smith said over the speakerphone.

Great, thought Emshwiller, and this from a person who'd actually made some sense out of the Rube Goldberg maze of California electricity deregulation. Seems he had managed to write a piece that was both tentative and indecipherable—no small feat. "I sure would like to get something in before the weekend," he said, thinking of two long days waiting to see the *Times*.

"I think it would be better to take another day and rewrite it," suggested Friedland, who added that he'd be happy to edit it over the weekend.

"Don't worry," Smith added. "Nobody else is going to do this story by Monday." Her tone suggested that she didn't think anyone was going to do a story on that topic for *any* Monday. She was concerned that Emshwiller had gotten interested in Chewco to the exclusion of everything else. With so many pieces to the Enron puzzle, it seemed he was expending a lot of effort on what might be a relatively minor and esoteric part of the story. She doubted it was worth it.

"You're right. I'll work on it some more over the weekend," Emshwiller finally said.

Starting on Saturday, he put in calls to Palmer to see again whether Enron had any comment on—and hopefully some confirmation for—the points in the Chewco story. On the day before, Palmer had said he hadn't yet been able to talk to anyone about Chewco. "They are all in meetings and I can't get to them."

"What are the meetings about?" Emshwiller asked.

"Well, there are a few things going on around here," he replied with a touch of sarcasm. Palmer wouldn't say anything more, though he did promise to continue trying through the weekend to get some answers.

"Where can I reach you over the weekend?"

"Oh, I expect to be in the office all weekend," Palmer replied wearily.

But through the weekend, Emshwiller put calls into Palmer's office, his home, and on his beeper service without hearing back from the Enron officials. He kept calling and stopped counting after he had left ten messages. As Saturday moved into Sunday with no response from Palmer, the reporter not so quietly cursed the PR man. At least the jerk could call, he thought. In truth, Palmer always had been good about responding promptly, even if it was just to say that Enron didn't have any comment. Something's going on, Emshwiller thought.

Emshwiller did receive a call at home that weekend from a public relations person. Mike Sitrick ran a Los Angeles–based public relations agency that bore his name. "I have a very big story that the *Journal* is really going to care about," Sitrick began in his smooth and intimate way, as if he were letting you in on the biggest secret going. "I wanted to give you a heads-up. It's probably going to happen in the next week."

The call mildly irked Emshwiller. He'd known Sitrick for years. His firm specialized in what was known as "crisis public relations." When troubles arose for a company, Sitrick was hired to handle the press and improve the client's image. Sitrick did work for some big-name clients—such as the giant California utility Pacific Gas & Electric Co., during the height of the California electricity crisis, and Orange County, California, when it went into bankruptcy in the early 1990s. But he also represented lots of small potatoes, some of whom had more than their share of troubles with law enforcement officials. Big or small, Emshwiller figured he wouldn't care about them this weekend unless they were at or near Smith Street in Houston. "Well, what's it about?" the reporter asked.

There was a brief pause at the other end of the line. "I can't give you any specifics," Sitrick said.

"That's very helpful, Mike."

"The client won't let me talk about it. I tried to convince them to let

me give you some specifics under an embargo. They wouldn't budge. But trust me, you are going to care about it. It's big enough that you are probably going to want to have more than one reporter on it."

"Well, I'm buried on Enron these days. Unless you're working for them, I'm not the guy to talk to."

"I'm not working for Enron," Sitrick said. There was the smallest pause before he replied. Emshwiller made nothing of it at the time.

"Maybe you should give Friedland a call. I have to get going," Emshwiller said as he gave a quick good-bye and hung up. He didn't think more about Sitrick that weekend as he turned his attention back to Chewco.

Late Sunday afternoon, with the Chewco story scheduled for the next morning's paper, Palmer phoned back. He sounded harried and tired. "Sorry I didn't get back to you sooner. I've been in meetings all weekend," he said. "I haven't been able to reach anybody about Chewco. All the people who know about it are still buried in meetings. We're just going to have to stay with a no-comment."

What were all these meetings about? Emshwiller wondered. Palmer again declined to say. Then he said he had to get back to his meeting and got off the line quickly. The reporter wondered whether Chewco was a topic of any of the meetings. Of course, as Palmer had noted, there were lots of things on Enron's plate. But at least Emshwiller was feeling better about the story he'd written. It ran the next day, November 5, under the headline ENRON TRANSACTION RAISES NEW QUESTIONS—A COMPANY EXECUTIVE RAN ENTITY THAT RECEIVED $35 MILLION IN MARCH. Besides raising questions about a possibly huge new windfall for another Enron executive, the story raised the issue of what Chewco did for the company. The $35 million payment "appears to have been the last step in a complex series of transactions that allowed Enron to keep hundreds of millions of dollars of debt off its balance sheet for the past three years," the story said.

19

"Those Liars!"

On Thursday, November 8, Smith, Emshwiller, and Friedland all logged on to their home laptops early in the morning with an extra measure of anticipation. Palmer had forewarned them and other journalists that the company planned to make an 8K filing with the SEC that morning.

This would be Enron's first 8K since the crisis began. Given the magnitude of the news that the company had been disseminating, including Skilling's resignation in August, the three journalists thought something big might be in the offing. However, they couldn't find out much about what was coming. Those they talked with said the filing would probably deal with the LJM partnerships and related matters. But nobody had—or would give—any details. Palmer insisted that he didn't yet know exactly what would be in the report.

"Will it deal with Chewco?" Emshwiller asked. It had been two days since his Chewco story had run, and he had gotten absolutely no response on it. Not from the company. Not from any new tipsters. Nobody. He was beginning to think that perhaps Chewco really was just an irrelevant sideshow of the Enron story.

"I think it will deal with Chewco," Palmer replied. "I just don't know for sure."

"Did you guys find any errors in the Chewco story?"

"You'll just have to wait and see what's in the filing," Palmer said.

As Emshwiller trudged up the stairs that Thursday morning to the spare bedroom that doubled as his home office, he felt a fresh jolt of anxiety. What if he had made some large error on Chewco? The more logical part of his mind reminded him that Enron likely would have already jumped on any significant error. But he didn't always listen to the more logical part of his brain.

After he sat at his desk and logged on to the *Journal*'s computer network, he went right over to the newswires. He entered "Enron" as a search word, and a long column of headlines began sprouting on the screen. Each headline seemed more incredible than the last: huge write-offs; renounced financial statements; executives fired. "My God," Emshwiller muttered. Chewco's name appeared in many of the stories. Well, at least Chewco doesn't seem irrelevant, he thought. He retrieved a copy of the actual 8K from the Internet and began reading.

By 7:00 A.M., Emshwiller and Smith were e-mailing each other and Friedland. "Enron has lopped several hundred million dollars off earnings for 1997–2000 because of consolidating Chewco, JEDI, and LJM results," Emshwiller wrote.

"Can we talk in an hour?" Smith asked the pair. Emshwiller reminded her he had an 8:30 A.M. breakfast meeting, and Friedland said he'd be in the midst of getting his children to school but would be available on the cell phone.

"We have plenty to do. We can wait till you're at your battle station," Smith told Friedland at 7:20 A.M. before returning to the twenty-one-page document. She read with a growing sense of disbelief. Practically every page contained a newsworthy surprise. The problem for the story that night would be to try to understand it all and then cram even a fraction of the news into limited space. She typed a hurried e-mail to Emshwiller: "This story just doesn't quit."

Enron had retroactively slashed its reported net income reaching back to 1997 by a total of $586 million, or 20 percent. It had increased its reported debt during that same period by hundreds of millions of dollars. In perhaps the most stunning admission of all, the company said that its audited year-end financial statements for 1997 through 2000 "should not be relied upon" by investors.

Enron publicly confirmed the existence of Chewco and identified Kopper as "an investor" in the entity and "the manager of the Chewco general partner." In the next breath, the company admitted that Chewco never should have been treated as an independent entity. This decision alone accounted for more than two-thirds, some $396 million, of the retroactive earnings reduction and all of the added debt. Somehow, Chewco's existence had allowed Enron to report huge amounts of earnings, though the SEC filing didn't explain how.

The mea culpas hardly stopped with Chewco, though. Enron had decided that an LJM1-related entity also should have been merged into Enron's financial statements. This move accounted for another $103 million of the retroactive earnings reduction. The remaining nearly $90 million in lopped-off net income was attributed to various accounting adjustments that were "previously determined to be immaterial in the year originally proposed." But now they were considered important enough to recognize.

For the first time, the company acknowledged the existence of the four entities known as Raptors I through IV, which had been set up in connection with LJM2 and whose names had appeared in that internal partnership document the reporters had obtained. And the Raptors had exerted an enormous impact on Enron's reported results, far vaster than anything the reporters ever suspected when they first saw that name in the LJM2 partners' report. From January 1, 2000, through September 30, 2001, transactions with the Raptors contributed over $1 billion to Enron's pretax earnings—nearly one-half of the company's reported total for that period. The size of that number stunned the two reporters. Instead of being some project created merely to help "manage risk," as Enron officials had insisted from the beginning, the LJM setup now appeared to be at the very heart of Enron's operations and the great engine of its earnings power. For the first time, the reporter wondered how much of Enron's success was real and how much was just accounting legerdemain.

Enron said it had paid LJM2 $35 million in the recently completed third quarter to close out the Raptors. So that's where Palmer came up with the measly $35 million number, Emshwiller said to himself. But

then he read further. For in that third quarter, the closing of the Raptors had resulted in a $711 million pretax charge to earnings, accounting for a huge chunk of the company's reported loss.

"Those liars!" Emshwiller said loudly in the empty bedroom as he stared at his computer screen. According to the filing, the Raptors were clearly connected to LJM2—the partnership had invested in the four of them. And he had specifically asked for any LJM-related charges on that earnings announcement day. Yet the company had insisted that it was only $35 million. Liars, he thought again.

Smith had her own reasons for fuming as she read the document. The company admitted that much of the $1.2 billion equity reduction in the 2001 third quarter had to do with the termination of Raptors. Seems like Lay would have remembered the name Raptor, Smith thought angrily as she recalled how the Enron chairman had chastised her for pushing the question. In the filing, Enron also admitted that $1 billion of the equity adjustment was due to an "accounting error." When Enron issued a huge slug of stock as part of one of the Raptor transactions, it received back an IOU in the form of a promissory note. Under generally accepted accounting rules, Enron couldn't show an increase in shareholder equity until it actually got cash for that stock.

They never mentioned anything about an accounting error, Smith thought. In the interview with Causey about the equity reduction, the chief accounting officer had made it all sound very routine. Enron, he said, was simply unwinding some transactions and calling back in some stock. Certainly she would have remembered if he had admitted such a huge mistake. After all, Enron rarely admitted to making any kind of mistake. At least until today.

Besides discussing the Raptors, Enron gave its most extensive rundown yet of its other LJM-related dealings. From June 1999 through September 2001, there had been "24 business relationships in which LJM1 or LJM2 participated," the filing said. There were new details about various LJM transactions, which included the sale of assets to the partnerships and the later repurchase of those same assets by the company. The partnerships had made investments in Enron ventures

and, in some cases, been involved in selling the company put options to protect the value of certain assets. Blocks of Enron stock were part of one or another deal.

Some of the LJM deals were vexingly complex. For example, Enron sold part of its broadband network of fiber-optic cable to LJM2 in June 2000 for $100 million. Of that amount, LJM2 gave Enron $30 million in cash and the rest in the form of a note. The company immediately recorded a $67 million pretax gain on the sale. Enron then helped LJM2 quickly resell some of the cable to unnamed "industry participants" for $40 million, with Enron taking another $20.3 million as a marketing fee. LJM2 sold the rest of the cable in December 2000 for $113 million to an unnamed Special-Purpose Entity, with financial connections back to Enron, which had been created to buy the asset. With part of those proceeds, it paid off its $70 million note to Enron, although the company somehow ended up with a $61 million credit exposure under a derivative contract with an unnamed lender to the Special-Purpose Entity that bought the cable from LJM2. Not bad considering that the fiber-optic cable being passed around wasn't yet operative. Increasingly, Enron looked less like a real company and more like a financial funhouse.

The LJM partnerships seemed to be enjoying some pretty tangible results. The Enron filing disclosed that the partnerships had put a total of $191 million into various deals. In return, the two partnerships had received back $319 million in cash and Enron stock and still had half a dozen open investments with the company. Fastow's personal take from the LJM partnerships was "in excess of $30 million," according to the filing. Well, Emshwiller thought, we were certainly "safe" going with our $7 million estimate. It seemed astonishing that practically everything having to do with Enron was worse than they'd thought.

At the bottom of page nineteen of the filing, tucked in almost as an afterthought, was the disclosure that Enron was "terminating the employment" of treasurer Ben Glisan and a senior company attorney, Kristina Mordaunt.

I just talked with Glisan about Marlin and some of those off-balance-sheet entities, Smith recalled as she read. The company had put him forward as one of its main financial experts. What could he have done

in the past two weeks, she wondered, to get himself fired? And who was Mordaunt?

The document was thin and confusing in its explanations for the firings. The matter had to do with LJM1 and Kopper. "Enron now believes that Mr. Kopper also was the controlling partner of a limited partnership that (through another limited partnership) in March 2000 purchased interests in affiliated subsidiaries of LJM1," the filing said. "Enron also now believes that four of the six limited partners of the purchaser were, at the time of the investment, non-executive officers or employees of Enron, and a fifth limited partner was an entity associated with Mr. Fastow. These officers and employees, and their most recent job titles with Enron, were Ben Glisan, Managing Director and Treasurer of Enron Corp.; Kristina Mordaunt, Managing Director and General Counsel of an Enron division; Kathy Lynn, vice president of an Enron division; and Anne Yaeger, a non-officer employee. . . . At the time these individuals invested in the limited partnership, LJM1 had ceased entering into new transactions with Enron. However, some pre-existing investments involving LJM1 and Enron were still in effect, and Enron believes that these investments resulted in distributions or payments to LJM1 and to the limited partnership in which these individuals invested." In other words, several additional Enron officials had made money from the LJM partnerships. The company didn't say how much. The filing noted that Lynn and Yaeger had previously left the company.

More partnerships, Emshwiller thought as he read. They seemed to be sprouting up like mushrooms. He noticed that Enron hadn't given the name of this new partnership. Like Smith, he wondered what Glisan and Mordaunt had done wrong. After all, Enron let Fastow make profits from the LJM partnerships. Why not these people? Had they failed to tell their bosses about the investment? But Fastow was their boss, at least in the case of Glisan. Lynn and Yaeger, he recalled, had been mentioned to the reporters previously as people who worked for Fastow on the LJM projects. Surely Fastow must have known about these investments. Had Lay and the board been kept in the dark? Or were they just getting nervous enough to sacrifice some smaller fish?

While almost every paragraph contained new information, each also raised new questions. Predictably, Emshwiller focused on Chewco. Ex-

actly why had Chewco failed to qualify as a separate entity? Enron said that it, like many companies, "utilizes a variety of structured financings in the ordinary course of its business to access capital or hedge risks. Many of these transactions involve 'special-purpose entities.' "

(The reporters would later learn that Enron had begun a hurried internal investigation into Chewco on October 26, the same day that the *Journal* first mentioned the partnership. By Saturday, November 3, Enron and Andersen officials had concluded that Chewco, from its 1997 inception, never had enough outside equity to satisfy accounting rules. Thus, the partnership should never have been treated as an independent entity capable of doing business with Enron. So all of the hundreds of millions of dollars of debt that Chewco had helped keep off Enron's books and earnings it helped produce were, in reality, a falsehood. When this fateful conclusion was reached by Enron and Andersen officials on that first Saturday in November, one participant recalled how Glisan—himself only days from being fired—pretty much summed up the situation facing himself and his company: "We're toast.")

"Pretty devastating," Smith said when she and Emshwiller finally hooked up to discuss the report by phone that morning.

"My favorite line is this one at the beginning about how 'the year-end financial statements for 1997–2000 should not be relied upon,' " Emshwiller said. "Not often that a company renounces four years of audited financial statements."

"I don't see how anyone can believe anything the company says after this," Smith said. The worst part of the report, she felt, wasn't even the financial restatements. Ugly as they were, those changes affected Enron's past periods rather than future ones. The company had no less cash or fewer operating units as a result of the restatements. It just no longer had any credibility.

The 8K filing helped speed Enron on its way to becoming the butt of a thousand jokes—perhaps the cruelest way to die in public. The on-line financial publication *CreditSights* ran an article under the headline A THREE-CAR PILE-UP IN A TWO-CAR FUNERAL. *CreditSights* granted that Enron had shown "a clear pattern of taking the much-vaunted 'asset-lite' business model to the level of 'accounting anorexic.' "

Though many stock analysts still had "buy" recommendations on En-

ron, support on Wall Street was slipping away. John Olson, the longtime Enron skeptic who'd put out a "buy" recommendation in early September when he thought the stock had been oversold following the Skilling resignation, perhaps best summed up the shifting Wall Street mood. "It took sixteen years to build Enron into a $63 billion asset powerhouse, but only 24 days for it to disintegrate," he wrote to clients.

Enron's battered credit rating seemed certain to fall further, despite repeated promises by McMahon, the new chief financial officer, that the company was working feverishly to enhance its financial strength. By November 5, Fitch had dropped Enron down to BBB-, the last stop before junk bond status. The more influential Moody's and Standard & Poor's still had Enron one notch above Fitch. But all three ratings agencies had the company on daily review for possible further downgrades. Now it was only a question of how much further the credit rating would fall. Absent some dramatic event, it seemed certain that the once mighty company would soon be relegated to "junk" status.

Externally, at least, Enron kept up a brave front. Company officials told reporters that the company had plenty of cash and was current with all its creditors. They claimed that their trading operation was humming along at normal levels.

Internally, though, Lay and the remains of his battered team had come to realize that only two viable options remained. The company could seek a merger partner to shore up its rapidly eroding situation. Or it could file for bankruptcy court protection. The one thing that the company could never again be was the Enron of old.

PART THREE
The Party's Over

20

"Does Ken Lay Know About This Meeting?"

It was almost impossible to believe Enron had fallen so far in just a little more than three weeks. Yet everyone knew the party was over, and for Enron, there was no time to nurse its splitting hangover—or its wounded pride. New circumstances demanded new measures. In this hour of need, Enron turned to a crosstown competitor, Dynegy Inc.

Dynegy was often described as an Enron wannabe, content—or at least consigned—to follow a few paces behind the larger company. When Enron bought power plants, Dynegy bought power plants. When Enron bought a utility, Portland General Electric, Dynegy followed two years later with the purchase of Illinova Corp. Enron launched EnronOnline in late 1999, and Dynegy followed with DynegyDirect. Now, after years of breathing Enron's exhaust fumes, it suddenly seemed that Dynegy had the chance not only to catch up with its rival, but to swallow it. On Friday, November 9, just after 5:00 P.M. Houston time, the two companies announced that Dynegy had agreed to buy Enron in an exchange of stock.

Who would have imagined it? Enron officials had looked down on Dynegy as one of the little kids on the energy block, with assets of a "mere" $25 billion compared with Enron's more than $60 billion. The planned merger was just one more example of the unintended consequences of the Enron debacle, Smith thought as she worked the phones and took notes for the story she was writing.

Smith had known for several days that Enron and Dynegy were nego-
tiating. She and the *Journal*'s mergers and acquisitions reporter Robin
Sidel had begun hearing unsubstantiated reports of such a move a week
earlier and first did a piece raising the possibility on November 7.
Though it was billed as a merger, there was no doubt about who would
emerge on top. The combined company would be named Dynegy. It
would be headed by Dynegy's chairman and founder, Charles L. Wat-
son. Eleven of the fourteen board seats in the new company would go to
Dynegy representatives.

Each Enron share would be swapped for a fractional share—actually,
0.2685 shares—of Dynegy stock. With Dynegy's closing price that Fri-
day on the New York Stock Exchange of about $38.70 a share, the ex-
change ratio meant that each share of Enron stock was being valued by
Dynegy at about $10. While pathetic by historic standards, ten bucks a
share was a lot better than where Enron's stock price had been re-
cently—or where it was likely to go if Dynegy didn't step forward.

To prop up Enron's trading business, Dynegy would immediately in-
ject $1.5 billion into its longtime rival. The money would come from
Dynegy's biggest shareholder, the oil giant ChevronTexaco Corp.,
through the purchase of additional shares of Dynegy stock. In return for
the $1.5 billion, Dynegy would get priority rights to a prime Enron nat-
ural gas pipeline, which it could keep, under certain conditions, even if
the merger fell apart. For all the company's extolling of "asset-lite," the
truth was that when people put down cold cash, they still preferred hard
assets in return.

When Emshwiller saw the list of public relations contacts for the
merger, he let out a small groan. Sitrick & Co. was listed as one of the
contacts for Dynegy. So that weekend call from Mike Sitrick had been
about Enron. Instead of asking the PR man whether he was working *for*
Enron, the reporter should have asked whether he was working *on* En-
ron. For his part, Sitrick had given Emshwiller an answer that would do
the word parsers at Enron proud.

Despite Enron's pronouncements about the fundamental soundness
of its business, the company had been searching for rescue routes since
late October. It quietly retained the law firm of Weil, Gotshal &
Manges, which specialized in bankruptcies and corporate restructuring.

Then it began looking for a party willing to pony up billions of dollars. It reached out to Dynegy.

As Smith's reporting progressed, she learned that the courtship between the two companies began on October 24 (Andy Fastow's last day of work, as it happened), with a call from Stan Horton to Dynegy president Steve Bergstrom. Bergstrom had worked in the gas pipeline side of Enron for many years and would meet regularly with his friend Horton, who headed the pipeline division of Enron. Just before a scheduled lunch, Horton called Bergstrom to ask if he could bring along some other guests: Enron's new president, Greg Whalley, and vice chairman Mark Frevert. Bergstrom realized it wasn't going to be the usual bull session with an old friend and wondered if Enron was going to make a pitch to bring together the two firms' European energy-trading operations.

The four met in a private dining room at the Plaza Club, which counted among its members many executives in the energy industry. Usually, Bergstrom and Horton sat in the main dining room and took advantage of the sumptuous buffet, but on this occasion the four men sequestered themselves in a private meeting room to avoid running into people they knew. After a minimum of chitchat, Whalley cut to the chase: Would Dynegy be interested in merging with Enron? Bergstrom would later tell Smith he was "flabbergasted" by the proposal. He had figured that business would come up, but he never imagined that it would be business that big. They must be in worse trouble than I thought, Bergstrom told himself. "Why would you be interested in us?" the Dynegy president asked Whalley.

Well, the executive replied, Dynegy had "management credibility" that Enron lacked. Dynegy also understood Enron's business lines and could move quickly to consummate a deal. And Enron needed a huge cash injection that maybe Dynegy's big brother, ChevronTexaco, could provide in order to fix Enron's balance sheet.

"Does Ken Lay know about this meeting?" was Bergstrom's next question. It seemed inconceivable that Lay would want his company sold to a company that had always operated in its shadow. "If he's truly supportive, Ken needs to call Chuck Watson," Bergstrom told the others.

The luncheon lasted an hour and a half. When Bergstrom returned

to Dynegy's headquarters a short walk away, he immediately called Hugh Tarpley, vice president of strategic investments for Dynegy. And he went to see Watson, the Dynegy chairman. Sitting in the paneled office, Bergstrom told Watson about the lunch conversation and that Ken Lay might be calling to follow up. While the overture had come from very senior Enron officials, Bergstrom still didn't give the idea better than a fifty-fifty chance of going forward. After all, Dynegy was one-fifth the size of Enron, as measured by revenue. Since when does the minnow swallow the whale? Watson also expressed skepticism, but both felt the proposal was worth taking seriously.

"They thought Enron made a lot of really stupid bets and was suffering from a liquidity crisis. The balance sheet was so broken, they had no choice but to do a merger—and it would have to be with someone very opportunistic," explained one individual involved in the negotiations. "The whole idea of moving quickly, taking risk, and getting rewarded appealed to Dynegy. It was the Dynegy way of doing business."

Smith could easily see why Dynegy would be interested in Enron. It competed in the same industries, lived in the same town, and prided itself on a bold business outlook, not unlike its bigger rival. And despite all its troubles, parts of Enron's empire, such as the trading division, remained highly desirable.

That night, Lay called Watson as he was heading home. He wanted to get together and talk merger details, in a private place where there would be little chance they'd be seen together. The two men settled on Lay's home at the Huntingdon—the thirty-four-story white edifice that was one of Houston's toniest condominium towers—on Saturday morning, three days hence. Watson spent the remainder of the week preparing for the meeting with his own mergers and acquisitions team, boning up on Enron's business, trying to nail down one surprisingly elusive fact: how much the company was worth.

A large, florid man with a Texas twang and a wide streak of pride bordering on arrogance, Chuck Watson had founded Dynegy in 1985, the same year Enron came into being. He'd built it into one of the nation's thirty largest companies. Dynegy considered itself a leading innovator. Its corporate logo was an ancient seven-piece Chinese puzzle called a tangram. "A tangram starts as seven precise parts," Dynegy explained on

its corporate Web site. "What's amazing is how many solutions can be created. The only limitation is one's imagination. And so it is with Dynegy."

When Watson arrived at the Huntingdon for the 8:00 A.M. meeting, Lay greeted him warmly. The two had known each other for years and shared many a dais at industry gatherings and Houston civic functions. Lay offered his guest coffee and sweet rolls. Watson took a cup of coffee, black, but turned down the rolls. He'd later regret that decision, since he would not get another shot at food for several hours.

The two chief executives quickly fell into negotiations. Watson didn't think Enron's broadband or international businesses were worth much. In fact, he assigned them almost no value. But he thought the trading business was basically sound. Clean up the balance sheet, sell the junk, and you'd have a good company, he thought, and his team had agreed.

Watson regarded Lay as his kind of CEO, hands-on and decisive. He assumed that Lay was the originator of the proposal. But Dynegy colleagues told Smith that he later concluded Whalley was the one pushing the merger deal. Lay seemed unusually concerned about what are euphemistically called "social issues"—in other words, what his own position would be if a deal was struck. "He wanted to stay on as chairman," one senior member of the Dynegy team later told the reporter. "He seemed in total denial about the condition of his company or what a merger would mean." Lay described the company's cash needs as something required to fix the balance sheet, but not as something needed to staunch the hemorrhaging.

Smith wanted to know how Watson had reacted to Lay. "Chuck is a very focused guy," the Dynegy executive replied. "He was just shocked at some of the things Lay said. Lay didn't seem to grasp the reality of the crisis or the fact Enron had just driven over a cliff. While they agreed that the deal should be done as a stock swap, Lay argued that the exchange formula should be set at a level above Enron's current depressed price. After all, the Enron CEO argued, in such takeovers the acquiring company usually pays a premium. Plus, Lay said, repeating his public mantra, Enron's core businesses remained fundamentally sound.

But Watson knew that he had Lay in a tight, probably desperate,

position; why else would he be dangling his empire in front of a competitor? While Watson felt a certain amount of pity for his fellow CEO, he also intended to press his advantage. There would be no premium for Enron stock, he told Lay flatly. It would be the market price or no deal. And it would have to be done quickly. Swallowing hard, Lay finally agreed. For his part, Watson offered to approach ChevronTexaco about making a major investment in the merger deal to shore up Enron's eroding cash position. Without a big cash infusion, there was no point in going forward, Lay said. What's more, much of the money needed to arrive almost immediately, even though the merger wouldn't be completed for months. The two dickered over what kinds of protections Dynegy and ChevronTexaco would get for that investment. Lay agreed to turn over the rights to Enron's Northern Natural Gas Co. pipeline. If the merger didn't go through, Enron could keep the cash and Dynegy would get Enron's most valuable pipeline. The two men shook hands and parted.

Watson returned to Dynegy headquarters and briefed his team in a meeting that started at 7:00 P.M. and ran about an hour and a half. One detail troubled Dynegy. Enron had drawn down all its bank lines, some $3 billion worth, yet the company still seemed desperate for a quick infusion of money. Where was it all going?

Dynegy's team discounted everything it was told by Enron. And they drove a hard bargain: $10 billion to acquire the company, plus a pledge from ChevronTexaco to buy an additional slug of Dynegy stock. Since Dynegy would be selling equity to ChevronTexaco, this would give it cash that it could, in turn, invest in Enron. Of the amount infused in Dynegy through the stock sale, $1.5 billion would be made available to Enron immediately. Another $1 billion would come when the merger deal closed.

Even after earmarking funds to cover lawsuits, Dynegy officials felt they were getting Enron for about half its actual value. If the deal blew up, they'd still emerge with a valuable pipeline system to augment their own network. The company was making a big bet, but it was comfortable with the odds.

Enron's two principal banks, JPMorgan Chase and Citigroup, also had a big stake in the proposed merger. Besides the billions of dollars they had already lent the company, both banks had been picked as

merger advisers, filling a lucrative niche that was traditionally dominated by other big Wall Street firms, such as Credit Suisse First Boston and Goldman Sachs. For decades, commercial banks had been sharply constrained by federal law from getting into the securities business, but those prohibitions had been largely cast aside in the deregulation wave that swept the American economy during the 1990s. The Gramm-Leach-Bliley Financial Modernization Act of 1999 helped clear the way for the creation of a sort of financial superstore that offered insurance, securities, and banking services. (The lead sponsor of that bill was Senator Phil Gramm from Texas, whose wife, Wendy Gramm, was a member of the board of directors at Enron.)

By late October, the two companies had the makings of a deal, but it wasn't ripe enough to announce. From Monday, October 29, through Monday, November 6, the merger teams worked without a day off trying to get everything ready to present to the public. On that second Monday, Dynegy's legal team got a phone call from Enron's general counsel, Jim Derrick. "I need to get you guys on the phone with Herbert (Pug) Winokur," Derrick told Dynegy's general counsel, Ken Randolph, referring to the longtime Enron director. Then Derrick dropped another of Enron's famous high explosives.

He told them about Glisan's and Mordaunt's investments in LJM. To Dynegy managers, who'd been working alongside Glisan to get the deal done, it was a real shocker. After all, Glisan was supposed to make the Dynegy team feel it was getting all the information it needed to go forward with the deal. Derrick let Randolph know that the two Enron employees would be taken off the merger team immediately.

Next, the Dynegy team was shown a copy of the dismal 8K filing. Dynegy started to think that it might be paying too high a price for Enron, and members of its team began intimating it might need to lower the exchange ratio.

There was another upset yet to come, in advance of the announcement. It appeared that the exchange ratio approved by Enron's board was slightly higher than the one approved by Dynegy's board, through a mix-up that necessitated a last-minute scramble. The night before the announcement was to be made, Lay and Watson were both roused for a 3:00 A.M. conference call to sort out the right exchange ratio. At 5:00

A.M., exhausted, the legal teams took a break after having worked all night. They were now nearly ready to announce the deal, but they needed to make sure the credit-rating agencies were on board. They couldn't risk having Enron's rating further lowered.

Dynegy's team walked over to a nearby health club so they could at least freshen up with showers. Then they reconvened at 6:00 A.M., poised to take a telephone call from Deborah Perry, chief credit officer for Moody's Investors Service, and colleagues. The credit analysts were concerned that Dynegy have a strong "out" clause, in case Enron unleashed any more surprises. Dynegy stressed that if the legal liability exceeded $3 billion, it would constitute a "material adverse clause" and the deal could be swiftly terminated. Moody's raised a red flag, warning it was worried about Enron's voracious cash needs. But in some ways, Dynegy was more worried about Moody's than Enron. That's because a downgrade by Moody's could cause cascading repayment demands on Enron, with as much as $3.9 billion coming due—which would sink the deal.

The merger terms were reworked to toughen the walk-away provisions. Morgan and Citibank were looking at investing up to $500 million cash in the deal. Morgan's chief executive William Harrison and Citigroup vice chairman Robert Rubin called Moody's officials to express their support for the merger. Finally, Moody's was persuaded to hold off on taking any debt actions.

Enron tried to bolster its position by soliciting support for the deal in Washington, D.C. It didn't net much. Lay put in calls to Federal Reserve chief Alan Greenspan, Treasury Secretary Paul O'Neill, and Commerce Secretary Don Evans. While Enron's top brass had enough political clout to reach all these top government officials, none of the calls produced anything more than expressions of sympathy and good wishes for Enron to find a way out of its troubles. It seemed that Enron had been deemed too hot to handle or too far gone to help.

The deal was announced on Friday, November 9. Watson sounded nothing short of euphoric when he spoke to Smith and Emshwiller about the deal as part of the two companies presenting the merger to the press. Watson called it a "tremendous transaction," where the "upside is enormous" and "functionality of the two systems is incredible."

Anticipating questions about Enron's tangled finances, Watson insisted that "we've had a good assessment" of the company's liabilities, and "even in the worst case we feel very comfortable that the value in [the] core business exceeds those liabilities."

For his part, Ken Lay tried to put on a happy face. He insisted that "things weren't desperate" and that the Dynegy deal really was the best of many courses of action open to Enron. He declined to elaborate on what the alternatives might have been. Still, Lay couldn't completely hide the beating he and his company had been taking. "We have had a long week, a long month," he conceded. "I wish the stock price were a lot higher," said Lay in response to a question about the merger's terms. In a more resigned tone, he added, "But we have to be realists here, too."

Anticipation of the combination initially helped stock in both companies. After dropping as low as $7 a share on November 7, Enron stock rallied to above $8.50 by the close of trading on November 9. Dynegy's closing price of $38.75 a share was up some $4 from the beginning of the month. Word of the merger also halted, at least temporarily, the potentially disastrous slide in Enron's credit rating, and not just by Moody's. By November 9 all three major ratings agencies had dropped Enron's credit standing to the lowest investment-grade level—but not below. And they'd made it clear that if the Dynegy deal wasn't consummated, Enron's next stop would be a junk level rating.

For Lay, things only got worse as the week progressed. On Tuesday, Enron made another SEC filing, this one laying out the severance package due the Enron chairman if the company was bought—all $60.6 million of it. No sooner had the filing been made public than it began setting off fireworks within Enron, particularly raising the ire of energy traders whom Enron least wished to antagonize, since they were what Dynegy primarily wished to buy. The traders didn't, per se, object to obscenely large payouts. But they did believe that you had to do something to earn the loot—such as make an even bigger amount of money for your company. In those nervous November days, keeping the traders happy became the prime goal of top management at Enron and Dynegy. If they walked, so would a lot of Enron's remaining value.

Within hours of disclosing his severance package, Lay amended it. Through Palmer, the Enron chief executive said he'd take only a third

of the money due him and he'd take that in stock of the new company. Another third he'd contribute to a relief fund for displaced Enron workers. The final third would go to pay taxes. Not good enough, replied the angry Enron traders. On the afternoon of November 13, traders had a tense meeting with the chairman. When the dust settled, Lay amended his amendment. Now, Palmer said, the chairman would take no severance, which presumably also meant no $20.2 million contribution to any laid-off colleagues.

The tension began taking its toll inside Enron. Palmer and his public relations crew had been fielding four hundred phone calls a day, getting no days off, and going long stretches without sleep. Some nights they didn't even leave the office, snatching a couple of hours of sleep on a couch, across a desktop, or under a desk. Palmer had no time for his family, let alone his favorite form of relaxation, woodworking. Now reporters were calling Palmer at all hours, even a couple of times at home past midnight. He'd lost weight and was haggard and frazzled, snapping at his staff and suffering from bouts of recurring back pain. Palmer had been a true believer in the Enron story, a dedicated Skilling follower. Like other Enron executives, he had much of his personal wealth tied up in company stock.

A few days after the blockbuster November 8 filing, one of the hundreds of press calls to Palmer came from Emshwiller. The reporter had been fuming about the part of disclosure indicating that the third-quarter write-off related to LJM had been far larger than the $35 million figure Palmer had given on October 16 when Enron released its earnings.

"You people misled us," Emshwiller said when he got Palmer on the phone.

"I'm sure we didn't mislead you," Palmer said wearily. But, yes, he'd pass along the reporter's complaint and get back to him. A short time later, he did. "What we told you before was accurate. The LJM-related charge was $35 million. The rest came from investment losses that we would have taken whether there was an LJM or not," Palmer said.

"But they were hidden in the Raptors, which were certainly related to LJM," Emshwiller shot back.

"That's not what you asked," Palmer replied. Enron had accurately answered the question asked.

" 'The 2001 pre-tax earnings amount includes a $711 million pre-tax charge in the quarter ended September 30, 2001, related to the termination of the Raptor special-purpose entities.' That's in your own filing," Emshwiller yelled.

"That's unfortunate wording," Palmer said.

The two argued for several more minutes, getting nowhere before hanging up. A few minutes later, Palmer called back with his boss, Steve Kean. Kean turned up the charm with a soothing, low-key tone that carried the same message. Enron had given an accurate response. But Emshwiller wasn't in a mood to be soothed. He was angry, as much at himself as with Enron. He realized the company had given him a technically correct answer in October, even though it didn't nearly reflect the full impact of LJM-related entities on the earnings. He couldn't really blame them, but he still didn't like it.

Emshwiller kept repeating that the company had misled him. Each time, Palmer interjected, "I didn't mislead you," as Kean tried to soothe the reporter. Finally, Palmer shouted at the top of his lungs, "I didn't fucking mislead you!"

That pretty much ended the conversation. Emshwiller trudged off to vent to Friedland, who commiserated but told his reporter that he didn't have a story.

On the Houston end of the phone, Kean looked at his subordinate and his friend. Go home, he told Palmer. Take a day off, get away from all this. That's an order. Palmer didn't argue.

On Wednesday, November 14, Enron's officials held another telephone conference call, taking their most contrite approach yet. Lay acknowledged to the investors on the line that the company had made some "very bad investments," particularly overseas, which "have performed far worse than we could ever had imagined. . . . Because of these investments and other matters, Enron became overleveraged . . . the negative impact of these investments on the company has been exacerbated through the extensive use of debt. . . . We entered into related-party transactions that produced various conflicts of interest, both real

and perceived. . . . The loss of investor confidence from these transactions has been very damaging. . . . We discovered and disclosed errors in our financial statements. . . . We fully understand and regret that the combination of these events has resulted in the complete loss of investor confidence. . . . We want to regain your support and trust."

Smith listened to the conference call. She was struck by the relative candor of the remarks, but her warning bells sounded when McMahon, now nearly three weeks into the chief financial officer job, mentioned that Enron planned to file its third-quarter financial report, called a 10-Q, with the SEC in a few days' time. This document, which was far more detailed than the earnings press release, was supposed to be filed within forty-five days of the end of the period, which in this case meant by November 15. But with all the turmoil, Enron had asked for and gotten a small extension from regulators. While McMahon and other Enron executives didn't go into details about the quarterly report, none gave any indication that it contained any nasty surprises.

Dynegy officials, more than anyone, wanted to know what numbers would be contained in the 10-Q, which was significant because it provides a snapshot of a company's cash position at each quarter's end. On Tuesday, November 13, Enron got the $1.5 billion promised by Dynegy and another $1 billion in bank loans. Dynegy executives started asking for an advance copy of the 10-Q. Enron officials kept stalling, saying it wasn't ready yet. They were assured that Enron's cash wasn't expected to go below $2 billion. "We relaxed," said one member of the Dynegy team.

On Sunday, November 18, Jeff McMahon suddenly called Dynegy chief financial officer, Rob Doty, with some news. He said it turned out that an Enron investment vehicle called Rawhide had a ratings trigger in it that caused $690 million in debt to come due at a triple-B-minus rating—low, to be sure, but still in investment-grade territory. McMahon said Enron was on top of the situation and not to worry. The company still would have plenty of liquidity, even after shelling out an unexpected $690 million. Doty was stunned. Once again Enron's team didn't seem to know what was happening inside its own company. In fact, Lay later said the Rawhide obligation was a shock to him, too.

At 11:00 the next morning, Dynegy finally got a copy of the 10-Q

that Enron intended to file just five hours later. Almost immediately there was a sense of horror and betrayal at the contents of the seventy-eight-page document. Enron was showing only about $1 billion in cash on September 30. In subsequent discussions, Dynegy came to understand that Enron had only $1.2 billion in cash as of November 16. It was far less than the sum Dynegy expected. After all, Enron had received infusions totaling $2.5 billion, so it should have had more than $3.5 billion. It meant they'd blown through a few billion dollars in less than a week.

"They kept saying they wouldn't go below $2 billion in liquidity, and here they were at $1.2 billion. It was a massive lie," a member of Dynegy's team told Smith. The conclusion: Enron had been using the money, as fast as it could get it, to bolster its trading book. "By Tuesday morning [November 20], we were back to being in a full-fledged crisis." Enron also said it might have to take a $700 million pretax hit to earnings during the fourth quarter because of the plunge in the value of assets held by another of its outside investment partnerships. Only a little more than a week had elapsed since the combination was announced. Watson got on the phone almost immediately with Lay. Doty did the same with McMahon. The message was pretty much the same. Why didn't you guys tell us what was going on? Where's all the money gone? How can we trust you? What the hell is going on over there?

Lay and Watson agreed to meet that afternoon—November 20—at the exclusive Coronado Club in the Bank One building. As soon as the two men were seated, Watson took control of the conversation. He worked from notes he'd prepared, citing the times and places that his team had felt they had been purposely misled. It quickly became apparent that Lay didn't understand Enron's cash position at all. He'd been told it was okay and appeared to have believed it. (One Enron official would later claim to Emshwiller that Lay was someone "who took the absolutely most optimistic interpretation of anything and presented it as reality.") Watson was incredulous. He reiterated a single message: You guys have got to quit surprising us and surprising investors. Incensed though he was, he still wanted the combination to happen. But he knew there had to be a change in the leadership team. Lay and McMahon had to go because they couldn't be trusted to know what was going on.

Dynegy officials said Watson told Lay that, for the good of the company, he and his team had to go. Lay later said he didn't recall being told that but was willing to step down if it would increase the odds that the deal would be consummated. Watson redoubled his effort to save the deal even though it was clear Enron would need still more cash.

The news in the 10-Q sent Enron's stock reeling again. On November 20, the day after the quarterly report was filed, Enron's shares plunged 20 percent to less than $7 a share, while the trading volume kicked up to an astronomical ninety million shares. Prices of Enron's bonds, already low, buckled further under renewed selling pressure. As Enron's share price slipped, it signaled that arbitrageurs were dumping the stock because they didn't think the merger was going to happen. (When mergers look likely, the spread, or difference between the market price and the merger price, narrows. When the gap widens, it means the market is skeptical and demands a bigger potential profit to continue holding the stock.)

With Enron again reeling and its stock price falling, rumors began swirling that Dynegy would have to renegotiate the merger terms. The Enron downdraft had caught Dynegy's share price as well. After hitting $47 a share on November 13, the stock was below $40 eight days later. Publicly, Dynegy officials would say only that they were continuing to do "due diligence" on Enron and its operation in connection with the planned merger. It was a far cry from the enthusiasm that Watson and his team exuded in the early days of the merger pact.

Throughout November 20, Dynegy teams huddled together. When the top financial guys got together in the afternoon, Dynegy demanded to know: Where the hell did all the money go? They met with their bankers, and it was clear that the exchange ratio would have to be lowered. The last vestiges of goodwill were destroyed.

The teams broke late on Wednesday, November 21, in preparation for the Thanksgiving holiday, expecting to be back at the negotiations that Friday. Everyone knew that the old exchange ratio was dead. Dynegy's group convened at 8:00 A.M. with all the lawyers, finance people, and investment bankers. Watson, meantime, had flown to Cabo San Lucas to spend Thanksgiving weekend with his family, though he spent much of each day on the telephone.

The group walked down the street to Enron's headquarters at 9:00 A.M. Lay, Whalley, and McMahon were there, although Whalley did most of the talking. It quickly became clear that the investment banks held the key to keeping the deal alive, and at one point Whalley reportedly told the group, "Look, I got to sit down with the banks and put a gun to my head and say, Help me or I'm done." No one was exactly sure how much money was needed, but it was clear something needed to be done to stabilize the trading operation.

On Saturday, November 24, the teams flew to White Plains, New York, to the Arrowwood resort near the homes of the key bankers. Morgan was represented by its vice chairman Jimmy Lee, and the Citigroup team was led by Mike Carpenter, head of investment banking, who reported to chairman Sandy Weill. Each bank had a team of fifteen to twenty people staked out in different meeting rooms, meeting with Enron executives and then alone. They gave Dynegy the lowdown: Enron needed $3 billion, and they proposed that the two banks and Dynegy go forward "shoulder to shoulder," each ponying up $1 billion.

Dynegy responded that it was ready to put in more money if the merger terms were changed. It wanted to make sure that what started as bank debt would quickly be converted into equity. Otherwise the deal would basically blow up Dynegy's balance sheet. But the banks were cool to the proposal. They were focused on creating a three-year bank holiday so Enron's maturities wouldn't come due before there were funds for repayment. What they didn't want was overdue loans that they'd have to place massive reserves against. The banks wavered, and in the end they agreed only to a financial package of $500 million to $750 million.

Late the next night, Sunday, the boards of both companies met and approved the revised merger terms. Instead of a conversion ratio of .2685, it would be .12—meaning that Dynegy would buy all of Enron's shares for less than half than originally agreed. And Ken Lay had to step down.

At 5:00 A.M. Monday, November 26, as the teams disbanded to return to their homes, one Dynegy attorney passed Ken Lay in a hallway. Lay stopped and extended his arm, and the two men gripped hands. Lay thanked the Dynegy team for flying to White Plains, for being away

from their families on Thanksgiving weekend, and for working through the night to keep the deal alive. "He was unfailingly polite and gracious," said the executive, impressed by Lay's composure. "He just had a bunch of forty-year-olds telling him he had to go. That's not the way it was supposed to be done."

But he also ended the exchange with his worst fears about Lay confirmed. He'd lost control of his company through inattention, and he'd been surrounded by people willing to tell him whatever he wanted to hear. He'd had relatively little contact with Fastow, unlike Watson, who talked daily with his CFO, Doty.

On Monday, the Dynegy team was back in Houston and back at work. Bergstrom and Watson met with their group at lunch, seriously concerned with whether enough money had been pledged by the banks to meet Enron's thirst.

Watson tracked down Lay while the Enron jet was on the tarmac in Teterboro, New Jersey. The two talked privately for half an hour with Watson expressing his misgivings about the merger deal. Lay's attorney later said his client expressed "grave disappointment" and concern that Watson's "action would cause serious consequences for Enron for which he would be called upon to share responsibility." The pair conferenced in Jimmy Lee and Mike Carpenter, the Morgan and Citigroup bankers, respectively. Lay's attorney said that the bankers "expressed shock" and "believed Mr. Watson was pulling the rug out from underneath everyone." The call lasted an hour. In the end, Watson agreed to go back to his team and consider options for going forward.

Tuesday morning there was another call. Watson wanted a guarantee that the banks would put in more money, and he wanted the debt converted to equity. The amount he had in mind was $1 billion. But the banks balked.

The negotiations continued, with Watson becoming more and more convinced that he was witnessing a train wreck. Enron was still bleeding, and it didn't look as if enough money would be coming in to create stability. Morgan lashed out once more, through Lee, and Citigroup got quieter and quieter.

By Wednesday morning, November 28, Enron was a $4 stock. Rumors were everywhere that the deal was off, which only pushed the

stock down further. The credit-rating agencies were closing in. S&P's Ron Barone called both Enron and Dynegy. He left word at Dynegy that unless CFO Doty called him back immediately, he would presume the merger deal to be dead. Doty didn't call back.

Barone called a senior executive at Enron. What are the chances of getting a renegotiated deal? the analyst asked.

About one in one hundred, his source replied.

Barone knew what needed to be done. He convened an emergency meeting of the credit committee. After clearing the decision with senior S&P officials, the agency lowered Enron to a deeply non-investment-grade rating. At 9:30 A.M., with the downgrade, roughly $3.9 billion worth of debt came due, probably four times as much money as Enron had by then. A short time later, Dynegy announced that it was calling off the merger deal. Enron's trading operation, long the company's crown jewel and biggest profit center, ceased operations. The nation's biggest energy trader went dark.

21

"Don't Approach
Their People Again."

THE LAST WEEK OF NOVEMBER, WITH ENRON'S WORLD CRUMBLING rapidly, Emshwiller flew into Houston. It was the first trip either Smith or Emshwiller had made to the city since Enron's crisis had begun a month earlier.

As Emshwiller sat on the Continental flight, he thought about his last trip to Houston some twenty years earlier. Then, too, he'd been chasing down an energy industry scandal for the *Journal*. That one had involved the massive violation of federal oil price controls during the 1970s, when international embargoes and political upheavals had sent petroleum prices soaring. Evidence suggested that a ring of oil traders, including some of the nation's biggest oil companies, had taken part in a scheme to defeat federal price controls in a series of complex trades known as "daisy chains," in which the same barrel of oil passed through many hands. Somewhere along the way, the barrel's classification would be changed illegally from controlled oil, which sold for about $6 a barrel, to uncontrolled oil, which sold for over $30 a barrel. Though this fraud involved hundreds of millions of barrels of oil and hundreds of individuals, only a handful of people ever went to jail.

By the early 1980s, a new gusher of wealth flowed into the Houston economy. As one of his first acts as president in 1981, Ronald Reagan had removed the last tattered vestiges of federal price controls on oil. For a time it was quite a party, a precursor to the one that Enron helped

throw in the late 1990s but short-lived. But by the mid-1980s, a lot of Houstonians were riche no more. The skyrocketing oil prices of the previous decade had stimulated oil production and encouraged conservation. By 1986, there was a world oil glut and prices had fallen to around $10 a barrel from above $30. Hundreds of oil-related businesses in Houston went out of business. Real estate prices plummeted. Many of the city's big banks, burdened by bad oil and real estate loans, either closed their doors or merged with out-of-state institutions. Indeed, the void left by the collapse of the local banking industry gave Skilling and Enron the opportunity a few years later for its great gas bank success.

The weather in Houston was gray and cold with rain threatening when Emshwiller's plane landed. He navigated his rental car downtown to the Hyatt Regency hotel, a block or so from Enron headquarters. Before coming, he'd made more than a dozen calls trying to set up interviews. Though most of the calls hadn't been returned, he had arranged meals with two analysts, Olson and Coale. He'd also set up a brief meeting for that afternoon with a person close to Fastow. The person had been reluctant to meet but had agreed after the reporter repeatedly emphasized that he really did want to get Fastow's side of the story. The source had suggested meeting in the café in the Hyatt lobby. The reporter checked his watch: he still had a little over an hour before that appointment.

He called Palmer at Enron. While still in Los Angeles, he'd tried to set up a dinner meeting, but the PR man had been unwilling to commit to a meeting, saying that things were too busy and in too much flux. "Call me when you get in," he had told Emshwiller.

When the reporter called from his hotel room, Palmer begged off any dinner meeting. He said things were incredibly busy and he was exhausted. "I didn't get any sleep last night," he said.

Emshwiller expressed his condolences. "How about if I just stop by now to say hello for a few minutes," he said. He thought he could at least get a look at Enron's offices.

Palmer said he was going into a meeting. "Call me back later in the day," he said.

While waiting for his interview with the Fastow friend, Emshwiller made a few more calls from his hotel room. He reached no one but left

messages with secretaries and voice mails. He didn't really expect any callbacks. He'd already called some of these people more than half a dozen times with no success. But, as a reporter, he had been taught to be persistent, if not optimistic.

Like other Hyatt Regencys, the Houston location featured a huge central atrium that went all the way to the top of the building, with the corridors to the rooms carved like layered ridges rising up the sides of a giant cave. It had all the intimacy of a train station. Voices seemed to echo, and the reporter instantly regretted having agreed to do interviews there.

His meeting with the Fastow friend was short, pleasant, and not particularly informative.

"Enron asked Andy to take on the LJM partnerships," the person said. "Everything he did was approved by the board. He doesn't feel he did anything wrong."

"Why was he essentially fired, then?" Emshwiller asked.

The source said Fastow still hadn't figured that out.

"Who actually told him he was being put on leave?"

"I think Lay called him." (Emshwiller and Smith would later be told by an Enron official that Greg Whalley, the new Enron president, actually delivered the news in his typically brusque way. "Greg called a meeting of senior executives, including Fastow and McMahon. He pointed at Jeff and said, 'You're in.' He pointed at Fastow and said, 'You're out.' ")

"Do you think Andy would be willing to give any details about his departure?" Emshwiller asked as he nursed a Diet Coke.

"I doubt it," said the person, who had turned down an offer of food or drink.

After the meeting, Emshwiller checked his messages. There were none. Again he called Palmer, who finally agreed to meet briefly, but not at the Enron building. "Things are too hectic here," he explained. Palmer, too, suggested they meet in the café in the Hyatt lobby. When they got together, Palmer passed on the offer of a beer, which he didn't feel would go well with a lack of sleep and the pain pills he'd been taking for his chronic back problem. "I can't stay long," he said. He de-

fended his current boss. "Lay felt misled on Chewco. There were things that he and the board didn't know," he said.

The next morning, the reporter walked over to Enron Center. The two towers gleamed through the rain and gloom, though the tops of both buildings had been swallowed in a fog of low-hanging clouds. The corporate logo—a big, tilted silver "E," bordered in blue and red and green neon strips—rose several feet up from the steps leading to the older tower. Emshwiller remembered reading that the logo had been created a few years earlier as part of a campaign to increase Enron's name recognition. According to one article, the company had done a survey, which found that members of the public thought Enron was a Klingon weapon on *Star Trek,* a fruit importer, a cosmetics company, a hiking shoe, or a brand of golf balls. Skilling had said at the time that the media campaign, which included buying TV spots during the Super Bowl, would help make Enron one of the most recognized corporate names in the world—right up there with Coca-Cola and McDonald's. Well, the reporter thought as he gazed at the logo, Enron had certainly become better known in recent weeks.

A giant American flag hung, like an apron, midway up the new building, apparently a touch of post–September 11 patriotism. The building was supposed to house the most sophisticated trading room in the world. As a reminder of the newness of that new building, the glass-enclosed elevated walkway that connected the two towers like an umbilical cord still contained packing crates and cardboard boxes. A TV news van was parked in front of the buildings. Emshwiller couldn't see any activity in it or around it. It just seemed to be waiting. On one local news show the night before, the big Enron story had been what would happen to Enron Field, home of the Houston Astros baseball team, if the company collapsed. Would its name be changed? (It was eventually renamed Minute Maid Park).

A steady stream of employees flowed into the two buildings, which at the company's height housed some 9,000 people. Some were chatting in pairs or groups, others walked alone, bundled against the cold and mist. Everything looked perfectly normal. Emshwiller wondered how many more days they'd all have jobs. If the Dynegy deal fell apart, most people

thought bankruptcy would be Enron's only alternative. A bankruptcy filing would likely bring large-scale layoffs and other cost-cutting measures. Though the last five weeks had sometimes seemed like forever, he marveled again at how fast and how far Enron had fallen in so short a time.

Walking through downtown Houston earlier in the morning, he had passed towers that carried logos for Dynegy and Reliant and other energy companies—a sort of yellow brick road of the power business, leading to Enron, on the edge of this skyscraper row.

Already reporters and pundits were beginning to talk about Enron and its excesses as a quintessentially Texas phenomenon—a mixture of western wildness and the wildcatter's nose for wealth in a place where bragging was considered a modest virtue and people viewed themselves as citizens of not just a giant state, but a giant state of being. Certainly Enron had ambitions and hubris big enough for a Texas tall tale. The conservative, generally free market politics of Texas meshed nicely with the company's deregulation preaching and support for Republicans. Enron had found Houston to be a most hospitable place.

At the same time, though, the Enron executives seemed very different from the good old boys Emshwiller had met twenty years earlier when he rooted around in the Texas oil business. Those were guys who could happily drive a vehicle with longhorns on the hood or a gun rack in the rear. But Lay of Missouri was a Mercedes man. Skilling of Illinois split his driving time between a Mercedes and a Land Rover. Fastow of New Jersey tooled around in a Porsche. Lay had a weekend house in Galveston. He also had several vacation homes in Aspen for himself and his family. Fastow had a sixty-eight-acre spread in Vermont, and Skilling had his own foreign investment in a house outside Rio de Janeiro.

While Houston had plenty of wretched excess, so did Hollywood and Manhattan and Silicon Valley in the 1990s. Enron's leaders—drawn to Houston from around the country—belonged to a national fraternity of business, where in the 1990s arrogance and greed took increasingly large places at the table. While Texas was big, the world was bigger. And cyberspace had no boundaries.

Emshwiller roused himself and walked into the Enron building. He got no farther than a set of guarded security desks, where identification cards were needed to get access to the elevators. Emshwiller called Palmer from a lobby phone, still hoping to get a little color for the feature by taking a quick tour of the building.

But Palmer turned him away. "It's another bad day. We're incredibly busy," he said.

"I'll just come up for a few minutes. Just to say hello," Emshwiller said.

"Maybe tomorrow," Palmer replied, adding that he had two calls waiting and had to get off.

That's great, Emshwiller thought. Can't even get in the building to see the flack. In the lobby was a large electronic message board that carried stock quotes, naturally including Enron's, which by then had fallen back down to about $4 a share as worries about the Dynegy deal grew. In recognition of the merger pact, Dynegy's stock price had been added to the message board. The reporter noticed that beneath the stock quotes, in a continuously moving band of electronic letters, ran the message: "Enron . . . endless possibilities. Enron . . . endless possibilities. Enron . . ."

He did set up a breakfast with Carol Coale, the Prudential analyst. Thankfully, she didn't suggest the Hyatt. Instead they met several blocks away at the Bistro. The restaurant, tucked into a corner of the venerable Lancaster Hotel, had good coffee, few customers, and ceilings that didn't stretch to the sky—an excellent place for an interview.

Coale was still seething over the way Enron had pulled the wool over her eyes and angrily remembered her lunch meeting with Lay on the day after Skilling quit. "He said, 'You are really going to like our third-quarter results,' " she recalled, shaking her head.

Emshwiller met John Olson, the analyst, for lunch. He was a weathered, slightly gaunt figure, as courteous and soft-spoken in person as over the phone. He wore a dark suit and tie. His office, though small and cluttered, had a nice view of downtown Houston. On one wall hung a framed note from Lay to the chairman of Olson's firm. "John Olson has been wrong about Enron for over 10 years and is still wrong.

But he is consistant," read the note, which was signed "Ken." When his boss passed the note on to Olson, the analyst had a good reply. "You know that I'm old and I'm stupid, but at least I can spell the word *consistent*."

Over soup and sandwiches at Treebeards, a cafeteria a short walk away, Olson said he'd heard that sixty people in Enron's non-energy-trading operation were being laid off. He expected many more layoffs. Morale at Enron was awful, he said. "The traders are totally pissed off," Olson said. "Some are just turning off their screens and refusing to trade."

The analyst was already trying to calculate Enron's postbankruptcy prospects. "It's now an asset game," he said. He figured that Enron had some $62 billion to $65 billion in assets, about $40 billion of that being "hard" assets of plant and equipment. "If they could get $3 billion in new financing, they could probably operate" the trading operation while in bankruptcy, he said. Companies in bankruptcy often got fresh borrowings after the filing because those lenders got priority in repayment over previous creditors. Even with additional funds, Olson said, keeping the doors of the trading operation open "would be hard."

Emshwiller continued calling people, trying to set up more meetings. That evening he called Ben Glisan's home. He had called a couple of times in the past but had gotten only an answering machine. This time Glisan's wife answered, and then the former Enron treasurer promptly came to the phone. He said he really couldn't talk about Enron, but he was friendly and seemed in no rush to hang up. He even apologized for not being more forthcoming. Emshwiller sensed that Glisan really did want to talk and might—with the proper prodding. The two chatted for perhaps five minutes, with Emshwiller dropping in suggestions along the way about meeting face-to-face. "If nothing else, we can just have a cup of coffee and you can listen to what I've heard about you and the company," the reporter said. It would be just a get-acquainted session, completely off the record.

"Okay, under those conditions, I'd be willing to get together," Glisan said finally. He named a coffee shop near his home, and they set a time for the next morning.

As he hung up, Emshwiller felt very good. Glisan had worked closely on LJM and Chewco. Here was someone who could answer all kinds of

questions about the inner workings of Enron. And while Glisan had hardly promised to talk, he had agreed to meet, and that was a first step.

But the reporter felt he had made a key mistake, which he realized moments later. Without thinking, Emshwiller had given him his cell phone number. The reporter had come to the view from some hard experiences that with a reluctant source it was never a good idea to be too reachable. That way, the source couldn't just call and cancel a meeting. He had to be either rude enough to stand you up—and most people weren't—or he had to come to tell you in person about his change of heart. Then, at least, you were meeting. Fifteen minutes after setting up the appointment, Emshwiller's cell phone rang.

"I'm sorry, we just can't get together at this point," Glisan said. "I wish we could."

Emshwiller figured Glisan had in those intervening fifteen minutes called his lawyer, who'd read him the riot act. Kicking himself, the reporter tried to change Glisan's mind. "It will be *completely* off the record. All you have to do is listen," he said, hoping that the emphasis would give his promise more punch.

Glisan remained polite but insistent. Now just wasn't the time to meet. He apologized again and said good-bye.

Emshwiller cursed himself silently, feeling as if he'd blown his chance. Emshwiller thought briefly about driving out to Glisan's house the next morning and knocking on the door, but he decided that would probably just make the guy mad. Instead he paid a visit to LJM's offices, which had moved to an office building across the street from the Enron tower.

The two buildings were connected by an elevated, enclosed walkway. When Emshwiller arrived in the late morning, the front door of LJM's twelfth-floor office was locked. He rang the bell and peered in through a border of glass panes. He could see a woman behind a long reception desk that had one end built into the wall. She gave him a long look before buzzing him in.

Emshwiller identified himself. "I'd like to talk with Mr. Kopper," he said.

"He's not here," she replied in a tone that didn't invite him to sit down and wait.

"Perhaps there is someone else I could talk with," Emshwiller said. "It's rather important."

The last sentence at least moved her to get up from her chair. "I'll be back in a moment," she said as she walked away and disappeared into a back office.

Emshwiller looked around. There was a large open area behind the reception counter with several empty desks. A row of offices lined a back wall. The place had a deserted feel. A woman briefly popped her head out of one office, looked at Emshwiller for a moment, and then popped back in. Just to his left was a small seating area with a couple of chairs and a table. On the table was a stand with what looked like the business cards of various LJM officials. Emshwiller was just about to walk over and take some when the receptionist reappeared.

"We don't have any comment," she said. "If you have any questions, call Kirkland & Ellis, our law firm." The receptionist was between him and the business cards. He eyed them for a moment and thought of going around her to pick some up. Instead he turned and left the office.

The front door had hardly clicked shut behind him when the reporter began to kick himself for not getting those cards. They could have provided new names of LJM employees or at least given him accurate spellings and titles for those names he already knew. Maybe, Emshwiller thought, under the guise of leaving one of his business cards, he could go back in and take some of theirs. Might look a little weird, but it seemed worth a try. He pulled out a *Journal* business card and rang the doorbell again.

The receptionist looked at him but didn't buzz him in. Instead a man came to the door. He peered through the glass. Emshwiller smiled, nodded, held up his business card. The man opened the door partway and then plugged the opening with his body. "I forgot to leave a business card for Mr. Kopper," said Emshwiller, moving forward a step, hoping the guy would step back and let him in. He took the card but didn't budge. The reporter introduced himself again, explained that he had some questions and really needed to talk to someone from LJM. "Could I get your name?"

"You should call Kirkland & Ellis in Washington," the man said.

"Well, whom at Kirkland & Ellis should I ask for?" the reporter said, trying to keep the conversation going.

"Just tell them you are calling about LJM," the man said as he closed the door.

Within half an hour, Emshwiller had a message on his office voice mail in Los Angeles from Dan Attridge of Kirkland & Ellis. Emshwiller called him back.

"I represent LJM," Attridge said in an icy tone. "Don't approach their people again."

"So should I approach you about questions about LJM?" Emshwiller asked.

"Yes, but I might not call you back," Attridge said. "We aren't commenting."

Join the club, the reporter thought sourly. But as Emshwiller stumbled around Houston, getting doors closed in his face and picking up precious little information, events were coming to a crashing climax.

22

"At Least We're Going to Be Part of the Biggest Bankruptcy Ever!"

WHEN THE NEWS BROKE ON NOVEMBER 28 THAT ENRON HAD FALLEN to junk bond status and Dynegy was terminating the merger deal, Smith was in Los Angeles finishing up a page-one story explaining how Enron's swoon was sending shock waves through the energy industry. When Friedland was editing one of her longer stories, she preferred to be there in person so she could pull up a chair and watch the bureau chief work his magic, chewing gum as he tapped away on the computer.

Smith felt she had her hands full with the "shock wave" story. Now Dynegy's decision to pull out of the Enron deal meant New York quickly ordered up another front-page story on how that $9 billion deal had come unhinged. That meant frantic rounds of calls to people she knew at both companies. Smith was surprised to learn that neither of Dynegy's top executives—Chuck Watson and Steve Bergstrom—had traveled to Westchester County, although Ken Lay was there. When Smith talked with Watson she asked him, "How, exactly, did you make the decision to go to Cabo [San Lucas]" with such delicate talks continuing in New York and Houston?

He took umbrage at the implication that he'd been derelict. "We worked our butts off to make this thing work," he said, speaking slowly and with a kind of jabbing emphasis. But he said the constant surprises from Enron—always unpleasant—left him no choice but to back away. "I wasn't about to put our balance sheet in jeopardy," he said.

On the day that the Dynegy deal publicly fell apart, EnronOnline went off-line. With all the turmoil and uncertainty, there seemed no point for Enron to try to do any more trading for the time being. Who wanted to do business with a company that didn't look as though it would be around to honor its commitment? Indeed, pretty much every business activity inside Enron headquarters halted as employees traded rumors about looming bankruptcy and mass layoffs. Even at that late date, some true believers still thought Enron could pull off one more trick, though nobody seemed to have any idea what it might be. All kinds of rumors were flying, not all of them about Enron's business prospects. One story making the rounds had the company placing a security guard beside Lay's car in the company parking lot to prevent any disgruntled worker from vandalizing it. Enron officials said it was true that a guard had been stationed there but said it was in response to the terrorist attacks of September 11.

As the day ended, Enron employees streamed out of Enron Center and headed, by the hundreds, to neighborhood watering holes, impelled by the news of the collapse of the Dynegy merger and the knowledge of what that meant for the company's future. Before leaving, one of the people who tended the electronic message board in the lobby had the presence of mind to remove Dynegy's stock quote. If Enron was going down, it would at least sink without flying the onetime ally's flag.

As Smith began to crash out a story for that night's paper, Emshwiller followed Enron employees to the bars around town. His guide was fellow *Journal* reporter Alexei Barrionuevo, who was based in the city and knew a lot of energy traders and a respectable number of bars. The first bar they visited had lots of energy company employees, but none from Enron. "Try the Front Porch," said a trader from Duke Energy. Barrionuevo knew the place. It was about ten minutes away in midtown in one of those neighborhoods near downtown that had undergone an economic revival thanks to the influx of thousands of highly paid young professionals at Enron and other big local corporations. Old apartment buildings were being turned into pricey condos. New restaurants and bars sprouted up, their parking lots filled with BMWs and Porsches.

The Front Porch did have a front porch with tables as well as a back room with more tables. A brick wall in the back of the bar was covered

with scores of small pieces of paper, handwritten messages from patrons with their thoughts about September 11. Pity for the victims, love for America, hatred for terrorists. That night Enron workers filled the place, wall to porch. They were drinking heavily and making a lot of noise. Barrionuevo and Emshwiller split up and began circulating, trying to strike up conversations. They found a number of people hostile toward the press, especially the *Journal*, whose coverage was blamed for unfairly sparking the company's fall. One tipsy woman tried stealing the belt off Emshwiller's raincoat as he talked with another Enron worker. She later explained that she hadn't appreciated the *Journal*'s coverage of the company, though she never quite said what she planned to do with the belt.

"The Fastow partnerships were only a small part of Enron," said a tall, thirtyish man who was wearing a small woven cap of many colors. "You guys didn't write about all the great, trailblazing things Enron did."

"You could make a market in anything with Enron," one guy who identified himself only as Bruno told Barrionuevo. "If I wanted to make a market in boogers, I could say to my manager, I'm going to sell them to ten-year-olds, who will sell them to five-year-olds and I can make a spread."

"No one else has the balls to make markets except Enron," added another. "No one would dare do what we did."

"I wouldn't trade the experience for the world," one Enron employee yelled amid the din of scores of people packed into the Front Porch. She had been with Enron seven years and worked in the retail electricity unit. Gesturing at the multitudes around her, she declared, "I feel most fortunate to have worked with these people. I loved it."

Midway through the evening, Emshwiller called Smith to see if he had anything she could use in the next day's story. He caught her as she was huddled with Friedland in his office, trying to improve the first version of the story that already had been sent back to New York for publication. It had been an extraordinarily hectic day. Emshwiller's call infuriated Smith. She was working full out, and he sounded as if he were having a grand time.

But Smith wasn't interested in being entertained. She felt Em-

shwiller had spent the last couple of days getting turned away by just about every venue except taverns. She could hear drunken shouts in the background of the latest call. Testily, she thought about how she'd written stories every day that week and Emshwiller hadn't come up with anything usable (though material he gathered in Houston did work its way into a later front-page story). They got off the phone after a few minutes. Even though Emshwiller made essentially no contribution to that night's story on the Dynegy deal going south, she told Friedland to add Emshwiller's byline, more for old times' sake than anything. After all, she thought, he *had* gone to Houston.

Emshwiller wasn't having quite as good a time as his colleague thought. The bars were packed and extremely noisy, making it difficult to have any kind of coherent conversation. He was beginning to lose his voice from shouting so much. He had called Smith on his cell phone while he stood outside in a rainstorm. It was simply too noisy inside to carry on a phone conversation. Fortunately, he managed to retrieve his raincoat belt.

Off the phone and back in the bar, Emshwiller was flagged by an Enron employee, who was sitting at a table with some colleagues and had been watching the reporter circulate around the room. "The Justice Department should investigate this company," he said.

He and others in the bar were in a lather over Skilling and Fastow. They were mad at Fastow for the partnerships that did so much to bring down the company, and they were mad at Skilling for letting Fastow do it. In their minds, both had deserted the company. "Skilling was an asshole," one person told Barrionuevo.

By contrast, almost nobody blamed Lay that night; good old Ken, the captain who was going down with the ship. "Ken Lay was a good guy!" shouted one person above the din. Maybe, thought Emshwiller as he smiled back and scribbled notes. But Lay had also been chief executive of the place for almost its entire history. CEOs were supposed to know what was going on at their companies.

The next morning, Emshwiller drove out to River Oaks, Houston's equivalent of Beverly Hills, with lots of big homes and lots of tall trees, some of them even oaks. Upscale shopping centers and high-rise condos

were sprinkled in the mix along with assorted country, equestrian, and garden clubs. According to one local guide he'd read, River Oaks had been developed in the 1930s along one side of Houston's main waterway, known as Buffalo Bayou.

Emshwiller visited the address he had for Michael Kopper's home. Rumor had it that Kopper was building a giant, multimillion-dollar mansion. The rumors had it only part right. He was clearly building, or at least rebuilding, a house. While it was a nice place on a nice street, it was in a part of town that looked like any upscale suburban neighborhood. The big estates of River Oaks were elsewhere. Clearly, nobody was living yet in the Kopper house and there were no construction workers around at the moment.

The reporter drove along Kirby Drive, one of the area's main drags, and passed the Huntingdon. According to local newspaper stories, the Huntingdon had been built in 1984 with some of those little touches designed to tickle the fancy of the wealthy and aspiring—such as an oval sitting room that had served as the boardroom for Lloyds of London, the insurance giant of the British Empire, complete with Waterford crystal chandeliers and burled wood paneling.

Taking up the Huntingdon's entire thirty-third floor was the home of Ken and Linda Lay. According to people who had been there, the Lays had filled their apartment with elegant furniture, rich rugs, and expensive art, with enough of an emphasis on religious themes to make one visitor feel she was walking through a five-star monastery. The place had the requisite oversize rooms and walk-in closets, one with a long line of blue dress shirts and the master's collection of cowboy boots. The elevator, key-coded for privacy, opened into the Lays' foyer. To ensure added privacy for residents, the Huntingdon kept a guard at the front of the building, next to the topiary. A second staffer manned a desk at the entryway. A third, at a desk in the foyer, provided the last line of defense before the elevators.

One Enron official had told Emshwiller of being invited, along with a few hundred others, to a Christmas party at the Lays' apartment in 2000, complete with valet parking and Victorian-garbed carolers in the lobby. It was a pleasant affair, but a brief one. The invitation noted that the party would last only an hour and a half. Promptly at the ninety-

minute mark, someone—presumably a servant—flashed the lights in the apartment to let the partygoers know it was time to go recalled one attendee.

But Emshwiller's main target that morning was a short drive away from Lay on a tree-lined cul-de-sac. Jeff Skilling's mansion was a Mediterranean-style palazzo with sandstone-colored walls and terra-cotta tile roof. The place was just built, and it had an unfinished look, with grounds still wanting for greenery and no fence around the property. Emshwiller remembered reading how Skilling often bragged about his dislike of walls at Enron, how they interfered with the free flow of ideas, how he had battled with building management staff when he had ordered that partitions that separated members of his team be torn down. Maybe, Emshwiller thought, Skilling had carried that no-barriers philosophy to the perimeters of his home. Or maybe the fence was coming with the shrubs. Whatever the reason, Emshwiller was grateful for this unexpected access and parked his rental car on the street, walking unimpeded up the driveway to the front door.

He peered in through a glass panel and saw a large, mostly black-and-white entryway with a staircase in the back curving up to the second floor. Emshwiller rang the doorbell. A woman's voice, with an accent that might have been Hispanic, crackled over the intercom. No, Mr. Skilling wasn't there. No, she didn't know when he would be back. Yes, she would tell him that a *Wall Street Journal* reporter had been there. Yes, that would do a lot of good, Emshwiller thought as he started walking back to his car.

Before he got halfway down the driveway, a black Mercedes turned in from the street and drove past him. Skilling was at the wheel. He threw Emshwiller a quizzical glance. The reporter gave a small but friendly wave. Car and driver disappeared behind a corner of the house. A moment later, Skilling walked back down the driveway. He was wearing blue jeans, a leather jacket, and what looked like a couple of days' growth of beard.

Emshwiller extended his hand, introduced himself, reminded Skilling that they had talked over the phone in August, and told him that he knew Skilling had been turning down interview requests but wanted make his pitch personally.

Skilling shook the reporter's hand. "I'm just not giving interviews at this time," he said in that same soft voice that had come through Emshwiller's phone in August.

Emshwiller hadn't actually expected to see Skilling on the visit to his house. Really rich guys usually don't come to the door or even have doors that can be reached. The two stood silently for a few seconds in the bright morning sun as Emshwiller tried to figure out what to say next. "I'm sorry I bothered you at home," the reporter said lamely.

"That's okay," said Skilling. "I understand this is a big story."

Emshwiller gave his pitch. "We're working on an Enron story at the *Journal* and obviously you'll be part of it and we'd really like to get your side of things. After all, you are viewed by many people as the architect of the company." The reporter hoped that either flattery or concern about what the *Journal* might write would get him to change his mind.

"I just don't think it would be appropriate for me to comment at this time," Skilling said in a slightly more emphatic tone. He started walking toward his door.

"Could I leave you my phone number in case you change your mind?"

Skilling stopped and looked at Emshwiller. "Okay. Give me your card," he said.

The reporter fished around in his pockets and then recalled that he had given out his last card the night before to an intoxicated Enron employee. Embarrassed, he pulled out his notebook and scribbled down his name and number, hoping it was legible. Skilling took the paper without comment. They shook hands and said good-bye.

That night, his last one before flying home, Emshwiller went back to the Front Porch. It was much quieter. While Enron employees were there again, the numbers were far fewer than the night before. As he circulated around, sipping a beer, Emshwiller wondered again how many of the people he'd seen in the last two days would soon be out of work. Probably most. It was a tough break. They hadn't done anything wrong. Yet the room didn't have the feel of some unfolding tragedy, not that night or the night before. Almost everyone he'd met from Enron was in their twenties and thirties. Most had come to Houston from somewhere else, with shiny résumés and lots of ambition, attracted by Enron's money and reputation. They seemed like the kind of people who could

pretty easily pack up and find work elsewhere. He thought back to covering the auto industry in the 1970s, when the big carmakers had begun permanently eliminating tens of thousands of assembly-line jobs; that had seemed much more the stuff of tragedy than this. .

Even the Enron workers, while expressing sadness about the company's fall, kept a certain braggadocio to the end. One bespectacled young Enronian, plump and hardly looking old enough to have been served beer, suddenly raised his arms as if his team had just scored a touchdown. "At least," he shouted with gleeful bravado to his table companions, "we're going to be part of the biggest bankruptcy ever!"

"Laydoff.com"

ON DECEMBER 2, 2001, ENRON FILED FOR PROTECTION FROM ITS creditors under Chapter 11 of the U.S. Bankruptcy Code in Manhattan federal court. The step itself was hardly surprising; indeed, it appeared to be the firm's only realistic option. But the enormity of what had happened was brought home to Smith and Emshwiller on that Sunday afternoon. In less than two months, Enron had fallen from the lofty heights of corporate America's upper crust to its most debased depths. Its name had become synonymous with corporate malfeasance. The two reporters had followed every development related to the company, yet the details of its demise and the culprits behind it were still very much in the shadows.

The external reasons for the collapse were straightforward: A massive loss of market confidence had produced a plummeting stock price, which in turn contributed to ever greater demands for cash collateral to back its positions in its trading book. That chain of events strained Enron's liquidity to the breaking point, which pushed down its credit rating, further tightening the financial vise.

But there were still crucial questions to answer about the root causes of the company's failure. The most fundamental of these was, why hadn't the company seen, at a much earlier stage, the folly of some of its business practices and reformed itself? From all appearances, a handful of opportunists managed to ruin the whole operation. Yet it seemed

clear, in hindsight, that Enron's consuming ambition had blinded it to basic rules of conduct. Like too many companies of its era, Enron had put a premium on producing stellar financial results rather than supplying high-quality goods and services. Senior Enron executives flouted elementary conflict of interest standards. The company hired legions of lawyers and accountants to help it meet the letter of federal securities law. While trampling on the intent of those laws, it became adept at giving technically correct answers rather than simply honest ones. Enron's leaders created a company that was stunning even as it rotted within.

Appropriately enough for a company that aspired to be a twenty-four-hour-a-day trading powerhouse in every corner of the world and the far reaches of cyberspace, Enron took advantage of a new electronic filing feature at the New York bankruptcy court and sent in its bankruptcy petition on a Sunday. Smith was home when she got a phone call confirming that the filing had been made, and she quickly turned on her computer to see if she could download a copy of it. Another Sunday fire drill, she thought, wondering how she was going to get what was surely a massive document downloaded on a plain old copper telephone line and wondering if she should go into the office and work from there. Although she wrote the main story that ran the next morning and contributed to two others, half a dozen reporters were pressed into action, including reporters in New York, London, and Houston.

Emshwiller didn't contribute to the bankruptcy story that Sunday. He was at home in the upstairs spare bedroom turned writing room, trying to bang out the first draft of a front-page story reconstructing Enron's collapse. This was a kind of bread-and-butter feature that the *Journal* often did on big, breaking stories. The idea was to step back and try to put events into some larger perspective, while giving the readers at least a feeling of being inside unfolding events. Smith was sending him copy for this latest joint venture, focusing her efforts in particular on what had happened in the Dynegy negotiations.

Emshwiller had been sitting in his home office pretty much nonstop since arriving home from Houston the previous Friday. Wrestling with the story, he silently cursed the company's decision to make its bankruptcy filing on Sunday. He had hoped that Enron would at least wait a

day or two more. Now, with the climactic event having happened, he knew the editors would be clamoring for him and Smith to finish up the retrospective piece as soon as possible—and certainly before *The New York Times* weighed in with one.

There was more behind the timing of Enron's filing than was at first apparent. Since the collapse of the Dynegy merger the prior week, Enron had been madly rushing to assemble the paperwork for the bankruptcy filing. Though the company had hired the Weil, Gotshal law firm in October to handle a possible bankruptcy, preparations had largely been put on hold because of the Dynegy deal. With that road to salvation gone, Enron quickly revved up the bankruptcy option. Adding urgency to this work was the fact that Enron officials wanted to be the first firm to file an action at the courthouse so they could choose the venue. New York had handled lots of big bankruptcies, and it was generally felt a court there wouldn't get as emotionally involved as would one in Houston, amid all the angry and soon-to-be-displaced Enron workers.

There were other, equally powerful reasons for Enron to want to be the first to file an action. It needed to halt the $3.9 billion in credit claims that were unleashed by the ratings downgrade. If it got the bankruptcy filing in before its creditors asserted their rights, it could delay the payments until an orderly process had been created and, most likely, reduce the total sum that eventually would have to be paid.

Top Enron officials figured that Dynegy was probably preparing its own lawsuit against Enron as a result of the failed merger. If Dynegy sued first, they figured, it would likely choose a Houston court, seeking a more sympathetic ear. Enron realized that it could no longer expect any hometown advantage. In fact, Dynegy was thinking less about suing than securing its claim to Enron's Northern Natural Gas pipeline. Dynegy feared that if Enron filed for bankruptcy before the claim was made, it might have to wait until the end of the bankruptcy case to get its pipeline. As quickly as it could, Dynegy gathered its board together to approve the merger termination notice.

A young lawyer from Dynegy walked down the street to deliver a letter to Derrick, Enron's general counsel, staking its claim to the pipeline. Dynegy followed up with e-mails and faxes. Enron didn't respond.

Enron lawyers and executives worked almost nonstop from the time

of the merger's collapse on Wednesday through the Sunday court filing.
Several didn't get home at all during that period. Late Saturday night,
they kept a watch on the Dynegy office tower a few blocks away. The
lights on the floors occupied by Dynegy's legal staff went out about 2:00
A.M. Sunday morning, though they were never sure exactly why. Enron
officials figured that Sunday, December 2, had to be their D-Day. Fortu-
nately for Enron, the New York bankruptcy court allowed electronic fil-
ing, so the company could get its papers in on the weekend. Along with
the bankruptcy filing, Enron filed a $10 billion damage suit against Dyn-
egy for calling off the merger. Dynegy countersued. Once again, it was
playing follow the leader with Enron.

Enron had made what's known as a Chapter 11, or "debtor-in-
possession," filing. This allowed the company's management to con-
tinue operating the firm, under the supervision of a federal bankruptcy
judge, while it tried to work out a plan of reorganization and debt re-
duction. Under a Chapter 11 reorganization, a company aims to pay off
as many of its outstanding obligations as possible and emerge from
bankruptcy as a viable company. However, if the debts are too great or
the problems intractable, the proceeding would be switched over to a
liquidation mode. Enron's operations and assets would be sold off or
closed down. Either way, with a company as giant as Enron, the bank-
ruptcy proceeding was almost certain to grind on for years.

The Sunday filing—along with separate filings by thirteen of its sub-
sidiaries—listed a total of $50 billion in assets and $40 billion in debts.
By a good margin, Enron was the biggest company ever to file for bank-
ruptcy law protection. The previous record holder had been oil giant
Texaco Inc., with $36 billion in assets, which filed for bankruptcy in
1987 after losing a multibillion-dollar lawsuit in connection with its
purchase of Getty Oil. Enron's preliminary list of creditors ran for fifty-
three single-spaced pages, topped by the company's favorite banks, Mor-
gan and Citigroup, which together claimed to be owed some $4 billion.

As Smith read through the filing, she was dumbfounded at all the dif-
ferent Enron units that were named. She never knew they had so many.
But the whole company didn't go into bankruptcy. Several of the more
profitable segments were left outside the proceeding, although in subse-
quent months more would be forced into the case. By the end of the day,

after sending through some small fixes and worrying about whether she'd been able to give the story enough "lift," Smith finally was off deadline and had time to feel the story instead of just thinking it.

She felt enormously let down. It was the same feeling she'd had some weeks earlier, when Enron's stock started its day-by-day descent. She remembered a friend saying that it was amazing how the market was punishing Enron. Smith felt sickened by it, actually, because she knew that sort of drubbing, in the end, always ended with people losing their jobs. How many thousands will lose their jobs now? she wondered.

The answer to that last question came quickly. The very next day, Monday, December 3, employees headed to work at Enron headquarters, just as at the beginning of any other workweek. People milled around talking, swapping new rumors about massive layoffs and emergency meetings of managers to decide who would stay and who would go. Signs of what was to come soon surfaced. Around 10:00 A.M., Mark Lindquist noticed that his office computer no longer had access to the company's internal network. Since the thirty-nine-year-old information technology specialist helped maintain and repair the company's computer network, this step seemed like an ominous sign. Lindquist soon found that other computer specialists had similarly been cut off. He and his colleagues figured that management was worried that Enron's own tech experts might sabotage the system in a fit of vengeful anger.

With nothing to do, Lindquist and some friends took an early lunch, around 11:00 A.M. When they got back, they were called into a department meeting. There, some man Lindquist didn't recognize read from a script and told everyone to go home. Take only what you could carry. Be out in an hour. Later in the day, a message would be left on each person's office voice mail about his or her employment status. And please be professional when leaving the building. As he read his script, though, the stranger himself seemed on the verge of tears.

As Lindquist listened, he felt a sort of numbness coming over him. Like others, he'd figured layoffs were coming. People at headquarters had been speculating about it for weeks. In late November, he'd even started polishing up his résumé. But now that the layoffs were a reality, it suddenly dawned on him that after more than six years working at the Enron building, this might be his last day on the job. People began hug-

ging, crying, snapping pictures with cameras they'd brought in, packing, and trying to say good-bye in the time they had left.

When Lindquist arrived home, he began putting out job-hunting calls and checking his voice mail, sometimes every hour or so, sometimes every fifteen minutes. But for hours, he received no official word about his future at Enron. As he waited, he worried about his wife, his fourteen-year-old daughter, and particularly his three-year-old son, Garrett. The young boy had autism and needed almost daily therapy, which cost thousands of dollars in out-of-pocket expenses each year. Taking care of him was a full-time job for his wife, Kim. What, Lindquist wondered, would they do if he lost his $56,000-a-year job and his insurance coverage?

Finally, at midnight the message came. It thanked him for his service to Enron, said he'd been an asset to the company, but his position was no longer needed. Another stranger's voice delivered the message. Lindquist had at least expected his supervisor to deliver the bad news. He later learned that his supervisor, as well as his supervisor's supervisor, had been laid off.

By the time the department meetings were done and the voice mails had all been delivered, some 4,000 workers in Houston had been let go. Another 1,100 got the ax in Europe. In its heyday, Enron had constructed a generous severance package for laid-off workers, which included two weeks of pay for every year of service and another two weeks of pay for every $10,000 increment of salary. So a ten-year veteran making $70,000 a year would get thirty-four weeks of pay, or more than $45,000. As the company prepared for bankruptcy, Lay pushed to keep that package intact. It was, he argued, the least the company could do for all those people. But Enron's lawyers countered that the bankruptcy court and the company's creditors would never allow for such a generous payout while there was the possibility that Enron might not pay all of its debts. It would be cruel, they said, to promise the laid-off workers something that couldn't be delivered. Better to commit to an amount that was certain to be approved and then work to increase the payout later. The amount deemed to be safe: a paltry $4,500 a head. (Eventually Enron gave laid-off employees up to $13,500 each.)

Marie Thibaut had been an administrative assistant in the broadband

unit, a fifteen-year Enron veteran. She and her whole group were laid off on Black Monday. That Wednesday she was home in her kitchen, making phones calls and trying to find out about her severance and her insurance, wondering how a sixty-two-year-old single woman was going to find a new job and make ends meet. Suddenly she heard a tapping on her kitchen window. It was her pool service man and his wife. She hardly knew them, but she must have looked so distraught that they were moved to ask if she was all right. Thibaut started crying after she let them in. For what seemed like the longest time, she couldn't stop crying as two near strangers hugged her and tried to offer comfort.

Janice Farmer had worked at Enron's natural gas pipeline operation in Florida for sixteen years. She'd done administrative work in the department that negotiated pipeline rights of way with landowners. She took pride in the company and the work she did. In November 2000, Farmer retired at the age of sixty. Her company retirement account, filled with nothing but Enron stock, had a value of nearly $700,000. She looked forward to a comfortable retirement. Her home in Orlando was paid off. She planned to use some of her Enron retirement money to travel a bit with her adult daughter and son.

Farmer had never seriously thought of diversifying her holdings and didn't worry even when Enron's stock started falling in early 2001. The entire market was in a slide, she reasoned. Enron stock had been down before and had always come back. But when Enron announced the big third-quarter loss in October, her faith began to fray. Perhaps she should move some of her cache, now down to about $350,000, out of Enron stock and into other securities. She called the firm that administered Enron's retirement accounts. The reply she received from a pleasant-sounding customer service representative turned Farmer's nervousness into panic. Earlier in the year, Enron had hired a new firm to administer its employee retirement accounts. As a result, all accounts had been "locked down" while the new firm took over. During the lockdown period, no changes could be made in an individual's retirement account. When would the lockdown period end? Mid-November, the representative replied.

Farmer suddenly had visions of her entire life savings evaporating if Enron stock kept plummeting. She begged, she pleaded, she cried on

that phone call. But the lockdown was set and couldn't be changed. The service representative did apologize for any inconvenience the arrangement caused. By the time Farmer was able to sell her Enron stock, the value of her retirement account was reduced to $20,000. Marie Thibaut pulled out about $22,000 from an account that once had been worth $485,000.

As part of the bankruptcy, Enron added insult to the economic injury. The company offered $50 million to scores of "key" employees to induce them to stay with the company postbankruptcy. Retention payments were commonplace in bankruptcy cases. But the amounts paid by Enron seemed outsize, particularly to the lower-level employees, who felt as if they'd lost everything.

Jeff McMahon, who had recently been elevated to the post of Enron president, received $1.5 million. Some executives received several million dollars. McMahon later acknowledged in congressional testimony that he probably hadn't needed that level of inducement to stay. The bonuses were especially generous given that they obligated recipients to stay only for ninety days, a fraction of the time it would take to get through bankruptcy reorganization.

Since this was a twenty-first-century business disaster, many laid-off workers gathered in cyberspace. Half a dozen Web sites sprang up with addresses such as "Laydoff.com," "Kenron.net," "EnronX.com," and "1400SmithSt.com." Anger and anguish, hope and camaraderie, mixed with bits of dark humor. One on-line discussion forum asked former employees to rate their overall experience at Enron. Many tried to answer that question earnestly, separating the good years with Enron from the nightmare of recent weeks.

Both Smith and Emshwiller trolled the sites occasionally, looking for people they could call who might have something interesting to say about the company.

At Yahoo Finance, a well-known Internet stock chat site, a message board about the Enron collapse elicited nasty messages about more than just Enron's top management. It was payback time for those years that Enron strutted around Houston and the energy-trading business as king of the roost. One person, who claimed to work at another trading firm, wrote that Enron "was nothing but a collection of arrogant assholes. . . .

I AM SO ELATED THAT THIS HAS HAPPENED!! . . . THE BEST PART IS WE ARE GETTING RESUME ON TOP OF RESUME AND YOU WILL NOT BE CONSIDERED!!!!!!!!!!!!!!!!!!!!!!!!!!!!!"

Enron had been an enigma when it was riding high, and it remained an enigma when it was laid low. While the world now knew something about LJM and Chewco and Raptors and various other assorted Enron-related creatures, it had precious little knowledge of their precise origins or operations or, in some cases, the reasons for their failures. What had gone on in the Raptors with all those hundreds of millions of dollars' worth of deals, and what exactly had been LJM's roles in those transactions? How had Andy Fastow made more than $30 million from the LJM partnerships? Or was it $45 million? How many other suspect transactions had there been that were still unknown?

Why had Enron decided to renounce its accounting treatment of Chewco four years after it created the device? Emshwiller continued to wonder. The company had given only the most cursory of explanations for a decision that contributed mightily to the company's restating four years' worth of financial statements, the move that delivered the coup de grâce to Enron's credibility.

What role had the enormously influential institutions had in helping Enron work up so many sleight-of-hand contrivances? The big commercial banks, the big investment banks, the law firms and accounting firms and consulting firms—all worked closely with and profited greatly from Enron in its glory days. How much did they know about the company's labyrinthine operations and the rot within?

Had any of Enron's activities broken laws, civil or criminal?

By the time of the bankruptcy filing, dozens of shareholder suits had been filed and the SEC still was investigating. Given the splash that Enron's fall had made, it seemed likely that the Department of Justice and its foot soldiers—the Federal Bureau of Investigation—might soon be fanning out across the company, looking for evidence of prosecutable wrongdoing.

And still larger questions loomed. If Enron had broken laws or accounting rules or simply broken the bounds of decent conduct, was the company an aberration or a disturbing emblem of what happened in the corporate world during the 1990s? It would have been comforting to

be able to label Enron simply as some rogue operator. 1 didn't seem plausible. The fact that no one went to authorit. what it was doing—when scores of people inside different p firms must surely have known—said something about how ins corporate blight likely was.

Ultimately, Smith wanted to know who was most to blame. H Lay really been as clueless as so many people represented? How did Jeff Skilling know, and did he quit just when it seemed to him the feat of keeping the house of cards upright seemed futile? Who re proposed that LJM be created—Fastow or Skilling or someone else? 1 were important questions, but the one that kept nagging at Smith w. why so many people cooperated in the schemes that seemed crooked o1 their face.

Smith and Emshwiller knew that the answers to these and other Enron-related questions wouldn't come quickly, if they came at all. But with Enron now resting quietly in bankruptcy, the reporters were look- ing forward to having a little more time to probe some of the many dark corners that they had only been able to rush past in the previous frantic six weeks.

PART FOUR
Aftershocks and Revelations

24

"There Will Be Something Else Fun and Exciting on the Other Side."

Now that Jeff is at the helm, we thought you might want to know a little more about him. We certainly did. So we asked him more than 20 insightful questions, and this is what he had to say:

> **What do you like best about your job?** An opportunity to change the world for the better
> **Who would you like most to meet?** Nelson Mandela or Johnny Carson
> **If you couldn't do what you are doing now, what would you do?** Fly DC-3s for the CIA in Africa
> **Favorite fictional character**—Yosemite Sam
> **Did you ever fail a class?** Business History (can you believe it? My favorite thing!) at Harvard Business School. In spite of it, graduated a Baker Scholar (top 5% of class)
> **Biggest regret**—got married too young, had children too old
> **Favorite lunch**—Arby's

The list went on. It had been sent to employees by the Enron public relations department in early 2001 as part of an effort to introduce Skilling as the new chief executive and make him seem more like one of the guys. It had been passed to Emshwiller in his reporting for a profile on Skilling. Profiles had long been standard fare at the *Journal* and other

big newspapers. They were a way to humanize big stories and make them more accessible to readers. Sometimes a profile might be just a quick overnight job that did little more than use two or three interviews to dress up an official biography of some central player. However, full-blown profiles, especially a front-page piece for the *Journal*, could involve weeks of reporting and dozens of interviews. The time and effort needed to do one of those stories was a major reason the paper hadn't yet done a profile of any of Enron's major figures.

Postbankruptcy, *Journal* editors wanted profiles of Lay, Skilling, and Fastow—the three men most closely tied to the rise and ultimate fall of Enron. Others were also interested in the trio. Congressional investigating committees subpoenaed those three and other Enron executives to testify early in 2002.

Fastow, who had long been the man in the shadows, showed no inclination to bask in the congressional spotlight. "On the advice of my counsel I respectfully decline to answer the question based on the protection afforded me under the Constitution of the United States," Fastow told a subcommittee of the House Energy and Commerce Committee. This committee, headed by Louisiana Republican Billy Tauzin, had quickly become Enron's most aggressive and outspoken inquisitor on Capitol Hill. While Fastow mostly looked serious, sometimes even stricken, his signature smirk also occasionally made an appearance. His new criminal lawyer, John Keker of San Francisco, blasted Congress for forcing Fastow "to present himself as fodder for this degrading spectacle."

For several weeks, Lay's representatives had assured the Senate Commerce Committee that the Enron chairman would testify. Despite the dangers of prosecutors using anything he said against him, one could understand why Lay was tempted to talk. He was a public man who had long cherished his public reputation. Almost right up to the day of the hearing in late February, it appeared that Lay might well choose the legal dangers of talking—without any promise of immunity—over the humiliation of taking the Fifth. But in the end, Lay also opted for certain embarrassment over possible incrimination and chose the path of silence.

Skilling, however, testified before both House and Senate panels.

Some of his former Enron colleagues thought that this courageous—or reckless—display was Skilling's attempt to quiet rumors that he had been a coward who had deserted the company when he saw troubles brewing. Others thought it was another exercise of an Enron-size ego that had no fear facing down a nest of hostile politicians. "He seemed eager to come," said one congressional staffer.

"I am here today because I think Enron's employees, shareholders, and the public at large have the right to know what happened," Skilling told the House panel in his opening statement. He then went on to say he didn't really know a lot about some of the company's crucial accounting and finance decisions. Off-balance-sheet entities, he said, "are commonplace in corporate America." Skilling insisted that he knew of no wrongdoing at the company. "It is my belief that Enron's failure was due to a classic run on the bank, a liquidity crisis spurred by a lack of confidence in the company," he declared. "At the time of Enron's collapse, the company was solvent, and the company was highly profitable, but apparently not liquid enough."

It was a bravura performance, but it hardly quieted his critics. "You were a self-avowed, . . . control-freak CEO," said Representative Edward Markey, a liberal Democrat from Massachusetts. "But what you have done today is invoked the *Hogan's Heroes'* Sergeant Schultz defense of 'I see nothing, I hear nothing.' "

"On the date I left the company, on August 14, 2001, I had every reason to believe the company was financially stable," Skilling shot back.

If that was the case, Emshwiller thought for perhaps the hundredth time, then why had Skilling sounded so stricken and obsessed with the falling stock price during their August 15 interview? The reporter had always believed that if he could only answer that question, he would have a keener sense of how culpable Skilling was. Emshwiller always thought that Skilling was the most intriguing personality of the three, perhaps because of that first, strange interview. Fastow seemed very much the corporate apparatchik, a competent technical guy who would do just about anything to keep his bosses happy and advance his own career. As for Lay, "willful blindness" often came to mind. It was a term most often used by law enforcement officials to describe respectable bankers who consciously tried to stay ignorant of lucrative drug money-

laundering operations going on at their banks. But the phrase seemed to fit Lay perfectly. Even though he was CEO for almost all of Enron's history, he was more than willing to float blissfully above the muck that was filling up his company—and to pocket tens of millions of dollars in the process.

Skilling clearly was the brains of the operation, but he also seemed to be a tormented soul. There seemed to be at least two Jeff Skillings. There was the soft-spoken man who could sound lost as he muttered to himself about the falling stock price. Yet Smith and others had encountered the other Skilling, the fast-talking, insufferably self-assured executive. Some described him as the classic type A personality, as in "Arrogant." An Enron official related an incident one morning in which Skilling cut in front of a line of employee cars waiting to drive into the company parking lot. The drivers honked and yelled at the rude behavior. Skilling flipped a middle finger in response and later expressed surprise that people had gotten upset at him. He had been late for a meeting. Couldn't others understand that he had important business? The questionnaire that Skilling had done at the beginning of his brief reign as CEO seemed a strange mixture of these two personalities, a document that was both self-deprecating and self-congratulatory—sometimes in the same sentence (for example, when he admitted flunking a course at business school but couldn't help adding that he still graduated in the top 5 percent of his class). And in all the world of fiction, from Austen to Zola, Skilling picked a cartoon character as his favorite literary figure? (Skilling would later tell people that he thought the questionnaire had asked for his favorite cartoon character and Yosemite Sam was, after all, pretty nifty.)

The line about Arby's certainly reflected Skilling's culinary tastes, according to former colleagues. On business trips, he would grouse about going to expensive places when they could have gone to a Jack in the Box. He regularly quaffed Diet Cokes from a Styrofoam cup. (Lay, by contrast, sipped Evian water from cut crystal and had his coffee served on a special blue-and-gold Noritake china service.)

Skilling had a personality that never quite fit into the traditional world of CEOs. Glatzer once told Emshwiller that in 1997, as part of his litigation, he flew to Houston to sit through his lawyer's deposition of

Skilling. It was a more than five-hour affair taken in the fifty-first floor conference room of one of Enron's law firms. Glatzer said he went to take the measure of a man that he never met but who had meant much to him. He found Skilling a mixture of insufferable arrogance and unexpected affability. He even showed a flash of humor.

When the Enron president walked into the deposition, he somberly asked whether others had heard about the airplane hijacking out of Dallas that morning. "He said that it was a plane full of lawyers on their way to a bar association meeting," Glatzer recounted. "And the hijackers were threatening to release one lawyer every hour until their demands were met." Glatzer thought that the joke, delivered in a deadpan style, had been pretty funny—though he wondered how Skilling's own attorneys felt being mocked by their client.

But Skilling also had a strange moment during that deposition, which like most depositions was a largely tedious affair of complex questions interrupted by lawyers' objections. So it was with some amusement—and a dash of amazement—that Glatzer said he watched Skilling break into song during a break in the deposition.

"I need some hot love," Skilling crooned. "Need some hot love, baby." As he crooned, Skilling was "gyrating his body," said Glatzer, who added that the performance went on like this for about 30 seconds. "I started laughing," he recalled, apparently breaking the mood. Glatzer did add that the episode took place when Skilling walked over to a window and peered out at a band playing music in a nearby park, fifty-one floors below, and joined in the song.

Emshwiller was tempted to tuck that particular story away as a Glatzer yarn—until he read the deposition transcript. There, after recording a series of questions and answers on "volumetric production payments," the transcript showed the witness crooning about "hot love," evidently unaware that the court reporter was still taking down events.

"That was off the record," Skilling said to the court reporter.

"You wish," shot back Glatzer's lawyer, Patricia Hill.

Then, there was the matter of Skilling smoking on the job. He was generally about a half-a-pack-a-day man. When the craving hit during the workday, Skilling didn't join his subordinates who were lighting up outside of Enron's headquarters, a non-smoking building. Nor did he

simply close the door to his spacious fiftieth-floor office and light up in private. Often he and his Enron buddy Cliff Baxter walked to a nearby parking garage, one not routinely used by company employees, to light up. Other times, he hotfooted it down to his car and drove around the block while having a smoke. Then, he'd whisk back up to the task of building a globe-girdling business empire for the new millennium.

In their own peculiar way, Enron executives often appeared intent on conforming to the rules, or at least the letter of them. Enron routinely and in some detail reported its LJM dealings in its SEC filings as required by the law. Unfortunately the law—at least as interpreted by Enron—didn't require SEC disclosures to be intelligible to the average person. Emshwiller and Smith had read the sections on the partnerships several times and still couldn't make heads or tails of it. They looked like they were written so that no outsider could.

In reporting the Skilling profile, Emshwiller and his *Journal* colleague Kathryn Kranhold learned that he'd been born in Pittsburgh but had grown up in Aurora, Illinois. He was the second oldest of four children—three boys and a girl—of Tom and Betty Skilling. As a teenager, he'd shown an aptitude for gadgets. He'd worked at a local cable television station and had wired his family's home with speakers and created a control room in the basement. Each of the kids took turns playing DJ—early career practice for his older brother, Tom, who grew up to become a TV weatherman.

Newsweek, however, came up with the most interesting insight into Skilling's family life when one of the magazine's reporters called his parents in Aurora. Tom Skilling said the kinds of supportive things you'd expect of a father. Betty Skilling was another matter; she didn't seem inclined to give him the benefit of the doubt. "When you are the CEO and you are on the board of directors, you are supposed to know what's going on with the rest of the company," she said. "You can't get off the hook with me there. . . . He's going to have to beat this the best way he can. . . . I don't think he knew he was in such high water, but I think he must have had some idea because he resigned. . . . That's what these high-flying jobs do to you. They distort your personality."

Skilling's younger brother, Mark, tried to provide some damage control when he spoke to Emshwiller. "My mother has been watching TV

and [has been] suffering like the rest of us. She is seventy-seven, soon to be seventy-eight, and she hasn't had experience in the corporate world." Mark Skilling was a lawyer who worked and lived in Turkey. When Emshwiller asked for an interview with Skilling, he was instead offered a chance to talk with Mark. Though Emshwiller could tell that Mark Skilling didn't relish being grilled by a reporter, he also clearly adored his brother, describing him as "one of my life heroes." He was happy to praise his older brother—both to Emshwiller and to other reporters—and recount their youth together. He was understandably less enthusiastic talking about his mother's magazine quotes.

"Our mom didn't cut us much slack when we were growing up," he said. "One of her favorite sayings was 'I'm from Missouri.' " He later called back from Turkey. If the reporter had to write about their childhood, he said, "just say that we weren't coddled."

Smith's reporting had unearthed details about Skilling's "mighty man" overseas excursions. While these trips, taken with Enron colleagues and business associates, were supposed to be relaxing, Skilling's idea of fun wasn't exactly laid-back. On several of the trips, he and William Kriegel, the French-born founder of Sithe Energies Inc., butted heads like Bighorn sheep. During a week-long trek across the Australian Outback, the two executives roared around in separate Toyota Land Cruisers, racing to be the first to that day's destination. New vehicles had to be brought in to replace damaged originals. Fellow travelers quit counting the flat tires that the pair produced. "These weren't trips for the fainthearted," one participant told Smith. When the group met aborigines, Skilling was one of the few who shared in their meal of grub worms—swallowing the creatures headfirst, without chewing, just as his hosts did.

Yet the adventurous, energetic Skilling could quickly be replaced by a sullen, withdrawn figure. "He definitely was moody," a former aide told Emshwiller. "If he was in a good mood, everything worked, but if he wasn't—don't even talk to him."

In the mid-1990s, Skilling came up with a bizarre-sounding plan under which he would be the chief executive of Enron's rapidly growing trading unit, working just half of each month. Another executive would run the place the rest of the time. The fact that Lay seriously enter-

tained the idea seemed to underline how much he was willing to accommodate his star executive and how, even then, Enron was willing to chuck the normal rules of corporate behavior. Skilling, who viewed himself as more of an entrepreneur than an executive, seemed to think the idea was perfectly sensible, given all the hours he put into building the trading operation. Ultimately, though, the idea was scrapped. Some Enron executives attributed the change of mind to Skilling coming out of a funk. However, Mark Skilling told Emshwiller that "Jeff decided there was just too much work to do at Enron."

Unlike Lay, Skilling wasn't a joiner, the patron of a hundred good causes. But when he did lend a hand, he threw in the whole body. Pat Bertotti, president of the Houston chapter of the National Multiple Sclerosis Society, told of how Skilling had become a major supporter of her organization's annual 180-mile, two-day fund-raising bike ride to Austin. He heavily recruited Enron employees to take part in the ride, tacking a sign-up sheet to his office door and appearing in commercials on the TV monitors in the Enron elevators. Skilling himself pedaled the entire distance and slept in a field with hundreds of other riders. Typically, senior corporate executives stayed overnight at a hotel or the home of a friend on the route. By 2001, Enron had a team of five hundred riders, who raised $1 million, nearly 20 percent of the event's total. Skilling personally accounted for $100,000 in donations.

Emshwiller asked Bertotti why her charity so caught Skilling's interest.

For one thing, she replied, Skilling had told her of his own near brush with multiple sclerosis, a degenerative and incurable malady that can cause paralysis. He had awakened one morning in the early 1980s with numbness in his limbs. A doctor told him he might have MS. Though a battery of tests proved negative, Skilling said the waiting period had been "terrifying."

"How would you describe Skilling?" Emshwiller asked.

"He is shy," she replied without hesitation. "When I read all the stories about his supposed hardness and arrogance, I wondered, 'Is that the same person?' "

Several Enron officials who had worked closely with both Lay and Skilling said they ended up liking Skilling better. Though Lay was

smoother and more amiable, they said, Skilling seemed more genuine. "Jeff is not Machiavellian so much as he is someone who's never figured out who he is," said one former colleague. "He's like a kid in some ways. Ken's more gracious on the outside but meaner on the inside." Unlike Lay, Skilling never seemed to care that much about the perks of being a big-time CEO. Lay loved riding on the corporate jets. Skilling looked at them as a way of getting from point A to point B.

Lay, somewhat surprisingly after his silence in front of Congress, agreed to be interviewed by Smith and *Journal* reporter Bryan Gruley for the profile they were doing. Perhaps he was reacting to the public ridicule that rained down on him after taking the Fifth before Congress. He was being raked over the coals in article after article. Adding art to the prose indignities, the cover of *Business 2.0* sported a head shot of Lay, doctored to include a long Pinocchio-like nose, accompanied by the headline LIAR!

Whatever the reasons, Lay decided to talk—with one very large condition attached. He wouldn't comment on anything having to do with Enron's recent history or collapse. And he wouldn't say anything about Jeff Skilling or Andy Fastow. He would, however, be happy to talk about his early life and how he built the company. Smith, who'd talked with Lay about some of that early history, in happier times, wondered if it was worth a trip to Houston to hear him talk about the good old days. Gruley was more philosophic. "You can't sit across from a guy for several hours and not have him say *something* useful," he insisted. So Smith and Gruley flew to Houston.

The two reporters had done dozens of interviews in preparation for the one with Lay, and Gruley had visited towns where Lay lived as a boy. They knew he had much to look back upon with justifiable pride. In many ways, his was a classic Horatio Alger tale. Indeed, in 1998 Lay had won a Horatio Alger Award for having "triumphed over adversity to achieve success." Previous recipients included Oprah Winfrey, Henry Kissinger, and Billy Graham.

Born on April 15, 1942, to Omer and Ruth Lay in the tiny town of Tyrone, Missouri, population 25, Lay, along with two sisters, grew up poor. After the family feed store went belly-up, Lay's father worked at various sales jobs. Money was so tight that the Lays had to live with rel-

atives for a time. Church was the center of family life, and Omer preached at small country churches while working different day jobs, until he was eventually hired as a regular minister by two small Southern Baptist congregations in Rush Hill and Columbia, where he pastored from 1950 to 1964.

As a boy, Lay worked in the fields, plowing or hauling hay, for as little as 25 cents an hour. By the time he graduated from Hickman High School in Columbia in 1960, he had been president of the madrigal singers, winner of an American history award, an honors student, a member of the track team, and chairman of the homecoming festivities. At the University of Missouri, he was president of Beta Theta Pi, the fraternity that prided itself on having the best frat-house grades on campus and required members to study five hours each weekday night and three hours on Sunday.

Bright and earnest, Lay was always good at impressing older men, who became his mentors. He was hired by Humble Oil (which later became Exxon) and ended up writing speeches for the CEO. During the Vietnam War, Lay completed a stint in the navy, where his writing ability caught the eye of Assistant Navy Secretary Charles Bowsher. Bowsher put him on a team at the Pentagon studying military procurement, quite an honor since Lay was a freshly minted ensign. This research later served as the basis of his doctoral dissertation in economics. When one of his former economics professors, Pinkney Walker, became a member of the Federal Power Commission (FPC), he hired Lay as an aide as soon as his navy duty was completed. At the FPC, Lay began to learn about the nation's natural gas system and form his beliefs about the need to deregulate the nation's energy markets.

The Natural Gas Act of 1938 was designed to keep natural gas pipeline owners on a short leash. As the act said, its primary purpose was to "protect consumers against exploitation at the hands of the natural gas companies." All prices, from wellhead to burner tip, were tightly regulated. But energy shortages after the 1973 Arab oil embargo proved to Lay that the regulatory system wasn't working anymore; it was discouraging drilling and the development of new production.

By 1978, price restrictions were eased in order to stimulate drilling. It created twenty-eight "flavors" of gas, with prices tied to the vintage of

production. That same year, a landmark act was passed to increase the sources of supply to the electric industry. Throughout this period, Lay argued that the government should let competitive market forces loose, believing "rational buyers" would favor natural gas as a fuel for generating electricity and running factories since the United States had enormous reserves.

After a stint at the Department of the Interior, where he was an undersecretary of energy in the Nixon administration, Lay joined the Florida Gas Transmission Co. He didn't stay long. By 1979, Lay was the number two man at Transco, a big gas pipeline operator in Houston. The offer forced Lay to confront a major personal decision. His wife, Judie, whom he had met and married while in college, said she didn't want to move to Texas and uproot their two children—Mark, thirteen, and Liz, eleven—from the small-town comfort of Winter Park, Florida. Lay decided to rent an apartment in Houston, alone. Two years later, in June 1982, the couple divorced. Lay agreed to pay Judie $5,000 a month in child support as long as one of their unmarried children was still living with her. After 1986, she got $3,000 a month in support and $30,000 to settle any property claims in their seventeen-year marriage. Even so, Judie didn't complain when she spoke with Smith. She said she'd remained on friendly terms with Lay and stressed that he'd always been a good father who'd bought a prom dress for Liz that was "beyond my means." She added that he'd paid for their kids' college educations and still invited her to share holidays with him and Linda and the rest of the extended family.

Lay had married Linda, his secretary, shortly after his marriage with Judie ended. She wasn't a "trophy" wife in the traditional sense of a successful business executive looking for a much younger woman. She was thirty-seven to his forty. She had three children from a former marriage, but there was romance between the couple and two decades later, the visible attraction was still there. "He worshiped her," recalled one Enron official. At one annual meeting of Enron shareholders, Lay introduced her as the company's "chief inspiration officer." He had her proofread some of the annual reports before they were sent to shareholders. For her part, Linda Lay was extremely protective of her husband. She once angrily phoned the Enron corporate flight center when

she noticed that her husband's travel itinerary didn't include dinner for him on the corporate jet. She frequently e-mailed her husband Bible verses.

By 1983, the gas industry was in the throes of another crisis. Gas "decontrol" was under way, and by 1985, federal regulators had created a law requiring gas pipelines to "unbundle" their services so customers could pick from a menu of services—gas storage, gas shipment, gas commodity purchases—and not be locked into buying everything from single sources. Gas utilities could go directly to suppliers and didn't need to buy natural gas through the pipeline companies. The combination of new regulations and takeover battles created enormous disorder. Many in the industry resisted the massive change; Lay embraced it as long overdue and as an opportunity. He was one of the few optimists.

The disorder also gave him his first big opportunity to take the national spotlight. In 1984, Houston oilman Oscar Wyatt Jr. made a hostile bid for Transco's crosstown rival, Houston Natural Gas (HNG). This gave Lay a chance to put his firm in the position of a white knight or savior. Even though HNG wriggled out of Wyatt's path and therefore didn't need Transco's services, the HNG board was impressed by Lay. He seemed to represent a new breed of economists who were bringing innovative ideas to an industry sorely in need of them. The head of the HNG executive committee, director John Duncan, soon called Lay off the tennis court one day and asked if he'd like to be HNG's next chief executive. (Duncan later became a fixture on Enron's board.)

Lay took the job and quickly began purging HNG executives to get his own forward-looking team in place. Mickey Pieri, former HNG chief financial officer, told Smith he "wasn't given a choice of joining the new team." But he and others didn't fight it because they were given generous severance packages, something that became part of the Lay pattern of dealing generously with people, as a means either to create loyalty or to nip dissent. Lay quickly began doing deals, buying more pipeline companies, including his old employer, Florida Gas Transmission, to increase HNG's clout.

In May 1985, a suitor emerged for HNG. Omaha-based InterNorth had a stronger balance sheet than HNG, which was heavily indebted because of Lay's buying spree. When the two management teams got to-

gether to work out possible merger terms, Lay impressed everyone, one participant later said, because he "wasn't just about pushing molecules down pipes. He was politically savvy and had a vision about where deregulated markets were going." Under the terms of the agreement eventually reached, InterNorth's chief executive, Sam Segnar, was to lead the combined company for two years and then Lay would step up. But four months into the arrangement, the board asked Lay to become chief executive "because he was the strongest man around," said Willis Strauss, a onetime director. Segnar retired with a generous package— and nothing negative to say about Lay, who became chairman and chief executive of the company, in February 1986, that soon was renamed Enron Corp.

Again there was an influx of new people, and Lay favored "bright young guys with fancy degrees," said Jim Walzel, Lay's first lieutenant for a time. "Ken's idea was to bring in as many as you could afford."

Soon enough, Lay was regarded as a visionary who could lead a company successfully through any market mishap or regulatory change. Supremely confident and optimistic, he seemed fearless. By 1987, he was promising big earnings growth for the rest of the decade, even though Enron had just squirmed past two money-losing years as it struggled to reduce indebtedness. He moved Rich Kinder into the president's position and began focusing more on national energy policy. In 1992, Congress passed the Energy Policy Act, which deregulated wholesale electricity markets throughout the nation, giving Enron a new market to go after. State-by-state retail market deregulation followed, beginning in 1996.

At every turn, it seemed, Lay had been presented with enormous challenges and had come out on top. Was it any wonder everyone described him as an inveterate optimist? On the night before their scheduled interview with Lay, Gruley and Smith had dinner with Lay's grown daughter, Liz Vittor, who was a former Vinson & Elkins attorney, as well as his publicist, Kelly Kimberly, who'd been a longtime Enron public relations manager. Though the off-the-record dinner was mostly chitchat, Vittor was personable, opinionated, and a staunch defender of her dad.

The next morning, the two reporters drove to Lay's office in a highrise next to his residence at the Huntingdon. After a brief wait, they

were ushered into Lay's office, and he gave each of them a warm greeting and hearty handshake. He didn't appear to have a care in the world. The office, neither spartan nor opulent, contained a desk, a small conference table with chairs, and a couple of easy chairs. The primary decoration came from a dozen or so framed family photos. Lay, wearing a monogrammed blue shirt with French cuffs and a tie decorated with little farm animals on it, politely offered them coffee and rolls from a tray.

Did he feel that he'd given too much authority to others over the years? the reporters asked.

"I don't think my style of leadership and management has changed," said Lay, not quite answering the question. "My style of management has always been to pick very, very good people, put them in key positions, give them a lot of authority, obviously keep an eye on them. If I feel like they need some help, I'll step in uninvited." In his thirty-five years in management, he'd always tried to staff key positions with "as close as you can get to superstars or breakaway players," but he declined to take the bait when asked if he felt that's what he'd gotten with Skilling and Fastow.

What about the values practiced at Enron?

The "value system was always very important to me. I was always on the forefront of trying to make sure that our people did in fact live and honor those values—respect and integrity. Excellence." But then Lay paused and added, almost as an aside, "And the culture, it's kind of hard to know how far we can go with this." He seemed to struggle about how to explain the disparity between the values he said he'd espoused and what appeared to have been practiced at Enron. But after a moment, he continued, as if by rote, and added with a stammer, "I think we continued to hammer at the importance of that value system."

Smith tried to sort out how he could talk about the value system in light of what had happened at the company. "Well, something happened somewhere. Or a series of things happened. What would you do if you could go back and change things?"

"We can't answer that," interjected Kimberly, the public relations woman.

"We'd like to sometime," Lay added quickly.

The conversation shifted to what Lay was doing these days with his

time. Of course, he said, he was spending "quite a bit of time on legal matters related to Enron's collapse." On a happier note, he added, "I am spending more time with my family which has been very enjoyable." He reminded the reporters that he had five children and seven grandchildren and gestured to their pictures behind him.

As ever, he expressed faith and optimism, the twin pillars of his life that he'd learned from his deeply religious parents. "We are put here for a purpose," Lay said. "We are put on this earth for a purpose. And in fact, with hard work and God's help, we can do great things."

He hadn't changed his beliefs? In light of all that had happened to Enron in the past year?

"No, no," Lay said quickly. "Throughout my whole life there's never been a door closed without another door opening. I don't know what that is. But I am absolutely confident we'll get through this and there will be something else fun and exciting on the other side."

After Smith and Gruley left the building, they got in a rental car and compared notes. Neither could quite believe what they'd just been told. Lay seemed almost preternaturally unruffled. He didn't convey any sense that he felt much of anything about what had happened. The man who had just recounted for the reporters intricate details of gas policy acts and regulatory minutiae was the same man who couldn't recall the grossest details of financial transactions that sank the ship. From a man who'd exerted tight control over a gas company, he became a man who knew almost nothing about the giant trading company. It struck Smith as unreal. Yet there was something plucky about his abiding optimism that reminded her of a quote she'd read years before, attributed to Kentucky frontiersman Daniel Boone. Asked if he'd ever been lost, Boone tartly replied, "No. But I've been bewildered for a few days." Like Boone, Lay seemed like a man who, on a bad day, could feel off his stride but hardly ruined.

In another part of Houston, *Journal* reporter Alexei Barrionuevo was visiting a local "gentleman's" club called Treasures, to gather information on Enron's "cowboy culture" of fast cars and high living. There, dancer Brittany L. Lucas recalled how eight Enron men strode in one day and announced they had $10,000 to spend. "Enron guys were known for spending big money and letting you know they worked

there," Lucas said, adding that she made $1,200 for herself that weekday afternoon, her best day ever. In late 1999, Enron advised employees not to use their company cards at the clubs, citing the clubs in a memo under their discreet billing names.

Other publications followed this same thread: that somehow an overindulgent, lascivious corporate culture had been a key factor in Enron's collapse. "Sex suffused the Enron atmosphere," proclaimed an article in *Newsweek* magazine, which added that young female employees who slept with their bosses were known as the "French Lieutenant's Women." The article talked of a string of office romances with particular attention to Skilling and Carter, who supposedly had the nickname "Va Voom" and was described as "an Enron secretary . . . promoted to a $600,000 job" by the Enron president. (A Skilling lawyer sent an angry letter to *Newsweek* pointing out that Carter had a master's degree in accounting and had been named *the* corporate secretary by the board of directors.) *Newsweek* also visited Treasures, where "in the high-rolling days, Enron traders on their lunch break would buy a bottle of Cristal champagne (up to $575) and repair to the 'VIP Room.' The Treasures manager, who identified himself as 'Mitch,' said he was 'unaware' of sexual favors being bestowed in the VIP Room. Said a stripper: 'If a guy's going to pay you $1,000, use your imagination.' "

Even *Playboy* joined the hunt with a cover story entitled "Women of Enron Uncover Their Hidden Assets." A ten-page photo spread showed five young former Enron employees, draped across various articles of executive furniture as well as a convertible sports car and a single-engine airplane. Pearls of wisdom were sprinkled amid the flesh. Though all criticized Enron, Vanessa Schulte, twenty-eight, said she would miss the company's "cutthroat but energizing competition. It was a lot like Hollywood: fancy cars and people who had more money than they knew what to do with."

While Emshwiller joked with Barrionuevo about his plum assignment at Treasures, he wasn't really sure what to do with the whole question of sex and sexual politics at Enron. Neither he nor Smith believed that Enron's downfall was due to a "sex-drenched, out-of-control corporate culture," as *Newsweek* proclaimed. It seemed predictable that the company would be attacked as being sexually amoral, along with every-

thing else, although Smith never sensed that the Enron crowd behaved any differently from any other group of highly paid people. Wealth went to some people's heads, but others continued to conduct themselves in the responsible, honest ways they'd always lived.

And some of the tales of wretched excess were simply laughable. The *National Enquirer* showed Rebecca Mark, from the time she was the international division chief, riding into a party in black leather vest and pants, clinging to a hunk of a guy driving a flaming red Harley. Smith found that Rebecca Mark's well-publicized ride on the back of that Harley hadn't been part of some late night, booze-soaked Enron bacchanalia. Instead she'd been one of three executives to make the motorcycle entrance, and it had been staged as a spoof, with the help of a local Harley club, for an annual planning session of the international unit. The meeting had begun at 8:00 A.M., and coffee was the strongest brew available.

As the *Journal* reporters chased their profiles of the main actors at Enron, new tips kept flowing into the newsroom. One that came to Smith would lead her into the maze of one of the most audacious deals that Enron had ever concocted.

"Enron Has a Problem You May Want to Write About."

THOUGH THOUSANDS OF INDIVIDUAL DRAMAS PLAYED OUT, FOLLOWING Enron's bankruptcy filing, on a news editor's scorecard, the bottom of the ninth had been reached and recorded. The dazzling Enron of old was gone, perhaps to be replaced by some scaled-down version of the company. It was unclear what the bankruptcy would bring. But whatever happened, the process would take years to reach resolution. And understanding what happened to the company in some detail would probably take longer still.

The press began dissecting past Enron deals and relationships. Transactions by the energy company—and there had been many thousands over the years—were being examined in a new and darker light. The company that once could do little wrong suddenly was being viewed as having done nothing right. Reporters rushed to exhume as many sneaky-looking Enron transactions as they could unearth. In the six months following the Chapter 11 filing, one major news database added ninety-five thousand stories containing Enron's name—more than six times the number that had appeared in the six months prior to the company's third-quarter earnings report.

One anonymous tipster began e-mailing Emshwiller with suggestions about scummy Enron deals to investigate. The person had detailed knowledge of the company, and some of the information proved useful. He also had a sense of humor, choosing as an e-mail moniker "Jeff Skill-

ing"—though the tipster also signed messages with the more self-serious "The Truth Will Be Told."

One of the more useful tips came in early November. Smith received a letter from an Enron employee who identified himself only as "Jim," although later he said it wasn't his real name. He said he'd worked on a number of deals that moved debt off Enron's balance sheet. It did so by tapping accounting rules, including SFAS 125, which let a "sponsor" create a limited liability corporation, also known as a "Special-Purpose Entity," to which it could transfer assets and related debts. The sponsor could retain an equity interest, but it had to attract outside investors willing to put up equity that was equal to at least 3 percent of the entity's total capital.

Smith found the 1996 rule on the Financial Accounting Standards Board's Web site and was amazed at how easy it looked to accomplish the deed. There were very few caveats. The assets transferred had to be isolated from the sponsor "even in bankruptcy" so that they were what bankers call "non-recourse" to other assets owned by the sponsor. The sponsor had to surrender operational control over the assets to others. The outside investors had to have ultimate control over the Special-Purpose Entity. Last, there could be no side deals obligating the sponsor to repurchase the assets committed to the new venture, prior to the maturity of the partnership.

As Jim explained it, Enron built on this rule and then added a few of its own bells and whistles that made the entity really attractive to outside investors. In all the cases he'd seen, Enron retained a significant risk of loss because it offered something called a "total return swap" on the back end of the deals to protect the banks that helped capitalize the vehicles against loss. The swaps were guarantees, in essence, that if there weren't sufficient assets in the partnership to pay lenders the amounts promised when the partnerships were dissolved in five to ten years, Enron would make up any shortfall. The assets he'd seen committed to the partnerships weren't very good, and he felt certain banks would have been reluctant to lend money against them without this special money-back guarantee. This arrangement sounded similar to Enron's commitment to cover shortfalls in the Marlin and Osprey trusts that the press had written about in October. But this person seemed to

be saying that Enron was on the hook for much more than was publicly known.

Jim felt it was probable that Enron would have to scrape together hundreds of millions of dollars in a few years to repay banks the amounts they were owed. He included a detailed diagram of a typical transaction showing assets placed in a vehicle, money borrowed against it, outside equity equal to 3 percent of the total capital being attracted, and how cash flow from the committed assets, such as a power plant or pulp mill, actually moved around and helped service the bank debt.

The operating rules for Special-Purpose Entities had been a subject of debate in accounting circles for some time. In 1988, staff of the SEC began pushing the major accounting firms to toughen the criteria for separation. In response, by 1991, the accounting industry had come up with proposed rules that required the entities to satisfy certain criteria, such as ensuring that the entities were separately managed. Outside investors had to have money at risk throughout the life of each vehicle. They couldn't be cashed out early.

A few days after the original letter from Jim, Smith got a call from someone who sounded young and skittish. "Hey, this is Jim," he said. "Did you get the letter I sent you? I can't talk for long—I'm in a phone booth—but I thought you might have some questions."

Smith was glad to hear from him and told him he'd been a great help. She then tried to get him to slow down, take a deep breath, and talk in some detail about the deals he'd reviewed. She wrote down the names as he spoke—Hawaii 125-0, Ghost, Anapurna, Slapshot, and Cornhusker, among others—and got as much information on each as she could. Before he jumped off the line, she gave him all her phone numbers—home, work, and cell—and then jotted down his cell phone number.

For the remainder of November and December, she tried to get corroborating information by talking with other Enron people. What she wanted was enough information on a single Special-Purpose Entity to write a very detailed story that would trace the anatomy of a deal. She wanted to show how the banks were actively lending money, taking their fees, and, presumably, hoping to get fat off the transactions. After all, Enron was like the proverbial turtle on a fence post. You might not know how it got there, but it was clear it didn't get there alone.

Establishing the cross-relationships between Enron and others was mostly discouraging work. But she knew that good luck could lope around the corner at any time. Indeed, it would make an appearance on the Saturday morning following Enron's bankruptcy court filing, thanks to another *Journal* reporter, Martin Peers, who covered Blockbuster, the video rental unit of Viacom, Inc. Peers forwarded an e-mail—with the subject line "Enron Has a Problem You may Want to Write About"—to Smith, who opened it as soon as she read the intriguing title. She felt as though she were looking into a familiar face. She remembered the so-called video on demand project that the e-mail described, between Enron and Blockbuster, primarily because of the press briefing she'd listened to some time back. She checked the *Journal*'s electronic morgue and saw that the story she'd written was dated July 19, 2000.

The briefing was led by Ken Lay and Blockbuster chief John Antioco. The pair had boasted that they were bringing the "ultimate bricks, flicks, and clicks" strategy to the entertainment market. The two companies were creating the "killer app" that would bring movies, games, and other entertainment into homes, on a pay-per-view basis. They sure know how to slather on the hype, Smith had mused to herself as she took notes on the project. The backbone of the system would be Enron's fiber-optic telecommunications network, its so-called broadband system, which was designed to carry large volumes of data over long distances. Enron's network linked to the phone systems of the Baby Bells, and the digitized movies would reach consumers' homes via ordinary telephone lines enhanced with DSL service. That DSL link looks like the weak link, Smith remembered thinking at the time. The partners didn't appear to see any obstacles in their path, though. "Our global broadband business is designed with a service like this contemplated," Lay had said. Antioco had added that the venture was expected to be a multibillion-dollar business in a few short years. He said Blockbuster was ready to "transition from retail only to multichannel provider" with the help of the twenty-year exclusive deal with Enron. Despite being put off by the PR push, Smith saw things about the deal that did look promising. If the delivery method worked, it could be great for Enron because it could help fill the largely empty "fat pipes" of its broadband operation. Movie watching happened mostly on nights and weekends,

so it would build demand for the telecommunications system at a time when usage otherwise was slack.

A week or so after the story ran, Smith was at a party in the Hollywood Hills and chatted briefly with a woman who worked for one of the movie studios. The woman said that the Enron/Blockbuster deal was "pretty oversold" and she didn't think it would pan out. The technology was untested, and studios didn't want to give up control of their content, she said. That comment sounded more grounded than anything Lay or Antioco had said. In fact, the joint venture collapsed eight months after the announcement, with both sides saying they wanted to pursue their separate visions of the future. Smith thought about it as she read the e-mail forwarded by Peers.

What the e-mail writer claimed seemed almost too incredible to be believed—for any company but Enron. He said Enron had taken the video-on-demand concept, built a partnership around it, and managed to book a $110 million profit over a two-quarter period even though the venture never had any legs under it. In the third quarter of 2001— months after the joint venture was dissolved—Enron had been forced to reverse the entire gain. It was lumped in with its broadband loss that quarter. Smith felt the perfect story had just galloped into view.

The writer had worked at Enron Broadband Services, often called EBS by employees, the part of Enron that had built the coast-to-coast fiber-optic network. By mid-2000, Enron had nearly fifteen thousand route miles of fiber owned or under contract in the United States, but only four thousand miles were "lit," or functional. The industry was afflicted with enormous overcapacity. Demand was anemic. Prices were soft. (Soon, many companies would be seeking bankruptcy court protection, and telecommunications losses, from eroded stock values, would top $2 trillion by late summer 2002.)

But in late 2000, Enron still was pouring in the money. The company had invested more than $2 billion in broadband, and it looked as though the business unit would have nothing but endless quarters of losses.

The writer of the e-mail said the story he wanted to tell was "big, complicated, and will need a lot of checking." But he said it would make

"the SEC and the U.S. Attorney's Office in Houston do back flips"—a bit of hyperbole that reminded Smith that the writer was, after all, a recovering Enron employee. That wasn't what most of the memo was about, though. It was clear that the writer was feeling bitter, a frame of mind Smith noted with caution. The three-page, single-spaced e-mail mostly was an angry tirade about the way broadband people had been fired, en masse, after the bankruptcy filing. Like others at the company, the writer had been called to an 11:00 A.M. floor meeting where he was told the company was slashing payroll.

Jim Fallon, head of risk management for the broadband division, said in an e-mail that most of the workers needed to be out by early afternoon and to "be professional and not take home laptops and cell phones" as they headed out the door. He said that he and a few others would be following in their footsteps "in the next 60 to 90 days."

Fallon was followed by Rich DiMichele, the unit's head of corporate development, who acknowledged the "tragedy that has befallen Enron and EBS . . . and those who have lost so much money." He said he knew people were "hurting" and was sorry departing workers might get only $4,500 in severance pay. He concluded by saying it had been "a pleasure working together." The meeting ended, and the shocked employees gathered up their belongings—pictures of kids, gym bags, books, and coffee mugs—and headed out. A few days later, they learned that Fallon and DiMichele had received retention bonuses, according to an internal company memo, of $1.5 million and $500,000, respectively, as part of the $50 million or so that was doled out to workers.

"Suddenly their sympathy and caring for those that have lost so much seems a little less heart-felt," said the writer. "It's all emblematic of a culture of greed . . . that has developed among the most senior ranks of Enron."

Put simply, the employee was in a mood to talk, though he declined to give his name in the initial e-mail. "For now, call me the Eagle—it's time to get above these turkeys."

Smith e-mailed him immediately, and they arranged a telephone conversation. She was happy that he sounded older and more grounded than "the Eagle" moniker had suggested. He gave her his real name but

asked that it not be used since he feared retaliation. He promised to tell her as much as he could, and he had a long list of names and numbers of others at the broadband unit, some of whom might be willing to talk.

The story, in a nutshell, was that Enron announced the deal with Blockbuster in July 2000 and then set to work making the venture a reality. Enron bankrolled the effort, spending about $20 million. Within a few months, it had a pilot project going in four cities—Seattle, New York, Salt Lake City, and Portland, Oregon—that was actually delivering movies.

But almost from the start, Enron was antsy that Blockbuster wasn't moving fast enough to get the best "content" (that is, movies) from the biggest Hollywood studios. Enron had very lofty ideas about how big the business would get and how fast. Those models showed five hundred customers in four cities by the end of 2000, and fifty thousand subscribers in a dozen or more cities by the end of 2001. Within ten years, revenues were expected to top $1 billion and the venture was supposed to have millions of subscribers.

In December, the top guys at the broadband unit—CEO Ken Rice and operations chief Kevin Hannon—decided to create a legal entity called EBS Content Systems LLC—known internally as "Project Braveheart" in honor of the Mel Gibson movie. Both men had been at Enron practically their whole careers. Rice was known as a proficient deal originator. Hannon was a skilled trader. Together, they'd been big players on the wholesale energy–trading side under Skilling and were expected to find ways to turn broadband into the next big business for the company.

Broadband, so the thinking went at the time, would provide the backbone for a booming new Internet-based economy. At Enron's annual analyst conference in Houston in January 2001, Skilling had used the company's supercharged broadband projections to paint a rosy outlook for Enron. He argued that an Enron share, which at the time fetched about $70, should actually be priced at $126. He reached this remarkably precise calculation by giving a value of $57 a share to the giant wholesale-trading enterprise, $40 a share to the nascent broadband effort, $23 to the money-losing retail energy services unit, and a mere $6 to the old utility and pipeline businesses.

The more Enron could do to rub up against high-tech stars, the more

luster it could rub into broadband. It soon inked a deal with nCube Corp., a company owned by billionaire Oracle Corp. chairman Larry Ellison to provide critical computer hardware. When it announced the Ellison deal, Enron didn't announce that nCube had also agreed to put up $2 million as part of the crucial 3 percent equity stake that would keep Braveheart separate from the energy company.

At its peak, the Braveheart venture had about a thousand customers. Most got their movies for free since it was still a pilot project. Some paid small fees. Total revenues, one senior manager said, were "a couple thousand dollars" over the life of the venture. Nevertheless, Enron booked a gain of $53 million from EBS Content Systems LLC for the fourth quarter of 2000. It barely got in under the wire, Smith later determined, since the entity wasn't registered until three days before the end of the calendar year, according to a search of Delaware records. Enron booked a gain of $57.9 million in the first quarter of 2001.

"The business had no revenues to speak of, no real customers. It's never had an officer or an employee. The only asset was a virtual asset—the Blockbuster deal," said "the Eagle," his voice betraying his disgust.

He provided an invaluable list of possible sources. About half the people Smith called were willing to talk, the highest success rate she'd had on any of the Enron stories. She later concluded that many were eager to talk because they'd been offended by the level of reported profit that their bosses had wrung from the unit. The ones who were the most outraged were the ones who really believed that the broadband technology had something to offer—they just felt it needed some honest nurturing. They weren't in a hurry to get rich quick; in fact, they took satisfaction in starting small and letting what they regarded as the actual strengths of a fiber-optic system come to the fore. One worker described how hard everyone had worked on the technology and how promising it had seemed. "When they came in and said they wanted to monetize $10 million, I gulped," said the manager. When he later learned that, in fact, Enron had booked $53 million off its video-on-demand business that quarter and not $10 million, "I was just floored. I mean, I couldn't believe it," he said. "Clearly they had a system set up where the very senior people figured out, by hook or crook, how to make their numbers" each quarter.

With a $110 million boost from Braveheart, broadband unit losses narrowed to $67 million during the two-quarter period. Another such deal or two and it might actually have begun to report profits.

The information provided by the employees and ex-employees was good, but there were still too many holes. Smith continued to talk to people, but she was bothered by stray bits of information that didn't seem to fit anywhere. One ex-employee said EBS Content Systems LLC had done a deal with Hawaii 125-0—Smith felt a rush, since this was one of the names she'd gotten from Jim earlier.—but it wasn't clear what the relationship was. There also was some involvement from something called "the McGarretts," which sounded like a link to Hawaii as well. As it was explained to her, the name Hawaii 125-0 was an inside joke. It was a reference to the accounting rule SFAS 125, which concerned "extinguishments of liabilities" as well as the 1960s action cop show *Hawaii Five-0*. Put them together and you got Hawaii 125-0. Steve McGarrett was the central character in the television show and appeared to be the name of another series of partnerships. But what was it all about?

With help from Palmer on the inside, Smith eventually got to talk by phone with Enron president Jeff McMahon, who said the company had "capitalized on an opportunity to sell part of the business at far above book value" to a third-party investor. But he wouldn't identify the investor and declined to provide more details.

Broadband employees couldn't even agree on which bank had bankrolled the effort. Some thought it was the investment-banking arm of CIBC, the old Canadian Imperial Bank of Commerce; others thought it was Bank of Ontario or Bank of Toronto.

The Blockbuster deal, McMahon said, "was a proxy for what the business could be valued at. They used it as a guide for what revenues could come into the business eventually." The deal had been "fully vetted" with Arthur Andersen, he said. However, he made clear that he hadn't personally been involved in the deal. "I'm not going to sit here and defend it," he added when Smith's questioning became pointed.

By the end of November, Smith felt certain that CIBC was the outside bank in Braveheart. She'd been told it had invested around $115 million. On November 29, in connection with the looming Enron

bankruptcy, the bank put out an opportune release that said "CIBC today reported it has credit exposure to Enron Corporation entities of approximately US$115 million in senior unsecured loans, letters of credit and derivatives."

Smith called the bank, but it wouldn't add anything to the statement. She made a stab at writing a story. But there still were too many holes. Finally, in desperation, she made a final round of calls telling all the Enron folks that she was sorry, but the *Journal* would be unable to print a story unless she could get definitive answers to some key questions. In essence, she told them, if you want to see this story run, you have to help me nail down the essentials. "The Eagle" called back. He knew somebody who might be able to help. "A packrat," he added.

"God bless packrats," said Smith, immediately jubilant. "What else has he got?"

"Oh, all kinds of stuff," said "the Eagle." "His wife isn't too thrilled."

The next day, Smith got an e-mail and a fax from the packrat, who confessed he had boxes of Enron files in his garage. The key document was titled "Project Braveheart Transaction Summary" and was dated November 2001. Smith felt she'd been given the keys to a hot rod. It was exhilarating to be able to run through the gears, really fast, and finally see the whole Braveheart landscape laid out in front of her. The four-page single-spaced report explained how EBS Content Systems LLC was formed and capitalized, how it was kept separate from Enron's balance sheet, how profits were "monetized," and how future revenues were to be divided. It even included an accounting analysis. The accounting justification may have been the most amazing part. How could the accountants support what was done?

As Smith read the report, it became clear to her for the first time that Arthur Andersen had become the Pharisees of the accounting world. They were so single-mindedly devoted to satisfying a narrow interpretation of the accounting rules that they had completely lost sight of the spirit of honest conduct that was supposed to illuminate and inform their work as certified public accountants. She was beginning to see that when Arthur Andersen gave its opinion, it was a device intended to get the client wherever it intended to go. It made her wonder what all those auditors' opinions, at the back of every annual report, were really worth.

Reading the document, which was a comprehensive analysis written for a reader who hadn't been part of the original deal making, made Smith grateful she hadn't rushed the story—and had put out that special, last-ditch appeal. The structure was far more complex than she had realized, and it explained why some of her sources seemed fuzzy on certain details. There simply were too many of them. Enron had created three classes of stock for EBS Content Systems LLC and raised money through each. Class A was owned by Enron Broadband and nCube, each of which had contributed a flat five hundred bucks and been given 50 percent of those shares. Class B stock was owned by Enron Broadband (a $3.9 million contribution for a 30.2 percent interest), nCube ($2 million, for 54.4 percent interest), and some outfit called SE Thunderbird LP ($7.1 million, 15.3 percent interest). Class C was owned by Enron Broadband ($3.773 million, 100 percent), although it subsequently sold Class C shares to the Canadian bank via the Hawaii 125-0 structure. CIBC advanced the partnership $115.2 million. Enron entered into a total return swap with Hawaii 125-0, guaranteeing the lender against loss.

The 3 percent outside equity requirement came from nCube's $2 million contribution, as well as a like amount carved out of Thunderbird's investment, achieved by taking that $7.1 million stake "and multiplying it by the percentage non-Enron ownership interest in Thunderbird of 28.5452%."

That was the easy part. Next came the division of the revenues.

To Hawaii 125-0, Enron transferred 93.3 percent of the cash flow from the Blockbuster contract for years one through ten. After a series of transactions involving two more Enron-sponsored vehicles—Asset LLC and McGarrett VIII—Enron Broadband reaped a $53 million gain for the fourth quarter of 2000. To come up with the funds, it tapped the $115.2 million from the Canadian bank. In the first quarter of 2001, Enron Broadband "updated its valuation" of the venture, taking into account different tax treatments, and realized another $57 million profit, pretty much soaking up the rest of the CIBC dollars.

It was complex and apparently intended to be. It also showed a pattern that Smith was to see repeated again and again. A plethora of enti-

ties invested and got odd-lot pieces of equity in return. The numbers were odd, too—why, after all, did Hawaii 125-0 transfer 93.3 percent of the cash flow? Why not 90 percent or 95 percent? Smith soon had the feeling she was seeing pieces of a jigsaw puzzle. It seemed clear that she would need to understand a lot of the partnerships before she would have a truly coherent picture of Enron's activities.

It reminded her of what she'd read about the great power trusts that dominated the electric industry in the 1920s and 1930s. One of the biggest, Middle West Utilities, run by Samuel Insull, had so many interlocking companies that it took the newly formed Federal Trade Commission seven or eight years to map them all and figure out how money had been moved among them. Similarly, Enron had become a kind of corporate genome project that could require years to fully map.

Reading through the document, Smith was exultant and appalled in equal measures. She was pleased to get her hands on the material, but it appeared to show a complete boondoggle, financial engineering intended to produce a $100 million gain from a venture that really only had a few thousand dollars in revenue—and no actual profit. By contrast, Blockbuster never recognized any revenues, much less profits, from its joint venture with Enron. Blockbuster officials expressed surprise, later in interviews with Smith, with how quickly Enron had seemed to lose interest in the project. It was as if the company didn't have any patience. It never wanted to do the slow, steady work required to build a business.

Some time later, a senior ex-broadband executive agreed to talk to Smith about the transaction. She asked him why Enron always seemed in such a rush.

"Enron *was* impatient," he agreed, speaking in a voice that seemed angry and defensive. "That was one of the best things about it. You didn't rebuild the goddamned electric and gas industries if you were patient. As we were remaking staid old industries, a lack of patience wasn't something people complained to us about!"

Perhaps impatience was integral to Enron, but it was a characteristic that posed terrible risk. The Braveheart transactions, at best, created the image of a frantically busy Enron beehive. What looked like a sin-

gle, chaotic mass from the outside in fact contained drones and worker bees all going about their assigned tasks. An amazingly complex community was toiling to create lots of honey out of very little pollen.

So much of Enron's energies were devoted, it seemed to Smith, to exploiting accounting rules to make profits out of thin air. So much brainpower went into temporary gains rather than into building projects with lasting value. By any means, was the Enron way, thought Smith. Service, to its customers and clients, didn't enter into it.

"I Really Got Sucked into This One."

"IN SERVING ENRON, MCKINSEY WAS NOT RETAINED TO PROVIDE AD-vice to Enron or any Enron-affiliated entity with respect to the company's financial reporting strategy, methods of financing, methods of disclosure, investment partnerships or off-balance-sheet financing vehicles."

So said a McKinsey & Co. spokesman in an obviously prepared response to two *Journal* reporters, Suein Hwang and Rachel Emma Silverman, for a story they did in January 2002 about the New York–based company's ties to Enron. By that time, McKinsey and many other erstwhile Enron allies were scrambling to distance themselves from the fallen giant.

Beyond that terse statement, McKinsey wouldn't discuss its work for Enron in any detail. Since its founding in 1926, the consulting powerhouse had taken the position that in client matters, discretion was the better part of future business. And in those seventy-five years, the consulting firm had accumulated an eye-popping client list that included hundreds of the world's biggest companies as well as sovereign governments, heads of state, and the Vatican. McKinsey had dispensed advice on everything from the reorganization of the American railroads to the introduction of supermarket bar coding.

While there wasn't any evidence that McKinsey had been involved in the most controversial Enron deals, such as the LJM and Chewco

partnerships, the McKinsey spokesman didn't give his employer nearly enough credit for its long and entwined relationship with the company. The ties between the two went back to the dawn of Enron. After the 1985 merger of InterNorth and Houston Natural, McKinsey was hired to advise whether the corporate headquarters should be in Omaha or Houston. The consulting firm recommended Houston. When Enron looked to cut jobs in the late 1980s, it retained McKinsey, which also provided Enron with strategies for the natural gas markets, according to news articles at the time.

McKinsey staffers, up to fifteen at a time, were almost constantly working out of Enron headquarters on one or another study of the company's internal operations or market strategies. McKinsey people were even among a select group invited to what must have been one of the priciest pizza parties in America. Each year, a group of Enron officials would informally meet one night right after the sixty-four teams had been selected to compete in the men's college basketball national championship tournament. There, fueled by pizza and beer, the participants bid against each other to "buy" the team of their choice. Though Lay and Skilling never made it to that party, several senior executives, traders, and company consultants did attend. One year, two young McKinsey consultants came, much to the amusement of others. "They were kids in suits and ties with laptop computers, preprogrammed on what they could bid," recalled one partygoer. Naturally, the two McKinsey men were razzed unmercifully. Emshwiller couldn't find anyone who remembered how successful the McKinseyites had been at picking basketball winners.

In their *Journal* article, Hwang and Silverman quoted a 1997 McKinsey in-house publication praising Enron's executives as a "new breed of tightly focused and vertically specialized 'petropreneurs' " whose "deployment of off-balance-sheet funds using institutional investment money fostered its securitization skills and granted it access to capital at below the hurdle rates of major oil companies." In English, McKinsey seemed to be complimenting Enron for using creative financing to raise money at a cheap price.

Of course, McKinsey's most significant contribution to Enron probably came in the form of Skilling, who was one of a long line of consult-

ing firm alums who went on to run a major American corporation. (IBM, Polaroid, Delta Airlines, Westinghouse, Levi Strauss, and American Express were among the others.)

Skilling brought many McKinsey concepts with him—such as the performance review committee—that the Enron president viewed as a method to retain Enron's best employees, but which some workers viewed as an unfair weeding-out program. His rush into new businesses, such as broadband, seemed in part a reflection of thinking that came out of McKinsey. One of the firm's senior figures, Richard Foster, coauthored a 2001 book called *Creative Destruction,* the title having been borrowed from a phrase by Joseph Schumpeter, the great Austrian American economist of the 1930s. Foster and his coauthor, a former McKinsey employee named Sarah Kaplan, argued that the only way for major companies to succeed over the long term was to embrace "discontinuity" and "creative destruction." A company should be willing to shed even successful business lines as part of the constant search for hot new growth areas. IBM, for instance, had become one of history's great business successes by selling large, complex computer systems. But that very success made it vulnerable to the rise of personal computers and such hotshot young companies as Microsoft and Apple.

The Foster/Kaplan book had been complimentary of Enron and particularly Skilling. When it came to balancing creativity, risk, and control in the creative destruction process, the authors wrote, "Enron offers one good example of managing these elements to a favorable outcome." (Of course, such praise of Enron and its top management was not confined to McKinsey-based analysts. "Much of Enron's genius for innovation" could be traced to Skilling's early work on natural gas financing that helped lay the groundwork for the company's trading successes, wrote author Gary Hamel in his 2000 book, *Leading the Revolution,* which celebrated the best in corporate management. He quoted the Enron executive as saying, "We knew we would conquer the world because we had a better idea.")

Skilling loved the whole idea of creative destruction, from tearing down partitions to sprouting new businesses to regularly shuffling people around to new positions—or out the door. Skilling was a big Foster fan, Palmer told Emshwiller. "Skilling credited Foster with having a huge in-

fluence on this thinking," Palmer said. In 2000, Enron's board of directors hired Foster to sit in on their meetings and come up with suggestions on how to better carry out their duties. He was still working on that project when the tsunami struck Enron in October 2001.

JPMorgan Chase went a step further than McKinsey in distancing itself from the energy company. In December, Morgan filed suit in the New York bankruptcy court against Enron, seeking $2.1 billion in cash and other assets involving a set of complex financing transactions that involved a whole new cast of obscure entities. Bank officials insisted the suit was more a matter of procedure than hostility, a step needed to protect its interests and the interests of other lenders in the bankruptcy proceeding. Still, Emshwiller thought as he worked on the story about the lawsuit being filed, it seemed inconceivable that Morgan would have taken such an action in Enron's salad days.

Morgan continued to fuel the questions about its dealings with Enron. In the month after the bankruptcy filing, the bank filed another Enron-related suit, this one against a group of insurance companies who were refusing to pay out on roughly $1 billion of coverage that had been written in connection with Enron contracts to deliver oil and natural gas. The deals had been done with a Morgan entity called Mahonia, which the bank had created in the early 1990s in the Isle of Jersey, off the British coast. The deals had apparently been done, at least in part, to help Enron reduce its tax bill as well as to bring cash into the company without increasing reported debt. In a *Journal* story about Mahonia by reporters Jay Sapsford and Anita Raghavan, Enron acknowledged that it hadn't paid any corporate income tax in four of the five previous years. Two tax experts contacted by the reporters described the "lower taxes through trading" strategy as unusual but potentially effective. Senate investigators would later question whether Morgan and Citigroup (which had its own Mahonia-like arrangement with Enron) were improperly helping the company spruce up its financial statements—an allegation that both banks vehemently denied.

While the banking world received post–Enron bankruptcy attention, so too did Wall Street, particularly Merrill Lynch. And with good reason, given its unique role as marketer of the LJM2 partnership. Ragha-

van, who had covered Wall Street in the *Journal*'s New York office before moving to the London bureau, snagged a list of LJM2 investors. It was far more extensive than the patchwork of names that Smith and Emshwiller had been able to assemble. With Enron in ruins, some of those partners were willing to talk in connection with a story the *Journal* was doing on the role of some of the big Wall Street institutions in the rise of the company.

A wealthy Miami-area businessman, Eugene Conese, told Emshwiller that when his Merrill broker first pitched him on a LJM2 partnership, "I thought there was a conflict of interest. My gut feeling was that it smelled peculiar." But after repeated assurances from the broker, as well as direct appeals by Fastow and Kopper, Conese committed $3 million personally and through a family partnership. After Skilling resigned, Conese said he asked LJM2 for his money back but didn't receive it. "I really got sucked into this one," Conese lamented, adding that he and other LJM2 partners had hired their own attorney. (Some of the LJM2 investors later went to court and succeeded in ousting Kopper as the general partner and having an outside firm appointed to oversee the unwinding of the partnership.)

One LJM2 investor told Emshwiller that some of the partners had gotten nervous about the Raptor deals, feeling that Fastow was pushing the limits on these transactions too aggressively. Around the end of 2000, Fastow was asked not to put the partnership into any more such deals. While this source thought the transactions were legal, he admitted that "the optics were very bad."

As sales agent for LJM2, Merrill had made investment pitches to some of its own officials. A few dozen Merrill officials collectively put about $16 million into a limited partnership that invested the money in LJM2. A Merrill spokesman said that all of the brokerage firm's actions in connection with LJM2 had been perfectly proper.

Thanks to Raghavan, the *Journal* was also able to start digging up some of the early history of Enron's executive-run partnerships. She learned that the company's interest in the idea went back to at least March 1995, when Fastow approached Donaldson, Lufkin & Jenrette, another of Enron's investment-banking firms, with the idea of setting up

a partnership that he would run and partly own. At the time, Fastow was only a vice president in Skilling's trading unit. The CFO post was still three years away. But even then, Fastow was viewed as an up-and-comer, who was representing an even faster up-and-comer, Skilling. So when Fastow talked, Wall Street was willing to listen—but not yet willing to always say yes.

Unlike Merrill Lynch four years later, Donaldson, Lufkin flatly turned down the proposal on the grounds that it presented a massive conflict of interest. A Donaldson, Lufkin official involved in the discussions later told Emshwiller that he suggested the conflict could be eliminated if Fastow left Enron to run the partnership. But Fastow told him that top Enron management wanted the arrangement as proposed. Fastow was cordial throughout, never succumbing to the histrionics that he was famous for. The two continued to talk over the next few years, Fastow occasionally bringing up the partnership idea and each time getting the same response. Looking back, even with the wreckage and growing scandal of recent months, this Wall Street veteran still thought that Fastow and his colleagues hadn't started out with any evil intent. They really believed they could handle the conflicts. "They just thought they were smarter than everyone else," he said.

However, some people who knew Fastow told Emshwiller that Wall Street had supplied inspiration for the LJM idea. By the mid-1990s, there was an evolving "merchant banking culture" at Enron. Wall Street firms often let senior officials invest in firm-related funds and projects, even though it raised conflict of interest questions.

And LJM, one Fastow sympathizer insisted, came as part of an evolution in Enron's thinking. Over time, the company with Lay's approval had been instituting a compensation system that rewarded top officials for specific projects, a sort of "eat what you kill" mentality that was common among investment bankers. Mark and her team split multimillion-dollar bonus pools for completing negotiations on new overseas power projects. Other executives had special compensation deals tied to the success of specific Enron businesses.

Certainly, the use of outside partnerships and other types of entities to manage debt and do deals wasn't confined just to Enron. Smith and Emshwiller were beginning to learn that many companies—perhaps

hundreds, no one had an exact count—used Special-Purpose Entities. Outside partnerships, set up to borrow money and use the funds to drill for oil wells, had long been a tool of the energy companies looking to grow without directly taking on large piles of debt. But nobody the reporters talked with had heard of entities with LJM's combination of features. In the other cases, either the entities were run by outsiders or the company itself had a financial interest in the partnership. But it appeared that only Enron had the chief financial officer running and partly owning a completely separate entity buying assets from the company.

"Skilling asked Andy to be the general partner of LJM," one Fastow associate told Emshwiller. That roughly jibed with what Lay had told Smith and Emshwiller in that August interview where he'd said that Enron had asked Fastow to take on the partnership assignment. "Andy just happened to be in the right place at the right time," the person added.

Emshwiller wondered if Fastow still viewed his LJM hookup as a fortuitous event. "Did Enron management know about Andy going to see Donaldson, Lufkin in 1995?" the reporter asked.

"Skilling and Causey knew. They were involved from the start," the person replied. "And it wasn't just them. This was all vetted by the general counsel's office and Andersen." (Skilling would later tell people that the idea for LJM had been Fastow's and that he approved of it as a way to give Enron access to outside equity at a lower cost than it could be obtained by using Wall Street investment banks. An attorney for Causey later told Emshwiller that the former Enron executive first learned of the LJM idea when Fastow approached him on the matter in late 1998 or early 1999.)

Smith and Emshwiller found that in interviews about Enron, Andersen's name often came up. Of all the major institutions that supported— or perhaps abetted—Enron, none had a more important or intimate role than the company's longtime outside auditor. Like others of their profession, Andersen auditors tended to work in the gray background of the business world. But all too soon, the venerable firm would find itself in the white-hot glare of scandal and crime.

"We Notified Enron's Audit Committee of Possible Illegal Acts Within the Company."

ON DECEMBER 12, JOSEPH BERARDINO, THE CHIEF EXECUTIVE OF Arthur Andersen, sat down in front of a subcommittee of the House of Representatives. He had been summoned to testify before one of the dozen congressional panels probing everything from Enron's financial reporting to the obliteration of employee retirement accounts. It was a mere ten days after Enron's bankrupty filing, and Berardino was in the hot seat, facing a barrage of prickly questions about the venerable firm's auditing practices. Andersen's purported role in the Enron scandal had shocked the business community and the public, illiciting questions that bordered on indictments: How did Andersen sign off on Enron's financial statements, with their indecipherable descriptions of the Fastow partnerships? Why didn't Arthur Andersen protect the investing public from Enron? Berardino had tried to respond to the criticism, writing in a *Wall Street Journal* op-ed page piece, "If we had made mistakes we will acknowledge them. If we need to make changes, we will."

After Enron's bombshell November 8 SEC filing, when the company took the huge write-off and renounced four years of audited financial statements, scrutiny of Andersen ratcheted up. Enron had issued $1 billion in stock to the Raptor entities, which paid for the shares with a note. Enron accounted for those newly issued shares as an increase in its shareholder equity, which made the company look financially stronger. But under accounting rules, a stock issuance had to be paid for in cash

in order to be counted in this way. "It is basic accounting that you don't record equity until you get cash," Lynn Turner, a former chief accountant at the SEC, told *Journal* reporter Jonathan Weil when he called in the course of reporting on Andersen.

Now the beleaguered Andersen chief would have to give some explanation for his company's actions—and Enron's. "The fact that Arthur Andersen's Mr. Berardino is here, I congratulate Arthur Andersen. I wish Enron had done the same thing," said Congressman Spencer Bachus, an Alabama Republican, at the opening of the proceedings. (Lay had turned down a subcommittee invitation and was at a meeting of Enron creditors in New York that day.) Berardino wasted no time lobbing a salvo at Enron. He gave the House panel a quick lesson in Special-Purpose Entities and the 3 percent rule that allowed a company like Enron to keep the entity's debt off its books. Citing the case of Chewco, Berardino said for the first time that the crucial 3 percent equity contribution, about $11.4 million, came from "a large international financial institution unrelated to Enron." He stopped short of naming the institution but noted that Enron had arranged a separate agreement with that institution under which cash collateral was provided for half of the required equity, an agreement that dated back to 1997. "With this separate agreement, the bank had only one-half the necessary equity at risk." Thus, Chewco had failed as a separate entity from its inception. "It's not clear why the relevant information was not provided to us," the Andersen chief concluded. "We are still looking into that. On November 2, 2001, we notified Enron's audit committee of possible illegal acts within the company" in connection with Chewco.

For the first time, someone from Enron's inner circle had used the word *illegal* in connection with the company's actions. Though Berardino hedged it with a "possible," the statement was potent enough to make headlines in newspapers around the country the next day. Major auditing firms almost never talked publicly about specific client matters, especially on matters of possible lawbreaking, so Berardino's revelations packed significant punch.

Smith and Emshwiller were not covering the Enron story, or Andersen's role in the company's activities, but they followed the stories with interest, particularly when congressional probing turned up new batches

of documents, and talked almost daily to other *Journal* reporters about some aspect of Enron.

By early December, federal officials confirmed privately to Emshwiller that the Justice Department criminal probe of Enron had begun. In a sign of the unusual level of interest the case was generating, several U.S. Attorney's Offices—including those in Houston, Los Angeles, New York, and San Francisco—in addition to Justice Department headquarters in Washington were vying to handle the Enron probe. Eventually, the Justice Department set up a special Enron Task Force headed by Leslie Caldwell, a senior prosecutor out of the U.S. Attorney's Office in San Francisco, who drew on prosecutors and FBI agents from around the country. A forty-four-year-old with short dark hair, Caldwell had built a reputation as an aggressive, no-nonsense prosecutor while chasing stock swindlers, mobsters, and other assorted crooks while she was part of the U.S. Attorney's Office in Brooklyn. She'd once even prosecuted the sixty-three-year-old mother of a drug kingpin as an accomplice to her son's crimes. Emshwiller had gotten to know Caldwell while covering some of her stock fraud prosecutions. Her appointment, he thought, gave Enron executives no cause to sleep easier.

Berardino's remark further whetted Emshwiller's interest in doing more Chewco reporting. "Berardino makes it sound like some big bank was involved in a criminal act," Emshwiller said to Friedland. "We should find out the name."

"Well, find out," Friedland said without taking his eyes off the screen.

Calls to Enron and Andersen brought no help. Officials there declined to comment. Calls to other sources also drew blanks. Some at least said they would do some checking to see if they could come up with the name. But none sounded hopeful. Chewco had been a very low profile deal.

On the other hand, Fastow's whereabouts had become a very high profile question. Indeed, rumors were flying that Fastow was no longer even in the United States, that he'd fled with his family to Israel to avoid possible prosecution. As a Jew, he would presumably have protections there against extradition back to the United States. But on the day Berardino testified Congress, Fastow surfaced publicly, in a Manhattan skyscraper, in a sixteenth-floor conference room packed with re-

porters. Sitting next to Fastow was superlawyer David Boies, who announced that his firm had recently started representing the former Enron executive. "There have been a variety of reports over the past twenty-four hours that Mr. Fastow was not available, not in the country, left for parts unknown, everything short of the caves in Afghanistan. In fact, Mr. Fastow is here," Boies told the assemblage as Fastow sat there, calm, pleasant-looking, and silent. Boies wouldn't allow his client to answer questions.

While the press conference in Manhattan quieted the speculation about Fastow's whereabouts, it set off a howl of outrage in the Bronx— more specifically, in the apartment of Bernie Glatzer. When Emshwiller saw Fastow and Boies sitting with each other in front of the cameras, he thought of Glatzer. After all, Glatzer had many times regaled the reporter with tales of how he and the Boies law firm, his high-powered attorneys, were going to bring Enron, Skilling, Fastow, and others to justice. Now, Glatzer's own attorneys had taken on one of his prime bad guys as a client. Even by Enron standards, this was a strange twist. When Emshwiller called him in the Bronx, he thought Glatzer might jump through the phone line. Glatzer let out a string of invectives aimed at the Boies firm. "I'll file malpractice charges! I'll sue them for damages! These guys are incredible. I can't believe it," he shouted. "Boies has gotten carried away with his press releases and publicity. He's just like Enron. And he is going to suffer the same fate!"

The *Journal's* editors expressed interest in a story about Boies and Glatzer. While Glatzer's claims against Enron were complex and years old, the dispute with Boies was current and involved claims of misconduct by one of America's best-known lawyers. Emshwiller began digging and learned of a 1987 ruling by an Ohio federal judge, which held that a law firm "may not drop a client like a hot potato, especially if it is in order to keep happy a far more lucrative client." The reporter also learned that Glatzer had fired the Boies firm in 2000 although he said he had hired it back in early 2001—a claim that the Boies firm denied. Was he a client or not?

Emshwiller kept putting off doing the piece, partly because it was complex and partly because there were so many other Enron stories to do. Ultimately, Glatzer's patience ran out. Emshwiller had pulled into a

grocery store to do some shopping on his way home one evening. He'd been talking on his cell phone with Glatzer for nearly half an hour while driving from the office. Finally, Glatzer concluded that the reporter wasn't going to do the story. Before hanging up, he yelled, "You and your editors are idiots! I'm going to *The New York Times!*"

On December 21, Jeff Skilling surfaced publicly, nine days after his onetime protégé Fastow sat silently through that strange press conference. Like Fastow, he'd been the target of flight rumors; the favorite had Skilling scurrying to his vacation home in Brazil. Instead of Rio, Skilling was found in the Washington offices of his legal counsel, O'Melveny & Myers, drinking a Diet Coke, the sleeves of his white shirt rolled up. He gave separate interviews to the *Times*, the Dow Jones News Service, and the *Houston Chronicle*. Besides vigorously defending his actions at Enron and giving physical proof that he hadn't skipped the country, Skilling did drop one nugget of news into each interview, disclosing the October offer he had made to return to Enron to help it deal with the crisis.

"The last two months have been horrible," Skilling said. "I've gone back to try and think of any decisions I was involved in that could have caused this. I've agonized over this, and I'm convinced I haven't found anything. I believe we made the right decisions at the time given the information we had. We kept the interest of the shareholders. I believe the decisions that we made were correct decisions, and we'd do it again."

Skilling repeatedly said that he believed Enron was in great shape when he left. Enron collapsed, he contended, because of a variety of external problems, including the admission of accounting errors and investor concerns over the executive-run partnerships, that came together like a "perfect storm" and produced a "classic run on the bank." He also insisted that he was unaware of the details of Enron's controversial executive-run partnerships and off-balance-sheet financing vehicles. He claimed to have left the nitty-gritty of those matters to others. Skilling said that the LJM partnerships were Fastow's idea. He said that he had no inkling Fastow had made so much money from them or that other Enron officials had been investors in some of the partnerships.

Skilling welcomed the government investigations. "Let the chips fall where they may," he declared.

Some people clearly felt that Skilling had tossed some chips of blame uncomfortably—and unfairly—close to Fastow. On the last day of 2001, a call came into the news desk in the *Journal's* Los Angeles bureau. Emshwiller happened to be staffing the desk that day. The caller said he had internal Enron documents that showed Skilling was deeply involved in the LJM partnerships. The *Journal* could have an exclusive story, he said.

A few minutes later, fifteen pages of excerpts from Enron board meeting minutes arrived over the fax machine. While the documents didn't constitute a smoking gun, they did show that Skilling had a more active role in the LJM partnerships than his public statements indicated. Minutes from the June 1999 board meeting where LJM1 was first approved showed Skilling telling directors about the need for off-balance-sheet financing vehicles. Those same minutes showed the board appointing Lay and Skilling as guardians of Enron's interests in its LJM1 dealings. Minutes from an October 2000 meeting of the board's finance committee showed Fastow identifying Skilling as part of a triumvirate, with chief risk officer Rick Buy and chief accounting officer Rick Causey overseeing Enron's dealings with LJM2. Emshwiller called Skilling's recently hired public relations person, Judy Leon, for comment. "Those sound like the same documents Fastow's camp gave to *The New York Times*," she said.

The reporter tried to sound nonchalant, figuring he would save any curses for the source that had called him. Well, did Skilling have any comment about the documents? he asked Leon.

"He wasn't aware of or intimately involved with details" of particular partnership transactions, said Leon. Such oversight was "handled at a lower level" of the company. (Skilling would later say in public statements that he never viewed himself as being part of the formal LJM review mechanism and wasn't aware of details of the transactions.)

Emshwiller quickly called his document source, demanding an explanation. Yes, the person admitted, he had sent copies of the documents to the *Times* first. "Then how could you tell me we had it exclusively?" Emshwiller said hotly.

"The *Times* had decided not to write a story," the source responded. So, he argued, the *Journal* actually did have an exclusive. Right, Emshwiller thought sourly, a hand-me-down exclusive. Though it made Friedland and him a little nervous, wondering why the *Times* chose not to run a story, they agreed it would probably be a bad idea to call and ask. After verifying that the minutes were authentic, the *Journal* used them as the basis for a story that ran on the first business day of 2002. If nothing else, Emshwiller thought as he reread the story in that morning's paper, the document leak was a tangible sign that under the weight of scandal and government investigations, divisions were starting to develop within the team that had once run Enron.

Early in January, Emshwiller heard from a most unexpected source— Andy Fastow, indirectly. In response to a question from the reporter, a Fastow associate had asked the former CFO for the name of the international financial institution that had been the supposed 3 percent equity investor in Chewco. The associate came back with the answer. "Try Barclays Bank in London," the person said.

A Barclays spokesman declined to comment. But armed with the name of the bank and the help of *Journal* colleague Raghavan, who had extensive banking industry sources, Emshwiller found people who agreed to talk, on a not-for-attribution basis. Among other things, they said that Berardino's congressional testimony had been inaccurate. Barclays had never owned the Chewco equity. It had merely lent the money used to buy the $11.4 million equity position. The actual equity holders were two paper entities called Big River and Little River. These, in turn, were owned and run by Kopper and his domestic partner, William Dodson.

These sources weren't sure of all the particulars but expressed surprise that Andersen claimed to be unfamiliar with Chewco's basic structure. One source said that when Barclays had balked about making a multi-million-dollar loan to two paper entities without some collateral, Enron suggested putting up $6.6 million in cash. "Enron officials told Barclays that they had discussed the matter with Arthur Andersen and received appropriate clearance," said this source. If the source's rendition was true, Berardino had given inaccurate information to Congress. This could be a big story, Emshwiller thought excitedly.

On January 10, Emshwiller wrote a story for the next day's paper about Barclays, the two Rivers, and what he knew of their respective roles in Chewco. He called Dave Tabolt, the Andersen spokesman, for comment. After checking, Tabolt called back and acknowledged that "we may have misspoke" in the congressional testimony about Chewco's ownership. "The people preparing the testimony weren't aware of Big and Little River," he said. However, Andersen believed that Berardino's congressional testimony remained accurate in all significant respects, and Tabolt reiterated that the accounting firm had only recently learned about the cash collateral arrangement. But Tabolt seemed preoccupied as he talked with Emshwiller. He mentioned that the accounting firm had an Enron-related announcement coming out later in the day. He wouldn't say what it was. It turned out to be easily the most important announcement in Andersen's eighty-eight-year history.

28

"Do You Guys Have a Shredder Here?"

THE ANDERSEN ANNOUNCEMENT WENT STRAIGHT TO THE POINT: THE company had discovered that some of its employees had destroyed "a significant but undetermined number" of documents related to its audit work at Enron. It had notified the Justice Department and the SEC, "suspended its current records management policy effective immediately," and told employees to keep all the remaining Enron documents in their possession. "Millions of documents related to Enron still exist," the announcement said.

Terse though it was, Andersen's admission spoke volumes. The Enron scandal had shocked the nation, to be sure, but Andersen's January 10 announcement seemed more ominous to ordinary Americans, who were beginning to wonder if there were any upstanding financial institutions left. Enron the brash wheeler-dealer might be expected to play it fast and loose, but accountants were considered bedrock conservatives of the ilk once described by columnist George Will as people "who would rather not order tutti-frutti, if vanilla is available." It struck Smith as hugely ironic. After all, company founder Arthur Andersen had been the picture of accounting rectitude—a vocal advocate for reliable financial measures to help investors make informed decisions and a champion of standardizing the way companies presented financial information to the public. As late as the 1920s, there was no universally accepted way to report balance sheet items. Over time, conventions

developed about what should be included and the rough form it should take: assets on the left (including cash, marketable securities, accounts receivable, inventories, real property) and liabilities on the right (including accounts payable, notes payable, taxes payable, and stockholders' equity).

However, it stood to reason that if a company could purge debt from its balance sheet, by hook or by crook, it would look more attractive to investors and would be able to show more impressive debt-to-capital or debt-to-equity ratios. During the bull market of the 1920s, many companies worked hard to dress up their financial statements to impress investors. Using financial ratios to pick stocks became a popular tool for millions of investors.

In an effort to restore investor confidence after the stock market crash of 1929, the New York Stock Exchange in 1933 required all listed companies to hire independent public accountants to certify the accuracy of their balance sheets and income statements. By 1934, Congress passed the Securities Exchange Act, holding auditors liable for losses that resulted from material omissions or misstatements in financial reports. It was in this environment of reform that Arthur Andersen and his firm rose to prominence.

The auditors became the public's eyes and ears. Andersen became the number one auditor of the energy industry after an accounting scandal in the early 1930s led to the collapse of half a dozen "power trusts" that controlled much of the nation's electric and gas supplies. A judge overseeing one of the most notorious of these collapses—that of the Insull empire bankruptcy—selected Andersen to help sort out the bookkeeping nightmare and see what could be salvaged. Andersen's reputation for honesty and competence was its chief asset, all of which would become ironic in the face of the Enron collapse three-quarters of a century later.

By the Roaring 1990s, green eyeshade conservatism and rectitude were severely strained. Public corporations felt ever greater pressure to meet ambitious and steadily rising earnings growth targets and turned increasingly to ever more exotic accounting techniques to do so. The companies' outside accountants, moving inexorably from watchdogs to lapdogs, blessed this financial legerdemain. They feared angering—and

possibly losing—lucrative audit clients. "There was a tendency to reach answers that represented the lowest common denominator," said Tim Lucas, retired head of research at the Financial Accounting Standards Board, who once headed a special task force to increase checks and balances in the industry.

What's more, the major accounting firms discovered they could make millions by helping their clients fashion the aggressive new accounting techniques. The firms set up consulting arms that soon became immensely profitable, often overshadowing the traditional auditing work and creating jealousies within the companies.

In the case of Enron, Andersen pulled in over $50 million a year in fees, more than half of it derived from the consulting side. In effect, one side of Andersen was trying to see how high it could help Enron soar, while the other side was trying to wind in the kite string.

At Andersen, the internal tug-of-war between public watchdog and private cheerleader had been going on for years, hidden from view. The accounting standards board had created a task force in 1984 that brought together top technical people from the major accounting firms with the SEC to reach consensus on tough new accounting questions. But the guidelines that the task force produced were often ignored. Many of the push-the-envelope accounting treatments adopted by Enron were clear exploitation of the task force rules, such as the one issued in 1990 that had permitted companies to sponsor "Special-Purpose Entities" and treat them as independent under the 3 percent rule. "We'd gotten into a mode—and that's the whole accounting profession— where it was the objective to see how far you could go and still stay within the rules. The more exotic and complex the rules got, the more people seemed to like it," Lucas told Smith.

Carl Bass, an Andersen accountant since right out of college, had witnessed how the rules were often bent and didn't like what he saw. These concerns became especially sharp once he began working on Enron accounting issues.

Andersen had been Enron's external auditor for about a decade. The firm's offices in Enron's headquarters often were decorated with enough Enron knickknacks to make it hard to tell whether you were in an En-

ron or an Andersen workspace. Andersen employees even dressed like Enron employees, favoring neatly pressed khakis and golf shirts. Enron hired dozens of Andersen accountants—including chief accountant Rick Causey. Eventually Andersen asked Enron to limit the poaching.

In 1996, Bass had joined the Enron "engagement team," assigned specifically to work on audits of Skilling's trading unit. But his assignment changed abruptly in March 1998. During his annual performance evaluation, Bass learned that he wasn't liked by at least one senior Enron manager. Bass later said that he was told he was too "rule oriented." Nonetheless, he was soon given a plum assignment at Andersen's professional standards group, which gave advice to Andersen auditors. (Bass's recollections, like those of other Andersen officials, were for the most part given during depositions or court testimony in legal actions that arose from the firm's document shredding.)

Bass had frequent contact with the head of Andersen's Enron engagement, basically the point man at the energy company, David Duncan. A smooth, charming graduate of Texas A&M, Duncan fit the classic description of tall, dark, and handsome. When Duncan became head of the team in 1997, Andersen had only a few dozen people stationed at Enron. He quickly built it up, justified by the seemingly limitless Enron appetite for accounting advice. By 2001, Duncan oversaw 140 people, who were doing either auditing or consulting work on the Enron account.

Though Andersen had separate offices in downtown Houston, Duncan and his team had extensive space at Enron headquarters and spent much of their time there. He later said that he liked having offices in the Enron building because it "enhanced our ability to serve" as well as to "generate additional work." At $750 an hour, Duncan personally could produce $9,000 for Andersen in a twelve-hour workday.

His team was a huge money machine for the firm. For his efforts, Duncan had become one of Andersen's youngest partners and soon was earning $1 million a year. Within Enron, the Andersen engagement team was regarded as family, according to one Enron attorney. He said that on one business trip to London by company executives, Andersen auditors "flew on the same planes, stayed at the same hotels, and ate at

the same restaurants. The Enron spin was, Look, we have our auditors with us, giving us real-time assessments. We don't have to go back to them to get an opinion. They're right here."

Company officials wouldn't let up until they had found a way to get the accountants to sign off, recalled Andersen partner Mike Jones, who described the Enron assignment as a "very stressful" environment. From the start of his stint at the professional standards group, Bass got questions about the Raptor structures that were being used to offset losses in other parts of Enron's business. Many of the questions came from Debra Cash, another Andersen partner working on the Enron account. Among other things, she wanted to know if Enron stock could be used to capitalize the Raptor deals, as the company was proposing. "My initial response was, I didn't think so," Bass later said. But since it was a particularly complicated question, Bass brought in his immediate boss, John Stewart. Later, Bass received questions about shoring up the credit capacity of the Raptors. Bass was skeptical about some of the proposals, which struck him as gimmicky. He said so. Bass also started raising questions about the Braveheart deal. Enron was seeking favorable accounting treatment for its broadband contracts but had gotten locked in a debate with Andersen over the use of mark-to-market accounting for contracts involving "dark" fiber that wasn't yet functional. An Andersen memo from early 2000 said there was "very low probability" of the more liberal valuation method being allowed for unlit fiber, unfortunate for Enron since only a quarter of its fifteen thousand route miles of fiber was lit.

One senior Enron broadband executive later told Smith that the Braveheart deal seemed to have been created as a way to get around the mark-to-market accounting problem. Braveheart, he said, "was a structure for us to effectively 'mark to market' something we couldn't technically 'mark to market,' which was content deals themselves."

Bass weighed in on the debate, complaining to his boss about how Enron was trying to count hardware contributions from nCube as part of nCube's 3 percent equity contribution in Braveheart. He also took pot shots at the way Enron was trying to create instant income out of the deal and showed frustration at Enron's pushiness. "I am not into 'negoti-

ating' with the client on accounting conclusions," Bass wrote in a memo, looking for support from his superiors.

He didn't get it. In January 2001, Bass was offered another assignment. He initially turned down the job but was urged to reconsider it. Again he refused. Then Bass got a call from another Andersen partner, whom he regarded as a mentor. "He felt he had to tell me that this client, Enron—specifically Rick Causey—requested that I no longer be involved consulting on Enron matters," Bass recalled. He knew that besides being a former Andersen partner, Causey was Duncan's close friend and frequent golfing partner.

Certainly Bass wasn't the easiest guy to get along with. "He'd just say no. End of discussion," recalled one Enron attorney. "That's not the way things were done." Causey's attorney later confirmed that his client had requested that Bass be kept off Enron assignments. The attorney said Causey had received complaints that Bass was difficult to deal with and sometimes made last-minute changes in accounting opinions that caused problems in closing deals.

Nonetheless, Bass was justifiably concerned that his own career was being damaged because he had stood up to Enron, as he later said in court. And by buckling to Enron's request to move him, Andersen seemed to be violating the very independence auditors were supposed to exercise. Bass complained to Stewart, his boss, who had special standing within the profession as a member of the industry wide task force dealing with cutting edge accounting issues. Stewart asked for a meeting in Chicago with other senior partners to discuss what looked to him, too, like a breach of the firm's independence.

Bass prepared a memo on March 4, 2001, which he sent Stewart, laying out his version of events. In it, he said that his fellow partners needed to consider the implications of letting a client dictate which auditors were allowed to comment on its business. He said he was curious how it was that the client knew "all that goes on within our walls on our discussions with respect to their issues" given that he'd never spoken with Enron folks directly. He also was puzzled how they'd reached the conclusion that he was "too caustic and cynical with respect to their transactions." The implication, of course, was that Duncan or others on

the Enron engagement team were trying to stay in Enron's good graces by blaming Bass for any objections to the company's accounting desires. Bass, Andersen spokesman Patrick Dorton later said, was "essentially removed from the assignment for personality reasons" and not because he created a fuss. Dorton added that Andersen replaced Bass with "someone just as tough."

Just a month before Bass wrote his March memo, Stewart had taken part in a high-level Andersen meeting that reviewed the firm's dealings with Enron. Andersen annually reviewed its major accounts to determine whether the risks of keeping the client outweighed the rewards.

About a dozen top Andersen officials in Houston and Chicago took part in the telephone meeting on February 7. A memorandum of that gathering makes clear that Andersen officials understood where the land mines lay. "Significant discussion was held regarding" LJM and "Fastow's conflicts of interest," as well as "the amount of earnings that Fastow receives" from LJM. "A significant discussion" was also held about whether Enron's mark-to-market accounting practices constituted "intelligent gambling," as well as about "the fact that Enron often is creating industries and markets and transactions for which there are no specific rules . . . and that Enron is aggressive in its transaction structuring."

At the same time, there was a frank recognition that Enron soon could account for $100 million a year in revenues to Andersen, at the current 20–25 percent annual rate of growth. "Ultimately," the memo said, "the conclusion was reached to retain Enron as a client . . . it appeared that we had the appropriate people and processes in place to serve Enron and manage our engagement risks."

Andersen put restrictions on Bass when it came to any Enron questions. According to Bass, his boss would call Duncan and ask "if it was okay for them to bring me on a consultation." Needless to say, the arrangement grated on Bass. In September, he was invited into a couple of meetings concerning the festering Raptor problems. Bass was surprised to learn that the merging of the credit capacities of the four Raptors had taken place despite his earlier objections. In his mind, this was a clear violation of Andersen's policy that any internal accounting dis-

agreements be taken to a regional practice director—in this case, Michael Odom. If that failed to settle the disagreement, the matter could be taken all the way up to Berardino. However, Duncan's team had short-circuited the process and made the Raptor decision itself.

It's not that Duncan didn't have qualms about some of Enron's practices. He and some fellow Andersen officials had blanched in 1999 when they first heard of the idea of Fastow running LJM1. "Conflicts of interests galore," wrote Benjamin Neuhausen, a member of the professional standards group, in a May 1999 e-mail to Duncan. "Why would any director in his or her right mind ever approve such a scheme?" Neuhausen added that the standards group would be "very uncomfortable" with Enron's recording gains on transactions with an entity controlled by the company's chief financial officer. "On your point 1 (i.e., the whole thing is a bad idea), I really couldn't agree more," Duncan wrote back. But ultimately, Duncan and Andersen acquiesced. It was a decision that Duncan and his colleagues would someday have lots of reason to rue.

Duncan's occasional worries about Enron continued right up to the company's earnings release for the third quarter of 2001. On October 12, four days before the release went out, Enron sent him a draft copy. He noticed with concern that Enron planned to identify the huge $1.01 billion charge against earnings as a "non-recurring" item. Enron had used the term *non-recurring* in the past and Andersen had objected—privately, of course. "We had always informed management that, although we understood that press releases were the company's responsibility, we did not advise the use of 'non-recurring' as a description and were concerned it could potentially be misunderstood by investors," wrote Duncan in a memo dated October 15. "We pointed out that such items are, more often than not, included in normal operating earnings in the GAAP financial statements. We also insisted that the Company not use such a description in public filings with which we may have some association," such as the annual report filed with the SEC. In other words, when the company made money from these activities, they booked them as normal profit. Only when the thing turned sour did they try to distance themselves from the stink by saying losses were

"non-recurring" on something they had quarantined. Such sloppiness had become a thorn in the side of regulators, because companies were having these "non-recurring" headaches with some regularity.

Duncan had been troubled enough to speak with Causey on October 14 and express Andersen's "strong concerns" about the use of the term. He noted that the SEC had undertaken enforcement action against companies where the agency felt the presentation was "materially misleading." He checked back with Causey on October 15, just prior to release of the earnings announcement, and was assured that the release "had gone through 'normal legal review'" at Enron. Nonetheless, "nonrecurring" appeared in the headline of the Enron press release of October 16.

Duncan indicated in his memo that the "magnitude" of the charge caused him to share excerpts of the Enron draft press release with others at the accounting firm, including Nancy Temple in Andersen's legal group in Chicago. On October 16, he got a reply from Temple, one that would play a fateful role in the future of Andersen. "I recommend deleting reference to consultation with the legal group and deleting my name on the memo," wrote Temple. "Reference to the legal group consultation arguably is a waiver of attorney-client privileged advice and if my name is mentioned, it increases the chances that I might be a witness, which I prefer to avoid." She went on to suggest "deleting some language that might suggest we have concluded the release is misleading."

Temple had joined Andersen only a year earlier. Four days before her October 16 e-mail to Duncan, she had sent out another Enron-related electronic missive that would prove equally fateful. This one went to Michael Odom, head of Andersen's Texas region, who passed it on to Duncan. It had to do with Andersen's document management policy, which covered what documents to retain and which ones to dispose of. Temple's message was brief and innocuous sounding: "It might be useful to consider reminding the engagement team of our documentation and retention policy. It will be helpful to make sure that we have complied with the policy. Let me know if you have any questions."

With the crisis mounting, Andersen brought in fresh eyes to look at the LJM structure and the Raptor vehicles. As federal investigators began to sniff around Enron, Richard Corgel, fifty-two-year-old head of

Andersen's North American practice directors operations and a thirty-year veteran of the firm, enlisted the help of John Riley. Riley had joined Andersen after eleven years with the SEC, his final posting as acting chief accountant. But when Riley arrived in Houston on October 24, Duncan parked him at Andersen's Houston office several blocks from the Enron building. He gave him some briefing materials to read and, Riley felt, generally ignored him. Riley later said that he observed closed-door meetings in Duncan's office on October 25 and 26 but wasn't invited in. He also said Duncan never arranged a meeting for Riley with Causey. Instead, Duncan went to Enron headquarters to meet privately with Causey.

On October 26, Riley heard a strange noise as he walked down the hallway at Andersen's offices. He ran into Duncan. "Hey, what's that noise? Do you guys have a shredder here?" Riley later recalled asking his colleague.

"Yeah. We do some shredding here," Duncan replied. "It's routine client confidential information."

"This wouldn't be the best time in the world for you guys to be shredding a bunch of stuff," Riley observed.

"Well, I'm sure that, you know, in your position, the worst-case scenario is to show up and find people destroying a lot of documents," Duncan conceded.

As it would turn out, Uncle Sam heartily agreed with that last assessment.

"I Didn't Look Closely.
I Didn't Want to Know Too Much."

News of the Andersen document destruction set off a fire-storm of news coverage and criticism. Berardino and other top Andersen officials realized they had to do more than put out a press release and promise cooperation with authorities.

On January 15, Andersen announced it had fired Duncan for his role in the document destruction episode. Though Andersen didn't specifically accuse Duncan of shredding material, Berardino in a press release said, "Andersen will not tolerate unethical behavior, gross errors in judgment or willful violation of our policies." Three other partners who worked on the Enron account were put on administrative leave. Andersen said it was continuing to investigate the document destruction episode. Unfortunately for Andersen, so was the Justice Department.

When Andersen made its document destruction announcement, Emshwiller berated himself for not pushing harder to pursue a tip he'd received a couple of days after Enron's bankruptcy filing. The reporter was talking on the phone with an Enron employee he'd met while bar crawling in Houston during late November. The two had met amid the crush at the Front Porch bar and talked amicably for about fifteen minutes. The Enron employee looked barely twenty-something, but he seemed more cynical about the company than many of his older colleagues. He spoke slowly, as if weighing his words, and softly enough that he was dif-

ficult to hear in the din. He was the person who'd told Emshwiller about a security guard being posted near Lay's car in the Enron parking lot. He said he expected to be laid off as a result of Enron's problems. "I might have something that would interest you," he said. He wouldn't give any details but did provide his cell phone number.

After the bankruptcy filing and the mass layoffs, Emshwiller called that cell number. A day later, the guy rang back. He had been among those let go. Emshwiller offered his condolences, though the now former Enron employee didn't seem particularly upset. After getting assurances that his name wouldn't appear in the paper, the source passed along his information. "On the Friday before the Dynegy deal fell apart, I went on to the accounting floor. I saw a bag of shredded documents," he said in that same biting tone Emshwiller had heard during their initial meeting. "A friend of mine said that there had been bags of shredded documents filling the floor. And another friend of mine from Arthur Andersen said documents were being shredded."

Well, that was certainly a tidbit to chew on, Emshwiller thought. Of course, shredding went on at companies routinely; the *Journal* had shredders. What company didn't? Then again, shredding at Enron in late November with government investigations sprouting up couldn't automatically be dismissed as just routine business. "What exactly did you see?" the reporter asked.

Just the one bag, on the nineteenth floor of Enron headquarters, where internal accounting personnel had offices. But, this person added, his friend had seen a lot more. "You should talk to him," the source said.

"I'd be happy to," Emshwiller replied. He added that he'd also like to talk with the person from Andersen.

The source was skeptical that the Andersen employee would talk. But he thought the Enron person might and added that Emshwiller had met the guy as well that night at the bar. A couple of days later, Emshwiller reached the second person. He was again friendly, though he seemed wary. When Emshwiller asked about document shredding at Enron, the source replied, "At this point I'm still employed." Emshwiller took the nonanswer as sign that he had something to say about shredding. "Did you see shredding going on?"

The Enron employee didn't answer immediately. "These people shred stuff all the time," he said at last. After a moment he added, "Like a lot of big corporations."

True enough, Emshwiller said. "Was there anything suspicious about the shredding you saw?"

Another pause. "I'm expecting to be laid off fairly soon. We should talk again after that. I'd feel a lot freer at that point," he said.

The reporter and the second source talked briefly every week or so through December. The guy continued to be employed at Enron and continued to drop hints that he had something to say about shredding. With a small pang of guilt, Emshwiller couldn't help hoping that if the guy was going to be laid off, it would come sooner than later.

Emshwiller talked with Smith, Friedland, and some of the *Journal's* New York editors about what he'd heard concerning document shredding at Enron. While very interested, they agreed that there wasn't anything solid yet. Emshwiller tried to find other people who worked on the nineteenth floor, but had no luck. Several editors, including Hertzberg, shot down his idea of posting a message on some of the Internet bulletin boards that had been created by ex-Enron employees, asking if anybody had seen any document shredding at the company. The editors worried that the *Journal* might appear to be accusing Enron of wrongdoing without having enough evidence. They also worried about tipping off any competing reporters who were reading those Internet boards.

Within minutes of the appearance of Andersen's January 10 press release on public relations newswires, Emshwiller called his reluctant source at Enron. The two hadn't talked in more than a week. The source was now much less reluctant. Perhaps the Andersen revelations had inspired him—along with the now firm layoff date that he'd recently gotten from Enron. He agreed to talk in return for a promise of anonymity. He said he walked into the room on the nineteenth floor where the shredder was kept. "There were four or five huge trash bags full of shredded material," the source said. In two years, he had never seen anything more than what was in the bin of the shredder. Curious, he walked over to the bin, which still contained paper shreds. He picked one up. The source paused briefly. "It said 'LJM $150 million.' "

No way, the reporter thought. He tried to communicate his doubts without sounding insulting. "I couldn't believe it, either," the source admitted. "I mean, what are the chances of me seeing a document with 'LJM' on it? I can only figure that they must have been shredding lots of LJM-related documents and I just saw one strip. Something must have been going on."

Or, Emshwiller thought, you're telling me one whale of a whopper. But if the guy was telling the truth and someone at Enron had purposely destroyed LJM-related documents in late November, then that someone had probably committed a felony. "Did you keep the strip?" he asked.

"No, I put it back," the source replied, sounding a bit sheepish.

The two talked several times over the next three days. Emshwiller had asked him to try to remember anything else he could about the incident or if anyone else might have seen something. Given the unwillingness of people to allow their names to be used, the *Journal* would need multiple sources who had seen the same, or similar, things before it could even consider running a story. The source said that a friend of his at Enron had also seen the bags of shredded documents and the shredded LJM strip of paper. He agreed to ask that friend about talking to Emshwiller.

During these conversations, certain small details changed with the source's retelling. Perhaps it was more like five to seven large trash bags full of shredded material, he said. He didn't stop to count. But he remained consistent in saying that there had been far more shredded material than he'd ever seen on the nineteenth floor, where he'd worked for two years. And the tantalizing three letters on that one strip didn't change.

The source said he had been talking to his friend who had also seen the trash bags. But the person still worked at Enron and feared getting involved. A familiar refrain. Emshwiller offered to fly to Houston to meet with the two, just to get better acquainted. A few days later, the second person agreed to a dinner meeting in Houston on January 21.

After checking into the Lancaster Hotel, Emshwiller called his source and arranged to meet him and his friend at 7:00 P.M. for dinner downstairs at the Bistro. Then Emshwiller walked over to the *Journal*'s news bureau a block away. About an hour before the dinner date, Fried-

land called from Los Angeles with urgency in his voice. The ABC evening news with Peter Jennings had just run an interview with a female former Enron employee named Maureen Castaneda. Bill Lerach, the well-known class-action attorney, accompanied her. Brian Ross, a top ABC investigative reporter, had handled the interview.

"We begin tonight," said Jennings as he opened the newscast, "with the first evidence that the giant energy company Enron was shredding documents more than two months after the federal government said that it was investigating the company's business practices."

Castaneda was identified as having been a $110,000-a-year executive in Enron's foreign investment section. Before leaving the company about a week earlier, she'd had an office on the nineteenth floor of the Enron building. "After Thanksgiving," Castaneda told viewers, "there was great interest in all the accounting—the accounting documents, which were stored in a—in a storage facility. They pulled out all the boxes and they lined them up in the hallway, and people had to go through every box." She said she also saw shredding going on all the while she was there. The shredded documents were also kept in boxes in the hallway.

Before leaving her job, Castaneda took a box of the shreds. "I got these when I was leaving work to basically use it for packing material," she said. "There were a lot more than this. This is filled with—with these shreds and very densely filled. I only took one box." She obligingly allowed the box and its contents to be photographed as she read over some of the thin strips of paper.

"The word *confidential* can be seen, financial transactions dated in December," said ABC's Ross. "Also, shreds with references to some of the secret off-the-books partnerships such as JEDI, partnerships believed by investigators to have helped bring down Enron." Castaneda added that she recognized many of the documents as related to accounting because of the customary yellow, gold, and pink of the forms.

"You just have to conclude, based on what we know to date, this was a deliberate, coordinated effort to destroy evidence," chimed in lawyer Lerach.

Closing out the segment, Ross gave a promo of sorts for a court hearing the next day in Houston regarding the various shareholder lawsuits

his firm was pressing. "Tomorrow," the reporter said, "attorney Lerach plans to take the box of shredded documents to federal court to demand an explanation and ask that all relevant Enron documents be put in the custody of the court."

Friedland told Emshwiller to drop everything and press ahead as quickly as possible on the shredding story. Smith was already trying to reach Castaneda. "See what you can get from your guys and call me back as soon as you can," Friedland said.

Emshwiller could only shake his head. He'd been beaten on stories before, but this one seemed almost surreal. While he'd been plugging away trying to get some people to talk anonymously and just minutes away from a preliminary, off-the-record meeting with two potentially good sources, ABC News finds a person willing to waltz onto national television and tell her tale.

As Emshwiller prepared to meet his sources, Smith reached Castaneda at her home in Houston.

When Castaneda was let go in January, she took some shredded paper from a bin on the nineteenth floor to use as packing material. "The strips were eleven inches long and half an inch wide or less with words still legible," Castaneda said. The words included "JEDI" and "Chewco" as well as lots of dollar signs. "You would expect normal shredding of documents at a company," Castaneda told Smith. "But there was nothing normal going on at Enron. You'd think they'd be keeping everything." Enron had "destroyed evidence about JEDI and Chewco," she added.

Smith was skeptical of the whole story. It seemed too pat. She would have found it all more believable if the words supposedly seen hadn't been "JEDI" and "Chewco"—both names that had been in the press repeatedly. She was bothered when sources seemed simply to be recycling information that was already out there. It also seemed suspicious that Lerach, a litigator with a big case against Enron, was involved in making the shreds public. It had publicity ploy written all over it, Smith thought, but the story had reached such a pitch that the *Journal* didn't feel it could ignore it.

Emshwiller walked back to the Lancaster. His source was waiting in the lobby. Next to him stood another man. They shook hands. "Some-

thing has come up, let's go to my room and talk for a few minutes," the reporter said.

Upstairs, with no seats to offer the pair in his small room, Emshwiller quickly explained what had happened with ABC News and how the *Journal* was putting out a story on the shredding for the next day's paper. The story would lead with Castaneda's statements, since she was on the record. "But anything the two of you could give me now would be a great help," Emshwiller said, repeating that he would protect their identities—assuming they weren't now willing to go on the record. Neither was.

"So what did you see?" Emshwiller asked the Enron employee.

As Emshwiller stood in front of him, furiously scribbling notes, the Enron employee told of how he'd been working at his desk on the nineteenth floor one day last November when his friend—he pointed to the other guy—stopped by and told him he had to come and see what was in a nearby area. When they got there, he saw several large, full trash bags near the shredders.

"Do you remember how many?" Emshwiller asked.

"No, I didn't count them," the source replied, adding that his friend then walked over to the shredder, pulled out a strip of paper, and showed it to him. "I saw 'LJM' and a number," he said.

"Do you remember what the number was?" Emshwiller asked.

He shook his head. "I didn't look closely. I didn't want to know too much." But, like his friend, he said he'd never seen such a collection of shredded documents before or since.

Emshwiller thanked them and asked if they wouldn't mind waiting in the restaurant downstairs while he phoned his editors. They readily agreed.

His two sources were waiting patiently at a table in the restaurant, chatting with each other, when Emshwiller came down about fifteen minutes later. The reporter planned to milk them for more information. But not far into the meal, another group sat down a couple of tables away. From the conversation, it was clear they were a television news crew. They talked about having to scramble to cover the Castaneda story. Just what I need, thought Emshwiller, a bunch of reporters sitting a couple of tables away while I try to talk to two supposedly confidential

sources. Though the dinner was enjoyable, Emshwiller was reluctant to ask too many Enron-related questions.

The next morning, January 22, held the prospect of a hot day, not just the unseasonably warm weather. There would be a hearing on Enron litigation at the Houston federal courthouse. By 10:00 A.M., dozens of spectators filled the wooden bench seats of the gallery. Additionally, some four dozen lawyers stood or sat in front of the judge's bench. As best as Emshwiller could tell, the hearing had a twofold purpose. The official reason was to consider motions by plaintiffs' attorneys about ways to protect Enron-related documents in light of Andersen's document destruction. While the accounting firm had destroyed large amounts of Enron information, it still held large amounts more. Andersen could no longer be trusted to retain sole possession of that information during the litigation, plaintiffs' lawyers argued.

But, in another sense, the hearing was part of a contest with some of the nation's more aggressive litigators. More than two dozen shareholders suits had already been filed in the Enron matter, and more were expected. In the name of efficiency, the suits were being consolidated. This process required naming a "lead" plaintiff's counsel—a position that gave the chosen attorney power to set legal strategy and take a bigger cut of any money won. Needless to say, many sought the lead counsel position. Federal judge Melinda Harmon was expected to make a choice within the next few weeks.

When Emshwiller arrived, Lerach and his team were already there, staking out prime space at the lawyers' tables and setting up large charts they had prepared. The charts showed a time line of Enron's stock price and the company's alleged false public statements and hidden deals. On a table rested the day's prize attraction, the Castaneda box of shreddings. The papers, a tangle of long, thin strips, looked as if they had been primped to rise up full, glossy white, and photogenic, out of the brown cardboard container.

That day in court, Lerach got to lead off the arguments in favor of a motion he had filed to have the judge take control of Andersen's remaining Enron records. Referring to Andersen's document destruction, Lerach told the judge: "I have never seen anything like this. It can't be tolerated. . . . Letting Andersen officials retain sole possession [of the re-

maining Enron documents] is like letting the fox remain in control of
the chicken house after he has eaten the chickens."

Lerach made sure the judge didn't miss the box on the table. A pa-
rade of other plaintiff's attorneys followed Lerach with various motions,
suggestions, and speeches of their own. Most paled in comparison with
Lerach. Some even tried to take advantage of that fact. "We're not here
to grandstand or produce grist for tomorrow's papers," said another
plaintiff's attorney.

One attorney arrived late to the proceedings and ended up having to
stand. However, he paced comfortably around the area in front of the
jury box like a man at home. He wasn't a large guy, but he caught your
eye. He had dark, wavy hair with just enough gray sitting atop of just
enough wrinkles to give him a distinguished, if slightly craggy, look.
Rusty Hardin was a trial lawyer, more specifically a Houston trial lawyer,
a particularly outrageous and entertaining litigation sub-breed. The
sixty-year-old former Texas state prosecutor had piled up a long list of
high-profile civil and criminal cases since he'd gone into private prac-
tice in 1990.

Hardin, not surprisingly, opposed Lerach's proposal for the court to
seize control of Andersen's Enron documents. "The court would be say-
ing that we can't be entrusted with protecting these documents,"
Hardin said with a slight accent that seemed to mix his North Carolina
birthplace with his Texas home. "I don't think we deserve that pre-
sumption." Nor did Hardin seem to think that Lerach deserved serious
attention. "We are getting much of our information from Mr. Lerach
giving press conferences," the attorney told the judge. "We have to ask
why we are having this crescendo of publicity twenty-four hours before
your decision. This kind of accelerated rhetoric that Mr. Lerach is pro-
viding is not going to move the ball forward at Arthur Andersen."
Hardin said that sixty Davis Polk lawyers were involved in reviewing re-
maining Enron-related documents at the accounting firm, which he es-
timated totaled twenty million pages.

As the proceeding droned on, Emshwiller's mind began to wander.
He wondered how many more thousands of hours of court hearings and
millions of pages of documents Enron's collapse would produce. This
troop of lawyers, he knew, was merely a vanguard of the legions that

would be attracted to Enron like iron filings to a magnet. And all of them would have their meters running. He wondered idly about the hourly tab for this day's gathering. When the Enron cases finally ran their course and all the lawyers and all their experts had been paid, how much would be left for the creditors?

Finally, Judge Harmon suggested that all the parties meet to see if they could find a mutually agreeable plan. Lerach took the lead here as well. "We have a war room at the Four Seasons that's large enough to accommodate all the attorneys," Lerach said. He'd be happy to host such a meeting that afternoon. With no better offer, the parties set a meeting time on Lerach's turf. (A few weeks later, Judge Harmon gave Lerach permanent hosting privileges when she named his firm lead counsel.)

Quite unexpectedly, the hearing produced one piece of news. Earlier that morning, FBI agents had entered the Enron building to investigate the shredding allegations, Enron attorney Kenneth Marks told the court. Enron personnel were cooperating and had already sealed off the nineteenth floor and searched it, he said. "We located a single trash can with shredded material. That was secured and bagged."

"You've Got to Be Kidding Me."

"New York wants you to come back to the office. They think we're getting our asses kicked by *The New York Times*."

Emshwiller received this message over his cell phone while standing in line with his wife, Deborah, at a Starbucks coffee shop in Encino, California. On the other end of the phone call was Emshwiller's Los Angeles bureau colleague Rick Wartzman. Wartzman was temporarily shepherding the bureau's Enron coverage while Friedland served on jury duty. Though Enron was perhaps the hottest story in America, Wartzman could be excused for considering the assignment as much a headache as a plum. At the time he made the call to Emshwiller, goodly chunks of the American media were in one of those full-scale reporting frenzies that occasionally take a big story into a new, usually unpleasant, realm.

In the week after the Andersen shredding announcement and the Bush administration's phone call disclosures, Enron's name appeared in over six thousand news stories. *The New York Times* alone carried over eighty pieces, involving more than thirty reporters and columnists. The *Journal* weighed in with over five dozen articles, involving some forty staffers. Besides the daily story meeting for the entire paper, *Journal* editors were holding a separate daily story conference just on Enron coverage. The paper had even created a special "WSJ Team Enron" e-mail address with some four dozen editors and reporters connected to it.

Friedland, serving on a jury for a murder trial, was trying to keep up with all the meetings and stories during his brief breaks via a BlackBerry device.

Despite the *Journal's* blanket coverage, the paper's New York editors, ever worried about their midtown Manhattan rival, went into overdrive on Friday, January 18, when the *Times* ran a dozen Enron stories on the front page and elsewhere. While the *Journal* carried eleven pieces, the editors clearly believed that the *Times* had beaten them on more than just the number of Enron headlines that day. This conclusion produced a frantic phone conversation with Wartzman—a highly regarded editor and reporter at the paper—which, in turn, prompted his harried call to Emshwiller.

Emshwiller and his wife, Deborah, had stopped at the Encino coffee shop on their way to Santa Barbara, where they had weekend hotel reservations to celebrate their twentieth wedding anniversary. Emshwiller and Smith had taken almost no days off since the Enron crisis began in October. When Emshwiller asked for a long weekend, Friedland had agreed that being out of pocket on one Friday wouldn't hurt. After reading the morning papers, some of the editors in New York clearly disagreed.

"You've got to be kidding me," Emshwiller said to Wartzman. He wasn't sure if he was angrier about being yanked from his anniversary trip or about the fact that his bosses thought the *Journal* was being beaten by the *Times*. For weeks, New York had been praising their Enron coverage, crowing about how far ahead of the competition they were.

Wartzman was apologetic and clearly uncomfortable in his role as messenger. He was being criticized, unfairly, by New York for having let one of the bureau's Enron reporters take a day off—a decision that Wartzman had had nothing to do with. The colleagues commiserated for a couple of minutes about the stupidity of senior editors. "Well, what should I tell them?" Wartzman asked.

Emshwiller thought for a moment about what he would like to tell them, then recalled that he had two daughters who still needed to go to college. "Tell 'em I'm coming back," he said.

When he gave his wife the news, she was as upset as he was, but as a

former reporter herself, she had no illusions about the inner workings of a newspaper. "That's okay, we will just get New York to pay for us to go on another weekend," she said, smiling. (There were no such offers, but a case of wine and an apologetic note from national news editor Marcus Brauchli arrived not a long time later.)

When Emshwiller called Smith to say he was being brought back, she tried to talk him out of it. It was the most ridiculous thing she had ever heard. The Enron story had become such a spectacle of pack journalism that there were already too many people working on it. "Tell them you'll be back at the end of the weekend," she told him. When he said he couldn't tell them no, she let it drop, even though she couldn't understand why he didn't simply tell them no.

There was another weird twist to the recall, at least for Emshwiller. On the front page of the *Times* that Friday was a story that had been brought to the paper by one Bernie Glatzer. After hanging up on Emshwiller in the parking lot, Glatzer had indeed gone to the *Times* and sent a packet of documents to Kurt Eichenwald, a topflight corporate crime reporter. He included the 1997 deposition taken of Fastow. There, Fastow discussed his early work at Enron, which focused on creating a set of off-balance-sheet deals known as the "Cactus" entities. Though the Cactus transactions had long been known about, even celebrated in a *Harvard Business Review* article, the *Times* piece, by Eichenwald and Michael Brick, was the first to cast them as the precursors to the darker off-balance-sheet deals that came later. Eichenwald also did a piece that day about Glatzer's dispute with the Boies firm.

Despite scores of hours on the phone with Glatzer, Emshwiller had never written a story. He vented to Smith, saying he wasn't sure if he was madder to have been called back to the office or to have seen a story in *The New York Times* compliments of Bernie Glatzer. Smith could only shake her head.

Enron's off-balance-sheet endeavors were much in the news in late January, thanks partly to the emergence of the scandal's first folk hero—or, more precisely, media darling. "Has Enron become a risky place to work?" So began a written message sent to Lay the day after Skilling's resignation was announced in August, made public as part of the con-

gressional investigations into the company. "I am incredibly nervous that we will implode in a wave of accounting scandals," the message continued.

The writer was Sherron Watkins, the LJM critic whom Smith had tried unsuccessfully to reach in October. The forty-two-year-old Watkins was a vice president in Fastow's global finance unit and a former Andersen accountant. She'd been with Enron eight years in a variety of jobs and was doing her second tour of duty with Fastow, whom she had worked for earlier in her career. Her job in the summer of 2001 involved evaluating Enron assets for possible sale. A number of those assets were being hedged through the Raptor vehicles. Watkins expressed deep alarm about the Raptors. "I realize that we have a lot of smart people looking at this and a lot of accountants including [Andersen] have blessed the accounting treatment. None of that will protect Enron if these transactions are ever disclosed in the bright light of day," she wrote. Referring to the deteriorating financial condition of the Raptors, Watkins wrote that "Raptor looks to be a big bet. . . . All has gone against us. . . . I think we do not have a fact pattern that would look good to the [Securities and Exchange Commission] or investors."

Watkins clearly had Skilling's resignation in mind. "Skilling is resigning now for 'personal reasons' but I think he wasn't having fun, looked down the road and knew this stuff was unfixable and would rather abandon ship now than resign in shame in 2 years," she wrote. "I firmly believe that the probability of discovery significantly increased with Skilling's shocking departure. Too many people are looking for a smoking gun." She added that other Enron officials had voiced similar concerns to her. "I have heard one manager-level employee from the principal investments group, say, 'I know it would be devastating to all of us, but I wish we would get caught. We're such a crooked company,' " Watkins wrote.

Watkins's missive to Lay made the Enron vice president an instant celebrity in Congress and the press when it surfaced.

Though Watkins's writings, penned before the public firestorm ignited, clearly reflected an understanding of some of the problems that helped bring down Enron, her motives for contacting Lay quickly be-

came a matter of controversy. Fastow, for one, believed Watkins was in cahoots with McMahon, the Enron executive who'd had problems with the Fastow operation for some time.

Adding to such suspicions, Watkins's letter to Lay specifically recommended against adding Fastow to the office of chairman, when the company was looking to realign top management following Skilling's departure. According to one Enron source, Fastow believed that she had been a source of information for Smith and Emshwiller about LJM, which prompted him to try to deprive her of access to her office computer, lest she leak out secrets.

Watkins's letter earned her a private meeting in August with Lay. Lay listened and promised to look into her concerns. He also agreed to move Watkins to a new assignment, out of Fastow's unit.

Lay assigned Enron's outside law firm, Vinson & Elkins, to look into the concerns raised by Watkins. The fact that the firm had done some of the legal work to set up the Raptors didn't seem to bother Lay. Vinson & Elkins lawyers interviewed more than a dozen Enron and Andersen officials.

Fastow, in his interview, insisted that all Raptor-related transactions had been reviewed with the office of the chairman, which included Lay and Skilling, though he didn't say specifically who had reviewed them. The chief financial officer added that the full board had been briefed on any restructuring of the Raptor transactions (a statement that directors would later vehemently dispute). The Raptors, Fastow said, had enabled Enron to avoid taking write-downs on its assets. "Although the structure may be in the gray area, it is fully approved by AA [Arthur Andersen] and is fully disclosed," the interview memo cited him as saying. The memo also mentioned Fastow's belief that Watkins "is acting in conjunction with a person who wants his job."

Vinson & Elkins prepared a nine-page report for Enron's top brass and sent it over to the company on October 15, the day before third-quarter earnings were announced. "The facts disclosed through our investigation do not, in our judgment, warrant a further widespread investigation by independent counsel and auditors," the law firm concluded. It did add that some of Enron's dealings "could be portrayed very

poorly if subjected to a *Wall Street Journal* exposé or class-action law-suit."

Unlike the typical whistle-blower, Watkins didn't take her complaints outside the company even after the Vinson & Elkins report. Indeed, by the end of October, she was helping to fashion a company strategy to deal with the exploding crisis. One of her key suggestions was for Lay to say that he relied on subordinates, particularly Skilling and Fastow, and was kept in the dark as they led Enron astray. "Lay to admit that he trusted the wrong people," Watkins wrote in an October memo. Watkins, who consistently denied ever working with McMahon to oust Fastow, later concluded that in the weeks after writing her letter she had put too much faith in Lay's willingness and ability to deal with the issues she raised.

Many at Enron already believed that Skilling and Fastow had misled Lay. But Lay's claims of ignorance became harder to sustain as more of the vast numbers of Enron internal documents, subpoenaed by the increasing number of government inquiries, began to surface. Lay had been telling subordinates that the first he'd heard of Chewco or Michael Kopper was when their names appeared in the *Journal* on October 26, 2001. But the minutes of a 1997 meeting of the board's executive committee indicated that he was either lying or had a lapse in memory.

The executive committee, which was empowered to act on behalf of the full board, convened at about 5:00 P.M. at Enron headquarters, according to the 1997 minutes. The five outside directors took part by phone. Lay, Skilling, Fastow, and other Enron officers attended in person, though the chairman arrived only after the Chewco discussion had begun. Kopper was among the Enron executives in attendance.

Skilling, followed by Fastow, told the directors of CalPERS's plans to sell its half interest in the JEDI partnership for $383 million. The buyer would be Chewco Investments. To make the deal come together, Fastow said, the executive committee needed to approve several hundred million dollars in loan guarantees, which Chewco would use to obtain bank loans to finance the JEDI purchase. Fastow "reviewed the economics of the project, the financing arrangements, and the corporate structure of the acquiring company," according to minutes. Among the anticipated

benefits from "Project Chewco" was "positive income impact to Enron," according to a handout appended to the minutes.

Positive income impact. Emshwiller rolled that phrase around in his mind for a moment. So, from the beginning, Enron had been looking at Chewco to provide a boost to earnings—from an engine that would be hidden from the outside world. He thought back to the conversation he'd had with Carol Coale, the Prudential analyst, where she recounted the November 1997 chat she'd had with Skilling. You're going to like our earnings from here on out, the Enron president had told her. Maybe Skilling really did have Chewco in mind when he made that remark, the reporter thought. But how, he still wondered, had Chewco produced all those earnings? That question still needed an answer, and Enron had done nothing so far to provide one.

As they wrote the story in late January about the 1997 executive committee meeting, Emshwiller and Smith called various participants for comments. Lay and his lawyers didn't call back. Fastow's spokesman merely said that his client never owned a piece of Chewco—even though the reporters hadn't asked that question. W. Neil Eggleston, an attorney for the outside directors, said his clients had been told only that Chewco was a Special-Purpose Entity unconnected to Enron. "The board never waived the conflict of interest policy for Mr. Kopper, nor was the board told that Mr. Kopper was involved with Chewco," he added. Skilling's spokeswoman merely said that her client wouldn't comment on "leaks, counterleaks, spin, or speculation."

But on January 25, the burgeoning scandal was thrust into the background, overshadowed—at least for a moment—by death.

"I Feel I Just Can't Go On."

THE CALL TO THE POLICE DISPATCHER CAME SHORTLY AFTER 2:00 A.M. on January 25, 2002. Officer Scott Head was patrolling the affluent First Colony subdivision of Sugar Land, Texas, when he saw a black Mercedes-Benz parked at a grassy median strip on Palm Royale Boulevard. He'd passed the car only a couple minutes earlier and was puzzled that it was still pulled over, lights on, motor running. He stopped to see if the driver needed help.

As he walked up to the sedan from the passenger side, he saw that the driver's body was tipped forward. A stream of blood ran down the right side of his head, ear, and nose. Both hands were resting on his thighs. His right hand lightly gripped a silver Smith & Wesson .357 Magnum pistol whose barrel lay on top of his left hand. He was dressed in what looked like thin pajamas with moccasin-type slippers on his feet. There was no sign of struggle or forced entry, and there didn't appear to be anybody else on the street that overcast, chilly morning.

In an account Smith would later piece together from the police investigative report, Officer Head tried to get the door open. All the doors were locked. Head radioed that a man with a gunshot wound to the head was in a car, and Sugar Land police officer K. D. Guthery radioed that he was heading to the scene to help Head. Guthery arrived at 2:27 A.M., and the officers tried to get into the black sedan, according to the reports they later filed. They jabbed the windows of the big S500 Mer-

cedes with a window punch, but it just made dimples in the glass. They took a police baton to it, but still it wouldn't shatter. Finally, working together, they poked a small hole in the rear passenger window and butted it out until it was big enough to reach through and unlock the door.

Engine five with the Sugar Land Fire Department arrived moments later. A firefighter removed the loaded gun from the man's hands and dropped it in a bag, which Guthery placed in the trunk of his squad car. The firefighter checked for vital signs, grimaced, but said his team would "work him" anyway since he still was warm. Emergency medics arrived next and took over, attaching electrodes to his chest. "They advised me that they would not be transporting him and they provided me with a copy of an EKG flatline strip," which confirms the man was dead, Guthery wrote. A black wallet lying on the front passenger seat identified the man as forty-three-year-old John Clifford Baxter. Its contents included three Enron health care cards and a business card identifying Baxter as chairman and chief executive of Enron North America.

It was not Baxter's current position or even the highest position he'd held at Enron, which he'd quit the prior May. But perhaps it represented in Baxter's mind the position he liked the most. Perhaps it reflected a time of high professional reward, when he was last involved in creating something worthwhile—raising a barn instead of shoveling out the stalls.

For most of his career, Baxter had helped Enron buy things and grow. An investment banker by training, he was regarded as an accomplished negotiator and had helped build up a portfolio of assets, including Enron's Oregon utility, Portland General Electric Co. His final, dispiriting assignment, as vice chairman, had been to help the company shed assets to raise money.

More officers arrived and closed off the street except for police and fire vehicles. At about three o'clock in the morning, a dispatcher roused Officer Mary Herbrig, a crime scene investigator, and asked her to go to the scene. She arrived forty minutes later and began videotaping the site and taking measurements. Herbrig, a twenty-three-year police veteran, continued "processing" the body and vehicle, noting the location of blood "backspatter" produced by a high-velocity bullet that left a

bloody haze on the seats, windows, ceiling. She was looking for "voids," or anyplace where blood wasn't present where it should have been. A void could indicate that a door or window was open when Baxter was hit or that he hadn't been alone in the car.

Guthery took a cell phone call from a justice of the peace who told him that the body could be released to a funeral home "of the victim's choice." But Herbrig didn't know that until later. She assumed the incident would be treated like a suspicious death and filled out the paperwork required for an autopsy.

Two attendants operating the "body car" from Angels Funeral Home arrived at 4:06 A.M. and placed Baxter on a plastic sheet and gurney. They gave his gold wedding ring to Herbrig, who filled out a property receipt form. The attendants finished wrapping Baxters' body in a linen sheet and plastic tarp and loaded him up and left for the medical examiner's office at 4:50 A.M. A wrecker arrived and hauled the $80,000 Mercedes back to the police department's sally port.

Three of the officers drove the mile and a half to the Baxters' newly built, redbrick home and rang the doorbell. It was a large home, but not as conspicuously splendid as the homes occupied by Sugar Land's many professional athletes whose homes backed right into the Sweetwater Country Club golf course.

There was the distinct possibility that Baxter's death was not simply a suicide, but a suicide following a murder. The officers waited nervously for someone to answer the door of the darkened house, not knowing what they would now encounter. They were relieved when a small, hazel-eyed woman answered the door and identified herself as Carol Baxter. As gently as they could, they told her what had happened. She told them they were mistaken. Her husband was in bed asleep, and she turned abruptly and headed back to the master bedroom. The officers followed. When they reached the bedroom, one officer wrote in his report, "we saw that there were pillows lying longways on the left side of the bed" under the covers so it appeared the bed was occupied. "Carol immediately began crying," he wrote. She said Baxter "had been extremely depressed for about the last five days." How, she wanted to know, was she going to tell her two children that their father was dead?

There wasn't a good answer, so the officers asked if there were friends

they could call. She asked them to call Mark Muller, who'd worked with Baxter at Enron, and his wife, Porsha, also a good friend. She also asked him to call Baxter's old secretary at Enron to let the company know what had happened. While one officer stayed with Carol Baxter, another went to make the calls. The third asked permission to look for a suicide note, and one soon was found on the console of Carol's car in the garage. It was written in blue ink, in block printing, on a note card that was inscribed "J. Clifford Baxter." It read:

> CAROL,
> I AM SO SORRY FOR THIS. I FEEL I JUST CAN'T GO ON. I HAVE ALWAYS TRIED TO DO THE RIGHT THING BUT WHERE THERE WAS ONCE GREAT PRIDE NOW IT'S GONE. I LOVE YOU AND THE CHILDREN SO MUCH. I JUST CAN'T BE ANY GOOD TO YOU OR MYSELF. THE PAIN IS OVERWHELMING. PLEASE TRY TO FORGIVE ME.
>
> CLIFF

Carol Baxter said her husband had been despondent, unable to sleep, even though he'd quit Enron nearly eight months earlier, before all the trouble started. On the Monday before his death, Baxter called Robert Gray, an attorney friend, saying he'd have to postpone a lunch date that week. Baxter said the Enron situation was eating him up and he was going to get some help, Gray later told Emshwiller.

Carol Baxter told police that two days before his death, her husband went to see a doctor who prescribed an antidepressant, Celexa, but Baxter complained it made him feel so tired. The doctor said that was normal, that it would take time for the medication to make him feel better. The doctor later told police that Baxter hadn't said anything about wanting to hurt himself, only that he was "pissed off at the media because they would not leave him alone."

He also gave Baxter a sleeping pill prescription, for Ambien, and the name and number of a psychiatrist. Baxter called the psychiatrist's office

later that same day but was told he couldn't get in to see the doctor until the following month. The receptionist later told police that Baxter said he "didn't want to wait that long" and declined to make an appointment.

A day before his death, Baxter called Gray and apologized for a tiff they'd had. "I should have known something was wrong then," Gray said. "In all the years I had known him, he never apologized for one of our blowups. Never [felt he] needed to."

His final night, Baxter went to bed early, about 9:15 P.M., his wife told police. Carol Baxter said she stayed up and watched television until about 11:00, when their sixteen-year-old son told her it was time for bed. When she let the dog out, she noticed that the alarm didn't chime, but she didn't reactivate it. Sugar Land was one of the safest communities in Texas, after all. Their subdivision had its own police shack and a twenty-four-hour patrol provided by the Fort Bend County Constable's Office, which supplemented Sugar Land police. She went to bed and found Baxter snoring peacefully and was grateful, she told the officers, "that he was finally getting a good night's sleep."

Sometime in the night, Baxter got up, stuffed the pillows in the bed, and slipped out of the house. Carol Baxter later told police she figured her husband had deactivated the alarm system knowing that she was a light sleeper and not wanting to risk awakening her, their eleven-year-old daughter, or their teenage son. He left the house with a gun police later determined he'd bought a year earlier for $502, loaded with blue-plastic-tipped bullets designed specially to stop an intruder but not to penetrate walls. They were the sort of bullets someone would buy who was thinking ahead and wanted to make sure he might not hurt anyone other than his intended target. Carol Baxter said he purchased the gun because he worried that an intruder might try to enter the house through the French doors of their bedroom. The house, which cost about $700,000 to build, would make an attractive burglary target, he feared, although his wife told police they'd never had an intruder or any threats.

Later that morning, Enron put out a brief press release saying that the company was "deeply saddened by the tragic loss of our friend and col-

league, Cliff Baxter. Our thoughts and prayers go out to his family and friends." That same day, the police department put out a press release that labeled the death a "suicide." The news media quickly grabbed the story, and officers were posted at the Baxter home to keep reporters away. Later in the day, the police department changed the headline on the press release to "Death Investigation," sensitive to criticism that it had jumped too soon to declare the death a suicide.

Out in California, Smith was getting ready for work when she got a call from Emshwiller. He had gotten an e-mail from his anonymous "Jeff Skilling" tipster passing along a rumor that Cliff Baxter had killed himself. Emshwiller knew that Smith and Baxter had been talking off and on. She'd had several conversations with Baxter the previous October and November, but he'd stopped returning phone calls after the December bankruptcy filing. Smith figured he'd start talking again when he felt like it and didn't press him. She always felt people had as much right *not* to talk as to talk. She wasn't certain of the date she'd last called him but thought it was a couple of weeks earlier, after the Sherron Watkins memo came out that said Baxter had "complained mightily to all who would listen" about the Fastow-led partnerships. He hadn't called back.

Smith was stunned and couldn't believe the information was correct. It didn't make any sense. She quickly turned on her computer and found Baxter's cell phone number, hoping it was a big misunderstanding and she would hear his voice on the other end. "Hello, this is Porsha," said the person who answered the phone. Smith stammered out a question: Was it possible to talk to Cliff Baxter? The woman said it wasn't possible and quickly hung up.

Smith knew there would have to be a story about Baxter's death, but she wasn't looking forward to writing it. She immediately called Palmer to see what he could tell her. And she asked if the company still had a biography, realizing there were gaps in his employment history that she couldn't fill. Then she started calling a handful of Baxter's friend, as delicately as she could. Together, they filled in all the holes.

Baxter had grown up in Amityville, New York, the son of a policeman, and he'd gotten a bachelor's degree with honors from New York University and an MBA from Columbia University, where he was vale-

dictorian. He did a tour of duty in the U.S. Air Force from 1981 to 1985, leaving as a captain, and went to work for PaineWebber as an investment banker, working on natural gas deals. He joined Enron's corporate planning group in 1991. Within a few months, he'd come to Skilling's attention and moved over as director of gas marketing in the trading operation.

Though he rose rapidly at Enron, company co-workers said he complained frequently. "Cliff was constantly threatening to quit," said one senior executive who worked with him on several projects. He actually left Enron in 1995, taking a job with Koch Industries in Wichita, Kansas. But he stayed just a few months before Skilling lured him back to the Enron fold as a negotiator and deal maker. Then in June 2000, he nearly quit again because of a dispute with Skilling, who Baxter felt had humiliated him in a meeting by questioning the accuracy of a statement he'd made. He also felt that Skilling was undermining his authority as chief executive of the Enron North America unit. Once again, Skilling patched things up, later testifying before Congress that he regarded Baxter as his best friend. Baxter eventually agreed to stay on as chief strategy officer—a fancy new title with significantly reduced duties and pay.

In October 2000, Baxter was named vice chairman, a title that had become an ejection seat for recent executives. Seven months later, he quit Enron for the final time. In a company press release, Skilling (himself only three months away from quitting), said, "Cliff has made a tremendous contribution to Enron's evolution, particularly as a member of the team that built Enron's wholesale business. His creativity, intelligence, sense of humor and straightforward manner have been assets to the company throughout his career. While we will miss him, we are happy that his primary reason for resigning is to spend additional time with his family and we wish him the very best."

Baxter told Smith that he thought the company had made a lot of ill-considered decisions, but he never dreamed they would be fatal to Enron. He objected to the Fastow partnerships, not because he felt they were illegal, but because "it was a very bad morale thing. . . . I didn't like it from day one. I sat down with people and said we shouldn't do it,"

he'd told Smith. He said he had a meeting with Enron general counsel Jim Derrick and asked whether the LJM deals had been "scrubbed" thoroughly and whether there was adequate public disclosure, skeptical on both counts.

"I said, 'Don't bullshit me,'" Baxter told Smith. "Derrick said, 'We did everything we need to do.' I said, 'You know, you can do damn near anything you want as long as you disclose it.'"

Baxter continued, "I've seen what happens in these companies. Shit happens. It makes sense the week you do this stuff, and then you stop thinking about it." He said that Skilling and Lay were comfortable "that Andy wasn't making a killing and that the lawyers had looked at it. I said, That's all well and good, but the employees are going to think the worst. How does it look to have Andy running these deals? I was the integrity guy . . . and I never liked this stuff at all."

Enron made so many big bets that never paid off, he said. It overpaid for so many assets—even ones he helped buy—because it always wanted to be a first mover. It dumped a ton of money into broadband and the retail electricity business. "Our thing was if you had a smart person who wanted to do something, you let them try. Some will be successful. Some will not be successful. That was the attitude."

The only really good business they had, he said, was energy trading, which was a "money machine. We should have stuck to that." Baxter said he spent "ten years drinking from a fire hose. We built this massive company and it wasn't as much fun to run as it was to build. We were building the most happening thing, at one time. It was great. Jeff said my leaving made it less fun to be there."

Why did he think Skilling quit the company so abruptly? Smith asked him at one point. Baxter paused while he thought about it. Then he said Skilling reached a height where he sort of got vertigo. "Rich Kinder left Enron, and Jeff couldn't let someone else step up; he's so competitive, so he had to be president," said Baxter. "Then he had to be CEO. Then all his buddies were leaving and it wasn't fun anymore."

The departure seemed abrupt, he admitted, coming so soon after Skilling had been elevated to chief executive. But Baxter didn't fault him for it, seeing no particular reason to drag it out. "When you decide it's time to leave, you almost have to leave right then," he explained.

"Ken [Lay] tried to talk him out of it for a couple of weeks, but Jeff said, you know, 'I gotta go.' "

Smith liked Baxter, not only because he seemed to have some grit, but because he'd argued against the lunacy of having the chief financial officer running his own game within a publicly held company. Of all the guys to shoot himself, she thought, remembering with a sharp stab of sympathy that he had a wife and kids. She wasn't sure how many children, but she thought it was two or three.

When Ken Lay, in a conversation with Smith some months earlier, had said a lot of senior executives had quit the company to spend more time "on the ranch or the boat," he'd been alluding to Cliff Baxter, among others. Baxter's yacht had been built in England a year earlier, and he spent a lot of time on it. Smith wished that when the pressure had gotten too great Baxter had simply gone down to the dock, cast off the lines, and gone to where time is reckoned by the changing of the tides and a "bad day" just means you didn't catch your limit.

It was clear that, at least initially, the Sugar Land police treated the death as they would any other suspicious death. But by noon, it had become a media event and was all over the television and radio stations. Now the police responded like any agency under the glare of lights.

Back in Texas, at 12:43 P.M., Herbrig received a page from a lieutenant telling her that the justice of the peace had changed his mind. Now he felt an autopsy was needed. He also wanted additional processing of the Baxter vehicle, just to be on the safe side. But by then the car had been hauled to a storage yard, breaking the police custody chain. That meant any additional evidence gleaned from an examination likely would be inadmissible in a court, if the district attorney ever tried to prosecute anyone. Herbrig phoned the storage yard and was told that a Fox TV-26 newsman had said he had permission to film the vehicle, confirming that Baxter's death was now a news event. Herbrig told the yard that he couldn't possibly have permission and to keep people away from the car and tow it back to the station for more tests.

An autopsy was set for 4:30 that same afternoon. Herbrig arrived at the medical examiner's facility, and Dr. Joyce Carter began the examination of the six-foot-one-inch male who weighed a trim 185 pounds. Carter said there were no markings on the body indicating any kind of

struggle before the victim was shot. She noted "strippling" or tiny marks on the left hand, indicating Baxter may have used it to steady his right hand.

During the examination, Herbrig received a page from the police chief asking her to see if the victim's watch was still on him; the family had reported it missing. (They later found it at the house.) The chief also said he was sure the officers were doing all they could, but it "might be wise to cover all the bases by having an independent expert examine the bloodstains inside the vehicle." He named an expert in bloodstain pattern reconstruction who would be "a most credible asset to our investigation."

Back in the autopsy room, Carter was continuing her examination. The autopsy report indicated that what she found was a tan, healthy man with no observable health problems—other than a fatal head wound. The doctor went on to say "that the bullet used by the victim" was a perfect cartridge to use if someone wanted to commit suicide." Carter advised that she was "confident the victim had shot himself," Herbrig wrote.

Nevertheless, the police went to work to see if the autopsy report was supported by other evidence, and they began talking to some of Baxter's friends. In some cases, friends were unconvinced Baxter would have shot himself and urged the police to make sure he hadn't been murdered. As the theory went, there were people who feared he'd tell the truth, if ever he were called to the witness stand. Brad Mitchell, another former Enron employee, said he'd had a fifteen- or twenty-minute conversation with Baxter about ten days before his friend's death. Baxter had opened the conversation by saying, "What the heck is going on with Enron?" in a half-joking way. He said he'd been named in about "forty lawsuits" even though he had never officially been part of Lay's office of the chairman. The exclusion from that upper echelon had "pissed me off at the time, but now I'm glad about it," Baxter told Mitchell, according to a police interview.

Baxter said Enron was in the papers every day in Houston and asked if it was the same up where Mitchell was, in Washington, D.C. Mitchell said no, though there was stuff on the television now and then. The conversation drifted to the officer-led partnerships, and Baxter said he

didn't know "exactly what Andy Fastow was doing with those partner-ships" but told Mitchell that "Andy was an asshole when you worked here and he is an asshole now."

"We talked about how the media was playing the story," Mitchell said in a letter to the Sugar Land police. "I said the media is basically playing this as a 'few guys at the top get rich and the working stiffs get screwed.' . . . In response to my statement, Cliff said 'the truth of the matter is some people made a boat load of money—including me—and other people lost a lot of money.' "

Mitchell said Baxter "did not sound depressed, distraught, or terribly disturbed when discussing these matters. He sounded annoyed but clearly not devastated." But then Baxter added something that stayed stuck in Mitchell's mind long after the conversation ended: "He said, 'Brad, you know what this is like—it's like when my dad died. I would wake up and the first thirty seconds of being awake everything would be fine. Then I would realize everything was not fine and my dad was gone. That's what this feels like. Thirty seconds after I wake up, everything is not fine.' "

There were other stories that suggested Baxter didn't handle stress well. Todd Stevens, a manager at Occidental Petroleum, later told Smith that he was involved in negotiations to buy some Enron assets in late 1998 or early 1999 and saw how emotional Baxter could get. Baxter got into a verbal joust, oddly enough with another member of the Enron team. After taking some shots from the other guy, Baxter went on the attack, "calling him every name in the book," Stevens said. He got more and more agitated and began jabbing his arm at the other guy.

Baxter was likable and honest and "seemed to have a real con-science," said Stevens. "But he also had a way of flying off the handle, and other people definitely knew how to push his buttons." The negoti-ations with Occidental soon ended without an agreement. Stevens said Baxter seemed guilty, somehow, that he'd wasted the Occidental team's time. One day, he said, they received a check, out of the blue, for $1 million as compensation. Stevens said they didn't feel they were owed a dime, but they kept the money anyway. "Nobody pays somebody money because they feel guilty in business," he told Smith. "But Baxter did."

Like a lot of guys who left Enron, Baxter had found it something of a

challenge to stay busy while enjoying the good life. So much of what wealthy or retired people did seemed like make-work. He had his seventy-two-foot yacht, the *Tranquility Base* (the name harking back to Apollo 11's immortal words: "Houston. Tranquility Base here. The Eagle has landed"). He had his membership in the nearby Sweetwater Country Club and at a yacht club. Sugar Land was a good place to go home to, but Baxter told friends it still was strange not to get up in the morning and make the twenty-six-mile drive to work.

When he quit Enron, he told people he was going to spend a lot of time on his boat. He'd even ordered a new, customized version but canceled the order after the problems with Enron began. It just seemed like the wrong time to trade up. Lately, he'd thought about going back to work, maybe getting a job teaching history at a local university. He went in for a get-acquainted interview at Rice University, but the meeting went poorly, he told his wife, because the interviewer had a relative that "had lost their savings" when Enron's stock tanked.

Once the shareholder suits began, most of the senior executives and former executives like Baxter quit talking to each other very much. That's what their attorneys advised them to do, so it wouldn't look as though they were trying to coordinate possible testimony. That made a rough situation even worse.

Enron hired a law firm to represent several current and former executives, and Baxter shared an attorney with Causey, Buy, and others. The attorney, Michael Levy, had been contacted by congressional staffers two days before Baxter's death and told that Baxter might be asked to testify. Baxter also had received a subpoena to surrender records to a U.S. Senate subcommittee though it was unclear what records he might have. This led to speculation that Baxter might have been afraid he'd be squeezed to provide incriminating information about friends.

When Jeff Skilling testified before the House Energy Committee two weeks after Baxter's death, he said Baxter had come to his house about a week before he died, very angry about the plaintiffs' lawsuits and devastated by what had happened to Enron. "He said it's like it's a beautiful day in Houston, Texas, and you're out in your front yard, and you've got a hose, and you've got a nozzle on it and you're watering your front lawn. And . . . all the kids in the neighborhood are out. Your neighbors

are out drinking coffee. They're all talking to one another, and it's just a great day. And then suddenly the guy that lives next door to you comes crashing out of his front door. He walks up to you and says in a voice loud enough for everyone to hear, that 'I hear you're a child molester,' and then he turns around and he walks back inside his house and closes the door. And Cliff said, 'You know, from that day forward your life is changed.' He said, 'They're calling us child molesters.' He said, 'That will never wash off.' "

People who knew Skilling say that he was devastated by the death of his friend. Mark Skilling told Emshwiller that he was so concerned about his brother's state of mind that he rushed to Houston from Turkey to help make sure that there wasn't a second suicide. "If there was even one chance in a thousand or one in a million," he said, "I wanted to be there to help."

Another Baxter friend, also a former Enron executive, told Smith that Baxter always took things too hard. He was more emotional than other men at the company, which sometimes resulted in some ribbing. Some people thought he had a sort of frat-boy sense of humor that meant criticism bounced off him, but that wasn't true. When Baxter was in a room, he tended to attract attention because he was the most garrulous. (A former Enron colleague said Baxter was so talkative and kept people in his office so long that it became known as the "black hole.") You'd talk to Baxter to get his opinion of something because it always was different from what you'd hear from others and was usually more blunt. You always knew where he stood. But it could be over the top sometimes. You'd "dial down" information that came from Baxter, he said.

Which was not to say he was some sort of renegade. He was very much one of Skilling's guys and had profited handsomely from his ten years at the company, retiring with millions. Shortly after an analysts meeting in early 2000, for example, Enron's stock jumped 25 percent, or by more than $13 a share, amid euphoric news that it was joint venturing with Sun Microsystems on its broadband system. Baxter, who was head of Enron North America (the new name for Skilling's old trading unit), filed an insider trading form with the Securities and Exchange Commission showing he'd taken advantage of that blip to sell $7.8 mil-

lion worth of Enron stock. In the twelve-month period preceding Enron's bankruptcy, Baxter received $5.6 million in compensation from Enron, even though he'd quit halfway through that period.

The Sugar Land police continued their investigation into Baxter's death under intense media scrutiny. The inevitable questions about motive were asked, and because of Enron's mounting difficulties, there was speculation, at least at first, about whether there was specific knowledge of some wrongdoing that had led Baxter to take his own life. The Sugar Land police wound up ordering just about every possible test, in part to demonstrate that it was not ruling out any possibility.

But they had a hard time getting their information out. Mrs. Baxter took out a court order to stop the police department from releasing any information. This, of course, fed into the hands of conspiracy theorists who saw Baxter as the next Vince Foster—the Clinton adviser who, like Baxter, had access to plenty of inside information and who died in what some people first suspected was a murder, not a suicide.

When the police completed their investigation, they concluded that the death was what they'd first suspected, a suicide. Ballistics tests supported it. The autopsy supported it. Exhaustive blood spatter analysis supported it—and ruled out the presence of any assailant. There was no reason to believe it was anything other than a suicide, except the gut feeling, maybe even a wish, that he wouldn't turn a gun on himself. Many months later, Smith called Robert Gray, the Baxter family friend and attorney. She left a message with a pleasant-sounding receptionist saying she wished to talk with Gray about Cliff Baxter. He didn't call back. A few days later, she called again and left a more detailed voice mail message saying she was working on a book about Enron, had spoken to Baxter at various times the prior autumn, and hoped to speak with Gray. Still, she didn't hear back.

Before heading into the news bureau one morning, Smith retrieved her voice mail messages and was surprised to hear one that said: "Ms. Smith, my name is Carol Whalen Baxter. My attorney, Mr. Gray, has forwarded your message to me. You can reach me at——. I do have one comment for you. Thank you." The voice was polite, but in the slow, restrained way of someone trying to control anger. She emphasized the word *Baxter*, as if it would carry some sort of shock value. The tone of

the message was, Call me if you dare and I'll give you a piece of my mind. Smith thought back on the voice mail message she'd left for Gray. It was nothing out of the ordinary, she thought, yet it had detonated something in a dark place.

She found a notepad and pen, wandered into the living room, and called the number. An answering machine picked up the call, and as Smith began to leave a message, Carol Baxter picked up the line. Smith identified herself again. Mrs. Baxter began by asking if the conversation was being recorded. Smith said no, that she never recorded phone conversations. "Are you getting this down, then?" Mrs. Baxter asked, her voice rising a few notes. Then she seemed to read a statement, but she spoke so rapidly that it was impossible for Smith to write it all down. All she could catch were the most emotionally loaded phrases that burned themselves into her awareness: "Shame on you for trying to further your career . . . by trampling on my husband's grave . . . increasing the agony of my children . . . wallowing in his death." After Mrs. Baxter finished the statement, she hung up. Smith felt as if she'd been slapped across the face.

She walked to the kitchen to get some coffee. Then she returned to the living room, sat down hard on a chair, and tried to think what to do next. She couldn't remember ever being in a situation anything like this. Smith recalled the saying "Cruelty is misery remembered" and thought about what life after Baxter's death must be like for his wife and two children. She couldn't even imagine. She remembered hearing from an Enron manager that one of the television networks had sent a lavish display of flowers to the Baxter residence shortly after the death, hoping to get an "exclusive" interview. It was all so dreadful.

Who could blame her for being angry? She decided to call back. "Mrs. Baxter," Smith said when the same voice answered the telephone, "can we have a conversation for just a minute? I'm sorry if my call upset you, although, actually, I was returning your call. I don't call bereaved people. That's why I called your attorney, Mr. Gray—"

Mrs. Baxter interrupted. "You don't think he was bereaved? He was one of Cliff's best friends, and that's why he won't let me pay him a dime for his services."

"I'm sorry. I didn't know," Smith said.

"No, you didn't know. There's a lot you didn't know," said Mrs. Baxter. The conversation continued in that vein for another minute or two, with Mrs. Baxter saying that the media had hounded her husband to death. They were responsible.

"I've never hounded anyone, and I certainly didn't hound Cliff," Smith said. "When he talked to me, it was because he wanted to."

"Are you a member of the media?" countered Mrs. Baxter. "Then maybe your idea of hounding is different from mine. Here's what I have to say to you," and again she read the agonized statement.

Smith ignored the statement, and there was a momentary pause. Then she thought about a conversation she'd had with Baxter in which he'd said the mess with the Fastow partnerships bothered him because "I was the integrity guy" and people looked to him to make the proper objections. But it hadn't done any good. "There's one question I'd ask you, if I could," Smith said. "Why did Cliff feel like he had to be the integrity guy at Enron? That seems like a heavy burden."

"He was full of integrity," said Mrs. Baxter. "He had it all his life and in everything he did. That's something you wouldn't understand, would you?" And for the third time she read the statement. Then there was silence. It was a futile conversation.

"I'm so sorry," Smith said.

Mrs. Baxter replied, "How big of you. What am I supposed to do with that?" Then, after a slight pause, she added, "Don't ever call me again," and hung up.

32

"There Was a Young Turk Arrogance."

CONGRESSIONAL INQUIRIES, BAXTER'S DEATH, ANDERSEN'S POSSIBLE complicity in a document-shredding cover-up—all kept Enron on the front page. At business gatherings and among friends, Emshwiller and Smith were asked about the company in tones that hinted at a web of intrigue stretching from Houston to Wall Street and Washington. Was Baxter, in fact, really murdered? Web sites speculating on that grisly possibility sprang up on the Internet as conspiracy theorists plied their bizarre formulations. More sensibly, there were questions about Lay's friendship with George W. Bush. Would some hidden history between the executive and the president—some unacknowledged political favors—protect the company from the full wrath of the law? Would Lay and other top executives escape criminal charges as a result? Many people assumed that the answer to these questions was "yes." Editorial writers and talk show hosts, displaying the American propensity for hyperbole, were calling Enron the greatest scandal in American history and lamenting the biggest tale of greed in the nation's annals of business.

Forgotten, Smith thought, were the Teapot Dome and Tammany Hall scandals, not to mention modern cases of corporate corruption such as the savings and loan industry collapse and the Milken/Boesky insider trading scam. She knew a milestone had been reached in February when she was standing at the supermarket checkout stand and saw

that Tom Cruise and Oprah had been pushed from the *National Enquirer*'s front cover in favor of a screaming headline over a shimmering photo of the crooked E logo. In giant type it read, ENRON, THE UNTOLD STORY: ADULTERY, GREED, HOW THEY RIPPED OFF AMERICANS. Smith bought the issue and reflected on how, in six short months, the company had been recast as a principal player in the "Axis of Evil"—complete with CIA agents secretly embedded in its ranks. It was almost as if it were easier to pin on Enron every sin known to man—murder, lust, larceny, avarice, duplicity—because so few really understood what had gone on inside of the company. And because it wasn't easy to explain what Enron had done, the subtleties of explaining what it *hadn't* done were being lost as well.

Nowhere did this darkening glare shine more brightly than on what had become Enron's unholy trio of Lay, Skilling, and Fastow. Not that they didn't deserve the attention. While perhaps dozens of people, not all of them Enron insiders, had a hand in the scandal that engulfed the company, none had roles equal to those of the three executives. Lay had been the captain of the ship during most of Enron's fifteen-year voyage, Skilling the navigator, and Fastow the master mariner ever ready to work whatever ropes or sails were needed to reach El Dorado.

Questions about the criminal fate of the three came up in almost every discussion of Enron. Smith was on television news shows now and then and grew to expect the question "When is Ken Lay going to be brought to justice?" One Democratic friend declared to Emshwiller that "Bush needs to arrest two people, Osama bin Laden and Ken Lay, and I'm not sure he'll get either." The reporter was astonished that someone whom he knew to be a generally reasonable person could put Lay into the same sentence with the world's most notorious terrorist. Emshwiller thought back to that comment from the California attorney general about dreaming of putting Lay in a prison cell with an amorous con. Now, even Spike probably wouldn't want him as a roommate.

From early in the federal criminal investigation, it was clear that Leslie Caldwell and her fellow Justice Department prosecutors would have to indict the three men or invite questions about whether the Bush administration had really tried to administer justice. However, while public outrage could certainly pressure federal prosecutors to in-

vestigate, it couldn't help them build a criminal case. On that front the Enron Task Force faced some formidable obstacles.

One of the biggest barriers to prosecutors was what some people referred to as the "experts' defense." In order to file a fraud case against Enron officials, prosecutors had to show that the officials lied to the public. Yet even with some of the most suspect actions, such as deals involving the LJM partnerships and the Raptor entities, Enron had received accounting and legal advice from well-regarded outside experts, such as Andersen. Having the blessing of such experts made it very difficult, if not impossible, to show the necessary criminal intent by executives. Enron officials could always say something to the effect of, "Well, our accounting and legal experts said it was okay. Who were we to question them?"

One way to breach this defense was to show that the experts had been in on the scam. "To prove criminality in those kinds of transactions, the government has to show that the lawyers and accountants were part of a conspiracy," one person familiar with the Enron investigation told Emshwiller and Smith. Emshwiller, ever the cynic, thought that mass indictments of Enron's lawyers and accountants wasn't necessarily a bad idea, but the person assured them that proving such a case would be exceedingly difficult, absent documentary evidence or insiders' testimony that the professionals knew that a fraud was going on.

A more promising route for the prosecution was to show that Enron officials had lied or failed to supply crucial information to the outside experts, the source said. Chewco was interesting to investigators, in part, because Andersen had already publicly proclaimed that crucial information about the partnership had been withheld from the accounting firm. Also to be explored were possible instances where no expert opinions were called but where Enron executives might simply have lied to the public in speeches or press releases.

However, unless Lay or Skilling or Fastow were planning to drop by the Justice Department to confess to something—and by early 2002 it was abundantly clear that they had no such intention—Caldwell and her team would have to build a case one brick at a time. The favorite Justice Department route for a complex criminal investigation involved investigators working their way up the ladder of an illegal enterprise,

initially targeting lower-level figures for prosecution. The aim was to secure the underlings' cooperation and get them to provide incriminating information on higher-ups. While a tried-and-true method, this type of investigative approach could also be very time-consuming, especially with a landscape as vast and complex as Enron's. Though Caldwell's task force grew to six attorneys and some two dozen FBI agents, it faced sorting through thousands of transactions and financial structures. By contrast, the examiner appointed by the federal bankruptcy judge to unravel some of Enron's financial dealings employed over 150 lawyers. Caldwell and her colleagues knew that their assignment— finding any criminal conduct and convicting the guilty parties—would take months, perhaps years. All the while, there would be pressure for action against the "Big Three."

Initially, the federal criminal team faced the same problem as reporters, congressional investigators, and the general public: What exactly had gone on inside Enron? Building a coherent explanation of what laws might have been broken required a better understanding of the company's internal operations.

At the beginning of February, the first stab at a more comprehensive analysis was made. Ironically, Enron itself supplied the document.

On February 2, Enron released the Powers Report, the product of the committee the company's board had created in late October to investigate the executive-run partnerships. The internal analysis, begun months earlier, proved to be the single most powerful and comprehensive primer on Enron's inner workings. The report was based on dozens of interviews and the review of thousands of pages of documents. The more than two-hundred pages, dense with names and numbers, painted a portrait of malfeasance, inattention, and greed. Nobody was spared criticism.

The report initially was posted on a Saturday at the Web site for the Enron bankruptcy case in New York federal court. Emshwiller and Smith tried to download it into their home computers, but the file was too big for their systems to swallow. Fortunately, *The New York Times* and *The Washington Post* came to the rescue and posted digestible-size pieces of it on their Web sites.

The committee, whose investigative staff was led by the former SEC enforcement chief Bill McLucas, concluded that several Enron employees—particularly Fastow and Kopper—"were enriched, in the aggregate, by tens of millions of dollars they never should have received." This unjustified flow of wealth, the report continued, "was merely one aspect of a deeper and more serious problem" of "overreaching in a culture that appears to have encouraged pushing the limits." Enron used the LJM and Chewco partnerships to enter into transactions, many with the Raptor entities it had created, that it could never have made with truly independent parties. In violation of accounting rules, such transactions were used "to conceal from the market very large losses resulting from" Enron's troubled business investments. The committee estimated that in the twelve-month period that ended on the prior September 30, the partnership deals allowed Enron to report earnings "that were almost $1 billion higher than should have been reported."

Enron's top management, its board of directors, and its outside auditors and attorneys all failed in their responsibilities to shareholders, the report asserted. Lay, Skilling, and the board should never have allowed the chief financial officer to take part in an arrangement so "fundamentally flawed" as the LJM partnerships. Management then compounded that failure by instituting controls that "were not rigorous enough, and their implementation and oversight was inadequate."

The committee said it found evidence that company officials "had agreed in advance to protect the LJM partnerships against loss"—a stunning claim that, if proved, could move some Enron officials much closer to the defendant's table in a criminal trial. Enron officials had repeatedly said in SEC filings and elsewhere that the LJM deals were true third-party transactions, done at arm's length. Arm's length wasn't supposed to involve reaching out and wrapping the other side in a protective blanket. The report cited seven cases where Enron sold assets to the LJM partnerships in the second half of 1999. The transactions, often occurring near the end of a quarter, allowed Enron to move the associated debt off its balance sheet and to then record tens of millions of dollars of gains for earnings purposes. But "after the close of the relevant financial

reporting period, Enron bought back five of the seven assets sold . . . in some cases within three months . . . the LJM partnerships made a profit on every transaction, even when the asset it had purchased appeared to have declined in market value."

As they read the pages over the weekend and prepared to write a story for Monday's paper, Smith and Emshwiller felt gratitude and surprise that the board had allowed such an unblinking look inside Enron. It added tremendously to what was publicly known, and the reporters were relieved that nothing they'd believed to be the case had been proven wrong.

Fastow came in for particularly harsh criticism. "He was in a position to exert great pressure and influence, directly or indirectly, on Enron personnel who were negotiating with LJM. We have been told of instances in which he used that pressure to try to obtain better terms for LJM," the report said. Fastow had wanted to head Chewco, but Skilling had supposedly quashed the idea when Enron attorneys said the connection of so senior an officer would have required disclosure in SEC filings. So Kopper had gotten the Chewco job and the partnership had remained in the shadows. (One source told Emshwiller that Skilling's position was that the only thing he was asked about and nixed regarding Fastow and Chewco was the CFO's suggestion that members of the Fastow family invest in the partnership. This person added that Skilling felt much of the Powers Report had been poorly researched and overstated.)

The report revealed that even Lea Fastow had a role in her husband's partnership adventures. For a time, she helped keep the books on Chewco and received more than $50,000 for her services.

Some of the report's most astonishing details concerned the Raptor vehicles and how the structures had been used to manipulate earnings. The idea for the Raptors first started kicking around at Enron in late 1999. Skilling pushed for creating a mechanism that could protect the value of some of Enron's investments. Glisan was involved in setting up the Raptors. Through the Raptors, Enron intended to use the value of millions of shares of the company's own stock and stock it held in other firms to offset any fall in the value of other investments it held. Such a

"hedge" arrangement meant Enron wouldn't have to report investment losses on its quarterly income statements. To execute these hedges, Enron set up various Special-Purpose Entities, such as the Raptors. In each case, the required 3 percent outside equity piece needed to keep the arrangement off its balance sheet came from LJM2.

But LJM2's participation looked fishy on two counts. In the case of the first Raptor vehicle, Enron guaranteed that LJM2 would earn at least an $11 million profit on its initial $30 million investment. But before the vehicle could do any hedging transactions with Enron, LJM2 had to get paid that $41 million—hardly a normal condition for a supposedly at-risk investment. The vehicle, like the others, also involved a complicated array of put options, promissory notes and stock infusions that utilized Special-Purpose Entities called Talon, Pronghorn, and Harrier.

As she read the Powers Report, Smith thought back to an April 2000 conference call with reporters and analysts, when the first Raptor deal was secretly in the works. Skilling had said the company was expanding at "warp speed" in all directions and achieving "an unassailable competitive advantage" over its rivals. Nearly breathless as he ran through a list of triumphs, Skilling said, "I feel a little bit like we have been swamped with new opportunities and we are just trying to sort them out and figure out what to do with them all." Such statements, happily swallowed by the market in those happy days, suddenly had to be viewed in a whole new light.

The $41 million payment raised a vexing question, though. Was LJM2 being paid a return on its investment or for a return of its investment? If it was the former, the payment would represent an astronomical profit. If it was the latter—and correspondence from Fastow to LJM2 partners said it was—the Raptors wouldn't have any outside equity and wouldn't qualify as an independent entity. In other words, the entire Raptor structure would have been one giant lie.

As Enron's portfolio of "merchant" assets, such as power plants, decreased in value, losses simply were gobbled up by the Raptors. But as the assets continued to fall in value and Enron's stock price started falling in late 2000, the loss-absorbing capacities of some of the Raptors

began reaching their limits, confronting the company with the very unwanted prospect of having to disclose some of the losses on its own quarterly income report to shareholders.

Enron executives took a number of steps to shore up the Raptors, including creating what was known as a "costless collar." Under this arrangement, Enron would *pay* money to a Raptor entity if the company's stock didn't rebound to a certain level.

"Well, at least we now know a little more about what Enron meant in all that gobbledygook about costless collars in the SEC filings," Emshwiller said to Smith as they read through the Powers Report.

"Yeah, except it wasn't costless if Enron's stock price was too low. Some hedging technique," Smith said sarcastically.

Yet even with gimmicks such as the costless collar, Enron was faced with a terrible problem by late 2000. The whole rickety Raptor structure was threatening to collapse under the weight of the company's deteriorating asset values. By then, Enron had entered into about $1.5 billion worth of transactions with a total of four Raptors, and it was looking at a $500 million hit to earnings as a result of their eroding credit capacity. But instead of taking its lumps, Enron officials embarked on a feverish program to shore up Raptors by stuffing millions of additional Enron shares into the entities. The public knew nothing about these frantic measures or what a hoax the prior profits had been. But by the time Skilling quit in August, the Raptors' credit deficiencies had ballooned again into hundreds of millions of dollars.

For all the new information that the Powers Report did provide, there were many questions it didn't answer. For instance, committee investigators had no success in discovering why the Chewco partnership had been set up with its fatal flaw in 1997 or whether anyone knew about the flaw at the time. The Powers committee said it was hampered by the unwillingness of key figures, such as Fastow and Kopper, to be interviewed about Chewco. The committee didn't interview any Andersen officials. After the report came out, Andersen and Powers committee officials argued over whether accounting firm personnel were ever invited to talk.

The Powers committee's work also had frustrating gaps. Its investigators didn't make verbatim transcripts of the interviews they did. They

merely took notes, and those notes were destroyed after summaries of the interviews were typed up. This was a common practice in internal corporate investigations. Transcripts could be subpoenaed by class-action lawyers, who might cull quotes to use against the company in lawsuits. Nor did the committee publicly release the scores of interview summaries it did create. While the report provided lots of damning new information, it left it to readers to guess whether any felonies had been committed. Clearly, Lay, Skilling, and Fastow had acted badly, in the report's view. Whether any or all had acted criminally wasn't a matter tackled by the committee.

After the report was released, committee chair Bill Powers initially declined interview requests. Smith phoned his office regularly and figured if she was patient enough, he would talk eventually. And he did. Powers told her that he was ambivalent about the committee's work. While he felt it had made an important contribution to investors, investigators, and Congress, he was unhappy that some of the most basic questions—who was responsible for the deceit and why others allowed it to flourish—had not been adequately answered.

In the beginning, he said, the committee's marching order had been to explain what had happened with the partnerships, "since the *Journal* was running articles about Fastow's involvement." But it soon became clear that "there was serious rottenness and deceit" at Fastow's division, Enron global finance, he said.

Powers said he had an "epiphany" of sorts in November 2001. By this time, the committee had become aware of how much abuse there had been, "but even then we didn't fully appreciate the intentionality of the schemes." By January, he said, "we did. The Raptors and the whole restructuring raised serious questions about how far the knowledge extended."

Powers sat in on some of the interview sessions with Enron employees. Powers especially wanted to hear what Ken Lay had to say.

During the interview, "I asked him whether he thought—at the time, not now—that the Raptors were legitimate, bona fide hedging instruments. He didn't understand the question," Powers said. "At the end of the session, a couple hours later, I came back to the question. He said he understood now they weren't bona fide hedging instruments. There

were a lot of times when he said he didn't know things. . . . We asked Ken if he knew the amount of money that came from the partnerships. It was well over a billion dollars. . . . He didn't understand how it translated into earnings. It was strange."

The fifty-seven-year-old Powers said he frequently was struck by how young Enron's senior team was. At one board meeting, he said, he saw a couple of guys hanging around, joking with each other. He figured they were aides who hadn't been trained how to comport themselves in public. It turned out they were Causey and Buy. From some Enron executives, "you didn't hear a lot of 'yes, ma'am' or 'yes, sir,' " said Powers. "There was a Young Turk arrogance."

In the end, Powers said he was disgusted by what he found, especially as a Texan who long viewed Enron as an innovative and solid corporate citizen. "Being technically proficient isn't good enough," he said. "One needs to be morally responsible." Though the Powers committee wouldn't make public its interview memos, it did turn over the documents to various congressional and law enforcement bodies. Not long afterward, the memos began leaking out piecemeal.

One of the first to surface was the Lay interview memo. The *Journal* got a copy courtesy of a source that Emshwiller had been cultivating for a few weeks. The person was involved in one of the many investigations into Enron's collapse and was privy to many of the internal documents of the Powers committee. The person had initially called both Emshwiller and Smith, looking for information about Enron. Smith had been cool to the overture, viewing the person as someone trolling for information garnered from confidential sources she had promised to protect. She never was comfortable feeding information to government or private investigators, though she knew that her reluctance was not universally shared. She didn't try to parlay information hoping to get more information back. It struck her as an inappropriate role for reporters and, too often she felt, resulted in reporters becoming tools of the government with the pair ganging up on news subjects. Smith felt strongly that the press's role was to be independent; government has its assignment, so did the media. Emshwiller would sometimes razz her by pointing out all the good material he'd gotten from people she stayed clear of,

but ultimately they accepted each other's philosophical differences on the matter.

Emshwiller's experience had taught him that winning the confidence of a source often involved a certain give-and-take. It was the reporter's job in such a relationship to try to take more than he or she gave and to never cross the line of giving out information that first needed to be put in the paper. Emshwiller decided to talk to this particular person for several reasons. Though the person didn't yet know much about the ins and outs of Enron, he had access to private information that no reporter, at least for the time being, could reach. If the person would pass along even a portion of that information, Emshwiller figured it was worth spending some time helping him get educated about Enron. It quickly became clear that the person wasn't looking for any secrets. He mostly wanted to talk with someone who had at least a familiarity with the complexities of the company. Emshwiller spent most of their conversations reviewing material he and Smith had already put into the *Journal*. The person seemed especially interested in Chewco, sharing the reporter's fascination with the partnership and the belief that it could be a key to unlocking some of the mysteries of how Enron went wrong. Plus, the guy was personable and Emshwiller enjoyed talking with him.

This person eventually turned into a valuable source for the *Journal* on the Enron scandal. He'd slipped Emshwiller a copy of the minutes of a 1997 meeting of the executive committee of Enron's board where Chewco was first discussed and hundreds of millions of dollars of loan guarantees for the partnership were approved. When Emshwiller and Smith began reading over the Lay interview memo, they found that much of the document consisted of Lay claiming ignorance about most of the company's dealings with Chewco and LJM. Lay said he wouldn't even recognize Michael Kopper if he saw him on the street. On a whim, Emshwiller began counting the number of times that Lay used some version of "don't recall" or "didn't know." He reached four dozen.

Lay's most interesting—and potentially incriminating—comments concerned Skilling. Asked to evaluate his onetime protégé, Lay praised Skilling as a strategic thinker who was creative, strong in finance, and

possessed of good judgment and integrity. Lay added that he felt Skilling kept him well-informed about Enron's business operations. Lay revealed that Skilling had told him of his plans to quit on July 13—more than a month before the public announcement. He gave no explanation as to why Enron waited so long to reveal this obviously material information.

Lay said that Skilling initially cited a desire to spend more time with his children. But "Lay pushed him a little more on the reason for his decision, and Skilling said that he was under a lot of pressure and felt that Enron's stock price was dropping and he could not do anything about it," the memo said. He was worrying so much about it and taking it so personally that he couldn't sleep at night.

"It looks as though he lied to you in August," Emshwiller told his bureau chief, referring to Lay's comment on the day of the resignation announcement that the departure had "absolutely nothing to do" with the stock price.

"It certainly looks like it," Friedland agreed.

The two reporters and Friedland discussed whether they should use the word *lied* in the story. The main thing holding them back was the fact that they didn't have a verbatim transcript of the Lay interview. While they had no reason to believe the memo was inaccurate, it was paraphrasing Lay rather than quoting him exactly. In the end, they decided to say Lay "may have deliberately misled the public in order to keep the energy giant's problems from becoming known." Wording aside, the story was the most tangible evidence the *Journal* had yet come across that Lay knew more about the decay inside of Enron than he had admitted. Innocent men usually didn't lie.

"Next Time Fastow Is Going to Run a Racket, I Want to Be Part of It."

ONE DAY, TWO LOOSE-LEAF BINDERS ARRIVED IN EMSHWILLER'S OFFICE, courtesy of a friendly source. They were filled with eight-by-ten papers, a few hundred pages. They were the dozens of Powers committee interview memos that had yet to be made public.

The reporter could hardly wait to read through them. Here was information from all kinds of Enron insiders, almost none of whom were talking to the press. Emshwiller hoped that the documents might contain all kinds of new information on Enron's financial deals. Maybe they would provide new insights into why Skilling quit or why Fastow and others were fired. Maybe they would help answer questions about who knew what when. He quickly read through the master list of interviewees that accompanied the documents. While many names were familiar, many rang no bells. In some ways, the latter were even more enticing than the names of the better-known executives, who could be expected to deny knowing anything incriminating. Some of these lower-level officials might have golden nuggets of information.

After conferring with Smith and Friedland, Emshwiller turned over a batch of the documents to a news assistant, who made two sets of photocopies, one to be sent via FedEx to Smith, the other to be couriered to the New York office. While the news assistant began photocopying one batch, Emshwiller began reading another. While the memos contained lots of interesting new bits of color about the partnerships and interof-

fice politics, none jumped out as a news story in its own right—except for the interview memo of Vincent Kaminski.

Kaminski had been the head of Enron's research group. In its public report, the Powers committee had made reference to Kaminski, who "told us he was very uncomfortable" about the company's initial dealings with LJM1. Kaminski told the committee investigators that he had complained to Rick Buy, his boss, about the "obvious conflict of interest" arising from Fastow's involvement. He also thought the arrangement was skewed in LJM1's favor. Buy told the committee that he didn't recall any such discussion with Kaminski or the involvement of Kaminski's group in the LJM1 matter. However, Kaminski's complaints were a tiny part of the Powers Report and were ignored in almost all the stories, including the *Journal*'s, about the committee's findings.

As Emshwiller read through the actual Kaminski interview memo, he found that it contained all kinds of fascinating details revealing the serious objections inside Enron that had been raised—to no avail—from the very inception of the LJM1 partnership, which was created in mid-1999 to protect, or "hedge," the value of Enron's stock holdings in Rhythms NetConnections Inc., an Englewood, Colorado, technology company whose shares had soared in the Internet boom.

As it later would with the Raptors, Enron turned to its own stock as the way to protect the value of its Rhythms holdings. A partnership headed by someone already familiar with the economics of the transaction and who understood Enron's interests could be just the ticket. Fastow would head the partnership, though his involvement would have to be included in Enron SEC filings. Approval from Skilling, Lay, and the board quickly followed.

To provide some working cash for LJM1, Fastow as general partner agreed to put up $1 million, according to the Powers Report. He also recruited two limited partners, each of whom ponied up $7.5 million. One was an affiliate of Credit Suisse First Boston, the big Wall Street brokerage firm and an investment banker for Enron. The other was an affiliate of National Westminster Bank, a big British financial institution and a lender to Enron. Enron tossed in 3.4 million of its shares, with a market value of about $275 million, to an LJM1-related entity in return for an

IOU. That entity then agreed to cover losses to Enron if the Rhythms shares declined in price.

Kaminski was uncomfortable with what he saw. A Polish immigrant and mathematics whiz, who had immigrated to the United States after earning a master's in finance and a doctorate in economics in his home country, Kaminski was widely admired by colleagues for his forthrightness and integrity.

As the LJM/Rhythms deal came together in June 1999, Kaminski told the Powers investigators that he had received an urgent call from his boss, Buy, who ordered the research group to immediately calculate the proper price for the put option on the Rhythms shares.

A couple of minutes later, Skilling came striding into Kaminski's office. Skilling almost never visited, Kaminski said. Skilling looked tired and wasn't his normally crisp, articulate self. He gave what Kaminski viewed as a rambling explanation of the Rhythms arrangement.

The more Kaminski learned about the Rhythms plan, the less he liked it. If both Rhythms and Enron stock fell at the same time, there might be no protection at all. When he explained the plan to his staff, they broke out laughing, it seemed so absurd. This is a bad idea, Kaminski told Buy. In fact, he added offhandedly, the whole idea is "so stupid that only Andrew Fastow could have come up with it."

Actually, Fastow did, Buy supposedly replied. And he was planning to run the partnership.

Kaminski was shocked. He'd long thought of Fastow as charming but glib and a lightweight in financial matters. Given Fastow's involvement, Enron definitely shouldn't allow this deal to go forward, Kaminski replied. Aside from the obvious conflict of interest, the whole thing just doesn't make economic sense for Enron.

Kaminski recalled that Buy acknowledged he, too, had qualms and supposedly jokingly added that, "Next time Fastow is going to run a racket, I want to be part of it."

(An attorney for Buy later reiterated to Emshwiller that his client didn't recall any such conversation with Kaminski. However, the attorney added, Buy did have concerns about the LJM partnerships because of the potential conflicts of interest created by Fastow's participation in them.)

As Emshwiller spent a weekend reading through the piles of inter-view memos, which had arrived on a Friday, the Kaminski document seemed the most newsworthy. The reporter reached Kaminski at his home in Houston on Sunday morning. He was friendly. "But if I talk to you, my lawyer is going to kill me," he said with a laugh. His lawyer, Nathan Hochman, was willing to confirm that the interview memo ac-curately reflected what Kaminski had told the Powers committee. "There is one thing that isn't in the memo," Hochman said. "It involves Skilling."

"What's that?" Emshwiller asked, immediately interested.

After Kaminski complained about LJM1, he and his research group were transferred to another part of Enron. When he asked Skilling why, Hochman said, Skilling told him that there had been complaints about Kaminski and his group, though he didn't specifically mention the Rhythms deal. Instead of helping close deals, they were acting like "cops."

It sounded more and more as though Skilling were trying to stifle any dissent about LJM, though his representatives would later deny that was ever the executive's intention. One person familiar with the matter later told Emshwiller that Skilling was surprised to read about Kamin-ski's version of events. The former president was a big admirer of Kaminski's. At one point, Skilling even made an Enron corporate jet available to Kaminski so that the research director could visit his family, who was living for a time in California. The Enron president main-tained that he would have listened if either the research chief or Buy had brought him concerns about the Rhythms deal. Supposedly, the transfer of the research unit had long been in the works and Kaminski had misinterpreted the "cops" remark. Buy's risk control unit already had plenty of "cops" to watch over deals, and Kaminski's group was needed to help do research in the trading operation. While Kaminski felt that LJM1/Rhythms was bad for Enron, the real death blows to the company came only later, with LJM2 and the massive Raptor deals.

"Often He Was Just Goofy."

As new details about Enron's inner workings emerged, it became clear that a number of company officials had raised questions about the LJM setup. In the course of their reporting, Emshwiller and Smith got to know an Enron insider who had a particularly close-up view of Fastow in action. While this person provided some damning new details about the whole LJM setup, he also painted a more complex—and in some ways stranger—view of Enron's chief financial officer.

The two reporters' first contact with this source came when Emshwiller called him at Enron in early 2002. By then, Smith and Emshwiller had made scores of such phone calls and had long since gotten used to cool, if not frosty, receptions. So Emshwiller was pleasantly surprised when the voice at the other end of this particular call said with a soft chuckle, "I was wondering when you or Rebecca would call me. I was sort of feeling left out."

The voice belonged to Jordan Mintz, a senior Enron attorney. From early on, the forty-five-year-old lawyer impressed both reporters as being a rare bird at Enron: someone who acted as though he didn't have anything to hide.

Starting in October 2000, Mintz had served as general counsel of Enron's finance unit. In other words, he was the chief lawyer for Andy Fastow's operation in the last, frenetic year of the CFO's tenure. And

within certain bounds, he was willing to talk about what he'd seen and done.

Emshwiller had first come across Mintz's name in a January article in *Salon.com,* an on-line newsmagazine, which said that in the summer of 2001, Mintz had become so concerned about the LJM partnerships that he'd sought an outside legal opinion as part of an effort to rein in the entities.

Mintz's name popped up again when congressional investigators leaked a damning tip about Fastow to Tom Hamburger of the *Journal's* Washington bureau. Fastow had supposedly ordered Mintz to fire one of the finance unit's attorneys because the lawyer had been negotiating too hard on Enron's behalf in a transaction with LJM2. If true, it was some of the strongest evidence yet of Fastow abusing his position at the company to advance his position at the partnership. Hamburger called Emshwiller and offered to do a joint bylined story. Hamburger would work the Washington end and write the piece, while Emshwiller would try to reach Mintz, Fastow, and others at Enron.

The allegation jibed with the Powers Report statements about Fastow pressuring subordinates to get better deals for LJM and with similar claims made by Smith and Emshwiller's original source. The reporter put in a quick call to Gordon Andrew, a public relations specialist Fastow had hired. Cool but cordial, Andrew gave his usual "No comment."

Though Mintz was friendly when Emshwiller called, he was also cautious. He agreed to discuss the incident only to correct some errors. Fastow had never ordered him to fire the attorney, who was named Joel Ephross. Instead, in the fall of 2000, Kopper and Glisan had visited Mintz, who'd just been named to the general counsel's job, and urged him to dismiss the attorney, who had supposedly been unresponsive and unprepared in handling a recent LJM-related transaction. Kopper said that Fastow wouldn't object to the dismissal.

Mintz eventually decided that Ephross had not acted inappropriately and kept him. In his initial conversation with Emshwiller, Mintz did confirm another part of the tip that had been passed to Hamburger. Ephross had told Mintz of receiving an expletive-laced phone call from Fastow, complaining about the lawyer's handling of the LJM negotiations.

Though not quite as juicy as the congressional version of events, the incident was interesting. It sounded as if Fastow had sent a couple of subordinates to do his dirty work, and then, when Mintz resisted, he didn't press the matter.

It turned out that Mintz, who would eventually testify before a House panel, had been a critic longer and more consistently than such better-known figures as Watkins and McMahon. Yet Mintz never came across as a crusader in his conversations with either reporter. His career course had been straightforward. He'd earned his bachelor's degree in the Ivy League, at the University of Pennsylvania. His law degree came from Boston University, and he had an advanced degree in tax law from New York University. He went to work in Houston for Exxon and then moved to one of the city's biggest law firms, Bracewell & Patterson, where he specialized in tax law. He joined Enron in December 1996 as head of the tax department in the trading operation and worked on tax-related matters for most of the next four years. Mintz rose quickly at Enron. He was smart, personable, and politic.

That October 2000 visit from Kopper and Glisan about firing Ephross gave Mintz his first taste of LJM. He soon got others.

A few weeks after settling into his new job at the finance unit, Mintz received a copy of a draft offering document for an LJM3 partnership. Fastow envisioned raising as much as $2 billion from investors—five times the amount of LJM2. As Mintz read through the document, he was appalled. "Fastow and Kopper were basically selling investors on their access to inside information at Enron," Mintz told Emshwiller—the very kind of information that as corporate officers they were supposed to use to the benefit of company shareholders. "I remember reading it and thinking, Can we be any more blatant?"

The lawyer wrote a carefully crafted, page-and-a-half memo that contained no direct criticism of the LJM concept or any of the individuals involved. But it repeatedly noted the close "linkage" that LJM3 was claiming to have with Enron through Fastow and Kopper. Mintz hoped that this might raise some sufficient concerns. He sent copies to several people, including Causey and Buy, the two men the board of directors had designated to be the watchdogs over the company's LJM dealings. As far as he could tell, his missive drew little response.

Fundraising work started for the new partnership, but early in 2001, LJM3 was shelved. Mintz said Fastow told him that Enron decided it didn't need the additional financing capacity—though, in retrospect, that seemed a dubious explanation. Enron's cash needs were growing quickly, and its efforts to raise billions in cash through the selling of assets was going slowly. Perhaps the company was becoming concerned about the rising resentment and criticism inside of Enron—and to some degree in the investment community—about the LJM setup. Adding another $2 billion to the pot certainly would have increased such tensions.

The controls over LJM activities were slipshod at best, said Mintz. The standardized LJM deal approval sheets consisted of extremely general questions with boxes to be checked "yes" or "no." One question was invariably answered "yes," with no explanation: "Will this transaction be the most beneficial alternative to Enron?" Another question, which routinely earned a "no": "Were there any other bids/offers received in connection this transaction?" One question that wasn't asked: If there were no competing bids, how was it possible to determine that the LJM offer was the best Enron could get?

In early January 2001, Mintz wrote a memo arguing that the review procedure needed to be strengthened substantially. Again, Mintz's memo was barely acknowledged.

Two months later, on March 8, he wrote again to Causey, Buy, and several Enron attorneys. The company needed a "more active and systematic effort in pursuing non-LJM sales alternatives" and "more rigorous testing of the fairness and benefits realized by Enron in transacting with LJM," Mintz wrote. Among his specific recommendations was the need to move people who were working full-time for LJM out of the Enron building: Mintz thought it was an awful idea to have Enron employees on the same floor who were on opposite sides of the negotiating table.

This time Mintz got a reaction. One day, Kopper came striding into his office and threw a copy of the memo onto his desk. He accused the lawyer of trying to shut down LJM. Mintz denied that accusation, and the confrontation quickly ended with nothing resolved.

Mintz was also bothered by the consistent blank space where Skill-

ing's signature was supposed to be on the LJM deal approval sheets. He told Emshwiller that he didn't know the ins and outs of Skilling's supposed involvement. He just knew that the form had a place for Skilling's signature. So he was going to try to get the president's signature. Plus, Mintz added, he had started thinking about sharing some of his LJM concerns with Skilling.

The lawyer went to Causey and Buy and asked their advice on the best way to approach Skilling about LJM. "I wouldn't stick my neck out," Buy said. "Jeff is very fond of Andy." Causey concurred.

(An attorney for Buy and Causey later told Emshwiller that while the two men met occasionally with Mintz to discuss LJM, neither remembers making such remarks about Skilling. He added that both Enron executives felt that they had gotten very little guidance from top management concerning what their duties as LJM watchdogs entailed. They also felt that the Mintz memos were suggesting changes that were largely the responsibility of Fastow's finance unit to implement.)

Nonetheless, in May 2001, Mintz sent Skilling a memo about the need for his signatures on the deal approval sheets and suggested that the two meet. Mintz didn't hear back. He had his assistant twice call Skilling's secretary and leave messages. But he never heard back from Skilling (who later claimed that he never knew Mintz had been trying to meet with him. He also said it wasn't his responsibility to sign the LJM deal sheets).

"I only saw Skilling once after that before he resigned," said Mintz. The two found themselves alone in an elevator at Enron headquarters. LJM didn't come up in their brief conversation. There was a moment of small talk about summer vacation plans; Mintz was taking his family to Hawaii. The attorney asked Skilling how things were going. He expected the kind of bland response that question usually gets. Instead Skilling replied in a pained voice, "Oh, man, the stock price is just killing me." (Another Enron source said that at the time of his resignation, Skilling was so discouraged about the company's stock performance during his tenure as CEO, that he bet a colleague that the price would rise as a result of his August resignation announcement. It didn't.)

Strangely, Andy Fastow seemed utterly unconcerned about Mintz's criticism of LJM. Mintz told Emshwiller that Fastow was unfailingly

courteous and cordial and even mildly amused by the lawyer's efforts regarding the partnerships. He would joke about the matter during finance group staff meetings.

"That does sound weird," Emshwiller said. He thought back to how Fastow had refused to talk with Smith and him and how he had supposedly urged the company to do the same. "I always got the impression that he was very sensitive about LJM," the reporter added.

He could be, Mintz agreed. When Mintz came on as general counsel at the finance unit, LJM's outside law firm, Kirkland & Ellis, was researching whether it would relieve Enron of any related-party disclosure obligations if the CFO turned over his general partner duties to a Fastow family foundation that he headed. The idea was dropped after Mintz and other attorneys argued there would still be a disclosure obligation because of the foundation's connection to Fastow.

Fastow seemed particularly sensitive about any disclosures concerning his LJM-related compensation.

Fastow once told Mintz that if Skilling ever found out how much he was making from LJM, the president wouldn't have any choice but to shut down the operation. Mintz had the sense that Fastow didn't feel Skilling would be upset by the number but that the board would. The CFO never told Mintz how much he made from LJM.

"Fastow sounds like he was a little schizophrenic about all this," Emshwiller said at one point to Mintz. "Sometimes secretive, sometimes joking. It's almost like there were two Andy Fastows."

"Andy was an enigma," Mintz said. "Sometimes he was charming and polished, but often he was just goofy."

PART FIVE

The Perp Walk

bles at the accounting firm. In the recent past, Andersen had reached
civil settlements in three embarrassing cases in which it had been ac-
cused of incompetence and misconduct. It agreed to pay $90 million in
a case involving a company called Colonial Realty. It had paid $110
million to settle charges related to its auditing for Sunbeam Corp.,
which, like Enron, ended up in bankruptcy court. And it paid $95 mil-
lion and agreed to an SEC injunction against any future violations of se-
curities law in connection with its work for Waste Management Inc.
Plus, the firm was still defending itself in connection with its audit work
for the Baptist Foundation of Arizona.

In each instance, Andersen was accused of helping a client company
inflate reported earnings and deceive investors who had relied upon
Andersen's integrity and independence for a correct reckoning of the
company's financial position. While Andersen didn't admit to wrongdo-
ing in any of the matters, this string of problems colored the thinking of
federal officials in the Enron investigation.

As the criminal probe progressed, Andersen started to see its business
fall apart. Each day, more Andersen clients announced they would seek
the services of other accountants. In a last-ditch attempt at damage
control, Andersen sent a letter to a senior Justice Department official.
The letter noted that most of Andersen's twenty-eight thousand U.S.
employees were innocent of any involvement with Enron and stressed
that the firm was serious about reforming itself. At the behest of An-
dersen CEO Joseph Berardino, former Federal Reserve chairman Paul
Volcker had agreed to head a new independent oversight committee to
create the kind of audit independence and rigor that the SEC wanted.
The firm argued that it needed time to let the measures work and that
an indictment would kill the reform effort—not to mention Andersen
itself.

Before announcing the indictment, federal prosecutors agreed to
meet privately in Washington with Andersen executives, led by
Berardino. The firm's officials made one last pitch for civil charges. The
prosecutors, however, felt that matters had gone well beyond a civil slap
on the wrist—especially given a recent history where civil penalties
seemed to have no impact on the firm's behavior.

At that meeting, prosecutors were particularly appalled when Ander-

35

"The Arrogance.
The Lack of Accountability."

As the Enron Task Force looked to climb the ladder of a criminal case against top Enron officials, the investigation of the Andersen document shredding presented a tempting but ultimately time-consuming sideshow. Certainly Andersen officials potentially had information that might be extremely useful to building a criminal case against top Enron executives. Destroying vast amounts of Enron-related documents doubtless suggested that the accounting firm had some very serious things to hide. But Andersen officials continued to maintain that, on balance, the accounting work done for Enron had been perfectly proper, based on the information that the company had given them.

In early March, federal prosecutors had gathered enough evidence in the Andersen document destruction investigation to take a proposed indictment for obstruction of justice to a federal grand jury in Houston. The government estimated that Andersen officials had destroyed literally a ton of Enron-related documents, along with deleting thousands of e-mails. Big empty trunks had been sent over to Enron, filled with Andersen papers, and transported back to the accounting firm's Houston offices to a five-foot-by-eight-foot room used for shredding. Andersen employees had been told that they could put in for overtime if it was necessary to complete the work quickly. The grand jury returned a sealed indictment against the firm for obstruction of justice.

The Justice Department built its case against a backdrop of past trou-

sen executives didn't seem familiar with details of one particularly important prior civil settlement involving the firm.

"The whole point of giving the company another chance was to change their behavior," said prosecutor Andrew Weissmann. Clearly it had had no effect. When the groups broke to caucus, prosecutors decided there would be no more warnings. "We were outraged with what we heard," Weissmann later told Smith. "The arrogance. The lack of accountability."

On March 14, the Department of Justice unsealed its indictment. In making its case, the government maintained that Andersen officials had violated a statute making it a crime for anyone to "corruptly persuade" another person to destroy documents or to attempt to "impair" the use of the documents that could be needed by "an official proceeding." Smith found the "corruptly persuade" phrase particularly apt for Enron, which had drawn so many seemingly upstanding companies into its web of deceit. Of course, Smith knew that these companies had not resisted involvement in Enron's schemes—and had profited handsomely from their cooperation. Corrupt persuasion was indeed a neat way to sum up the symbiosis that existed.

But it was still a tricky case. It wasn't enough to show that Andersen had destroyed Enron documents. That was irrefutable. The government had to show that Andersen carried out the action to subvert possible inquiry by the SEC or other government investigators.

The firm immediately attacked the criminal count as an "extraordinary abuse of prosecutorial discretion" and as "a gross abuse of government power." Andersen said its own internal investigation, involving interviews with more than eighty people and a review of thousands of documents, "revealed that the expedited effort to destroy documents was confined to a relatively few partners and employees of the firm and was almost entirely limited to the Houston office. None of the destruction occurred with the knowledge, much less the consent, of senior firm management." Andersen said it was "beyond comprehension" that the entire firm would be charged based on the actions of a few people.

After the indictment was filed, the defections by clients and staff picked up speed. "The flood gates opened," said Patrick Dorton, Andersen spokesman. Different Andersen offices were cutting deals to move

to other accounting firms. If this trend continued, there soon would be nothing left to fight over.

On April 24, a new blow struck Andersen. The Justice Department announced that David Duncan, the former lead partner on the Enron account, had agreed to plead guilty to obstruction of justice in the document destruction episode and had signed a "cooperation agreement" with prosecutors. Under the terms of the agreement, Duncan faced anything from probation to up to ten years in prison and a maximum fine of $250,000. He was obligated to be "fully debriefed" by Justice. If he was a good witness, the department would recommend a light sentence, maybe even probation. If not, or if he lied, he could be fully prosecuted and likely spend years behind bars.

In the weeks that he talked to prosecutors, Duncan's initial assertion that he had done nothing wrong was gradually worn down. Perhaps he came to the realization that he had done something wrong. Perhaps, as some speculated, he simply feared spending years behind bars—away from his wife and three young daughters—and pleaded guilty to something he really didn't believe he had done.

While Duncan's guilty plea had enormous implications for Andersen, it turned out to be far less meaningful for Enron. That's because Duncan insisted, even after signing the cooperation deal with Uncle Sam, that he stood behind all the accounting decisions Andersen had made concerning Enron. Based on the information that the accounting firm had been given by Enron officials, it had acted correctly in approving the company's manifold transactions, even the most controversial ones. Given that position, it was clear to Caldwell and her colleagues that Duncan would provide no magic bullet into the heart of Enron's hierarchy. They still had to get around the expert's defense problem.

There was, of course, a contradiction inherent in Duncan's position, one that the Enron Task Force chose to live with in return for his guilty plea. If Duncan really believed that Andersen had acted properly in its Enron decisions, why had he felt the need to destroy documents? While the government seemed willing to live with that contradiction, it could make Duncan less credible as a witness.

Seeing it wasn't going to negotiate its way out of trouble, Andersen began preparing for war. To lead its criminal defense team, Andersen

turned to Rusty Hardin, the flamboyant Houston litigator who knew how to put on a good show as well as a good defense. Hardin had spent fifteen years as a prosecutor in Houston, never losing a major case and putting fourteen people on death row. The trial accusing Andersen of obstruction of justice began on May 6 and ran for six weeks to packed crowds in a large, Houston federal courtroom. Opinions among commentators were divided about whether the case represented justice or vendetta.

From the start, Hardin cast himself as the folksy foil to the government prosecutors. In his opening argument, Hardin reminded the jury that the government would have to prove that there were Andersen individuals who "corruptly persuaded" others to destroy documents and obstruct a government investigation. But Hardin pointed out that the government had yet to actually name these people, implying they didn't really exist. He repeatedly compared the search for the corrupt persuaders to the *Where's Waldo?* children's books, where the game is to spot the hatted character in mammoth crowds of minutely drawn figures. Hardin would sometimes begin his cross-examination of a government witness with the question "Are you Waldo?"

He also tried quickly to dispel the idea that document shredding was inherently bad. "Shredding is not a dirty word in the accounting world," he told jurors. After all, accountants processed reams of information, and they had to cull it somehow, keep what they needed, and protect discarded material from falling into the wrong hands. That's why they used shredders. It was their duty. In fact, shredders actually protected information.

The government prosecutors were no match for Hardin's tactics. More than once they called witnesses who, under Hardin's skillful cross-examination, ended up being more helpful to Andersen than the government. On May 8, the government called Andersen accountant James A. Hecker to the stand. He said he'd received a telephone call from Enron manager Sherron Watkins, a former Andersen accountant, on August 20 when she was concerned about Andersen's work and afraid, as she famously said, that Enron would collapse in a wave of accounting scandals. But it was quickly established that Hecker, who'd worked primarily on the Dynegy account, somehow disliked Enron. In

fact, he'd even written humorous lyrics to a song he'd titled "Hotel Kenneth Lay-A," sung to the tune of the 1970s Eagles' hit song "Hotel California."

Hardin quickly turned Hecker into a sideshow diversion, getting the accountant to recite his lyrics:

HOTEL KENNETH LAY-A

> On a sidewalk on Smith
> Current text in my hand
> Warm smell of kolaches
> Aren't Saturdays grand?
> Up ahead on my schedule
> Nothing else was in sight
> My head grew heavy, and my hair grew thin
> I knew then I'd work through the night.
> Managers in a doorway
> Thinking out of the box
> And I was thinking to myself
> I'll bust my butt, and then I'll bust rocks
> Then they burned up my schedule
> And they threw it away
> Then I found out
> What I thought before
> Smith Street was a one-way
> Welcome to the Hotel Can't Afford Ya
> Such a gravy train
> C-A-S or main
> Plenty of work at the Hotel Can't Record Ya
> Any time of year, you can charge it here
> Her mind is Black and Scholes twisted
> Though her margins are thin
> She got a lot of pretty, pretty spread
> That she takes in
> How we work in the bullpen, no budget sweat
> Big house on the summary, but nothing much net

So I called up the partner
I said, "Please book this entry"
He said "We haven't had a debit here since 1993"
And still the gurus are calling from far away
Worry wart in the middle of the night
Just to hear them say
Welcome to the Hotel Mark-to-Market
Such a lovely face,
Such a fragile place
They livin' it up at the Hotel Cram It Down Ya
When the suits arrive,
Bring your alibis
Mirrors on the 10(k)
Makes it look real nice
And she said, "We only make disclosures here
Of our own device"
And in the partner's chambers
Cooking up a new deal
Three percent in an S-P-E
But they just can't make it real
Last thing I remember, I was running for the doors
I had to find the entries back
To the GAAP we had before
"Relax," said the client.
"We are programmed to succeed.
"You can audit anytime you like, but we will never bleed."

Hardin got Hecker to talk about how he'd responded to the company's document destruction policy, and he agreed that he often shredded three or four garbage cans' worth of information every few months. It was no big deal. Hardin and his team presented information repeatedly suggesting that the Andersen employees at Enron simply were following the company's standard "document retention" policy—aimed at protecting client confidentiality—and the last minute attention to the company shredding policy wasn't anything criminal. In fact, in a much earlier video recording, not specific to Enron, that was shown to jurors,

Michael Odom said it was okay to destroy documents until the day a subpoena arrived, a view that the prosecutors clearly thought was outrageous.

On May 13, the government called its star witness, David Duncan. Clad in a finely tailored charcoal gray suit with matching burgundy-and-gray tie, Duncan was poised and collected. Duncan testified that Enron had been considered a "high risk" client by top Andersen officials. He talked about the February 2001 meeting in which he and colleagues had discussed those risks and whether Andersen was becoming too dependent on Enron for income. "Our fees were in the, you know, past the $50 million level and had been growing, you know, in the 20 percent to 25 percent range a year," Duncan said. "It was not inconceivable that they would continue to grow and, you know, reach a very high level."

It became clear that Duncan viewed Enron as pushy, demanding, and posing unique problems. But it was also clear that he felt caught in the middle: his higher-ups wanted more accounting caution but Enron never seemed to feel that it had enough leeway. Duncan began to look like a sympathetic character caught between conflicting needs.

Hardin tried to suggest that Duncan didn't always know which side of the line he was on because the lines weren't always clear. Which wasn't necessarily a bad thing, Hardin intimated. That was just the way life was for an accountant at the top of his game, playing against the toughest team in the league.

Then Hardin turned up the heat. Was Duncan aware, the lawyer asked, that he could face up to eighty years in prison if convicted of accounting fraud versus maximum jail time of ten years for obstruction of justice? Was this—rather than the facts of the case—the reason that he was cooperating with the government?

Duncan said he wasn't aware of the exact difference in possible sentences but said he knew his exposure would be greater if he fought the government—and lost—rather than cooperated. He agreed that with a wife and children aged eight, six, and three, even a relatively short prison sentence could effectively remove him from their lives until they were grown. Whereas under his plea agreement the sentencing judge

could elect to give him probation. The way Hardin painted Duncan's situation, it didn't sound as though the accountant had much of a choice but to take the plea deal.

By early June, when both sides rested, it looked as if a slam-dunk case against Andersen had bounced off the rim somehow. The government never was able to establish for the jury what, if any, incriminating documents had been destroyed. Prosecutors conceded privately that this lack of a smoking gun weakened their case—though they groused that it was a bit unfair to ask them to evaluate the importance of documents they had been unable to read since they'd been destroyed.

The jury deliberated for ten days. With each passing day, the prospects grew for a hung jury and a new trial—a possibility that prosecutor Andrew Weissmann described, in a later interview with Smith, as the "legal equivalent of putting on a wet bathing suit."

Finally, on June 15, the jury handed down a verdict, finding the entire Andersen firm guilty of obstructing justice. The jury's decision was based not on the high-speed, wholesale destruction of documents, but on the suggested alteration of a single e-mail—the one in which Andersen attorney Nancy Temple had suggested that Duncan remove any reference to conversations with her concerning Enron's press release for third-quarter earnings. The suggestion struck the reporters as not all that different from the position attorneys often took. Indeed, an attorney friend of Emshwiller's said lawyers make similar suggestions to clients every day. Telling a third party what you've talked to your lawyer about could weaken attorney-client privilege and allow adversaries to obtain details of the conversation.

But in the jury's view, Temple's suggested deletion made her the "corrupt persuader" in the Andersen hierarchy that the federal obstruction of justice statute required for a guilty verdict. Hardin later told Smith he was "stunned" at the verdict, since the Temple e-mail had never been treated as a particularly important piece of evidence by the prosecution. During the trial, the prosecutors never contended that her editing suggestion was illegal.

Andersen was also hurt by Temple's refusal to testify, Hardin added. Worried about her own possible criminal exposure, Temple invoked her

Fifth Amendment right to avoid possible self-incrimination. "Whenever we were able to put a human face on what looked, at first, like questionable conduct, the jury didn't think it was a crime," Hardin said.

Perhaps Temple had been unfairly singled out, Smith thought as she talked with Hardin. But it was clear that Andersen had, in the larger sense, done something very wrong. The fact remained that the firm had destroyed a ton of documents, at warp speed, just before investigators were expected to come knocking at the door. It had a long history of carrying water for its clients and then disavowing its labor when challenged. Without its help, Enron could never have grown into what it became. Temple might not have been a corrupt persuader, but Andersen had been a corrupt enabler. Some penalty seemed in order. But Smith wondered, again, whether guillotining an entire company was a just outcome.

36

"Enron's CFO, Kopper, and Others Devised a Scheme to Defraud Enron and Its Shareholders."

CALDWELL AND HER PROSECUTORIAL TEAM WERE DEEPLY RELIEVED when victory was finally theirs. Winning the guilty verdict had been much tougher than expected, and the team braced for the worst. A hung jury or outright acquittal would have damaged the Enron investigation and allowed critics to heap further scorn on the Justice Department. No one would have been surprised, in the wake of such a debacle, if potential witnesses thought twice about cooperating with law enforcers who appeared incapable of nabbing culprits who had destroyed evidence by the truckload. Plus, a hung jury would have forced Caldwell's team to go through a time-consuming retrial when it had other, bigger game to hunt.

As the summer of 2002 rolled on, the cries for a muscular response grew louder. The financial and accounting scandals roiling giant companies had forced investors, analysts, and regulators to take harder looks at the books of corporate America. Revelations had surfaced at such multibillion-dollar business empires as WorldCom Inc., Tyco International, Ltd., Adelphia Communications Corp., and Global Crossings Ltd. In early June, Manhattan's nearly legendary eighty-two-year-old district attorney, Robert Morgenthau, indicted Tyco chief executive L. Dennis Kozlowski for conspiring to evade taxes on $13 million of art purchases. Kozlowski pleaded not guilty. Prosecutions began to come out of investigations of other companies—but not Enron. "—Not a sin-

gle charge has been brought against the executives of the firm that was first in what has become a season of corporate scandal—Enron," Lou Dobbs said in late June 2002 on his CNN show, *Moneyline*. Members of the Enron Task Force were stung by criticism that they were moving too slowly. They felt frustrated that the public didn't understand the complexity of unraveling Enron and were actually quite proud that, given all the obstacles, they were making good progress. While the probe of document shredding at Enron, itself, hadn't produced evidence of criminal wrongdoing, Caldwell's team was finding what they believed to be felonies in other corners.

The task force was able to file its first criminal charges on Enron-related transactions in late June 2002. True, the defendants weren't Enron officials. But the case did follow Caldwell's strategy of moving up the ladder from smaller to bigger quarry. And this particular prosecution clearly seemed to be a first step toward grabbing one of Enron's "Big Three" executives.

The defendants were three former bankers for National Westminster who had allegedly reaped $7 million from a scheme to defraud the bank out of its full partnership share of LJM1 profits. The government contended that the defendants had convinced the bank to sell out its LJM1 interest for $1 million to the Southampton partnership, which then received millions from Enron for closing out the Rhythms deal.

Though neither Fastow nor Kopper was charged, the filings made clear that federal prosecutors had the pair in their sights. The Enron CFO, for instance, had allegedly flown to the Cayman Islands in March 2000 to meet with one of the bankers in hatching the plot. The court papers quoted an e-mail from one banker to another saying, "I will be the first to be delighted if he [Fastow] has found a way to lock it in and steal a large portion for himself. . . . We should be able to appeal to his greed."

It certainly looked as though Fastow took the bait, Smith and Emshwiller thought with rising indignation as they read through the charges. Emshwiller wondered why National Westminster Bank had agreed to sell its interest for a mere $1 million. After all, only about nine months earlier, the bank had invested $7.5 million in LJM1. Then he reread the government's filings, which said that National Westminster

had already made over $20 million from LJM1, so the extra million might have looked like a pleasant little bonus.

The Southampton partnership held the threat of criminal action against other favored Enron insiders who had feasted off that killing. Kristina Mordaunt, the former Enron lawyer, and Glisan, the former treasurer, had each reaped $1 million on their $5,800 investments.

As the investigation gathered force, Emshwiller and Smith regularly speculated on which Enron official might be the first to cut a deal with the Justice Department—a distinction that would offer some strong advantages. Prosecutors usually cut their most lenient deals at the beginning, when they were still in need of information on higher-ups. So an early plea bargain often led to a relatively light sentence, sometimes even probation. That was the upside. The downside: You had to confess to committing a crime.

Many people, including Smith and Emshwiller, believed that Glisan might be the first to crack. He seemed like the kind of guy who would *want* to cooperate with the government. Kopper was another leading candidate to cough up the goods. He had been a partner in LJM, so he knew about high-level goings-on. But Kopper's closeness to Fastow also argued against his cutting an early deal. He might have been too deeply involved for the government to let him off easily.

On August 20, 2002, about two months after filing the National Westminster case, the Justice Department called a press conference to announce that Kopper had agreed to plead guilty to two counts of conspiracy. Perhaps more important, he had agreed to cooperate with the government's ongoing investigation. "Starting in at least early 1997, Enron's CFO, Kopper, and others devised a scheme to defraud Enron and its shareholders by enriching themselves through the use of certain special-purpose entities," the government said.

In early 1997, Fastow and Kopper allegedly set up partnerships to buy electricity-generating wind farms from Enron that it needed to divest following its purchase of Portland General Electric. These transactions, the government argued, created the appearance that Enron had severed its relationship with the wind properties when it hadn't. Enron, ever generous with its friends, had loaned the partnerships most of the

money for the asset purchases, some $16 million. The outside equity needed to satisfy accounting rules had been supplied by some supposedly independent investors in the Houston area. The government, however, contended that the investors were friends of Fastow and Kopper and that at least part of their investment money had come via a hidden loan (later pegged at $419,000) from Fastow.

Along with Kopper, these friendly investors then took a cut of the eventual $4.5 million that the investment produced for the partnerships. While relatively small potatoes, these transactions set the stage for bigger things to come. These partnerships, the government argued, had provided financial benefits to Enron by means of a false facade that hid the relationships between the investors and lucrative returns to some of the company's own executives.

As part of his plea bargain with the Justice Department, Kopper agreed to give up $12 million. Using Kopper's guilty plea as evidence that ill-gotten gains had gone to others, the Justice Department filed motions in court to seize money and assets from Fastow, Glisan, and Mordaunt—even though they hadn't been criminally charged.

With the Kopper plea, the government's Enron investigation took a giant leap forward, both in style and in substance. Suddenly newspaper articles and TV commentaries were speaking positively about the probe's progress. And now it seemed only a matter of time until the grand jury would issue an indictment of Fastow. Then, if the prosecutors could pressure Fastow to cooperate, they might finally reach to the very top of the company.

While Caldwell's team represented the main flank of the federal criminal probe, the U.S. Attorney's Office in San Francisco had also convened a key grand jury investigation into the role of Enron and other big power traders during the peak of the California power crisis— a period of periodic blackouts, extraordinary wholesale energy costs, and effective political paralysis. Even once the turmoil had subsided, the state was facing a permanent rupture in its once-stable energy costs.

Quite unexpectedly, Enron voluntarily waived attorney-client privilege and surrendered a trove of memos, written by Enron lawyers for an internal audience, that provided the most colorful and damaging confir-

mation yet that Enron traders had attempted to manipulate the California market.

One memo, dated December 6, 2000, explained several "popular trading strategies" used by Enron traders. The date was important, for it was the single most costly month for electricity in California history. Electricity costs topped $6.1 billion that December. In all of 1999, by comparison, wholesale power costs in the state had been only $7.4 billion. The memo explained how traders plied their craft, engaging, for example, in a practice known as "megawatt laundering," in which energy was sold to suppliers out of state, then sold back to California's electric grid operator to circumvent price caps that applied to in-state generators. It went on to describe other trading strategies, with colorful nicknames such as "Get Shorty," "Ricochet," and "Death Star." The latter involved implementing a set of transactions so that "Enron gets paid for moving energy . . . without actually moving any energy . . . ," the memo said.

The tone of the memos was just short of gleeful, explaining how the company got paid for energy that was never supplied and how it created transmission line congestion, knowing it would be paid to relieve it. When the news of those memos hit the newspapers, Californians were outraged. "We always knew we were getting screwed," said Claudia Chandler, spokeswoman for the California Energy Commission. "We just didn't know they had names for it."

Once the memos were released, attention focused on Timothy Belden, a thirty-five-year-old trader who headed Enron's western power-trading desk in Portland, Oregon, and who was described as the architect of the strategies. Belden had once worked for Portland General Electric. People who knew Belden described him as bright, aggressive, and driven. "I think he must have played a lot of board games as a kid, because he was very interested in how the rules were set up and what they'd let you do," said Dianne Hawk, an energy consultant in Oregon who knew Belden both before and during the time he worked for Enron. Even so, she said, "He appreciated the need for regulation. . . . He understood the inadequacy of a pure free market approach and didn't seem like a free market zealot," like some at Enron.

Though Enron and others later were blamed for causing the California electricity crisis, Enron's role was far more shaded. It exploited gray areas between rules, and it lied about what it was doing. Spence Gerber, who'd worked with Belden at Portland General Electric, said that the mantra of Enron's western trading desk was, "Tell me the rules. As long as they were operating in the rules, they felt they were okay. That was how they rationalized what they did. It was okay if it hadn't been prohibited."

There was also resentment in California due to Enron's quick exit from the state's retail electricity market in early 1998—less than two months after that market opened for competition and Enron ran a huge advertising campaign proclaiming its ambitions.

For a time, Enron's retail unit was run by Lou Pai, a former Conoco economist who had become a Skilling favorite while working in the wholesale-trading operation. His flat, unexpressive personality stood out in a culture that favored wits and bravado. "He was regarded as something of an idiot savant," said one former Enron senior executive. "He'd sit in meetings and say nothing for long stretches of time and then all at once come out with something that Skilling would think was brilliant and incisive." But others considered him a total lightweight.

Whatever his business shortcomings, Pai was brilliant when it came to looking out for his own interests. When he moved over to the retail unit from the trading side in 1997, he cut himself a fat deal that included base pay of $400,000 a year, a near certain annual bonus of $300,000, and numerous options. Every two years, Pai was eligible for a $700,000 additional bonus, and the company gave him use of its corporate jets. Moreover, in his decade at the company, Pai had net proceeds from stock sales that approached $200 million.

Enron did not seem to care if its actions cost California billions or brought down the electric system. But even so, the company's controversial trading activities accounted for only a fraction of the money extracted from California as a result of deregulation. The biggest source of cost was a pricing system that had the blessing of top economists—and, even two years after the crisis ended, remained staunchly in place. That "single-price auction" determined that most suppliers would get paid whatever price could be extracted by the highest-cost supplier. In times

of tight supplies, that high cost got amplified throughout an entire market. Generators outdid themselves to devise means of pushing up this price.

For a 13-month period, from May 2000 to June 2001, California was wracked by high prices. Adding to the complications, Enron had purchased priority access to a key transmission corridor in late 1999. Enron paid $3.6 million for first dibs on moving energy from north to south on "Path 26," a key choke point for power flows. If it didn't need the capacity to execute its own contracts, the space was released to others. But Enron got a cut of the fees this generated. The Federal Energy Regulatory Commission (FERC) later concluded that Enron made $33 million in a two-month period from these fees—nearly ten times as much as the rights had cost.

In July 2000, FERC—under tremendous pressure from California governor Gray Davis, state legislators, and Congress—launched an investigation into California's market distress. Wholesale electricity prices for the months of May, June, and July had nearly equaled the tab for all of 1999. FERC took a very passive approach to its investigation, and the toothless report it eventually issued did nothing but embolden traders to continue. Still, Enron understood it had a growing public relations problem and set up a "California war room" in Houston. Sandi McCubbin, one of the company's California lobbyists, recalled that when she visited the room during the middle of the crisis, she was given a T-shirt and button reading CRISIS KILLERS with a drawing of little ants running across it: "The mentality was, we're at war with California." Ken Lay stopped by the war room to give everyone a pep talk. When McCubbin introduced herself and said she was working on California, she says he replied, "I'm so sorry for you."

As prices soared throughout 2000, the state grid operator, with federal approval, repeatedly lowered the wholesale bid cap, trying to cool a superheated market. By December 2000, the crisis hit a new peak. Power plants in unprecedented numbers were shut down, leaving California perilously low on electricity supplies. Half a dozen times, the grid operator couldn't get the power it needed and had to order brief rolling blackouts that unnerved more than inconvenienced the state.

Finally, in early December, the independent system operator asked

FERC for permission to eliminate a hard cap that wasn't working and replace it with a "soft cap" based on suppliers' actual costs. Prices immediately soared to new heights. This blowout in prices brought huge windfall profits to Enron's trading arm. Federal regulators later calculated that Enron made $1.8 billion trading electricity in the West during 2000–2001 and another $900 million from gas trading during the same period. For 2000, California's wholesale energy costs topped $27 billion, nearly quadruple the $7.4 billion they'd cost a year earlier.

By March 2001, the great deregulation dream was charred rubble. Finally, in June 2001, federal regulators imposed price caps on the entire western market, including all or portions of fourteen states. The crisis ended, though it wasn't until Enron collapsed into bankruptcy that federal regulators reopened their own Enron investigation in February 2002.

On top of the incriminating "smoking gun" memos written by the Enron lawyers, FERC staff said there was solid evidence that western markets had been manipulated by Enron and others. "We have retrieved information indicating Enron may have been involved in considerable electricity and natural gas round trips or wash sales," the commission said in a report. For example, on January 31, 2001, the height of the energy crisis, Enron engaged in 174 natural gas trades with a single unidentified partner over EnronOnline. Many of those trades involved a key delivery point in Southern California where gas prices jumped 25 percent that day.

The revelations caused convulsions in the power-trading industry. In short order, power-trading companies saw their stock prices plummet, their credit ratings slashed, and their executives forced out. An entire industry was thrown into disarray. And the prosecutorial machine finally got rolling. On an overcast morning in October 2002, federal prosecutors in San Francisco announced that they had won a valuable ally in their efforts to prosecute those who had gouged California: Tim Belden.

Belden had recently resigned from Enron and had agreed to plead guilty to a federal charge that he'd conspired with others to manipulate the California market. Smith went to the courthouse in San Francisco

to see Belden arraigned. A tall, pale man with a bald spot, dressed in a dark suit and blue shirt, he stood before the judge and confessed his guilt. "I did it because I was trying to maximize profit for Enron," he said. "I knew at the time I was submitting false data" to officials who operated California's electric grid. When Smith read the criminal information, it seemed largely circumstantial; perhaps, like Andersen's Duncan, he had concluded that it was better to cooperate with the government than struggle against an overwhelming tide.

That same month, Caldwell and her Enron team turned its attention to one of Enron's marquee names, Andy Fastow, accusing him of being part of a broad criminal conspiracy. The scheme involved the "fraudulent manipulation of Enron's reported financial results so that Enron would appear more successful than it was," according to an indictment filed in the case. The alleged misdeeds ranged from the backdating of documents to Fastow asking Kopper to destroy personal computers to keep them from falling into government hands. The litany of charges eventually grew to 47 pages and 109 counts that covered everything from fraud and money laundering to conspiracy and obstruction of justice. Conviction on the charges could put Fastow behind bars for decades. In a nicely ironic touch, the government charges disclosed that this supposed wizard of high-octane financial manipulations had stuffed some of his ill-gotten millions into nice, staid municipal bonds.

Fastow stood accused of being a man who stole from his employer, lied to cover it up, and even used his young sons to advance his fraud. He supposedly had some of the illicit gains wired into his kids' bank accounts to hide the trail.

To Emshwiller, that portrait was very much like those of the career swindlers he had long written about, men who awoke every morning planning how they'd spend another day of thievery. Yet there were things about Fastow that didn't quite fit with the image of a man who knew that he was doing wrong. He thought back to the tip he had gotten from Fastow via an intermediary, naming Barclays Bank as the financial institution on Chewco. It still didn't make sense that Fastow would pass along that bit of information to a *Wall Street Journal* reporter who had been chasing him for weeks if he felt he had something to hide

about Chewco, an entity that, according to government accusations, had dispensed "kickbacks" offered to him from Kopper.

And while Fastow could be very secretive about LJM, he was at times almost proud of what he had done. Congressional investigators had discovered the videotape of a September 1999 presentation he had made to Merrill Lynch officials as part of the LJM2 sales effort. He made no bones about where he thought his future lay. "This is what I want to be my next step," Fastow said. "I want to have a—I want an investment business, and this is a unique opportunity to set it up with unique access to deals and to develop the track record that I need to develop." Enron, it seemed, had become Fastow's springboard to running his own group of investment funds.

For Smith, the most interesting aspect of all the cases was that Fastow was described as having been Kopper's "corrupt persuader," which was the same phrase that had been used to describe Nancy Temple's role in Andersen's downfall. "Corrupt persuaders" clearly flourished in and around Enron.

By May 2003, the web of indictments had caught ten more individuals in its sticky threads. This time, the indictments by the Department of Justice and a civil complaint by the SEC focused on those who'd worked at Enron's broadband unit. Two of them, finance vice president Kevin Howard and accountant Michael Krautz, were accused of helping to concoct the Braveheart partnership, which prosecutors said fraudulently manipulated earnings.

Almost as an afterthought, Lea Fastow, the chief financial officer's wife, was accused of money laundering, conspiracy, and tax evasion in connection with her participation in the wind farm schemes that had involved the "friends of Enron." The government said that Lea Fastow, who'd worked in Enron's finance unit for six years from 1991 to 1997, had obtained money at Enron shareholder expense and through "materially false and fraudulent pretenses." Like her husband, Lea Fastow pleaded not guilty.

But these charges were preliminaries to the real contest—the indictments of Skilling and Lay—which still lay in the future, if they lay anywhere.

"If It Isn't Criminal, It Ought to Be."

As THE CRIMINAL PROBES GROUND ALONG, SO DID THE PROCESS OF trying—or at least promising—to reform the practices of American corporations. "In my lifetime, American business has never been under such scrutiny," Goldman Sachs chairman Henry M. Paulson Jr. said in a speech at the National Press Club. "To be blunt," he added, "much of it is deserved."

One of Emshwiller's Enron-related *Journal* assignments in 2003 involved going through the SEC filings of over four hundred of the nation's biggest companies, searching for examples of related-party transactions. Though he and his editors didn't expect to find another LJM, they wanted to see what other corporate decision makers were doing in the arena that precipitated Enron's downfall. After all, back in August 2001 when Enron was still trying to portray LJM as utterly routine, Lay had told Smith and Emshwiller that "almost all big companies have related-party transactions."

Turned out that Lay was right—in part, anyway. While the search of the SEC records didn't turn up another LJM or Chewco, it did show that corporate America carried lots of potential conflict-of-interest baggage. Some three-quarters of the companies surveyed had one or more related-party transactions, ranging from multimillion-dollar loans to executives to six-figure consulting deals for outside directors. Dozens reported having a representative from the companies outside law firm sitting as a di-

rector, raising questions about the independence of the companies' legal advice. Some thirty companies had deals to lease a top executive's corporate jet for business use, a potential route for stockholders to subsidize a mogul's globe-circling travel. Not surprisingly, all the companies argued that all the related-party transactions had sound business purposes and plenty of safeguards to protect shareholder interests.

Creating webs of insider dealings, and all the potential for mischief that they held, hadn't always been the corporate norm. In the years after the Civil War, courts frowned upon related-party transactions and gave shareholders wide latitude to have them voided. This hostility seems to have been fueled by a reaction to abuses, particularly by the big railroads of the era. In 1880, for instance, the Supreme Court upheld voiding a contract in which a railroad agreed to buy coal at inflated prices from a company partly owned by some of the railroad's top officials. In a statement that Enron's board of directors should have read before their LJM votes, the High Court found that "it is among the rudiments of law that the same person cannot act for himself and at the same time, with respect to the same matter, as agent for another whose interests are conflicting."

By the early twentieth century, though, that seemingly obvious logic about conflicts had largely been abandoned as related-party transactions became ever more popular in a national economy where big companies were playing an increasingly important role. In examining that period of American business history, University of California at Berkeley law professor Melvin Eisenberg wrote in his book *Corporations and Other Business Organizations* that courts seemed "simply to admit that the practice has grown too widespread for them to cope with." By the 1990s, related-party transactions were so commonplace that Enron operated the LJM partnerships for two years with hardly anyone aware of them.

Yet the arguments against related-party transactions are "as true today as one hundred years ago," Charles Elson, director of the University of Delaware business school's Weinberg Center for Corporate Governance, told Emshwiller. If anything, the arguments were even more persuasive now than then. The ubiquity of communications networks and interconnected global markets make it difficult to conceive of any situation where a company would have to obtain a particular product or ser-

vice from a related party, Elson argued. Elson believed that a ban on sig-
nificant related-party deals would have prevented the Enron crisis from
happening. As Emshwiller listened, he couldn't help wondering
whether or not the academic might be underestimating the resourceful-
ness of the Enronians.

Though there wasn't any move following Enron's collapse to outlaw
related-party transactions, there were moves to prune back the practice.
Some came from individuals. Former United Nations ambassador Don-
ald McHenry was paid $125,000 a year to be a member of Coca-Cola's
board of directors while he also headed and partly owned a consulting
firm that in 2002 did $153,000 worth of work for Coke. But in the wake
of Enron and the other corporate scandals, McHenry decided to stop
the consulting arrangement. "Obviously, the times have changed," he
told Emshwiller. While he said that his firm's Coca-Cola consulting
work never compromised his independence as a director, he admitted
that nowadays there was a "certain taint" to such an arrangement.

The New York Stock Exchange and the Nasdaq stock market, which
together handle the trading of practically all the biggest American cor-
porations, have each issued new rules aimed at increasing the indepen-
dence of corporate boards. The rules limit the number of directors who
could have any "material" outside relationship with the company—that
is, a related-party deal. Only independent directors could serve on cer-
tain committees, such as the panel that reviews top executive compen-
sation.

Besides promising more independent boards, companies vowed to
make their audit committees more vigilant and their executive pay
structure less dependent on the narcotic of stock options. Some compa-
nies even took a step that corporate America had long resisted and be-
gan recognizing stock options as an expense against earnings rather
than simply an increase in the shares outstanding, which many argued
had hidden the practice's cost.

Wall Street, under the prodding of regulators, promised to show more
backbone when it came to analyzing—and criticizing—companies.
Goldman, for one, announced it was revamping its system for rating
stocks and henceforth would have as its lowest rating "underperform."
Even in reform, the firm couldn't quite say "sell." A Goldman

spokesman added that the firm's sophisticated clientele didn't need to be told when to sell a stock.

The major accounting firms promised that they would be more independent of their big clients and more willing to challenge transactions that pushed, and perhaps tore, the envelope. Amid the promises of something better, the remaining members of the Big Five accounting firms (which some wags rechristened the Final Four) found time to sign up the major corporations that had heretofore been clients of Andersen.

As usual, the loudest calls for and promises of reform came from the vicinity of the Potomac River. "We will act against those who have shaken confidence in our markets, using the full authority of government to expose corruption, punish wrongdoers, and defend the rights and interests of American workers and investors," said President Bush on July 30, 2002, as he signed the Sarbanes-Oxley Act of 2002. Sarbanes-Oxley, among other things, increased the criminal exposure of chief executives whose companies issued false financial statements to the public. The law also sharply curtailed one popular form of related-party transaction: corporate loans to officers and directors. The *Journal*'s related-party survey had found that about one hundred companies had such loan arrangements, often to help officials buy stock in the company or help a relocating executive buy a new home.

Congress voted increased funding to the SEC, which had been overwhelmed by the torrent of the 1990s. A new accounting standards board was created. Prison sentences for corporate fraud were increased. Workers were given more flexibility to diversify their company pensions away from company stock. Money was set aside to help create independent stock analysis firms, free from investment banking pressure. The list went on.

As the days after Enron's collapse turned into months and then years, press interest inevitably faded in the never-ending cycles of newsworthy events—though hardly a day passed without Enron being mentioned in some story having to do with fraud and corruption. Enron had entered the lexicon as the nameplate for business sleaze.

The Enron saga could still produce flurries of stories whenever a big enough development occurred in the ongoing investigations and litigation. In its own way, the Enron bankruptcy proceeding provided a

weirdly fitting sequel to the company's tales of greed and excess. Law and accounting firms from around the country had flocked to the case— with hourly billing rates of up to $900 a head. The company estimated that the professional bills in the bankruptcy would approach $1 billion by the end. Unlike some of the figures from Fastow & Co., this number represented real cash.

Though Enron faded as a white hot news story, the journalistic partnership between Smith and Emshwiller lingered. They signed on to do one of the several books that the Enron flameout had spawned. Coauthorship kept the two colleagues working longer than they knew was sensible. They argued more often, on issues such as whose name would go first on the book cover; that was decided, at Smith's stubborn insistence, by a coin toss. Sometimes they argued over more substantive matters, such as what should be emphasized or included. Emshwiller was as fascinated by Chewco as Smith was by the California electricity crisis. Neither could fully understand the other's obsession. But they always found some way to work out their differences and hang together. Ultimately, the forced march produced a powerful bond often found among reporters who have been thrown together by circumstances and asked to cover a story requiring more stamina and cooperation than they could have anticipated.

In their work for the *Journal*, however, the reporters' paths began to diverge. Smith went back to focusing on the broader electricity industry, which had no shortage of major new breaking stories, such as the bankruptcies of several power traders and the massive grid power failure that blacked out much of the northeastern United States and Canada on August 14, 2003.

Since Emshwiller had a less structured beat with fewer daily demands, Jonathan Friedland, the Los Angeles bureau chief, gave him the task of keeping tabs on the ongoing Enron criminal probe. While there were many important matters to be resolved in the bankruptcy case and all the lawsuits, the most important question concerned who would go to jail.

In the unfolding criminal drama, Emshwiller found that some of the accused were surprisingly sympathetic figures. He came across one in the so-called Nigerian barge deal.

At the end of 1999, Enron was hurriedly trying to unload some electricity-producing barges that it had parked off the coast of Nigeria. It wasn't a big deal, producing about $12 million in reported profits in a year when the company as a whole booked $893 million in net income. But for a company striving to meet aggressive growth targets, quarter after quarter, every few million counted.

The barge transaction had first come to public attention in an April 2002 *Journal* story by reporter Anita Raghavan. She reported that in mid-December 1999, Enron had asked Merrill Lynch to invest $7 million as the buyer of the barges. While Merrill had no interest in owning barges in Africa, officials at the brokerage giant told Raghavan that they agreed to the deal as a favor to a valued client. The deal closed by December 31, 1999, Enron booked its profit, and about six months later Merrill sold its Nigerian barge stake, at a profit, to Fastow's LJM2 partnership, which later sold the barge interest to a third party, again at a profit.

Federal investigators were interested in the barge deal "to see if it was done simply to temporarily, and artificially, bulk up Enron's earnings," Raghavan wrote. Among the points of interest, the story said, were claims by some Enron officials that there had been a conference call "in which Andy Fastow gave Merrill Lynch a verbal assurance that he would make sure Merrill Lynch was relieved of its interest in the Nigerian barge by June 2000." If Fastow had guaranteed Merrill's exit from the deal, it could have meant that the brokerage firm was never truly the "at risk" owner of the barges. If it wasn't, then Enron had never actually sold the barges and couldn't book a profit—at least not legally. Merrill and Enron officials denied wrongdoing. As usual, Fastow's camp declined to comment.

Early on, the barge deal caught the eye of Leslie Caldwell, the Justice Department's Enron Task Force chief. Despite its small size, the deal seemed to encapsulate many of the practices that had been going on at Enron. There seemed to be a good paper trail of memos and e-mails that suggested foul play. Plus, the transaction involved Fastow, one of the task force's key targets, as well as Merrill, which was emerging as one of the key financial enablers.

Eventually, the government filed criminal charges against eight peo-

ple over the Nigerian barge deal, more than for any other single trans-action. Four came from Enron, among them Fastow, and four from Merrill, including Daniel Bayly, the former head of investment banking. Bayly was allegedly the top-ranking Merrill official on that conference call of late December 1999, where the illegal guarantee was allegedly made. All of the accused entered not guilty pleas.

Among the eight was a former Enron vice president named Daniel Boyle. Boyle attorney William Rosch, a veteran of the Houston bar association, had garnered some attention when he likened the charges against his client to "prosecuting the piano player in a whorehouse."

But Emshwiller didn't start paying attention to Boyle until the former Enron executive's name kept coming up in interviews. Company officials, current and former, kept volunteering their disbelief, mixed with outrage, concerning Boyle's indictment. All voiced the opinion that Boyle was probably the least likely person they knew to have been knowingly involved in a criminal act. "The guy is a Boy Scout," one declared.

Of course, by then, kudos from Enron executives weren't exactly the stuff of résumé writers' dreams. Still, the reporter wanted to learn more about Boyle and his role in the barge deal. While Boyle wouldn't grant an interview because of the criminal case, lots of other people did talk.

Though Boyle worked in downtown Houston, his life was centered twenty-five miles to the south, in the suburb of Clear Lake, where he lived with his wife, Pam, and four children. Active in the Clear Lake Church of Christ, the Boyles hosted in their home a weekly Bible study group of about two dozen teenagers. Boyle helped organize an annual Christmas gift drive for a Texas orphanage, worked on the church's volunteer gardening crew, was a regular at the weekly prayer breakfast, and was generous whenever there was a fund-raising need.

Although Boyle's wife suffered from lupus, a serious immune system disorder, the couple determinedly built a family. They adopted four children, who in 2003 ranged in age from six to sixteen. One came from China and two from Russia. Initially, said fellow church members, the Boyles had planned to adopt just one girl from Russia. But when Boyle traveled to the orphanage there, he discovered that she had four siblings. Rather than separate the kids, the Boyles also adopted one of the

four and helped arrange for the remaining three to join other families from the church. "For Dan to be guilty, he would have to be a completely different person from the one I know," said Randy Mulvaney, a friend and fellow church member.

Former Enron colleagues said that Boyle, though he worked in Fastow's finance unit, didn't fit into the go-go deal culture. "Dan expressed concerns about pushing the envelope because of the pressure that was on to get deals closed in such a quick fashion," one said. But like most people at Enron, Boyle had little power to affect the company's deal-making culture, this person argued. "Dan was not a decision maker. He was an implementer." Another person said that Boyle actually met Fastow in person only once, for a few moments, when he delivered some papers to the CFO's home.

Of course, Emshwiller knew, implementers had committed many crimes. Conspiracies needed soldiers as well as generals. And past criminal cases had seen examples of otherwise law-abiding, God-fearing individuals committing criminal acts. The Nigerian deal documents, internal memos, and e-mails from within Enron and Merrill that had surfaced publicly contained suggestions of a possible criminal conspiracy—and one that might have involved Boyle.

Yet questions lingered. The crux of the alleged wrongdoing revolved around that conference call a couple of days before Christmas 1999, where Fastow allegedly made his poisoned promise to Merrill. The call had always struck Emshwiller as a bit odd. If Fastow knew that he was going to be making an illegal guarantee, why do it on a conference call? Wouldn't such a pact best be whispered between only two? Perhaps, in his arrogance and the deal-making frenzy at Enron, Fastow didn't care who heard. Maybe he didn't even think about it. Or maybe he didn't think he was doing anything illegal.

Before he was indicted, Boyle, like dozens of other Enron employees, allowed himself to be interviewed by Justice Department investigators. For Boyle, the decision turned out badly as prosecutors suspected that he wasn't being fully forthcoming.

Boyle had acknowledged that he took part in the fateful 1999 conference call. He said he'd been on vacation, surrounded by kids and in the whirl of holiday preparations, and didn't recall Fastow making any profit

guarantees to Merrill. He admitted knowing that Enron had promised to get Merrill out of the barge investment within six months but said that he believed this commitment was legal. He estimated that the entire call lasted about five minutes.

Five minutes, Emshwiller thought: long enough to turn a man's life upside down.

Like other lawyers representing people accused in the Enron scandals, Boyle's attorney professed the belief that his client would be exonerated at trial. The reporter, though, wondered how many of the accused would actually get to court. For defendants, the pressure to cut a deal with the government was intense and grew as time passed. For some, the pressure came from the inner knowledge of guilty conduct. But even for people who believed themselves innocent, the risks of going to trial in the American criminal justice system of the early twenty-first century couldn't be easily dismissed.

In response to the often scandalously short sentences handed out to white-collar criminals through the 1990s, the government had been ratcheting up the penalties. A person convicted by a jury of a multi-count fraud indictment involving tens of millions of dollars in losses could face a prison term counted in decades rather than months. A plea bargain, by contrast, could limit incarceration to a period that would ensure the accused reached home before his Social Security payments did.

In early 2004, the case of Jamie Olis underlined the dangers of going to trial. A midlevel Dynegy executive, Olis had been accused of taking part in a scheme to dress up that company's financial results, though not on the scale of the Enron makeovers. Two of his former Dynegy colleagues reached plea bargains and capped their prison exposure at five years. The thirty-eight-year-old Olis—who had a wife, an infant, and another baby on the way—insisted he had done nothing wrong and exercised his right to a trial. He was convicted and under the toughened federal sentencing guidelines, which based prison terms partly on the size of losses suffered by shareholders, was given over twenty-four years in prison. That sentence, more than any other handed out yet on the corporate scandals of the '90s, shocked people who'd been following the procession of charges against executive malefactors. For one thing,

the disparity between the sentence of the one who hadn't cooperated with prosecutors and the sentences of those who had—at nearly five to one—was so great that it threatened a person's right to demand a trial, said some defense attorneys. Exercising that particular constitutional right was getting very risky.

Smith felt the sentence was way out of proportion to the crime. For one thing, it was based on the fall in Dynegy's stock price, after the so-called Project Alpha transaction was detailed in a page-one *Wall Street Journal* story written by Jathon Sapsford and the company subsequently restated its financial results. But the Project Alpha controversy came at a time when other forces, such as Enron's collapse, were battering Dynegy and the rest of the energy-trading business. Giving too much importance to any one event or transaction didn't seem right to Smith.

The issue of plea bargains came up again at Enron in September 2003. Former treasurer Ben Glisan appeared in Houston federal court and pleaded guilty to one count of conspiracy to commit fraud in connection with the Raptor entities. His plea dealt with one of those $30 million LJM2 investments, the money from outside of Enron that was needed to make each of the Raptors independent under accounting rules. Glisan told the court that he had been part of a secret agreement to quickly pay back LJM2 all that money plus a profit—which meant that the Raptor in question didn't have the necessary outside equity, which meant that all the subsequent deals Enron had done with that Raptor had been illegal. In his plea, Glisan said that he and "others," unnamed, had been part of this conspiracy.

Glisan's plea settled a twenty-six-count indictment that had been handed up against him as part of the broader Fastow indictment. Unlike his former colleague Michael Kopper, Glisan made no deal to cooperate with authorities. He was sentenced to five years. If Glisan had been convicted at trial on all counts, he would have faced a much longer prison stay. Under the terms of his deal, Glisan began serving his sentence immediately, thus becoming the first Enron official to see the inside of prison.

Though the Justice Department didn't win Glisan's cooperation, the plea did mark the first time anyone had admitted wrongdoing in connec-

tion with the Raptors. Caldwell and her fellow prosecutors considered the Raptors central to the Enron fraud. In the wake of Glisan's plea, Acting Assistant Attorney General Christopher Wray reiterated that "we fully intend to see to it that all those who have criminal responsibility are brought to justice."

As Emshwiller wrote the *Journal* story of Glisan's plea, he thought about the guy's wife and two young kids, ages six and eight. He thought about the brief, but always pleasant, phone conversations he'd had with Glisan over the prior two years and the laudatory things that former colleagues had said about him. Some Glisan sympathizers argued to Emshwiller that the former Enron whiz kid's plea had as much to do with fatigue and fear as it did with a feeling of guilt. A trial would have cost hundreds of thousands of dollars or more in additional legal fees, money that Glisan didn't have to spend. Supposedly, his one big Enron strike had been when his $5,800 investment in the Southampton deal had quickly turned into $1 million. And that deal certainly wouldn't have looked good to a jury. All in all, these people argued, a sure five years—a little less with time off for good behavior—was a lot better than a ten- or fifteen-year sentence, if he lost at trial. At his plea hearing, according to the Associated Press, Glisan told the judge, "I think I would simply like to say I take full responsibility for my actions." By taking a plea, Glisan would get out of jail in time to take part in some of his children's childhood, his sympathizers said.

Maybe, thought the reporter as he listened to these arguments. He'd never really thought much about questioning the sincerity of a man pleading guilty to a felony. Still, it would be interesting to have that cup of coffee someday with Glisan—though it appeared that the someday was still a ways off.

Glisan's guilty plea did allow the Enron Task Force to move another notch up the corporate ladder of admitted wrongdoers. And the prosecution team was picking up momentum. In late October 2003, a little over a month after the Glisan plea, the government announced its next big criminal catch.

David W. Delainey wasn't widely known to the public. But as the former head of both Enron's giant North American operation and its highly touted retail electricity business, the thirty-seven-year-old

Delainey was in a position to know lots of corporate secrets. He had also been a Skilling favorite, with direct access to the former Enron president.

While Glisan and Kopper had pleaded guilty to fairly specific criminal acts, Delainey, in his plea agreement, stipulated that "Enron's executives and senior managers engaged in a wide-ranging scheme . . . to deceive the investing public about the true nature and profitability of Enron's businesses by manipulating Enron's publicly reported financial results." The admitted wrongdoing included manipulation of company reserve accounts to boost earnings, jacking up the reported value of assets, and entering into improper business transactions.

In pleading guilty to one count of trading Enron stock while possessing insider information about the company's true financial condition, Delainey agreed to return $8 million in stock profits and serve up to ten years in prison. But he could be given far less jail time if the government decided that he had provided "substantial assistance" to the Enron probe. Given Delainey's closeness to Skilling, it was pretty easy to guess one target of such assistance. The federal noose seemed to be tightening around Jeff Skilling's neck.

Skilling realized it. After his appearances before Congress and on TV with Larry King, Skilling stopped speaking out publicly, though he didn't stop talking about the company that still dominated his life. On some nights he would go to a favorite bar, where he would spend hours sipping wine or gin and tonics, insisting that he had done no wrong. Former Enron colleagues said that they feared running into their old boss at some Houston haunt. Some wished to avoid him out of anger over what had happened, others for fear of being pulled into the federal investigation.

The Skilling camp was clearly sensitive about mentions of him in connection with the criminal investigation. In the course of writing a story about a criminal complaint filed against two men accused of putting together the Braveheart transaction, Smith called one of Skilling's attorneys, Bruce Hiler, to ask about the implications of the charges for his client, who had been deeply involved in Enron's broadband effort. Hiler angrily insisted that there was no reason to mention his client and that everyone was looking for someone to scapegoat. He con-

tinued in this vein for such a long period of time, giving Smith no tact-
ful way out of the conversation, that she was tempted to begin reading
office e-mail. Finally, his spring wound down and she was able to get off
the phone.

·As Skilling sat month after month in his River Oaks mansion, a sort
of prisoner amid splendor, unable to do much in his professional life
other than wait, he became increasingly frustrated and angry. He com-
plained to people he knew that the Justice Department was on a
vendetta to get him and wasn't going to let a lack of evidence stop it. He
read much of the reams that had been written about Enron and replayed
events from his days at the company. He was convinced, he told friends,
that he had done nothing wrong and that Enron really had been a great
company—despite all the scorn being heaped on it now. He was livid at
the way the government was going after his former subordinates, ruin-
ing their lives and the lives of their families. Perhaps Fastow had done
illegal things on some individual deals, such as Southampton, but even
that still had to be proven. Certainly, Skilling felt, whatever wrong-
doing had been done didn't justify what the government was doing to
get at him. He bitterly likened the federal investigators to the Gestapo.
If the government wanted to get him so badly, he said, they knew where
to find him. And *he* wouldn't be cutting any plea bargain.

But before Caldwell and her fellow prosecutors grabbed Skilling, they
had another stop to make, at a neatly kept brick-and-wood house on
Wroxton Road, in the Southampton section of Houston. The house be-
longed to Lea and Andy Fastow.

Since Enron's collapse, the Fastows had continued to keep a low pub-
lic profile, resolutely declining to talk to the press. They continued with
the small daily routines of domestic life. Fastow helped coach his son's
Little League team and drove carpool to school. He and Lea met peri-
odically with a circle of friends who had formed a support group to help
the couple get through the trying times. And they met with their crim-
inal attorneys.

In happier days, the Fastows had laid plans for moving to a much
larger and fancier house they were building in River Oaks. But with the
criminal case and all the notoriety, they decided to sell the uncompleted
place. Instead of a move up from colonial to baronial, the Fastows' next

housing stop might well be penal. As 2004 opened, Lea Fastow's criminal trial loomed. It had been pushed back slightly to avoid the January crush coming into Houston for the Super Bowl. But once the football fans left, the U.S. government in February would get to the task of incarcerating the mother of Andy Fastow's sons. The matter of trying to incarcerate Andy Fastow, for perhaps a few decades, was scheduled to go to court in August.

Journalists and attorneys following the Enron criminal probe doubted that the government cared all that much about Lea Fastow in her own right. It was widely assumed that she'd been thrown into the criminal docket largely as a way to force Andy Fastow to cut a deal with prosecutors, by putting the couple under enormous pressure to avoid the possibility of them both being in prison at the same time. For months, though, Andy's representatives insisted that he was going to fight the charges—all ninety-eight counts of them—in court.

But as Lea's trial approached, the pressure on Andy to cut a deal mounted. Andy had to know that he faced little chance of being acquitted at trial. The prosecution team was setting Fastow up to be the poster child Enron defendant who would serve real prison time. On the public image front, he was easily the least sympathetic of the Enron defendants. Plus, his indictment looked pretty powerful. How was Fastow going to explain the millions that he and his associates had seemingly stolen through the Southampton partnership? Arguing complex accounting questions was one thing. Stuffing wads of someone else's money into your pocket was another.

While Lea made a much more defendable defendant—jurors might feel sympathy if they viewed her as a wife and mother targeted because of her husband's transgressions—she was hardly guaranteed an acquittal. And if she lost at trial, those two boys could be parentless for several years. To avoid that possible outcome, there was only one alternative, though hardly a painless one: plea bargain.

Caldwell was certainly willing to cut a deal and had been for months, as long as it involved a substantial prison sentence for Fastow and his full cooperation in the ongoing investigation. Lea Fastow had always been a secondary target, a means to an end. Caldwell could live with

giving her as little jail time as the law would allow. Of course, Lea would have to plead guilty to at least one of the six counts against her. The Justice Department almost never just dropped indictments.

By early January 2004, both Fastows had tentatively worked out plea deals with the government. She would plead guilty to one count of filing a false tax return and serve five months in prison followed by five months of home detention. He would plead guilty to two criminal counts—one involving the Southampton scheme and the other involving the same Raptor conspiracy that Glisan admitted to. He would serve ten years in prison and pay over $23 million in penalties. And, of course, he would cooperate with the ongoing investigation.

The deal nearly went off the tracks when the federal judge in Lea Fastow's case, David Hittner, indicated that he might sentence her to more than five months in prison. Under federal sentencing guidelines—which take into account a number of factors ranging from the type of crime committed to the damages done—judges retained a certain discretion in meting prison times. Tentative guideline calculations indicated that Lea could be given ten to sixteen months in prison.

Privately, Caldwell and her fellow prosecutors were surprised and angered by Hittner's response. They told people that Lea would get ten months of incarceration, just not all of it in prison—conveniently looking past the fact that five months confined to one's house was a lot better than five months behind bars.

The judge's reaction spooked Lea Fastow. Suddenly, instead of a maximum of five months away from her children, she was staring at possibly well over a year. And if she didn't go ahead with her deal, Andy Fastow was telling prosecutors, he wouldn't go ahead with his.

The Fastows' lawyers and government prosecutors talked to see what else could be worked out. But there wasn't a lot of room for maneuvering. Prosecutors said that when Hittner actually sentenced Lea in a few months, following the completion of a mandatory presentencing report, he might well go along with the government's recommendation. If she did get additional prison time, prosecutors promised to try to ensure that Fastow didn't begin his sentence until she got out. That way the children would always have one parent at home. After a few days of agoniz-

ing, Lea decided to go ahead with her plea, though she reserved the right to withdraw it and go to trial if Hittner didn't eventually agree with the plea recommendation.

Fastow had no such out clause. He would have to go ahead with his deal, including the full cooperation, or face a much longer sentence. In his plea, Fastow said that he and other senior officers "fraudulently manipulated Enron's publicly reported financial results. Our purpose was to mislead investors and others about the true financial position" of Enron.

Caldwell savored her biggest catch to date and signaled her hopes for even bigger ones to come. In a rare public statement, she said that Fastow's cooperation "gives us a window into Enron's executive suites. Whatever knowledge that he has of who did what and who knew what at Enron will now be our knowledge."

Caldwell was determined to quickly follow up on the Fastow plea. For months, the task force had been gathering evidence on another member of the Enron inner circle, Rick Causey, the former chief accounting officer. As a sign of what was to come, Fastow said that the chief accounting officer had been among those who had been part of an illegal "unwritten agreement" regarding the Raptors.

A week after the Fastow plea, the government indicted the forty-four-year-old Causey. Prosecutors claimed that Causey was part of a wide-ranging scheme to doctor Enron's statements through accounting trickery and the misuse of off-balance-sheet transactions. The indictment called the accountant a "principal architect and operator" of the alleged scheme. Causey, through his lawyers, denied any wrongdoing and vowed to fight the charges in court.

People familiar with the investigation were telling Emshwiller that a Skilling indictment wasn't far off now, probably a matter of weeks. Prosecutors wanted Causey, who had direct dealings with Skilling as Andy Fastow did, on board with a plea bargain. They had offered him several deals over the course of the investigation, but he had turned them all down. Caldwell and her team hoped that the jolt of being actually charged and handcuffed might make Causey reconsider. But if he didn't, Caldwell felt that she had enough—with Fastow, Delainey, and others—to finally charge Skilling.

On the morning of February 19, 2004, a little more than a month after

Fastow's plea, Skilling, accompanied by several lawyers, arrived at the FBI offices in downtown Houston to go through the ritual surrender to authorities. Skilling looked as though he had gained a good deal of weight. Confinement in his new River Oaks mansion, which by then had added an imposing fence of iron bars, had apparently taken a toll. He wore slacks and a tweed blazer but came without a tie or belt. He told people that he didn't want to give government agents the satisfaction of removing those articles when they handcuffed him to take him to court.

Once in court, Skilling donned a belt and tie that had been brought by his brother Mark, who was in town from Turkey in a show of support. Just prior to the start of the hearing, Skilling got a chance to read the more than thirty counts against him. He could be seen angrily shaking his head as he read. After listening to a summary of the government's case, Skilling, flanked by five of his attorneys, said in a strong and clear voice, "I plead not guilty to all charges." He was released on a $5 million bond. Attorneys estimated that the actual trial likely wouldn't begin for a year, possibly two.

The Skilling indictment painted another picture of a wide-ranging conspiracy to make Enron look far healthier financially than it really was. It accused Skilling of everything from lying in public gatherings to giving his blessing to the Raptor secret deal that had already produced guilty pleas from Glisan and Fastow. Lest the former Enron president feel alone as the hammer of the law fell upon him, the Justice Department combined his indictment with Causey's.

One of the most fascinating parts of the superseding indictment, for Smith, accused the pair of concealing more than $1 billion in profits that Enron reaped during the California energy crisis. Prosecutors said Enron fraudulently used "prudency" reserve accounts within Enron Wholesale "to mask the extent and volatility of Enron Wholesale's windfall trading profits," both to hide the fact it was making a killing off California's misery and to use profits in that area to hide massive losses at Enron Energy Services and Enron Broadband Services. That sleight of hand, the indictment said, enabled the company to maintain the fiction that it was succeeding wildly—but legally—on all fronts. Smith, who remembered conversations with Skilling in which he'd said profits from California weren't especially impressive, was galled, anew, at the apparent duplicity.

To defend himself against the charges, Skilling had assembled a big, expensive legal team, led by attorneys from the Los Angeles–based law firm O'Melveny & Myers. On the day of the indictment, O'Melveny attorneys Daniel Petrocelli, who would lead the defense team, and Bruce Hiler, who had been with Skilling from the beginning of the investigations, talked to reporters. The pair contended that their client's activities at Enron were essentially the same as the actions of senior executives at dozens of corporations during the 1990s. The charges are really "a general indictment of corporate business" and an attempt to "demonize some normal procedures of corporate activity," said Hiler. Skilling had even taken a lie detector test and passed, Petrocelli said, "with flying colors."

As Emshwiller listened to the two lawyers, he thought such a strategy could make for a very interesting trial—though in the end it likely wouldn't get Skilling the acquittal or vindication that he sought. But perhaps the era of Enron should be put on trial somewhere, available for examination by all. And why not do it in the case of the man most responsible for Enron?

But Skilling's trial, if it occurred, would be without the executive's chief goverment tormentor. Shortly after the announcement of the Skilling indictment, Caldwell disclosed that she was leaving the Justice Department to go into private practice. After two years of climbing, she felt that she had finally gotten to the top of the Enron pyramid. Others could finish up the work. Her deputy and longtime colleague Andrew Weissmann took over as head of the Enron Task Force. He immediately made it clear that the investigation was continuing and even adding new staff.

Like many people, Emshwiller and Smith had tried to figure out the lessons of Enron as they plowed through their work together on the stories and the book. To Smith, Enron was the domain whose fall set off a spate of corporate scandals and marked, in a psychological sense, the end of one of history's greatest bull markets. She felt that the long swoon in stock prices, already eighteen months old when Enron collapsed, was doubtless extended by investor disillusionment as new waves of corporate scandals broke upon them. The stock market woes, perhaps as much as anything, spurred the government to seek corporate reforms it might not otherwise have undertaken.

While Enron was a business and political story, Smith also viewed it as a cautionary tale that warned individuals against allowing themselves to get mesmerized by the beguiling influences of "corrupt persuaders." Those persuaders included greed, ambition, pride, and a sense of invulnerability to common ethics. Together, they had blended to form a toxic cocktail from which top Enron executives had drunk.

While Smith often heard people lament that justice hadn't been done in the Enron scandal, she felt it was too early to tell. For one thing, the criminal process kept grinding away. Plus, a rough justice had been meted out at the beginning of the scandal. Enron was being taken apart, brick by brick, in an astonishingly short period of time. UBS Warburg bought the trading operation, early on after the bankruptcy, but later had to largely shut it down once the markets that Enron pioneered had been reduced to dust. The Enron name became synonymous with duplicity and avarice, just as the names Tammany Hall and Teapot Dome, in an earlier era, came to mean political graft.

Once Enron had spent its "reputational capital," to use Federal Reserve Chairman Alan Greenspan's phrase, Smith felt the market had punished the company with a pitiless vengeance. Indeed, Wall Street, that citadel of freewheeling capitalism that was often perceived as amoral, had shown a surprising streak of puritanical outrage about Enron's dishonesty. Didn't that amount to sufficient punishment? she thought.

Smith found it uplifting in an odd way. The market didn't just shrug off the apparent self-dealing and duplicity. At every step of the way, as the story had unfolded, the market had reacted. People had stepped forward with information, looking for no more reward than the satisfaction of seeing the truth come out. Our basic sense of integrity had been violated, and people wanted the guilty brought to heel. Smith still felt amazed by it all.

She wondered how long all the zeal for reform would last. Most likely, the reporter thought, only until the stock market picked itself up. It was unfortunate that things had to get as bad as Enron before the market clamored for reform. But maybe that was the way it always had happened. As she reflected on the meaning of Enron, Smith mulled a quote from Teddy Roosevelt, who once observed that "Americans only learn from catastrophe and not from experience."

There was no question that the Enron scandal had been a catastrophe. It had gone off like a dirty bomb that spewed an almost radioactive disgrace on all it touched—regulators, accountants, attorneys, politicians, Wall Street, and others. It derailed an entire deregulation movement. But perhaps the most lasting blight lay in the damage that Enron did to people's belief in essential institutions. Indeed, as time passed, venerable and trusted organizations as dissimilar as the Catholic Church and *The New York Times* weathered scandals of their own. Both cases—one involving errant priests and the other an errant reporter—added to the cascading public sense that people weren't doing their jobs anymore.

Smith thought that the scandals, from Enron on down, underscored a need for public discussion of the importance of personal integrity and ethical action. She believed strongly that if each person had asked one simple question—"What effect will the actions I am taking have on the trustworthiness and credibility of my institution?"—none of the scandals would have happened. The shameful acts of a few would have been nipped and never would have caused such broad mayhem.

Each institution's disgrace had required the quiet complicity, and often ingenious labor, of many individuals. Over time, institutions had become the corrupt enablers of the ever present corrupt persuaders. Fundamentally an optimist, Smith hoped the scandals would stun the public so much that they would inspire renewed commitment to truth telling and honest conduct, at all levels of organizations and in all kinds of institutions.

For his part, Emshwiller, too, often wondered about individual responsibility and complicity in the Enron scandal. As the investigations progressed, it became clear that many people involved in the company's deals had qualms about individual transactions. Some worried about the conflicts of interest, as Jordan Mintz did with the LJM partnerships. Others worried about whether a particular sale would really pass the smell test, as with the concerns of a Merrill official on the Nigerian barge deal. Yet none had gone outside their institutions to the authorities or the press before Enron's collapse, not even Sherron Watkins, who had gotten so many kudos as a whistle-blower. The only whistle-blower Emshwiller knew about was the original source who had called Smith

and him after their first story mentioning the Fastow partnerships. And that person continued to ask for anonymity.

Mostly, though, Emshwiller found that his own efforts to come up with the greater meaning of Enron served to remind him why he became a journalist and not a philosopher. At one point, he tried making up a list of lessons learned. Most of them seemed almost idiotically obvious: Tell the truth. Being honest is usually better than being smart. Be wary of things—or companies—you don't understand. Don't cut corners or rely on financial gimmicks. As a senior executive of a giant corporation, don't assume your IQ is automatically greater than your weight. Read the footnotes.

The reporter also found himself occasionally thinking back to a quote from California lieutenant governor Cruz Bustamante. Short, rotund, and balding, Bustamante was hardly the most memorable of pols, though he did have one flirtation with national prominence. In late 2003, the California electorate got mightily fed up with Governor Gray Davis and recalled him from office. Bustamante became the Democratic standard bearer to stop the Arnold Schwarzenegger juggernaut. Pitting Cruz against Arnold was a little like asking a twenty-five-watt light bulb to outshine the Las Vegas strip. At least Bustamante got to keep his old job after being stomped at the polls.

But what Emshwiller remembered most about Bustamante occurred in May 2001, during the heat of the California electricity crisis. That month—the same one in which Attorney General Bill Lockyer had uttered his prison-dating dream about Lay and Spike—saw all kinds of efforts by state political leaders to rein in and punish the major energy-trading companies. Bustamante introduced legislation to broaden the definition of criminal activity in the electricity markets. During an interview, Emshwiller asked him about the reasons for the bill. Given what the Enrons of the world were doing to California, Bustamante declared, "If it isn't criminal, it ought to be."

That line kept coming back to the reporter as the muck of Enron—all the too-sharp deals, the corner cutting, the pretzeling of rules, the avarice, and the arrogance—oozed out through various investigations. The wisdom of Cruz seemed particularly appropriate in relation to En-

ron's once-respected board of directors, who were emerging unscathed by any criminal charges. Yet these supposed guardians of the shareholders' interests had blithely approved the LJM operation, with all its blatant conflicts of interest, and then largely ignored the mess for two years as it ate away the insides of the company. What blame and what punishment did those directors deserve compared to a Dan Boyle or an Andy Fastow or a Jeff Skilling? And what about the leaders and "implementers" at all those august financial institutions, law firms, and accounting houses who did their parts to build the edifice that ultimately crashed? Would some of the people now so critical of the conduct of the Enron players have done better, acted more ethically, blown the whistle, if they had been part of the company's inner world in 1999 and 2000? After spending more than two years chasing the Enron story, Emshwiller wished that he had better answers to such questions.

And then there was Ken Lay—who, in a sense, was the first man there and the last man standing at Enron. He and Linda could be seen around town, seemingly relaxed and comfortable despite all the scandal. Linda had even started a store called Jus' Stuff, where she sold hand-me-down furniture and knickknacks of hers, her family, and her friends. Early on, she had told the *Today* show that the couple was in financial distress because of Enron's collapse—though her lament might have been more convincing if she hadn't delivered it from the splendor of the Lays' floor-through apartment at the Huntingdon.

While Lay's hands-off management style made it hard for prosecutors to find his fingerprints on the most suspect transactions, they continued to try. They focused their efforts on the last six months before the bankruptcy, when Lay was back in the CEO's job and no longer had Skilling to blame for whatever was going on. Prosecutors were looking for evidence that during this period Lay had finally paid enough attention to realize that very bad things had been going on for a very long time in front of his eyes. As 2004 aged, it became clear that the task force under Weissmann was focused on Lay as its number one remaining target. Numerous witnesses were called to talk to the FBI or testify before the Enron grand jury. Even Lay's lead criminal attorney, Mike Ramsey, acknowledged that his client was under heavy federal scrutiny. Of course,

Ramsey added, he felt that there were no grounds on which to file criminal charges against Lay.

Emshwiller suspected that the happiest man in America to see Lay indicted might well be George W. Bush. All the past political friendship and campaign largesse of "Kenny boy" had been buried under the avalanche of scandal. As long as Lay remained unindicted, he was the perfect example for anyone—especially a Democratic presidential candidate—who wanted to argue that at least one corporate chieftain was above the law in the Bush administration.

Whatever his criminal future, the image of "good old Ken" had certainly been trashed. Lay's image had taken a particular beating in relation to his sales of Enron stock. In 2001 alone, he had cashed out tens of millions of dollars, much of it by using a line of credit that had been extended. He would routinely borrow $4 million at a pop and then repay it by turning back Enron stock that the company had issued him. Cynics likened the arrangement to the world's biggest and most user-friendly ATM. In a particularly suspicious series of transactions, he cashed out some $16 million in the roughly two weeks after Sherron Watkins first went to him with her Raptor concerns in August 2001. Lay's representatives said all his stock dealings were proper and often done to raise cash to meet pressing demands on other investments.

Not surprisingly, some of Enron's outside directors professed to be shocked when they learned how much money Lay had taken out of the company. Charles LeMaistre, the onetime head of the board's compensation committee, told a Senate hearing in May 2002 that he thought Lay's options-for-cash deals were "very devious. It is very difficult for me to understand why that did not hurt Enron."

In July 2004, a harsher criticism of Lay finally came out of the Justice Department when the Enron federal grand jury in Houston handed up an eleven-count indictment against him. The indictment accused Lay of being part of a conspiracy to manipulate Enron's financial statements and give a falsely rosy picture of the company's health in the months before it filed for bankruptcy-court protection. Emphasizing the group nature of the alleged crimes, prosecutors added Lay to the pending indictment against Skilling and Causey—setting the stage for a trial that

could be the defining courtroom moment of the criminal probes into the 1990s corporate scandals.

Lay and his legal team had an unusual response to the long-anticipated indictment. Most defendants give a tight-lipped denial of the charges and keep mum until trial for fear that saying more could give ammunition to prosecutors. Lay, however, went on the public-relations offensive, holding a press conference shortly after the charges were filed and then giving a series of print and TV interviews. He consistently denied wrongdoing and blamed any misdeeds at Enron on others, particularly Fastow—whom Lay said had "betrayed" his position of trust at the company. Lay's defense team said the aggressive response was justified by what they saw as the government's weak case and the need to convince the public—particularly potential jurors—that their client wasn't guilty of crimes simply because he'd headed Enron. On that latter point, Emshwiller suspected that Lay had an uphill road.

On one of his trips to Houston, Emshwiller went back to the Front Porch Pub, which had been so filled with Enron workers the night that the Dynegy deal fell apart. He visited on a Saturday night and was glad, though mildly surprised, to see it bustling. He'd assumed that the collapse of the energy-trading business had been hard on Houston bars.

Emshwiller later talked to the bar's owner, Josh Harris, who said the Front Porch had been "the designated Enron place." Roughly half his patrons were company employees. So losing Enron hurt, Harris said, but the bar reached out, found new clientele, and was now doing nearly as much business as ever.

Harris said he liked most of the Enron people, but some "were full of themselves," cocky from making too much money too young and too easily. When Enron fell, some of those people told Harris that his bar would fail. They couldn't imagine it surviving without Enron. Harris said he'd like to see those doomsayers one more time. "I'd like to tell them we made it."

As Emshwiller boarded his plane back to Los Angeles, he thought about what the Front Porch's owner had said and wondered how larger businesses throughout America would answer the question "How did you survive Enron and how did it change you?"

Probably a more powerful protection than any new rule or oversight

body was the giant kick in the head that the scandals delivered to the nation's business leadership and investors. Though the scandals of the 1990s didn't trigger a 1930s-style economic collapse, they did immolate tens of billions of dollars of shareholder wealth, along with the careers of more than a few executives. They were the kinds of experiences that made "cautious" and "skeptical" much more popular adjectives in the vocabulary of commerce. Companies suddenly strained to demonstrate just how conservative they could be when it came to finance and accounting—a refreshing change from the go-go 1990s.

They were, however, changes that history suggested probably wouldn't endure. Though there was plenty of wisdom in that old saw "If something looks too good to be true, it probably is," it was a message that never matched up well with the acquisitive side of human nature. People routinely wanted to believe that something too good to be true could happen to them. It was a desire that sometimes led to great accomplishments and wonderful discoveries. And sometimes it led to greed and ruin and enormous financial fiascoes: Holland's great tulip mania of the early seventeenth century; the American canal- and railroad-building frenzies of the nineteenth century; the investment follies and frauds too numerous to mention that dotted the twentieth century. The Enron scandal was a new century's first entry in a very thick ledger. It almost certainly wouldn't be the last.

Index

Abbott, Susan, 96–97

ABC, 300–301, 302

accounting/financial practices: and analysts, 112; and board of directors, 90; and Braveheart, 267; Chanos's views about, 41; and collapse of Enron, 229, 282; and corporate culture, 229; and criminal investigations, 331; "mark-to-market," 77–82, 150, 290, 292; and partnerships, 40–41, 149–50, 276–77; and Powers Report, 333–34; and SEC, 288; reform of, 376; and "Special-Purpose Entities," 259–70, 288; terminology in, 81; and third-quarter earnings report, 95, 96; tips and sources about, 259–60; and trading business, 77–82. *See also* Arthur Andersen

accounting firms, 236, 287, 288, 377, 394. *See also* Arthur Andersen

analysts: and accounting/financial practices, 112; and conflict of interest issue, 121–22; and corporate reform, 375–76; and "death spiral" of Enron, 162; Enron's relationships with, 112; and equity reduction issue, 125, 127–28; expectations of, 111–12, 113, 114; and feelings of being duped, 121; and "Heard on the Street" story, 45; Houston conference for (January 2001), 264; impression of Fastow by, 72; and investment bankers, 36, 147; and *Journal*'s package of Enron stories, 173; lack of knowledge about Enron of, 31–33, 37, 146; language of, 147–48; and

October 23 conference call, 147; and partnerships/trusts, 31–34, 44, 132–33; ratings of, 33, 35–36, 37, 45, 113, 120, 147–48, 160, 173, 189–90, 375–76; reactions to *Journal* stories by, 121; reliance on Skilling by, 37; and Skilling's resignation, 10, 16; Smith's views about, 27; and stock options, 17; and third-quarter earnings report, 94, 107, 108, 111–12, 113, 148; and trading business, 162. *See also* conference calls; short sellers; *specific person*

Anapurna, 260

Andrew, Gordon, 346

Antioco, John, 261–62

Arkansas Teachers Retirement System, 53, 59–60

art collection, Enron, 69

Arthur Andersen: and Braveheart, 266, 267; and Chewco, 189, 284, 285; civil settlements by, 354; as consultants, 288; and credibility of Enron, 112; criminal/federal investigations of, 294–95, 296, 331, 353–62; document management policy at, 294, 359–60; Enron's relationship with, 287–92, 360; and Fastow's conflict of interest, 292, 293; fees of, 288, 292, 360; former clients of, 376; lack of comments from, 280; loss of business by, 354, 355–56; and "mark-to-market" accounting, 80; and October 23 conference call, 144; and October 23 employees' meeting, 154; and partnerships, 91, 277, 278, 292, 293,

Arthur Andersen (*cont.*)
294; and Powers Report, 333, 336;
professional standards group at, 289, 290;
and Raptors, 290, 292–93, 294, 309, 310;
reputation of, 287; SEC injunction
against, 354; shredding by, 285, 286–87,
295, 296, 297, 303, 353–62; and third-
quarter earnings report, 95, 96, 99,
293–94, 362; trial and conviction of,
357–62, 363; and Vinson & Elkins
review, 310; Volcker oversight committee
at, 354; and Watkins-Lay letter, 309. *See
also specific person*
Asset LLC, 268
Associated Press, 137, 383
Astin, Ronald, 141
attorneys, Enron: and California energy
crisis, 366–67, 370; and Chewco, 334;
and collapse of Enron, 229; and corporate
culture, 229; and hearing on Enron
litigation, 303–5; and October 23
conference call, 141; and partnerships,
277, 348; and Powers Report, 333, 334;
and shareholder lawsuits, 139; and
unanswered questions about Enron, 236;
and waiver of "Code of Conduct," 98. *See
also specific person*
Attridge, Dan, 219
audit committees, 375
Azurix Corp., 40, 94, 107, 143

Bachus, Spencer, 279
balance sheet: accepted way of reporting
items on, 286–87; and Braveheart, 267;
CFO story about, 70; and Chewco, 181;
complexity of, 96–97; and "death spiral"
of Enron, 163; and direct LJM-Enron
transactions, 133; and Dynegy merger
discussions, 197; and equity reduction
issue, 126, 128–29, 137; and October 23
conference call, 144; and off-balance-
sheet financing, 55, 70, 95, 146, 163,
187–88, 243, 259–60, 271, 272, 282, 283,
308; and Powers Report, 333–34, 335;
and reasons for Enron collapse, 282;
requirement for certification of, 287; and
third-quarter earnings report, 95, 96–97;
tips about, 259–60
Ballmer, Steve, 32
bankruptcy, 160–61, 190, 213, 221, 228–37,
274, 332
banks/brokerages: and Braveheart, 266; and
"death spiral" of Enron, 165–66, 168; and
Dynegy merger discussions, 206, 207,

208; and Fastow's departure, 157, 158;
Fastow's relationship with, 70; Glisan's
contacts with, 73; and LJM partnerships,
52, 53–54, 58–59, 105, 150; and
"Special-Purpose Entities," 260; and
unanswered questions about Enron, 236.
See also credit lines; investment banks;
specific bank or brokerage house
Barclays Bank, 284, 285, 371
Barings Bank, 76
Barone, Ronald, 96, 120, 123, 149, 209
Barrionuevo, Alexei, 221, 222, 223, 255–56
Barry, Dave, 147–48
Bass, Carl, 288, 289, 290–93
Baxter, Carol, 315–16, 317, 324, 326–28
Baxter, John Clifford "Cliff": compensation
for, 325–26; and congressional
investigations, 324; death of, 313–18,
321–22; Enron attorney for, 324; and
Enron partnerships, 318, 319–20, 321,
323, 328; on Fastow, 323; friends'/
colleagues' comments about, 322–23; and
lawsuits, 324–25; and Lay, 321; personal
and professional background of, 318–19;
retirement life of, 323–24; and Skilling,
246, 319, 320–21, 324–25; stock sales of,
325–26
Bayly, Daniel, 379
Bear Stearns, 19–20
Belden, Timothy, 367, 368, 370–71
Benson, Mitchel, 62
Berardino, Joseph, 278, 279, 280, 284, 285,
293, 296, 354
Bergstrom, Steve, 195–96, 208, 220
Bertotti, Pat, 248
Big River, 284, 285
Blockbuster, 261–62, 264, 265, 266, 268,
269
Blue Heron I LLC, 66
Blundell, Bill, 14
board of directors, and corporate reform,
373–74, 375, 376, 394
board of directors, Enron: blame and
punishment for, 394; and Carter as
corporate secretary, 256; compensation
for, 90; corporate loans to, 376; and
Dynegy merger discussions, 199–200;
employees as members of, 89; Emshwiller
and Smith attempt to contact, 89–93;
and follow-up of third-quarter report,
120; Gramm (Wendy) on, 199; minutes
of, 283–84, 311, 339; and October 23
conference call, 141; and October 23
employees' meeting, 153, 154; "outside,"

89, 312, 373–74; Palmer fax to, 92–93; and Powers's investigation, 174, 333, 334; and related-party transactions, 141, 373–74, 375; and SEC inquiry, 135, 137; selection of, 90; time problems for, 89–90; waiving of "Code of Conduct" by, 50, 92; and written response to prescreened questions, 87. *See also specific person or topic*

Boies, David, 20, 281–82, 308

bonds, 164, 165, 172, 206

Bowsher, Charles, 250

Boyle, Daniel, 379–81, 394

Boyle, Pam, 379

Brauchli, Marcus, 308

Braveheart, 264–70, 290–91, 372, 384

Brick, Michael, 308

broadband operations: analyst's views of, 31–32; and Andersen-Enron relationship, 290; and Baxter's stock sales, 325; Baxter's views about, 320; and Blockbuster deal, 261–62, 264; and Braveheart, 264–70; and Dynegy merger discussions, 197; and LJM partnerships, 65, 187; and McKinsey's influence on Skilling, 273; and SEC investigation, 372; setbacks in, 31–32; Skilling as champion of, 10; and Skilling-Emshwiller interview, 23; and "structured finance vehicles," 127; and third-quarter earnings report, 94, 107, 108

Brunswick Group, 166–67

Bryan-Low, Cassell, 172

Buffett, Warren, 173–74

Bush, George W., 9, 20, 329, 376, 395

Bush (George W.) administration, 13, 306, 330

Bustamante, Cruz, 393–94

Buy, Rick, 283, 324, 338, 342, 343, 344, 347, 348, 349

buyback, stock, 123, 140

Cactus, 308

Calame, Barney, 167

Caldwell, Leslie, 280, 330–32, 356, 363, 366, 371–72, 378, 383, 385, 386–87, 388, 390. *See also* Enron Task Force

California, elections of 2003 in, 393

California electricity crisis: and Bustamante, 393; and Causey and Skilling's indictments, 389; and deregulation, 6, 14, 368, 370; and derivatives trading, 76–77; and Edison International, 136; and Enron, 6, 13,

14–16, 22, 23, 41, 76–77, 366–71, 389; grand jury investigation of, 366–71; and Sitrick, 181; Smith-Emshwiller as reporters for, 5–6, 14–15, 27–28, 29, 84, 104, 377, 389

California Energy Commission, 367

California Public Employees Retirement System (CalPERS), 53, 60–63, 65, 176–78, 179, 311

Carpenter, Michael, 207, 208

Carter, Joyce, 321–22

Cash, Debra, 290

Castaneda, Maureen, 300–301, 302, 303

Catholic Church, scandals in, 392

Causey, Richard: and Andersen, 289, 291, 294, 295; as chief accounting officer, 74; and conflict of interest, 80–81; and corporate culture, 338; and 8K filing, 186; Enron attorney for, 324; and equity reduction issue, 126, 186; indictment of, 388, 389, 395; and October 23 conference call, 142, 143; and partnerships, 80–81, 277, 283, 347, 348, 349; and prescreening of questions, 84–85; Smith interview of, 126–27; and third-quarter earnings report, 294; and trading-accounting relationship, 79–80

CFO magazine, 70, 71, 74

Chandler, Claudia, 367

Chanos, James, 40

chatboards, 24

ChevronTexaco Corp., 194, 195, 198

Chewco: and Andersen, 279, 284; and Berardino's testimony, 279; and board of directors, 213, 311–12, 339; and conflict of interest, 312; and criminal investigations, 331; and "death spiral" of Enron, 169–70, 171; and 8K filing, 183–84, 185, 188–89; Emshwiller's call to Kopper about, 169–70; Emshwiller's investigation of, 169–70, 176–81, 183–84, 188–89, 377; Fastow's information about, 284, 371–72; internal investigation into, 189; investors in, 284; and JEDI, 176–79; and Kopper, 75, 169–71, 179, 185, 213, 284, 311, 312, 334, 336, 372; lack of knowledge about, 75, 236; and Lay, 169, 213, 311, 312, 339; and McKinsey, 271–72; offices of, 169; and Powers's investigation, 174, 333, 334, 336; as related-party transaction, 373; and shredding at Enron, 301; and Skilling, 311, 312, 334

CIBC (Canadian Imperial Bank of Commerce), 266–67, 268

Citigroup, 53, 165, 174, 198–99, 200, 207, 208, 231, 274

CNBC, 111, 113

CNNfn, 113–14

Coale, Carol, 147–49, 173, 211, 215, 312

Coca-Cola, 375

"Code of Conduct," 50, 85, 92, 97–98, 117

Collins, Bruce, 92, 116, 146, 158

Commerce Committee (U.S. Senate). *See* congressional investigations

commercial paper, 164–65, 168

Conese, Eugene, 275

conference calls: and board of directors' meetings, 90; and equity reduction issue, 128–29; Fastow's role in, 67; Fleischer urges Lay to have daily, 144; and Lay interview, 42; about Nigerian barge deal, 378, 379, 380–81; of November 14, 203–4; of October 23, 139–40, 141, 142–45, 146, 151–52, 156, 157–58, 161, 165; and Project Summer, 151; reasons for, 140; and Skilling's resignation, 10–11; and stock price, 140; and third-quarter earnings report, 108, 114–15, 123, 126

conflict of interest: analysts' reactions to stories about, 121–22; and Andersen, 292, 293; and board of directors, 120; Causey's views about, 80–81; and Chewco, 312; and collapse of Enron, 229; and corporate culture, 229; and direct LJM-Enron transactions, 133; and Donaldson, Lufkin proposal, 276; and Fastow's reluctance to take on partnerships, 33; and Fastow's withdrawal from partnerships, 80; and investors in partnerships, 57, 60–62, 275; Kaminski's views about, 342, 343; and Lay, 43, 203–4; and lessons of Enron, 392, 394; and LJM-Enron transactions, 132, 392, 394; and LJM quarterly report, 131–33; and LJM2 "road show" presentation, 50–51; "Mutual Friend" reports about, 48, 50–51; and November 14 conference call, 203–4; and Rhythms deal, 343; and third-quarter earnings report, 117. *See also* Insider stock sales; related-party transactions

congressional investigations: and Baxter, 324; Berardino's testimony in, 278, 279, 280, 284, 285; and Fastow's appearance, 242; and Fastow's departure, 158–59; and Lay, 242, 279; and LeMaistre's testimony, 395; and LJM partnerships, 372; and Merrill Lynch's records, 36; and Mintz, 346, 347; new information discovered in, 279–80; and Powers committee interview memos, 338–40; and profiles of Enron executives, 242; Skilling's testimony in, 242–43, 319, 324–25, 384; and Watkins-Lay letter, 308–9

Continental Bank, 68, 69–70

Corgel, Richard, 294–95

Cornhusker, 260

corporate reform, 373–76, 390–91

corrupt enablers, 392

corrupt persuasion, 355, 357, 361, 362, 372, 391, 392

"costless collar," 336

Craig, Suzanne, 173

"creative destruction," 273–74

credit lines, 143, 146, 165–66, 168–69, 174, 175–76, 198

credit rating: agencies offering, 63, 71, 94–99, 157; and bankruptcy filing, 230; and collapse of Enron, 228; daily review of, 190; and "death spiral" of Enron, 163–64, 168; downgrading of, 173, 190, 201, 220; and Dynegy merger discussions, 200, 201, 209; and Fastow's CFO Award, 72; and Fastow's departure, 157; and JEDI, 178; as junk bond status, 220; and keeping debt off balance sheet, 70–72; and McMahon's attempts to enhance financial strength, 190; and October 23 conference call, 143, 165; and partnerships, 96, 138; and stock price, 173; and third-quarter earnings report, 94–99, 113–14; and trading business, 78, 370; and trigger provisions, 138

Credit Suisse First Boston, 58, 137, 199, 342

credit watch, 97, 163–64, 173

criminal investigations: of Andersen shredding, 353–62; and California electricity crisis, 366–71; and Fastow, 332, 371–72; and Kopper cooperation, 365–66; and media, 366; and National Westminster-LJM partnerships, 364–65; obstacles in, 330–31, 332; and penalties for white-collar crime, 381–82; and Powers Report, 332–35; and shredding at Enron, 364; and Skilling, 332; strategy in, 331–32; and risks of going to trial, 381–82. *See also* Caldwell, Leslie; Enron Task Force; Justice Department, U.S.

Dabhol power plant, 6, 7, 23, 38–39
Davis, Gray, 369, 393 .
Davis Polk (law firm), 304
Delainey, David W., 383–84, 388
Deloitte & Touche, 174
deregulation, 6, 14, 153, 368, 370, 392
Derrick, Jim, 174, 199, 230, 320
Dietert, Jeff, 128
DiMichele, Rich, 263
Dobbs, Lou, 364
Dodson, William, 284
Donaldson, Lufkin & Jenrette, 275–76, 277
Donnell, Jim, 163
Dorton, Patrick, 292, 355
Doty, Rob, 204, 205, 208, 209
Dow Jones News Service, 282
Dresdner Bank, 130
Duke Energy Corp., 106, 108, 109, 114, 163, 221
Duncan, David, 158–59, 289–90, 291–92, 293, 294, 295, 296, 356, 360–61, 371
Duncan, John, 252
Dynegy, Inc.: lawsuits of, 230, 231; logo for, 213; merger discussions with, 193–209, 215, 220, 223, 229, 230, 297; and Olis case, 381–82; as possible partner, 176
DynegyDirect, 162, 193

e-mail: *Journal* creates special address for, 306; and Nigerian barge deal, 378, 380; as source of tips, 258–59, 261–64, 267
"Eagle" (source), 263–64, 265, 267
Eassey, Donato, 36, 132, 133, 160
Eavis, Peter, 124, 137–38
EBS Content Systems LLC, 265, 266, 268. *See also* Braveheart
Edison International, 136
Eggleston, W. Neil, 312
Egret, 66, 82
Eichenwald, Kurt, 308
Eisenberg, Melvin, 374
elections of 2003, 393
electric grid power failure (August 14, 2003), 377
electricity business: Baxter's views about, 320; deregulation of, 6, 14, 253, 368, 370, 392; Smith's interest in, 377; and wind farms, 365–66, 372. *See also* California electricity crisis
Ellison, Larry, 265
Elson, Charles, 374–75
employees, Enron: and corporate culture, 256; Emshwiller's talks with, 222, 223, 226–27, 296–97, 298–99; hostility

toward press by, 222; image of, 396; layoffs of, 215, 221, 232–34, 297; Lay's October 23 meeting with, 151–55; and Lay's return, 44; pizza parties of, 272; relief funds for, 202; retention payments for, 235, 263; and shredding at Enron, 298–303; Web sites of, 235. *See also specific person*
Emshwiller, Deborah, 24, 104–5, 306
Emshwiller, John: Enron criminal probe as focus of, 377; Houston trips of, 210–19, 221–27, 296–97, 299–305; and lessons of Enron, 380, 390, 392–94; personal and professional background of, 14, 24; reporting style of, 28; Smith's relationship with, 27–28, 59, 175, 222–23, 377; views about sources of, 339; wedding anniversary of, 306–8. *See also specific person or topic*
Energy and Commerce Committee (U.S. House). *See* congressional investigations
energy industry: Andersen as number one auditor in, 287; and "death spiral" of Enron, 162–63; decline in stock price of, 160; effect of Enron bankruptcy on, 220; Enron's centrality in, 133; "Special-Purpose Entities" in, 277. *See also* trading business
Energy Policy Act (1992), 253
Enron Broadband Services (EBS), 262, 263, 389. *See also* broadband operations
Enron building, 213–15
Enron Capital and Trade Resources, 39
Enron Corp.: compensation system at, 276; cost of bankruptcy proceedings for, 376–77; creation of, 253; credibility of, 43, 97, 112, 121–22, 132, 144–45, 160, 189, 195; culture of, 8, 44, 57, 214, 229, 247–48, 254, 255–57, 263, 269–70, 276, 338, 380; "death spiral" of, 159–71; discussion of future of, 156–71; discussions of possible demise of, 159–71; dismemberment of, 391; divisiveness at, 284; excesses of, as Texas phenomenon, 214; fear factor concerning, 132; as greatest scandal, 329; Grubman-Lay exchange as pivotal for, 145, 146; image/reputation of, 7, 8, 41, 74, 137, 153, 161, 162, 166–67, 228, 236–37, 329–30, 376–77, 391; and individual responsibility and complicity, 392; jokes about, 189; lessons of, 390–94, 396–97; liabilities of, 37, 138, 143–44, 167, 168; logo of, 213; as "momentum stock," 32;

Enron Corp. (*cont.*)
 morale at, 215; postbankruptcy prospects
 of, 215; as PR headache, 166–67; reasons
 for collapse of, 228–29, 243, 282;
 "reputational capital" of, 391; sex and
 sexual politics at, 256–57; shareholder
 base of, 32; subsidiaries and affiliates of,
 82; unanswered questions about, 236–37;
 Wall Street as model for, 276. *See also
 specific person or topic*
Enron executives: accessibility of, 18, 84,
 86, 88, 93; conformity to rules by, 246;
 and congressional investigations, 242;
 and "corrupt persuaders," 391;
 culture/lifestyle of, 214; and October 23
 employees' meeting, 153; and
 partnerships, 53, 54, 64, 85, 91, 282; and
 pizza parties, 272; and Project Summer,
 151; and third-quarter earnings report,
 94–99. *See also specific person*
Enron Field, 213
Enron Finance Corp., 68
Enron North America, 314, 319, 325,
 383
Enron Task Force (U.S. Justice
 Department), 331, 353, 356, 363–66,
 371–72, 383–84, 388, 390, 394–95. *See
 also specific person*
EnronOnline, 41, 81–82, 160, 162, 163,
 193, 221, 370
Ephross, Joel, 346, 347
equity reduction, 95–96, 122–29, 132, 136,
 137, 143, 150, 161, 186
Evans, Donald, 200
executives, compensation of, 374, 375;
 corporate loans to, 373, 376; relocation
 of, 376. *See also* Enron executives
"experts' defense," 331, 356

Fallon, Jim, 263
Farmer, Janice, 234–35
Fastow, Andrew: appearance of, 73;
 background/profile of, 53, 67–73, 242;
 banking relationships of, 70; and Boies
 press conference, 280–81; cabbie
 punches, 69–70; calls for resignation of,
 122; CFO Excellence Award for, 72; and
 collapse of Enron, 311; compensation for,
 48, 49, 51, 52, 53, 54, 85, 91–92, 93, 105,
 117, 130, 131, 158–59, 236, 292, 333,
 350, 366; credibility of, 121–22;
 departure of, 157, 158–59, 195, 212;
 deposition of, 67–68, 308; employees'
 views about, 223; first newspaper notice

of, 69–70; hiring of, 67, 68;
 image/reputation of, 73, 276, 330, 371,
 386; indictment and plea bargain of, 366,
 382, 385–88, 389; inside information of,
 85; lack of press accessibility to, 158; and
 Lay, 92, 143, 153, 157, 158, 208, 212,
 249, 254, 396; LeMaistre's confidence
 in, 92; and lessons of Enron, 394;
 lifestyle/homes of, 214, 385–86;
 McLean's interview of, 124; motions to
 seize money and assets of, 366; and
 October 23 conference call, 141, 142,
 143–45, 165; and October 23 employees'
 meeting, 153; personality and ambitions
 of, 73, 86–87, 276, 372; and Powers
 Report, 333, 334, 336, 337; reactions to
 Journal stories by, 121; responsibilities of,
 117; sentencing of, 387; and shareholder
 lawsuits, 139; and Skilling, 52, 53, 54,
 67, 68, 72, 283, 349, 350, 385, 388; stock
 trades of, 172; and unanswered questions
 about Enron, 237; waiving of code of
 conduct for, 50, 52; Wall Street as model
 for, 74. *See also* conflict of interest; LJM
 partnerships; partnerships, Enron; *specific
 person or topic*
Fastow family foundation, 350
Fastow, Jeffrey, 53
Fastow, Lea, 53, 68–69, 334, 372, 385–88
Fastow, Matthew, 53
Fastow source, 211, 212
Federal Bureau of Investigation (FBI), 236,
 280, 305, 332, 389, 394
Federal Energy Regulatory Commission
 (FERC), 369–70
Feygin, Anatol, 147
Fifth Amendment, 362
filings, SEC: and analysts' feelings of being
 duped, 121; and backlog at SEC, 135;
 and Chewco, 75, 169, 334; and "costless
 collar," 336; 8K, 96, 183–90, 199, 278;
 Emshwiller first reviews, 18–19, 20–21;
 and equity reduction issue, 123, 126; and
 "Heard on the Street" story, 46; and
 insider stock sales, 172; and JEDI, 177,
 178; lack of interest in reading, 34; and
 "non-recurring" items, 293; and
 partnerships, 34, 45, 51, 65, 66, 246; and
 pending litigation against Enron, 18; and
 Powers Report, 333, 334; and related-
 party transactions, 373–74;
 renouncement of, 184, 189, 278; and
 Rhythms deal, 342; and severance
 packages, 201; and Skilling's resignation,

35; 10-Q, 204–5, 206; unintelligibility of, 25, 246

Financial Accounting Standards Board (FASB), 79, 171, 259, 288, 293, 376

"financial engineering," 61, 112, 269

financial statements. *See* filings, SEC; third-quarter earnings report

Financial Times, 111, 132

First Union Bank, 53

Fitch, 63, 74, 113–14, 163–64, 190

Fleischer, David, 31–33, 74, 120, 127–28, 144, 159–60, 173

Fleishman, Steve, 132, 133

Florida Gas Transmission Co., 251, 252

Forbes magazine, 60

Fortune magazine, 4, 32, 124

Foster, Richard, 273–74

Fox channel, 114

Francis, Theo, 1

Frevert, Mark, 195

Friedland, Jonathan: and ABC-Castaneda interview, 299–300, 301; and Chewco investigation, 177–78, 179–80, 280; and 8K filing, 183, 184; and Emshwiller-Smith collaboration, 29, 104, 223; and Emshwiller's belief that Palmer misled him, 203; and Emshwiller's time off, 307; encourages further investigation, 12–13, 16, 25, 27, 55–56; and Enron criminal probe stories, 377; and equity reduction issue, 124–25; and investors in partnerships, 60; jury duty of, 306, 307; and Lay's views about *Journal*, 167; and LJM partnerships, 104, 131, 203, 284; and minutes of board of directors, 284; and package of Enron stories, 172; and Powers committee's interview memos, 341; and "shock wave" story, 220; and shredding at Enron, 298; and Sitrick call, 181; and Skilling-Emshwiller interview, 24, 25; and Skilling's resignation, 3–5, 6–11, 340; and Skilling's role in partnerships, 284; and third-quarter earnings report, 108, 109, 110, 116, 117

Front Porch (Houston, Texas), 221–22, 226–27, 296–97, 396

FT.com, 111

GE Capital, 58–59

General Electric, 58–59

Gerber, Spence, 368

Gerth, Jeff, 13

Getty Oil, 231

Ghost, 260

Glatzer, Bernard, 19–21, 28, 67–69, 160–61, 244–45, 281–82, 308

Glisan, Ben: appointed treasurer, 54, 139; background of, 73; bank contacts of, 158; and criminal investigations, 365; and Dynegy merger discussions, 199; and 8K filing, 187–88; and Emshwiller's trip to Houston, 216–17; and Fastow's departure, 158; and internal investigations, 189; McMahon replaced by, 139; and Mintz, 346, 347; motions to seize money and assets of, 366; and October 23 conference call, 142, 144; and partnerships, 52, 54, 138, 346, 347; personality of, 73, 74; plea bargain of, 382, 383, 384, 387, 389; and Powers Report, 334; and Raptors, 334; Smith's interview of, 146; and Southampton investigation, 365; termination of, 187–88; and waiving of Code of Conduct, 85

Goldman Sachs, 199, 375–76

Gramm-Leach-Bliley Financial Modernization Act (1999), 199

Gramm, Phil, 199

Gramm, Wendy, 199

Gray, Robert, 316, 317, 327, 328

Greenspan, Alan, 200, 391

Grubman, Richard, 143, 145, 146

Gruley, Bryan, 249–55

Guthery, K. D., 313–14, 315

Hamburger, Tom, 346

Hamel, Gary, 273

Hannon, Kevin, 264

Hardin, Rusty, 304, 357, 359, 360–61, 362

Harmon, Melinda, 303, 305

Harrier, 335

Harris, Josh, 396

Harrison, William, 200

Hawaii 125-0, 260, 266, 268

Hawk, Dianne, 367

Head, Scott, 313–14

"Heard on the Street" column, 25–27, 31–41, 45–46, 64, 117

hearings: on Enron litigation, 303–05. *See also* congressional investigations

Hecker, James A., 357–59

Herbrig, Mary, 314–15, 321, 322

Hertzberg, Dan, 29, 120–21, 298

Hiler, Bruce, 384–85, 390

Hill, Patricia, 245

Hittner, David, 387, 388

Hochman, Nathan, 344

Horton, Stan, 195
"Hotel Kenneth Lay-A" (Hecker song), 358–59
House of Representatives, U.S. *See* congressional investigations
Houston Chronicle, 282
Houston Natural Gas (HNG), 252–53, 272
Houston, Texas: business culture of, 214; Emshwiller's trips to, 210–19, 221–27, 296–97, 299–305, 396; hearing on Enron litigation in, 303–5
Howard, Kevin, 372
Hwang, Suein, 271, 272

Illinova Corp., 193
income taxes, 274
India. *See* Dabhol power plant
Ingrassia, Larry, 27
insider stock sales, 172, 325–26, 368, 373–75, 384
institutional investors, 156, 272
insurance companies, 274
Intercontinental Exchange, 162
international operations, 38, 40, 197
InterNorth, 252–53, 272
investment banks, 36, 147, 207, 236
investor confidence/trust, 120, 157, 161–62, 204, 287, 374, 390

Jaedicke, Robert and Mrs., 92, 93
Jennings, Peter, 300
"Jim" (source), 259–60, 266
Joint Energy Development Investments (JEDI), 62, 176–79, 184, 300, 301, 311
Jones, Mike, 290
JPMorgan Chase, 53, 130, 165–66, 174, 177, 198–99, 200, 207, 208, 231, 274
Justice Department, U.S., 223, 236, 280, 286, 296, 353–54, 356, 363–64, 382–83, 387. *See also* criminal investigations; Enron Task Force; *specific person*

Kafus Industries Ltd., 66
Kaminski, Vincent, 342–44
Kaplan, Sarah, 273
Kean, Steve, 86–87, 203
Keker, John, 242
Kimberly, Kelly, 253, 254
Kinder, Richard, 39, 44, 253, 320
Kinder Morgan, 39
King, Larry: Skilling interview by, 384
Kirkland & Ellis, 218–19, 350
Koenig, Mark, 142

Kopper, Michael: background on, 74; and Chewco, 75, 169–71, 176–77, 179, 185, 284, 311, 312, 334, 336, 372; compensation for, 333; cooperation with Justice Department by, 365–66; and criminal investigations, 365–66; and 8K filing, 185, 188; Emshwiller's call to, 169–70; and Emshwiller's trip to Houston, 217–18; and Fastow, 54, 74–75, 365, 371; home of, 224; and JEDI, 179; and Lay, 311, 339; and LJM partnerships, 275, 346, 347, 348, 364, 365; as managing director, 74, 171; and Mintz, 346, 347, 348; and National Westminster-LJM partnerships, 364; as not an officer at Enron, 170–71; and partnerships, 52, 54; personality of, 73–74; plea bargain of, 382, 384; and Powers Report, 333, 334, 336; resignation of, 170; and waiving of Code of Conduct, 85; and wind farms, 365–66
KPMG, 130
Kranhold, Kathryn, 83–84, 246
Krautz, Michael, 372
Kriegel, William, 247

Launer, Curt, 137
Lavorato, John, 152
law firms, and lessons of Enron, 394; and representation on boards of directors, 373–74. *See also* attorneys, Enron; *specific attorney or firm*
lawsuits: and bankruptcy filing, 230, 231; and Baxter, 322, 324–25; and Dynegy merger discussions, 198; by JPMorgan Chase, 274; by LJM partnerships, 275; and October 23 conference call, 144; shareholder, 122, 139, 236, 300–301, 303, 324
Lay, Judie, 251
Lay, Kenneth: alternatives open to, 190; attorneys for, 394–95; background/profile of, 9, 242, 249–55; as board member, 89; board's shock at compensation for, 395; and Bush (George W.), 9, 329, 395; cartoons of, 249; and collapse of Enron, 311; and criminal investigations, 249, 254, 332, 394–95; and "death spiral" of Enron, 166, 167; and Dynegy merger discussions, 195, 196, 197–98, 199–200, 201, 205–6, 207–8, 220; employees' views about, 223; and Fastow, 92, 143, 153, 157, 158, 208, 212, 249, 254, 396; financial affairs/compensation of, 16,

244; ignorance of, 205, 243–44, 311, 338, 339, 340; image/reputation of, 242, 330, 395; indictment of, 372, 395–96; lifestyle/home of, 214, 224–25, 394; management style of, 208, 254, 394; mentors of, 250; October 23 employees' meeting with, 151–55; personality of, 8–9, 45, 208, 244, 248–49, 255; and Powers committee, 333, 337–38, 339–40; protégés of, 37–38; public relations offensive of, 396; reaction to criticism by, 35; refuses to talk about Skilling and Fastow, 249, 254; return as president and CEO of, 3, 44; role in Enron of, 9; and SEC inquiry, 134–35, 137; security for, 221, 297; severance package of, 201–2; and Skilling, 8, 37–38, 43, 44–45, 247–49, 254, 339–40, 394; and Skilling-Emshwiller interview, 22; and Skilling named as president and CEO, 39; and Skilling's offer to return, 145–46; and Skilling's resignation, 3, 4, 9, 10–11, 23–24, 321, 340; Smith and Emshwiller's interviews of, 41, 42–46, 108–9, 110, 115–16, 126; Smith and Gruley interview of, 249–55; stock options of, 16, 395; and stock price, 44; stock sales of, 172, 395; and unanswered questions about Enron, 237; views about *Journal* of, 166, 167, 395; as visionary, 253. *See also specific person or topic*

Lay, Linda, 251–52, 394
Lay, Omer, 249–50, 255
Lay, Ruth, 249–50, 255
layoffs, 232–34
Lee, James, 166, 207, 208
Lehman Brothers, 53
LeMaistre, Charles A., 90–92, 93, 117, 158–59, 395
Leon, Judy, 283
Lerach, Bill, 300, 301, 303–4, 305
Levy, Leon, 60
Levy, Michael, 324
Lindquist, Mark, 232–33
Lipin, Steve, 166–67
Little River, 284, 285
LJM Cayman LP, 34
LJM partnerships: and Andersen, 292, 293, 294; Baxter's views about, 320; and board of directors, 394; and broadband operations, 187; and Causey interview, 80; and collapse of Enron, 344; compensation for Fastow from, 117, 187, 188; complexity of, 65–66, 187; and

conflicts of interest, 373, 374, 392, 394; and congressional investigations, 372; controls on, 348, 349; creation of, 149–51, 237, 277; and criminal investigations, 331, 364–65; criticisms of, 53–54, 139, 342–44, 345–50; and "death spiral" of Enron, 161, 168; direct Enron transactions with, 131–33; and Dynegy merger discussions, 199; Eavis articles about, 124; and 8K filing, 183, 184, 185–87, 188; and Emshwiller's belief that Palmer misled him, 202–3; and Emshwiller's trip to Houston, 217–19; and equity reduction issue, 126; and Fastow, 50, 65–66, 80, 142, 159, 212, 236, 275, 292, 350; financial/partners' report from, 129–33, 185; and Glisan's plea bargain, 382; investors in, 49–51, 52–53, 57–64, 105, 117, 150, 274–75; and JEDI, 178–79; Kaminski's views about, 342–44; lack of information about, 31–41, 97–98, 236; lawsuit by, 275; and Lay, 283, 339; and lessons of Enron, 392, 392; and McKinsey, 271–72; and "Mutual Friend" reports, 52–56; and National Westminster Bank, 364–65; *New York Times* coverage of, 120; and Nigerian barge deal, 378; and October 23 conference call, 141, 142–43, 144–45; and October 23 employees' meeting, 154; and Powers's investigation, 174, 333–34, 335; "principals" in, 73; and private placement memorandum, 54–55, 97–98, 117, 129, 176–77; and Project Summer, 151; and Raptors, 133, 136, 185–86, 202–3, 275, 335; and reactions to *Journal* stories, 84, 121, 167–68; as related-party transaction, 373, 374; "road show" presentation for, 49–51; and SEC filings, 246; and shredding at Enron, 298–99, 302; size of investment in, 59, 60; Skilling's role in, 283–84; and "structured finance vehicle," 127; terms of, 54–55; and third-quarter earnings report, 97, 104–5, 108, 109, 110, 115–17, 124, 127, 202–3; and unanswered questions about Enron, 237; and waiving of "Code of Conduct," 85, 98; and Watkins-Lay letter, 310. *See also* conflict of interest; partnerships, Enron; *specific partnership*

LJM1. *See* LJM partnerships; partnerships, Enron

LJM2. *See* LJM partnerships; partnerships, Enron

Lockyer, Bill, 14, 15–16, 330, 393
Long-Term Capital Management, 76
Los Angeles Times, 119, 140
Lucas, Brittany L., 255–56
Lucas, Tim, 288
Lynn, Kathy, 188

Mahonia, 274
management fees, 130, 159
managing directors, 74, 171
Margaux, 131
Mark, Rebecca, 7, 37–39, 40, 45, 94, 107, 257, 276
Market, Edward, 243
Marks, Kenneth, 305
Marlin Trust, 137–38, 143–44, 163, 164, 187, 259
McCubbin, Sandi, 8, 369
McGarretts, 266, 268
McGee, Suzanne, 172
McHenry, Donald, 375
McKinsey & Co., 7, 8, 271–73
McLean, Bethany, 32, 124
McLucas, William, 175, 333
McMahon, Jeff: appointed chief financial officeer, 156; and Braveheart, 266; and credit lines, 168; and credit rating, 190; and "death spiral" of Enron, 168; and Dynegy merger discussions, 204, 205, 207; and Fastow, 53–54, 139, 212, 310, 311; and LJM partnerships, 53–54, 105, 139, 346; and November 14 conference call, 204; retention payment for, 235; Skilling's meeting with, 53–54, 139; and 10-Q report, 204; transfer of, 54, 105, 139; and Watkins, 310, 311
media: and analysts' expectations, 112; and Baxter's death, 318, 321, 323, 326, 328; and criminal investigations, 366; expansion of Enron coverage in, 258–70; knowledge about partnerships of, 34; loss of interest in Enron by, 376; and October 23 conference call, 140; reporting frenzy of, 306; and Skilling's indictment, 390; Smith's views about role of, 338–39; and third-quarter earnings report, 111, 112–13; and Watkins-Lay letter, 309. See also newspapers; specific organization or person
Merrill Lynch, 35–36, 53, 64, 133, 274–75, 348, 372, 378–79, 380–81, 392
message boards, electronic, 235–36
Mintz, Jordan, 345–50, 392
Mitchell, Brad, 322–23

Moody's Investors Service, 63, 71, 96–97, 113, 138, 163–64, 173, 190, 200, 201
Mordaunt, Kristina, 187–88, 199, 365, 366
Morgenthau, Robert, 363
Muller, Mark, 316
Muller, Porsha, 316, 318
Mulvaney, Randy, 380
"Mutual Friend," 46, 47–56, 57, 139

Nasdaq, 375
Nash, Jack, 60
National Enquirer, 257, 330
National Multiple Sclerosis Society, 248
National Press Club, 373
National Westminster Bank, 342–43, 364–65
Natural Gas Act (1938), 250
nCube Corp., 265, 268, 290
Neuhausen, Benjamin, 293
New Power Holdings, 64–65, 107–8, 111, 130
New York Stock Exchange, 375
The New York Times: and board of directors' minutes, 283, 284; criticism of Enron in, 140; Enron coverage in, 306; and Glatzer-Boies story, 282, 308; Journal's rivalry with, 13, 29, 179, 189, 230, 306, 307; and partnerships, 283; and Powers Report, 332; scandals of, 392; Skilling interview in, 282; and Skilling's resignation, 9; and third-quarter report, 119–20
newspapers: public views about power of, 58. See also media; specific organization
Newsweek magazine, 246–47, 256
Nigerian barge deal, 377–79, 380–81, 392
Niles, Ray, 34
"non-recurring" items, 293–94
Norris, Floyd, 140
Northern Natural Gas Co. pipeline, 194, 198, 230
nuclear terrorism, 106, 109

Occidental Petroleum, 323
October 23 conference call, 139–41, 142–45, 151–52, 156, 157–58, 161, 165
Odom, Michael, 293, 294, 360
Ogunlesi, Adebayo, 58
Olis, Jamie, 381–82
Olson, John, 35–38, 144–45, 190, 211, 215–16
O'Melveny & Myers, 282, 390
O'Neill, Paul, 200

$1 billion write-off: *New York Times* coverage of, 119, 120; and third-quarter earnings report, 95, 107, 108, 109, 110, 113–14, 116, 124, 148, 293–94
$1.2 billion. *See* equity reduction
Oracle Corp., 265
Osprey Trust, 131, 137–38, 164, 259

"packrat," 267
Pai, Lou, 368
Palmer, Mark: and Baxter's death, 318; and Braveheart, 266; and Calame, 167; and California electricity crisis, 15; and Chewco investigation, 169–70, 179, 180–81; credibility of, 111; and credit lines, 168; Emshwiller's anger with, 202–3; and Emshwiller's attempt to reach Skilling, 14; and Emshwiller's trip to Houston, 211, 212–13, 215; and Enron's complaints about *Journal*, 167–68; and equity reduction issue, 125–26; Fastow's relationship with, 86–87; and Foster, 274; and "Heard on the Street" story, 46; and JEDI, 179; and Kopper's role at Enron, 170; and Lay interview, 42, 43; and Lay-Smith interview, 125–26; and Lay's severance package, 201–2; and October 23 conference call, 145; and partnerships, 19, 21, 88, 89, 97–98, 126, 202–3; and prescreening of questions, 84–85, 86, 88; and SEC inquiry, 136–37; sends fax to board about *Journal*'s calls, 92–93; and September 11 aftermath, 83, 84; and Skilling-Emshwiller interview, 30; and Skilling's resignation, 3–4, 17, 30; stress of, 202; and third-quarter earnings report, 98–99, 109–11, 118, 125–27; and trading-accounting relationship, 78–79; and waiver of "Code of Conduct," 97–98
partnerships, Enron: and accounting/financing practices, 41, 276–77; analysts' views about, 31–34, 44, 132–33; and Andersen, 91, 277, 278, 292, 293, 294; and board of directors, 48, 49, 50, 51, 52, 85, 87, 91–92, 130, 141, 145, 154, 158–59, 188, 212, 283–84, 347, 350; and collapse of Enron, 282; creation of, 33, 141; and credit ratings, 96; and "death spiral" of Enron, 160, 161; employees' views about, 222, 223; Emshwiller first finds references to, 18–19, 20–21, 29; Enron executives's role in, 85, 91; and equity reduction issue, 125, 127–28; Fastow's compensation from, 91–92, 93,

130, 131, 159, 366; as Fastow's idea, 282; and Fastow's inside information, 50, 85; Fastow's reactions to *Journal*'s stories about, 121; Fastow's role in, 212; Fastow's time spent working for, 52, 85, 130, 158–59; Fastow's withdrawal from, 21, 43–44, 91, 151; Glatzer's comments about, 20–21; and "Heard on the Street" story, 25–26, 46; investors in, 282; lack of knowledge about, 33–35, 41, 82; and Lay, 43–44, 49, 51–52, 92, 115–16, 126, 157, 188, 277, 283, 320; and "Mutual Friend," 47–56, 57; need for continuing story in *Journal* about, 120–21; and Powers committee, 174, 332–35, 337; as private partnership, 51; and SEC filings, 33, 34, 45, 51, 65, 66; and short sellers, 138; and shredding at Enron, 300; and Skilling, 25, 49, 52, 54, 141, 277, 282, 283–84, 320, 344, 348–49, 350; and stock price, 33; and third-quarter earnings report, 108; and waiving of "Code of Conduct," 50, 85, 92, 117. *See also* conflict of interest; Fastow, Andrew; LJM partnerships; "Special-Purpose Entities"; *specific person or partnership*
Pathnet Telecommunications, Inc., 65
Paulson, Henry M., Jr., 373
Peers, Martin, 261, 262
Pellecchia, Ralph, 164
pension funds, 376
performance review committee/process, 8, 53, 273
Perkins, Joe Bob, 163
Perry, Deborah, 200
Petrocelli, Daniel, 390
Pieri, Mickey, 252
pipeline business, 175–76, 264. *See also* Northern Natural Gas Co. pipeline
Playboy magazine, 256
plea bargains, 381–83. *See also specific person*
Portland General Electric Co., 143, 193, 314, 365–66, 367, 368
power plants: security issues at, 84
Powers (William "Bill," Jr.) committee: creation of, 174–75; interview memos from, 338–40, 341–44; Powers's comments about, 337–38; report of, 332–37, 346
prescreening of questions, 84–88
private placement memorandum (LJM2), 54–55, 97–98, 117, 129, 176–77
Project Alpha, 382
Project Summer, 151

Pronghorn, 335
Prudential Securities, 148, 149

Raghavan, Anita, 274–75, 284, 378
Ramsey, Mike, 394–95
Randolph, Ken, 199
Raptors: and Andersen, 278–79, 290,
 292–93, 294, 309, 310; and assets,
 335–36; and board of directors, 310; and
 Causey indictment, 388; as central to
 Enron fraud, 383; and collapse of Enron,
 344; and criminal investigations, 331;
 and 8K filing, 185–86; amd Fastow
 indictment and plea bargain, 387, 389;
 first appearance in Smith-Emshwiller
 story of, 133; and Glisan plea bargain,
 382, 387, 389; lack of knowledge about,
 236; and Lay, 186, 310, 337; and LJM
 partnerships, 133, 136, 185–86, 202–3,
 275, 335; Powers's comments about, 337;
 and Powers Report, 333, 334–35; and
 Skilling, 310, 334, 335, 336, 389; and
 stock price, 335–36; and third-quarter
 earnings report, 185–86; Vinson & Elkins
 review of, 310–11; and Watkins-Lay
 letter, 309, 395
Rawhide, 131, 204
"Ray," 149–51
Reasoner, Harry, 174
Reg S offerings, 72
related-party transactions, 18–19, 20–21,
 43, 98, 134–41, 144, 171, 174, 203–4,
 333, 350374–75, 376. See also
 partnerships, Enron
Reliant Energy, 163, 213
retention payments, 235, 263
retirement funds: lockdown on, 234–235
reverse stock splits, 123
Rhythms NetConnections Inc., 342–43,
 344, 364–65
Rice, Kenneth, 264
Rice University, 324
Riley, John, 295
Roosevelt, Theodore, 391
Rosch, William, 379
Ross, Brian, 300–301
Rubin, Robert, 200
"run on bank" phenomenon, 243, 282
Rundle, Rhonda, 134, 135

Salomon Smith Barney, 165
Sapsford, Jathon "Jay," 172, 274, 382
Sarbanes-Oxley Act (2002), 376
Schulte, Vanessa, 256

Schwartzenegger, Arnold, 393
Schwieger, Jim, 152, 154–55
Scism, Leslie, 27
SE Thunderbird LP. See Thunderbird
Securities and Exchange Commission, U.S.
 (SEC): and accounting/financial
 practices, 288; and Andersen, 286, 354;
 backlog at, 135–36; functions/powers of,
 135–36, 137, 175; funding for, 376;
 inquiry/investigation into Enron by,
 134–37, 140, 141, 144, 145, 148–49, 175,
 236, 372; inquiry vs. investigation by,
 137, 148–49; and "mark-to-market"
 accounting, 79, 80; and "Special-Purpose
 Entities," 259–60; and third-quarter
 earnings report, 294; and Watkins-Lay
 letter, 309. See also filings, SEC
Securities Exchange Act (1934), 287
Segnar, Sam, 253
Senate investigations. See congressional
 investigators
sentences for corporate fraud, 376, 387
September 11, 2001, 83–84, 152, 161, 221,
 222
severance packages, 201–2, 233, 252, 263
SFAS 125, 259–60, 266
Shell Oil, 40
Shirron, Bill, 59–60
"shock wave" story, 220
short sellers, 40–41, 81, 82, 122, 123, 124,
 129–31, 138
shredding: by Andersen, 285, 286–87, 295,
 296, 297, 303, 353–62; at Enron,
 297–303, 305, 364
Sidel, Robin, 194
Siemens-Westinghouse, 59
Silverman, Rachel Emma, 271, 272
Sitrick, Mike, 181–82, 194
Skilling, Betty, 246–47
Skilling, Jeff: analysts' reliance on,
 37; attitude about being CEO of,
 17, 23; attorneys for, 389, 390;
 background/profile of, 37, 241–49; and
 blueberry pie incident, 16; as board
 member, 89; bond for, 389; and collapse
 of Enron, 243, 282–83, 311; and
 corporate culture, 256; employees' views
 about, 223; Emshwiller's interview with,
 21, 22–30; Emshwiller meets, 225–26;
 family/personal life of, 4, 10–11, 17,
 23–24, 30, 44, 246–47, 340, 385, 389;
 and Fastow, 52, 53, 54, 67, 68, 72, 283,
 349, 350, 385, 388; follow-up story on
 resignation of, 12–21; health of, 248; and

Houston business conditions, 211; image/reputation of, 276, 330; indictment of, 372, 384–85, 388–89, 395; as innovator, 273; and Lay, 8, 22, 37–38, 39, 43, 44–45, 145–46, 247–49, 254, 339–40, 394; and Lay-Lockyer relations, 15–16; and lessons of Enron, 394; lifestyle/home of, 214, 225, 385; and logo of Enron, 213; and "mark-to-market" accounting, 150; named president and CEO, 39–40; and October 23 conference call, 145; offers to return for no pay, 145–46, 282; as one of best corporate executives, 32; personality and ambitions of, 7, 8, 9, 16, 31–32, 40, 225, 244–46, 247, 248–49; and pizza parties, 272; plans for future of, 23; post-bankruptcy media interviews of, 282–83; and Powers Report, 333, 334, 337; resignation of, 3–11, 23–24, 35, 44, 49, 148, 237, 308, 309, 320–21, 336, 340, 349; and rumors, 140; and shareholder lawsuits, 139; Smith's contacts with, 7–8, 9, 384–85, 389; stock options of, 16; and stock price, 9–10, 11, 16, 22–23, 24, 25, 30, 243, 244–45, 340, 349; surrender to federal officials of, 389; and trading business, 77; trial for, 390; and unanswered questions about Enron, 237; views about federal investigation of, 385; vision of, 31, 37; Wall Street as model for, 74. *See also specific person or topic*

Skilling, Mark, 246–47, 248, 325, 389

Skilling, Tom, 246

Slapshot, 260

Smith, Rebecca: Emshwiller's relationship with, 27–28, 59, 175, 222–23, 377; personal and professional background of, 4–5, 7; and lessons of Enron, 390–92; reporting style of, 28; views about role of press of, 338–39. *See also specific person or topic*

sources: Smith's and Emshwiller's views about, 338–39. *See also specific source*

Southampton, 364–65, 383, 385, 386, 387

"Special-Purpose Entities," 187, 189, 259–70, 279, 288, 335. *See also partnerships, Enron; specific entity*

Standard & Poor's (S&P), 63, 71, 95–96, 113–14, 123, 138, 149, 163–64, 190, 209

Steiger, Paul, 29, 167

Stevens, Todd, 323

Stewart, James, 29

Stewart, John, 290, 291, 292

stock options, 16–17, 40, 375. *See also specific person*

stock price: and bankruptcy filing, 232; and Baxter's wealth, 325; and Braveheart, 264; and collapse of Enron, 228; and conference calls, 140; and "costless collar," 336; and credit ratings, 173; and "death spiral" of Enron, 160, 161, 165; decline in, 32, 132, 134, 156, 176, 208–9, 335–36; and Dynegy merger discussions, 201, 215; and Fastow's CFO Award, 72; and "Heard on the Street" story, 45; influence of interviews on, 82; and Lay interview, 43, 44; and LJM-Enron transactions, 132; and October 23 conference call, 142, 143; Olson's view about, 37; and partnerships, 33, 150; and Raptors, 335–36; and rumors of takeover, 174; and SEC inquiry, 135; Skilling's concern about, 9–10, 11, 16, 22–23, 24, 25, 30, 243, 244–45, 340, 349; and 10-Q filing, 206; and third-quarter earnings report, 118, 122; and trigger provisions, 138

Strauss, Willis, 253

"structured finance vehicle," 107, 108, 109, 110, 115–16, 123, 126–27, 128, 189

Sun Microsystems, 10, 325

Supreme Court, U.S., 374

Tabolt, Dave, 285

takeover target: rumors of Enron as, 173–74

Talon, 335

Tarpley, Hugh, 196

Tauzin, Billy, 242

Temple, Nancy, 294, 361–62, 372

Texaco Inc., 231

TheStreet.com, 124, 137–38

Thibaut, Marie, 233–34, 235

third-quarter earnings report: analysts' recommendations following, 148; analysts' views about, 94, 107, 111–12; and Andersen, 293–94; contents of, 106–18; and credit rating agencies, 94–99; delay in announcing, 98–99; and Dynegy merger discussions, 204; follow-up to, 119–29; Lay-Smith interview about, 115–16; and Lay, 106, 107, 108–9, 112–13, 115–16, 126; Lay's conference calls/interviews about, 112–15; and LJM partnerships, 202–3; media coverage of, 104, 111, 112–14, 115; and October 23 employees' meeting, 154; pipeline profits reported in, 175; Temple's memo about,

third-quarter earnings report (cont.) 361; and 10-Q filing, 204. See also equity reduction; filings, SEC: 8K; $1 billion write-off
Thomson Financial/First Call, 16, 40, 111
3 percent rule, 259, 260, 279, 284, 288, 290, 335
Thunderbird, 66, 82, 268
The Times of London, 140
Today Show (NBC-TV), 394
"total return swap," 259
traders, Enron, 151, 201, 202, 215, 256, 367, 369
trading business: and accounting, 77–82; audits of, 289; Baxter's views about, 320; and California electricity crisis, 76–77; and collapse of Enron, 228, 382; and credit ratings, 78, 209, 370; and "death spiral" of Enron, 160, 162–63; and Dynegy merger discussions, 194, 196, 197, 205, 207, 209, 221; Enron statement about, 190; and Mark-Skilling relations, 38, 39; research about, 76–82; and Skilling as innovator, 273; and third-quarter earnings report, 95; and "wash" trades, 81–82. See also California electricity crisis; EnronOnline
trading floor: Fastow comes to, 155
Treasures (Houston, Texas), 255–56
trial, risks of going to, 381–82
trigger provisions, 138, 204
trusts, 162. See also specific trust
Turner, Lynn, 279
Tyco International, Ltd., 363

UBS Warburg, 119–20, 391
USA Today, 140

video on demand, 261–62
Vinson & Elkins, 141, 174, 253, 310–311
Vittor, Liz, 253
Volcker, Paul, 354

Wachovia Corp., 58
Walker, Pinkney, 250

Wall Street Journal: and analysts' expectations, 112; culture of, 26; discretion of reporters at, 82; Enron coverage in, 306–7; Enron employees' hostility toward, 222; front-page stories of, 55–56; headlines exposing Enron in, 102–3; Lay's/Enron's views about, 166, 167–68; New York Times's rivalry with, 13, 29, 179, 180, 230, 306, 307; package of Enron stories in, 172–73; placement of stories in, 28–29; profiles in, 241–42; readership of, 26; related-party survey by, 373–76. See also specific person
Walzel, Jim, 253
Wartzman, Rick, 306, 307
"wash" trades, 81–82, 370
The Washington Post, 120, 140, 332
Watkins, Sherron, 64, 154, 308–10, 311, 318, 346, 357, 392, 395
Watson, Charles L., 194, 196–98, 199–201, 205–6, 208, 220
Weil, Jonathan, 78–79, 173, 279
Weil, Gotshal & Manges, 194–95, 230
Weill, Sanford, 207
Weingarten family, 68–69
Weissmann, Andrew, 355, 361, 390, 394–95
Weyerhaeuser pension fund, 53
Whalley, Greg, 142, 152, 195, 197, 207, 212
whistle-blowers, 392–93. See also specific person
Whitewing Associates LP, 66
Whitewing Management LLC, 66
Will, George, 286
Wilmer, Cutler & Pickering, 174
Winans, R. Foster, 27
wind farms, 365–66, 372
Winokur, Herbert "Pug," 199
WorldCom Inc., 363
Worth magazine, 32
Wray, Christopher, 383
Wyatt, Oscar, Jr., 252

Yaeger, Anne, 188
Yahoo Finance, 235–36